University of Wales

Centre for Advanced Welsh

and Celtic Studies

THE VISUAL CULTURE OF WALES

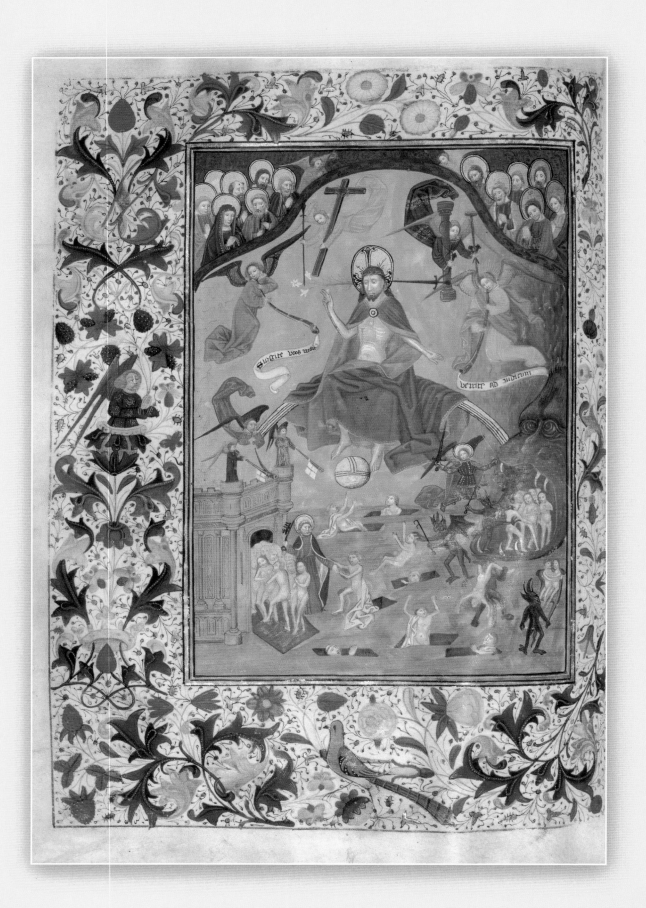

THE VISUAL CULTURE of ❧ WALES :

Medieval Vision

Peter Lord

Research Assistant:
John Morgan-Guy

UNIVERSITY OF WALES PRESS, CARDIFF

2003

The Visual Culture of ℘ Wales

General Editor: Geraint H. Jenkins
Designer: Olwen Fowler

© University of Wales, 2003

Printed in Wales by
Cambrian Printers, Aberystwyth

**British Library
Cataloguing-in-Publication Data**
A catalogue record for this book is available from the British Library.

ISBN 0–7083–1801–0

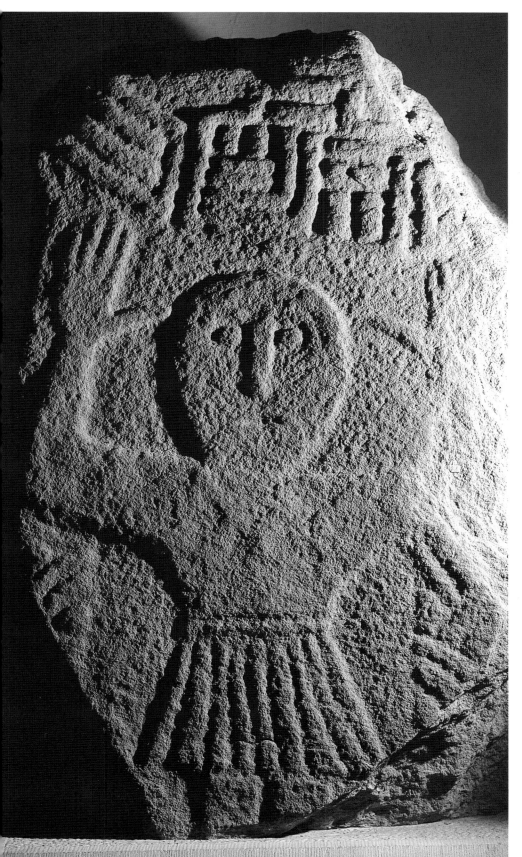

Contents

PREFACE

It gives me great pleasure to bring into the public domain the third and final volume in the series 'The Visual Culture of Wales', the fruits of a major international project carried out at the University of Wales Centre for Advanced Welsh and Celtic Studies at Aberystwyth. When this project was launched in 1995 it marked a new departure in the research portfolio of the Centre and over the years it has more than fulfilled our expectations. The previous volumes by Peter Lord – *Industrial Society* and *Imaging the Nation* – have made a seminal contribution to our appreciation of the visual culture of Wales and have been received with warm critical acclaim. We are confident, too, that this pathbreaking volume will stimulate debate within scholarly circles and open up to the public at large a field which is evidently rich in visual imagery.

Collaborative teamwork is the leitmotif of the Centre and, as general editor of the series, I'm deeply sensible of the hard work, dedication and co-operation of those who have made this enterprise an outstanding success. My greatest obligation is to Peter Lord, the leader of the project and author of the trilogy. By dint of intellectual leadership and unflagging determination, he has spearheaded the recent breakthrough in the documentation and interpretation of the artistic history of Wales. He has been singularly fortunate in his research assistant, John Morgan-Guy, whose expertise in medieval theology and eye for visual detail have been indispensable. In the initial stages Gillian Conway compiled useful data from printed sources and, more recently, Martin Crampin, whose principal task is to design and produce the accompanying CD-ROM series, has proved an invaluable ally. Members of other projects at the Centre have been pressed into service, particularly those working on Welsh medieval poetry, and special thanks are owed to M. Paul Bryant-Quinn, R. Iestyn Daniel, Rhiannon Ifans and Ann Parry Owen. Glenys Howells, our editorial officer, brings to the Centre editorial standards which are second to none, and everyone associated with this project is deeply beholden to her, as indeed they are to Hawys Bowyer and Nia Davies for administrative and secretarial assistance. William H. Howells expeditiously compiled the index and the skill of the designer, Olwen Fowler, has ensured that this book, like its forebears, is a delight to handle and to read.

Since this volume offers a new interpretation of the visual culture of medieval Wales, we were pleased to receive generous (and sometimes forthright) guidance and advice from three wise and experienced readers – the Very Reverend J. Wyn Evans, Mr Daniel Huws and Professor Emeritus J. Beverley Smith – each of whom read the entire typescript. We are truly grateful to them. Professor Miranda Aldhouse-Green was also kind enough to read, and comment on, the first chapter. Members of the Advisory Panel of the project – Oliver Fairclough, Michael Francis, Emma Geliot, Isabel Hitchman, Sheila Hourahane, Donald Moore, Nich Pearson, Richard Suggett and John Williams-Davies – have given freely of their time and expertise.

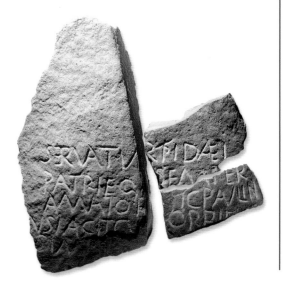

Only those closely associated with this project will appreciate how much planning, research and fieldwork have been devoted to the task of discovering, recording and analysing the material reproduced in this book. Significant detective work was carried out in America, Belgium, England and Ireland as well as in Wales. We are particularly indebted to a host of private individuals, the incumbents of parish churches, the curators of museums and the staff of archaeological trusts and libraries for their patient co-operation. Our debt to Charles and Patricia Aithie, who were specially commissioned to provide new photography, is immense, and at the end of this volume we gratefully acknowledge permission received from a wide range of institutions and individuals to reproduce visual material. We also warmly thank Scanagraphics Ltd., Cambrian Printers, and the University of Wales Press for their full co-operation. It is a matter of pride for us that this whole enterprise – from the initial research to the final binding of the volumes – has been undertaken within Wales.

A venture like this can only succeed with the approval and support of major cultural institutions, trusts and foundations. The University of Wales has invested heavily in this project and we gratefully acknowledge in particular the support of the Senior Vice-Chancellor, Professor Derec Llwyd Morgan, the Secretary General, Dr Lynn E. Williams, and the Director of Resources, Mr D. Ian George. Our nearest neighbour is the National Library of Wales, upon whose splendid resources we depend on a daily basis. Its President, Dr R. Brinley Jones (who is also Chair of the Centre's Management Committee), and its Librarian, Mr Andrew Green, have been staunch champions of this project, as indeed have their staff at all levels. Likewise, the staff of the National Museums and Galleries of Wales have placed their rich resources at our disposal, for which we sincerely thank them. A key factor in the success of the project has been the extremely generous financial support of the Lottery Division of the Arts Council of Wales, and we are also deeply grateful to the British Academy, the University of Wales Board of Celtic Studies, the Jane Hodge Foundation, the Leverhulme Trust and the Pilgrim Trust for awarding substantial grants to the Centre to promote this particular enterprise.

At a time when the appetite for history is increasing by the day and when the people of Wales are acquiring greater confidence in their identity, a thorough understanding of our past, especially our visual inheritance, has never been more necessary. We hope that the wealth of material contained in this volume, and in that of its predecessors, will prove to be a lasting contribution to a rapidly developing field of study.

Geraint H. Jenkins
June 2003

INTRODUCTION

Even if we do not attempt to travel far, entering the country of the past makes great demands on our imagination. For instance, the actions of many of our forebears in the western world of the late nineteenth century were conditioned by assumptions about race, which now seem to most of us not only absurd but also obscene. Such ethical discontinuity makes it difficult to write about them with empathy. Nevertheless, we remain sufficiently close to that period to find there the dissenting individuals whose ideas evolved into the mainstream of our own thought. If we choose to do so we may construct a narrative of history which leads from them to us, like an open pathway. We must travel much further if we wish to enter, through our imagination, the European Middle Ages. Fundamental perceptions about the place of individual human beings in the universe were different then, and it is impossible to make pathways which are not, from time to time, interrupted by chasms which seem too wide to cross. Furthermore, the country we enter provides us with less material evidence to inform our thoughts than does the nineteenth century. Yet our occupancy of the same piece of the earth and our inheritance of some of the signs made here by our predecessors drive us to make the attempt. Our instinct to value the relics of the past of this place and make them our own demands to be informed by imagining the experience through which they were created.

The first stage in the preparation of this book was simply to identify and locate as many medieval images and relevant artefacts as possible. As is the case in the two volumes in this series dealing with the modern period, architecture is not part of our remit, except in so far as a building can be considered as an image. Thus Caernarfon Castle is discussed because its design was intended to reflect the walls of Constantinople, with all the symbolic resonance they carried. Other Edwardian castles are dealt with mainly as a part of the late thirteenth-century context surrounding the images which are the main concern of the text. Nevertheless, because so many of those images were conceived either as a physical part of a

building or were very much dependent in their design on their
architectural context, building is discussed more often than was
the case in the other volumes. The initial search for images was
undertaken mainly by my colleague Dr John Morgan-Guy, for
whom written sources from the nineteenth and early twentieth
centuries proved particularly important. *Archaeologia Cambrensis*,
published from 1846, and the periodicals of the county history
societies revealed a far larger number of survivals than had been
anticipated. Together, John and I made a preliminary assessment of,
and selection from, these secondary sources and undertook some two
years of fieldwork in which we examined and photographed nearly every image
and artefact. Close inspection frequently revealed the inadequacy of the published
descriptions, many of which had never been reviewed. In particular, we were struck
by the extent to which the political, social and theological attitudes of the writers
determined that which they did and did not see. Alongside simple parochialism,
the description of objects with a view to the reinforcement of Nonconformist and
Nationalist ideas was very apparent. This observation does not devalue the work
of pioneers such as Stephen W. Williams, who excavated Cistercian and other sites
in the late nineteenth century, any more than comments about the implications
of the political and religious views of individuals such as Iorwerth C. Peate, made
in the volumes in this series which deal with the modern period, devalue theirs.
The observation is intended to emphasize the importance in all three texts of my
belief that, above all else, history reflects the needs and aspirations of the present
of the historian.

It became clear that professional standpoints had also played an important part
in determining what was and was not seen. Until the end of the twentieth century
almost every aspect of the visual culture of Wales in the modern period had been
neglected, but the situation in the study of visual culture in the medieval period
was somewhat different. Although no attempt had been made to consider the
subject as a whole, certain fields had been examined with care and by individuals
able to deploy considerable expertise. The work of V. E. Nash-Williams on early
Christian inscriptions and stone carvings, and that of Colin Gresham on the
carving of stone memorials in north Wales in the later Middle Ages were, perhaps,
the most notable examples. Nevertheless the disciplines of archaeology as perceived
in the period of these writers – apparent in attitudes to the categories of artefacts
considered relevant to their studies, for instance, and the emphasis placed on

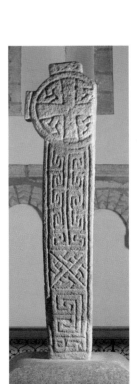

description rather than social interpretation – set limits which it was necessary to transcend in order to meet the needs of a general history of visual culture written in the twenty-first century.

The depredations of the Victorian rebuilding of churches deprived us of many medieval images and artefacts recorded in written sources and often distorted the context in which the survivals were subsequently to be seen, adding to the difficulties of empathetic understanding. In the second half of the twentieth century the decline in church attendance and the consequent decay of buildings made access to much of what remained increasingly difficult and threatened its long-term survival. Nevertheless, the majority of the images and artefacts presented in this book are to be found in churches. Examining extraordinary survivals in dark and crumbling ruins, such as the font in the Church of St Peulan, Llanbeulan in Anglesey, aroused in us conflicting feelings of elation and depression. We hope that the revelation of such artefacts, most of which have been photographed for this volume by Charles and Patricia Aithie, will assist the efforts of those people all over Wales who work to secure their future. We thank the many such individuals who allowed us access to places and artefacts in their care and shared with us their often extensive knowledge.

In four of the five chapters of this book images and artefacts have been described broadly in chronological order and in terms of the intellectual and material circumstances surrounding their manufacture – the general political and economic context and the more particular whys and wherefores of patronage and practice. Sometimes we have suggested a broader visual context than that which can be illustrated by examples, though this is a difficult and contentious matter. For instance, it seems probable that wood carving played an important part in our visual culture in the early medieval period. However, no examples survive and so the attempt to adjust the widespread perception of Wales as a barren and mountainous country dotted with stone crosses and very little else is fraught with difficulty. Partly in response to the problem created by the random nature of survivals, in the fourth chapter we have approached the material in a different way. The lives of most people in Europe in the Middle Ages were governed by their consciousness of the annual cycle of the Life and Passion of Jesus, and the interlocking cycles of the lives of the Virgin Mary and the saints. The theology of the salvation cycle gave the individual his or her sense of place in the universe, whether it was perceived by means of the deep contemplation of the pious or

simply by observing the Christian festivals which marked the agricultural year on which all, pious or otherwise, depended. We have attempted to gain some insight into that sense of place by presenting and explaining the religious icons which symbolized the fixed points in the turning of the medieval year. Clearly, within the narrative of a single chapter it was possible only to suggest the significance of images which were invested with great depths and many subtle variations of meaning. In the footnotes we have deepened the discussion of some matters which seemed to us particularly important or difficult, and we have suggested sources to which the reader may turn for further insight. The chapter appears in the second half of the book rather than at the beginning (as might seem more appropriate) simply because it is not until the fourteenth and fifteenth centuries that a sufficient body of work from a time-frame small enough to be coherent can be assembled to give a reasonably full picture.

It is in this fourth chapter that we face most directly the difficulty of crossing those chasms of perception which divide the medieval period from our own. In modern western societies a view of the world which is informed by Christianity (or, indeed, by any other religion) is one into which an individual may opt. With the exception of some religious minorities, the most important of which were the Jews, in the Middle Ages people were born into Christendom and although an individual may have been a weak Christian, perhaps a bad Christian, or even a sceptical Christian, nevertheless he or she remained within the Church and a system of belief which encompassed all things. The distinction between scientific truth and religious truth, drawn with increasing clarity through the modern period, would have had no meaning to a medieval European. In order to understand the medieval world view it is necessary to grapple with elusive notions of the simultaneous and harmonious reality of different kinds of being, and of a fluid interchange between them. As the images so often demonstrate, people had a sense of the events of the Life and Passion of Jesus as a present reality. Past and present time stood in relation one to the other rather as events depicted in different parts of a painted image – distinct, yet bound together in a common space by the continuity of the picture plane. The meaning of images had a similarly fluid quality. The depiction of an animal, for instance, will be read by most modern observers initially in

naturalistic terms, but in the Middle Ages it would have been understood primarily in narrative and symbolic terms as explicating the Christian understanding of life. Among the most taxing problems of any attempt to empathize with the medieval mind is the obscurity of many of these narratives which, while they sometimes remain accessible to specialists familiar with early written sources, are certainly beyond the residual memory of most western people, even those who retain some biblical knowledge. Many orally transmitted folkloric narratives are irretrievably lost.

For those, like myself, who are not Christian believers, perhaps the best we can hope to achieve in our attempt to understand the medieval mind is an imaginative crossing of the chasms of perception, informed by intellect. For Christians it may still be possible to cross in a more intuitive way, though I suspect the difficulties are great. The text of *The Visual Culture of Wales: Medieval Vision* arises from some four years of discussion of such issues in the company of John Morgan-Guy. John is an Anglican priest ordained in the Church in Wales, and a teacher of church history and of theology. This background and his particular interest in the Middle Ages has informed the text in fundamental ways. As I have noted, together we inspected almost all the artefacts described, argued about the main themes which they suggested and about many matters of detail revealed by John's meticulous research. Furthermore, although the construction of the narrative has been my work, I will not repeat the form of words, conventional in such circumstances, to the effect that any misconceptions it incorporates are my own, because John's final task was to subject the text to careful scrutiny, chapter by chapter. It was returned to me with much red ink applied and, by and large, adjusted accordingly. Therefore, I fear he must bear his share of the responsibility for any professional hats blown off by the draught of fresh air which we have tried to direct at the large body of significant, often powerful, but sadly neglected images from medieval Wales presented here. This book is as much his as it is mine, and I thank him for four years of happy and enlightening co-operation.

c h a p t e r

o n e

WALES AND THE WESTERN CULTURES

[1] A wide range of evidence relating to the question of the transition from Roman to early medieval society in the emergent Wales is summarized in Christopher J. Arnold and Jeffrey L. Davies, *Roman and Early Medieval Wales* (Stroud, 2000).

[2] Similarly, a Roman altar stone, reused as a grave marker at Loughor, was probably taken from nearby Leucarum. F. Haverfield, 'Military Aspects of Roman Wales', *Transactions of the Honourable Society of Cymmrodorion* (1908–9), 160.

[3] Gildas, *The Ruin of Britain and other works*, edited and translated by Michael Winterbottom (London and Chichester, 1978), p. 17.

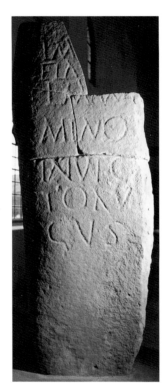

1. The Stone of Cantusus, found near Port Talbot, Glamorgan, inscriptions c.309–13 and 6th century, ht. 1530

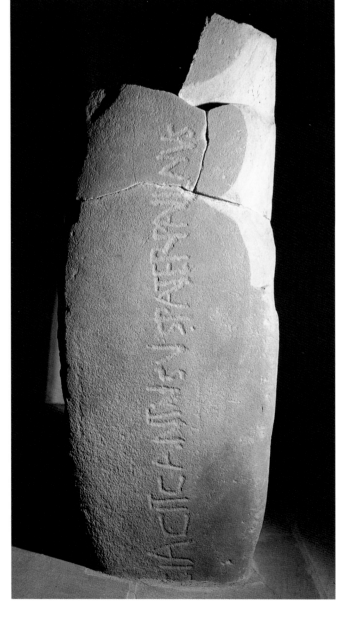

Sometime between the years 309 and 313 a milestone was set up near what is now Port Talbot on the Via Julia Maritima, the road which reached out from the legionary fortress of Isca (Caerleon) to the westernmost extent of the Roman Empire. As that empire crumbled, the authority which protected such official markers was weakened and in the sixth century the stone was removed, cut with a new inscription, and reset to mark the grave of one Cantusus, son of Paulinus. Although the use of this redundant stone clearly indicates a discontinuity in culture, ways of life established over the four hundred years of the Empire did not disappear immediately.[1] Continuity is also apparent, since the new inscription from Port Talbot was written in Latin and cut with well-formed Roman capitals. Although Roman towns and military settlements were gradually deserted during the fifth century, elements of their way of life lived on in the Latin language and its visual representation.[2] Indeed, some deserted Roman towns survived in substantial measure through the early Middle Ages. Any materials and artefacts of intrinsic value no doubt disappeared at an early date, but the demand for building stone does not seem to have been sufficient until the twelfth century to have caused much disturbance. Archaeological evidence tends to confirm that building in the early Middle Ages was on a limited scale and primarily in wood. How these ghostly reminders of an older order at Caerleon, Caer-went, Carmarthen, Caernarfon and many smaller sites were perceived in the sixth or seventh centuries is difficult to imagine. For Gildas, they were reminders of 'the devilish monstrosities' of paganism, 'numerous almost as those that plagued Egypt, some of which we can see today, stark as ever, inside or outside deserted city walls: outlines still ugly, faces still grim'.[3] However, the stringent historical and religious framework of Gildas's thought may have been exceptional, and it is not unreasonable to suppose that individuals of a more pragmatic turn of mind were impressed by what they saw.[4] The contrast of the ruins with the small scale of new settlements, whether secular or religious, reflected the straitened economic circumstances of the post-Roman

period, and must have given those who viewed them pause for thought. Even as late as 1188, by which time many large Romanesque churches had been built, the scale of Roman Caerleon impressed Giraldus Cambrensis:

> You can still see many vestiges of its one-time splendour. There are immense palaces, which, with the gilded gables of their roofs, once rivalled the magnificence of ancient Rome. They were set up in the first place by some of the most eminent men of the Roman state, and they were therefore embellished with every architectural conceit. There is a lofty tower, and beside it remarkable hot baths, the remains of temples and an amphitheatre. All this is enclosed within impressive walls, parts of which still remain standing. Wherever you look, both within and without the circuit of these walls, you can see constructions dug deep into the earth, conduits for water, underground passages and air-vents. Most remarkable of all to my mind are the stoves, which once transmitted heat through narrow pipes inserted in the side-walls and which are built with extraordinary skill.[5]

Only at Dinas Powys have relics of the immediate post-Roman period survived in abundance.[6] Nevertheless, supported by scattered finds from comparable sites, such as Pant-y-saer in Anglesey and Dinas Emrys in Caernarfonshire, they are sufficient to give a broad picture of the material culture of the fifth and sixth centuries, and have been well summarized by Leslie Alcock, the archaeologist who excavated the site:

> [Dinas Powys] was the seat of a princely household, wealthy enough to import wine and pottery from the Mediterranean in order to maintain a romanized way of life; wealthy enough, moreover, to patronize jewellers working in bronze, gold, and glass as well as blacksmiths and other craftsmen ... the basis of the economy seems to be stock-raising and the utilization of animal products, but this was certainly supplemented by arable farming and to a lesser extent by the exploitation of local mineral resources. The lord of Dinas Powys lived in a hall which appears to have been a dry-stone building with parallel sides and round ends; there were subsidiary buildings of stone and perhaps of timber ... within the framework of early Welsh society, it may conveniently be described as a *llys*.[7]

Whether the retinue of the occupant of Dinas Powys included the masons and carpenters who built the *llys* (court), or whether they were drawn, as and when required, from an independent pool of peripatetic specialists is unclear. The church at Monkwearmouth, Co. Durham, was built in the late seventh century by masons borrowed by Benedict Biscop from his friend Abbot Torhthelm in Gaul, though unusually high ambitions on the part of that particular patron may have required exceptional measures.[8] Among the earliest Welsh commentators on artisan practice was Nennius, who, writing in the early ninth century, said that Gwrtheyrn (Vortigern) 'brought together skilled workmen, that is stone-cutters,

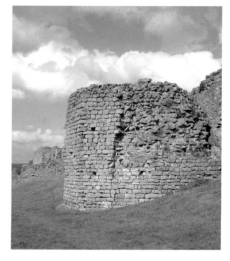

2. Bastion at Caer-went, Monmouthshire, c.330–40, on earlier south wall

[4] The archaeologist Leslie Alcock, who excavated Dinas Powys, believed that luxury Roman ceramics found at the fifth- and sixth-century site in Glamorgan were instances of 'the collection of curios from deserted Roman sites ... sentimental mementoes, perhaps, of the happier days of Roman rule'. Leslie Alcock, *Dinas Powys: An Iron Age, Dark Age and Early Medieval Settlement in Glamorgan* (Cardiff, 1963), p. 25.

[5] Gerald of Wales, *The Journey through Wales and The Description of Wales*, trans. Lewis Thorpe (Harmondsworth, 1978), pp. 114–15. The principal basilica at Caerleon was larger than the cathedrals and abbeys being built as Giraldus wrote. On the other hand, writing of the contrast between Roman and post-Roman building in smaller scale domestic settlements scattered outside the towns, such as Din Llugwy in Anglesey, Wendy Davies warned that 'there is no reason at all to visualize them as miserable hovels'. Wendy Davies, *Wales in the Early Middle Ages* (Leicester, 1982), p. 27. Nevertheless, in proceeding to liken such buildings to Roman villas, Professor Davies would seem to overstate the case substantially, since in terms of architectural sophistication even the smaller villas were of a different order from the settlements which succeeded them.

[6] For an archaeological overview of the material culture of post-Roman Wales down to the Norman conquest, see Mark Redknap, *The Christian Celts: Treasures of Late Celtic Wales* (Cardiff, 1991).

[7] Alcock, *Dinas Powys*, p. 61.

[8] See Nikolaus Pevsner, *County Durham* (2nd ed., Harmondsworth, 1983), p. 65.

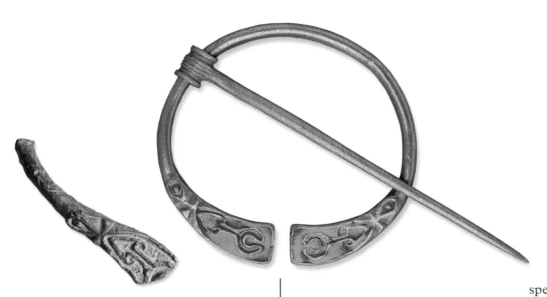

3. Fragment or Failed Casting
of a Penannular Brooch, found
at Dinas Powys, Glamorgan,
6th century, Copper alloy, 50 × 6,
and reconstruction, diam. 100

[9] A. W. Wade-Evans (trans.), *Nennius's 'History of the Britons'* (London, 1938), p. 62.

[10] 'Pais Dinogad i fraith, fraith: / o grwyn balaod ban wraith', translated by Anthony Conran, *The Penguin Book of Welsh Verse* (Harmondsworth, 1967), p. 79. For the poem and its context, see Marged Haycock, ' "Defnydd hyd Ddydd Brawd": Rhai Agweddau ar y Ferch ym Marddoniaeth yr Oesoedd Canol' in Geraint H. Jenkins (ed.), *Cymru a'r Cymry 2000: Wales and the Welsh 2000* (Aberystwyth, 2001), pp. 42–6.

[11] For a description and analysis of the finds at Dinas Powys, see Alcock, *Dinas Powys*, pp. 103–88. The glass included broken fragments from a wide range of sources, and it is most unlikely that it was intended for the manufacture of drinking vessels and the like. Penannular brooches are ring-like, but the circumference is incomplete. They have been found at several contemporary sites in other parts of Wales, notably Pant-y-saer, Anglesey, where the raw material was a silver-copper alloy. See James Graham-Campbell, 'Dinas Powys metalwork and the dating of enamelled zoomorphic penannular brooches', *Bulletin of the Board of Celtic Studies*, XXXVIII (1991), 220–32.

and he collected together timber and stones', which tends to confirm the view that a skilled workforce was not readily available and required that specialists be brought together from far and wide.[9] On the other hand, the residents of Dinas Powys certainly practised a range of craft skills, and in particular the women, who were given voice in a Welsh poem of the seventh century, 'Pais Dinogad' (Dinogad's smock):

Dinogad's smock is pied, pied –
Made it out of marten hide.[10]

Tools for leatherworking were found at Dinas Powys and it is clear also that both locally mined iron ore and imported bronze were smelted and formed into a range of artefacts. The amount of waste generated by the metalworkers suggests that they also may have been resident. Although no examples of their work survive intact, pieces of enamelled jewellery of late Celtic design were found among the waste. Broken glass for the manufacture of enamel was discovered in substantial quantities, as well as crucibles, and, most importantly, a lead die (or possibly a trial casting) for a penannular brooch.[11] The type, in which the raised design would have been offset against red enamel, has been found at various Irish sites, indicating contemporaneous manufacture on both sides of the sea. It exemplifies the orientation of emergent Welsh culture towards influences transmitted over water in the period of the westward movement of the pagan Anglo-Saxon peoples from which England would ultimately develop. An intense cultural interaction between western Britain and Ireland developed, enriched by influences from southern Europe and north Africa.[12] Finds of imported wares originating in the Mediterranean basin bear out reports in literary sources of regular travel to that area. Although written down much later than the period in which, in all probability, it was conceived, a story in 'Culhwch and Olwen' in the Mabinogion about Cei masquerading as an itinerant craftsman furbishing swords probably reflects a reality of craft practice and patronage. Demand in any one place would have been insufficient to sustain craftspeople practising highly specialized skills, so that peripatetic practitioners would have flourished alongside residents working in wood, leather, textile and more general metalwork

in the larger settlements, where regular supply and renewal was necessary. The welcome afforded Cei in the story reflects the high status of such a peripatetic craftsperson, and probably the metalworker in particular.[13] Both objects and people travelled considerable distances and exerted their influence on the material culture of western Britain.

The everyday attitude of the inhabitants of places such as Dinas Powys to material culture is more difficult to discern since the early poetry in which they feature is heroic and aggrandizing. Nevertheless, occasional glimpses of the simpler pleasures of such *llysoedd* (courts) bring the heroic warriors closer to ourselves. The writer of the early seventh-century 'Marwnad Cynddylan' (Elegy for Cynddylan) recalled 'Fresh rushes under foot until bed-time / Feather pillows under me to the depth of my knee'.[14] The sense of loss following the destruction of the hall of Cynddylan's court, mourned in a later text, transcends the intervening centuries:

> The hall of Cynddylan is dark tonight,
>> Without fire, without bed.
>> I shall weep awhile, and then be silent.[15]

Cantusus, commemorated on the reused Roman milestone at Port Talbot, was a Christian. Whether the presence of Christians in Wales in his time represents a continuity of communities from the later Roman period or the work of conversion is a matter of dispute among historians. Cantusus lived in the period mythologized in the manuscript Lives of the saints, in which an ascetic, monastic church developed which had its origins in the eastern Mediterranean and north Africa. Monasticism was known in Britain as early as the fifth century, although the earliest monastic foundations which can be inferred with any certainty from written sources date from the late sixth century.[16] The Lives of the Welsh saints were nearly all written many centuries after the events they described, and are, therefore, problematic historical sources. Nevertheless, the relative lack of stories of the conversion of the indigenous people in the Welsh Lives, compared to their frequency in the Irish stories, supports the case for continuity of Christian belief from the Roman period onwards. Whatever the fact of this matter, it is generally agreed, consistent with the evidence of the Lives, that monasticism was well established in Wales by the early sixth century and that, as the century progressed, the number of foundations increased and monks travelled widely, establishing houses in Cornwall, Brittany and Ireland. The Welsh foundations which have been conclusively identified were located largely around the coastal fringe, as at Llantwit Major in Glamorgan and Clynnog Fawr in Caernarfonshire or, if inland,

[12] Irish immigration into western Britain, probably in the fifth century, and the later flowering of Christian Celtic culture in Ireland, have given a general impression that the flow of influence and ideas was exclusively from west to east. However, it is certainly the case that Wales was a medium for the transfer of religious ideas from the south into Ireland, and that some artefacts and metal-working technology also spread from western Britain. For examples, see Alcock, *Dinas Powys*, pp. 59–60. For a wide-ranging discussion of the interactions of culture groups on the Atlantic-facing coasts of Europe, see Barry Cunliffe, *Facing the Ocean: The Atlantic and its Peoples, 8000 BC–AD 1500* (Oxford, 2001).

[13] 'Quoth Cei, "Porter, I have a craft." "What craft hast thou?" "I am the best furbisher of swords in the world." "I will go and tell that to Wrnach the Giant and will bring thee an answer." The porter came inside. Said Wrnach the Giant, "Thou hast news from the gate?" "I have. There is a company at the entrance to the gate who would like to come in." "Didst thou ask if they had a craft with them?" "I did, and one of them declared he knew how to furbish swords." "I had need of him. For some time I have been seeking one who should polish my sword, but I found him not. Let that man in, since he had a craft."' *The Mabinogion*, translated by Gwyn Jones and Thomas Jones (London, 1993 ed.), p. 101.

[14] 'irwmn y dan fy nhraed hyd bryd cyntun / plwde y danaf hyd ymhen fynghlun.' R. Geraint Gruffydd, 'Marwnad Cynddylan', in idem (ed.), *Bardos: Penodau ar y Traddodiad Barddol Cymreig a Cheltaidd* (Caerdydd, 1982), p. 21, lines 65–6. For the poem and its context, see ibid., pp. 10–28.

[15] 'Stafell Gynddylan ys tywyll heno, / Heb dân, heb wely; / Wylaf wers, tawaf wedy.' Thomas Parry (ed.), *The Oxford Book of Welsh Verse* (Oxford, 1962), p. 12. For the translation, see Ifor Williams, *The Beginnings of Welsh Poetry*, ed. Rachel Bromwich (Cardiff, 1980), p. 147. Cynddylan was probably ruler of Powys in the middle of the seventh century, and would have occupied a *llys* not dissimilar in its essentials to that of Dinas Powys in Glamorgan.

[16] Welsh Bicknor and Llandinabo, both in the south-east. The evidence for foundation dates is summarized in Davies, *Wales in the Early Middle Ages*, pp. 141–8. For a summary of opinion on the development of the early Church, and references to more detailed studies, see Oliver Davies, *Celtic Christianity in Early Medieval Wales* (Cardiff, 1996), pp. 7–11.

along river valleys as at Llandeilo Fawr.[17] At Llandough in Glamorgan an extensive burial ground has been excavated, which was in use from the sixth to the early eleventh century, when the site was apparently abandoned. The founding saint, Docco, is a particularly shadowy figure, though he is mentioned in the earliest of the surviving Welsh Lives, the Life of St Samson, which was probably written in the seventh century.[18] Perhaps the most interesting feature of Llandough, however, is its close proximity to Dinas Powys, only a mile away, and to a Roman villa, which lies a short distance to the south. It is possible that a monastery arose here on the lands of what had been the villa estate. It may have provided for the educational needs of the children of the local rulers who occupied Dinas Powys.[19]

Identified settlements such as Llandough represent only a small proportion of the total number of monasteries and individual cells constructed in Wales. Although some persisted as ecclesiastical centres until after the Norman conquest, the nature of their material culture is suggested only to a limited extent by archaeology. The Lives of the saints offer some suggestions about the nature of their buildings. For instance, the Life of St Cadog reports that 'he built a notable little monastery of timber', and an oratory, a dormitory and a refectory, as well as a cemetery.[20] However, the Life was not written until the eleventh century and clearly cannot be relied upon for accuracy in describing the buildings of five centuries earlier. The same Life reports that Cadog built 'an elegant basilica of stone' and that 'he caused to be built by masons a stone bridge skilfully constructed with vaulted work, having the arches joined together with quarried stone'.[21] The scale of this work suggests that the author was projecting backwards onto Cadog the practices of large settlements at a time nearer to that in which the Life was written. Nevertheless, the story of the itinerant mason Llywri is consistent with that of Gwrtheyrn and his masons, written in the early ninth century. Llywri was an 'Irish stranger, a truly skilful master-builder' who had arrived at Neath, apprised of Cadog's intention to build a monastery there, 'that he might acquire food for himself and his sons by the exercise of his art'.[22] However, it seems more likely that, in the period of the foundation of the monasteries, mainland sites were constructed on a small scale by the monks themselves, using timber and turf, though it is not unreasonable to suppose that buildings with different purposes and therefore different architecture developed early. The Life of St Asaph, written in the twelfth century, gives a convincing account of the building of such a site:

> ... at the first when these sons of God coming under the inspiration of the Holy Spirit had finished their prayers and the divine offices, they set manfully and eagerly about their different operations; some cleared the ground, some made it level and others prepared the foundations. Some too carried the timbers and others welded them together, and erected with skill and speed the church and other out-buildings, of planed woodwork, after the British fashion.[23]

[17] D. P. Kirby, 'The Church in Ceredigion in the Early Middle Ages' in J. L. Davies and D. P. Kirby (eds.), *Cardiganshire County History, Volume I. From the Earliest Times to the Coming of the Normans* (Cardiff, 1994), pp. 365–77, provides a concise summary of the evidence for Christian continuity from the Roman period and the subsequent development of the Church prior to the Norman conquest.

[18] The presence of a highly decorated cross shaft of the late tenth century reinforces the archaeological evidence of an important site in a more graphic way. For the stone, see below, pp. 41–2.

[19] Alan Thomas and Neil Holbrook, 'Llandough', *Current Archaeology*, 146 (1996), 77.

[20] A. W. Wade-Evans, *Vitae Sanctorum Britanniae et Genealogiae* (Cardiff, 1944), p. 45.

[21] Ibid., p. 99.

[22] Ibid., p. 67.

[23] Quoted in D. R. Thomas, *The History of the Diocese of St Asaph* (3 vols., Oswestry, 1908–13), I, p. 270.

[24] For the stone, see V. E. Nash-Williams, *The Early Christian Monuments of Wales* (Cardiff, 1950), pp. 180–2, no. 301. Much new work in this field is yet to be published, notably the British Academy's 'Corpus of Romanesque Sculpture in Britain and Ireland' and the revision of the work of Nash-Williams initiated by the National Museums and Galleries of Wales, the University of Wales Board of Celtic Studies, and the Royal Commission on the Ancient and Historical Monuments of Wales.

[25] Thomas Taylor, *The Life of St Samson of Dol* (London, 1925). Some scholars have argued for a ninth-century date for the Life. See Davies, *Wales in the Early Middle Ages*, p. 215. Having reviewed the evidence, Davies favoured a seventh-century date.

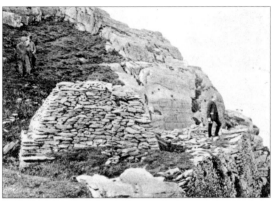

4. Members of the Cambrian
Archaeological Association at Skellig Michael,
Co. Kerry, Ireland, 1891

5. The Stone of Cadwgan,
Caldey Island, Pembrokeshire,
inscriptions 5th–6th century
(ogham) and early 9th century,
approx. ht. 900

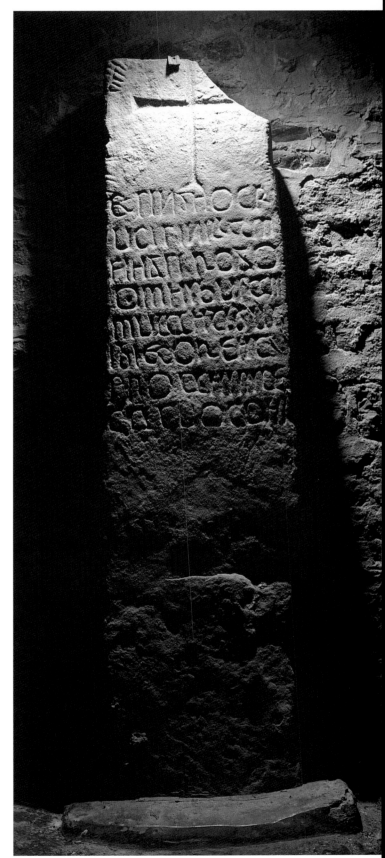

Archaeological evidence from Irish sites such as the island of
Skellig Michael, which provides close parallels, suggests that, within
a surrounding bank, circular huts provided living accommodation,
but that churches were rectilinear and orientated from west to east.
Island settlements such as Caldey were more likely to have been built
of stone, since that was the most readily available material. The early
date of Caldey is attested by a Goedelic inscription of the sixth century
cut in the ogham alphabet of grooved marks incised on both sides of
a vertical centre line, in this case the long edge of a roughly dressed
stone. The reuse of the stone, probably in the early ninth century,
demonstrates the evolution of the site. The later inscription is
written in the first-person: 'And by the Sign of the Cross (which)
I have fashioned upon that (stone) I ask all who walk there that
they pray for the soul of Catuoconus', that is, Cadwgan.[24]

The subsequent evolution of the site, and its continuous occupation
into the twenty-first century have obliterated archaeological evidence
of any early buildings. Evidence for the way of life of those who lived
in the monastery in the sixth and seventh centuries is better, since it
is recorded in some detail in the Life of St Samson.[25] The Life was
probably written on the basis of the testimony of a contemporary
of Samson, who made his home on Caldey after leaving the larger
monastery of Llantwit. His departure seems to represent a movement
towards greater asceticism, which may reflect elaboration of the material
culture at the mainland site in the form of more substantial buildings
and enriched artefacts. On Caldey monks lived according to a strict
rule which prescribed their daily activities and responsibilities,
among which was the manual labour by which they survived
in an inhospitable environment.

6. The Stone of Paulinus,
found at Cynwyl Gaeo,
Carmarthenshire, c.550, ht. 850

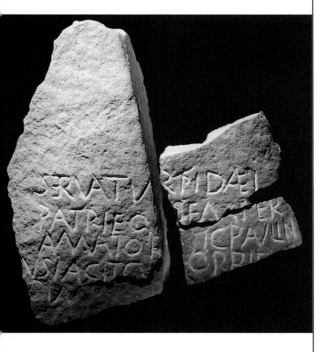

[26] For the Latin form, see Nash-Williams, *The Early Christian Monuments of Wales*, p. 107, no. 139. For the Synod, see J. E. Lloyd, *A History of Wales: from the earliest times to the Edwardian conquest* (2 vols., London, 1912), I, p. 157.

[27] Nash-Williams, *The Early Christian Monuments of Wales*, p. 84, no. 78.

[28] Nevertheless, as the incident recorded below, in the Life of St Samson, reveals, and also the case of the pillar of Eliseg, see below p. 30, reorientation as a result of the emergence of England did not mean cessation of contacts with Rome.

[29] Only one inscription in the Welsh language has been identified with certainty, on a stone at Tywyn, Merioneth. See Nash-Williams, *The Early Christian Monuments of Wales*, p. 172, no. 287; Williams, *The Beginnings of Welsh Poetry*, pp. 25–40. It is of outstanding importance since it represents the oldest extant Welsh writing and is perhaps datable to c.800. Huw Pryce, 'The Medieval Church' in J. Beverley Smith and Llinos Beverley Smith (eds.), *History of Merioneth. Volume II. The Middle Ages* (Cardiff, 2001), p. 261.

[30] Taylor, *The Life of St Samson of Dol*, p. 39.

[31] Ibid., p. 48.

[32] Ibid., p. 36.

Because of their durability and lack of intrinsic value, objects made of stone proved by far the best survivors of the material culture of the early Middle Ages. Sufficient remain to provide both important sources for constructing the social and political history of the emergent nation, and some sense of a visual culture which must also have included metal and woodwork, weaving and leatherworking, most of which is now lost. The nature of the stone artefacts evolved gradually, with occasional innovations, from the end of the Roman era down to about the middle of the ninth century. In this early period the objects are unified by the incising of their inscriptions and imagery onto the surface of found or only roughly shaped slabs. At Cynwyl Gaeo in Carmarthenshire, for instance, a memorial inscribed in Roman capitals was set up to one Paulinus, perhaps to be identified as the teacher of St David. That Paulinus was a distinguished cleric, a 'Saint' who had been present at the Synod of Llanddewibrefi, supposed to have been held about the year 545, is attested by the unusually laudatory form of words: 'Preserver of the Faith, constant lover of his country, here lies Paulinus, the devoted champion of righteousness.'[26] The everyday organization of the Church led by such individuals in the sixth century is celebrated in inscriptions such as those at Aberdaron, one of which names Senacus, a priest and 'the multitude of the brethren' also buried there.[27]

The Aberdaron inscription is cut in Roman capitals, but by the sixth century the visual record of continuity from the Roman period had begun to change in several ways, thereby demonstrating the realignment of the culture towards sources in the south and in Ireland.[28] Interaction with Ireland is apparent in the number of inscriptions not only in Latin but also in Goedelic and cut in ogham. The ogham alphabet was of Irish origin, and although it became redundant around the end of the sixth century the frequency of its use before that date, especially in the southern and northern promontories of Wales reaching out towards Ireland, indicates a considerable degree of Irish settlement. On the other hand, the gradual replacement in the sixth century of the Roman capitals in which Latin inscriptions were cut by the letter style known as half-uncial indicates a cultural transfer in the opposite direction. These new rounded letter forms, appropriate to writing rather than incising, were developed in north Africa and adopted in Italy and southern Gaul. From there they spread to Wales and thence to Ireland.[29] The routes for transmission of Christian ideas and artefacts were often the same as the trade routes which brought secular material to sites such as Dinas Powys. Sometimes they reflected routes more particular to the travels of ecclesiastics and pilgrims. For instance, the Life of St Samson records the arrival in Wales of 'certain distinguished Irishmen, on their way from Rome',

in whose company the saint himself travelled to Ireland.[30] Individuals such as these carried not only ideas about the visual representation of the faith but also examples. Even Samson, noted for his asceticism, arrived in Brittany from Wales (via Cornwall) with 'holy vessels and books' sufficient to necessitate their carriage by cart.[31]

No Welsh manuscripts from this early period survive, and so the record of this change is confined to the carved or picked inscriptions, which are often crude. The new letters were more difficult to execute than the straight forms of the Roman letters which had been specifically developed for cutting on stone. During the sixth century, therefore, inscriptions appear in various combinations of Roman capitals, half-uncials and ogham, to which mixture was added the sign of the cross. The Christian Church did not adopt the cross as its universal symbol until the fifth century, but thereafter it rapidly proliferated into a variety of forms, particularly in association with the circle. It soon acquired more than symbolic meaning, and belief in its supernatural power was commonplace by the seventh century. The writer of the Life of St Samson reported that the unwelcome attentions of a serpent were repelled by the saint making 'the sign of a circle' and 'planting within it the emblem of the cross which he bore'.[32] The same Life includes a report of the saint himself cutting such an emblem in stone. This incident occurred in north Cornwall, but immediately following Samson's landing there from Wales:

> On this hill I myself have been and have adored and with my hand have traced the sign of the cross which St Samson with his own hand carved by means of an iron instrument on a standing stone.[33]

Christian worship was offered in consecrated buildings and sacred places, and included devotion to relics. Holy wells, usually associated in the mythology of the Lives with a saint's ability miraculously to draw forth water from the dry ground, undoubtedly date from the earliest period, though whether they reflect the practicalities of establishing tenable sites or continuities of older religious practice is very difficult to determine. Among the Welsh sites, Capel Trillo, which stands on the seashore at Llandrillo-yn-Rhos, Denbighshire, may represent closely the form of the earliest stone-built structures, though the original corbelled roof has been replaced by one of a lower pitch, thereby altering the overall proportions of the building.[34] Its entrance is at the opposite end from the well. Whether such structures represent a dwelling or a sacred space adjacent

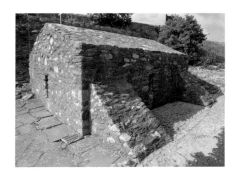

7. Capel Trillo, Llandrillo-yn-Rhos, Denbighshire, early medieval, restored 1892 and 1935

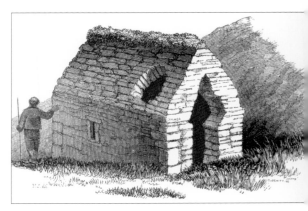

8. C. Jewitt after H.J., *Capel Trillo, Llandrillo*, 1855

[33] Ibid., p. 49. The incident occurred in the context of Samson's observation of pagan rituals and it may be that the author intended us to understand that the stone on which Samson carved the cross was already of religious significance. Although it would be unreasonable to treat this account as factual, nevertheless it lends weight to the speculation that letters and symbols were not always cut by specialist masons. Several inscriptions of the period, mostly related to burials, name the maker as a relative of the deceased, suggesting that, sometimes at least, the work was carried out as an act of personal respect rather than of professional employment.

[34] A building of closely similar design covers Higgons Well near Haverfordwest, and retains its high-pitched roof. The oratory at Gallerus, Co. Kerry, Ireland, provides an example of a corbelled building of this type, which is complete and in good order. There is no reason to suppose that it differs substantially from many monastic buildings of the period in Wales.

35 The drawing was accompanied by a written description, Museum of Welsh Life, T. H. Thomas material, 2591/19.

36 Taylor, *The Life of St Samson of Dol*, p. 71.

37 'A'r uagyl eur y phenn'. Gwynfardd Brycheiniog, 'Canu i Ddewi' in Kathleen Anne Bramley et al. (eds.), *Gwaith Llywelyn Fardd I ac Eraill o Feirdd y Ddeuddegfed Ganrif* (Caerdydd, 1994), p. 445, line 186. For the poem and its context, see Morfydd E. Owen (ed.), 'Canu i Ddewi', in ibid., pp. 435–78.

38 Wade-Evans, *Vitae Sanctorum Britanniae et Genealogiae*, p. 97.

39 Gerald of Wales, *The Journey through Wales and The Description of Wales*, p. 78. Giraldus provides descriptions of several objects clearly of early medieval date, such as the torque of St Cynog and St Patrick's horn, for which see ibid., p. 86.

to which a religious lived in a hut is obscure. The architecture of the wells of St Seiriol at Penmon, Anglesey, and of St Cybi in Caernarfonshire represents a process of successive rebuilding but without great elaboration over a very long period. Belief in the healing power of such wells and the depositing of tokens continued well into the twentieth century. When the painter T. H. Thomas drew Saintwell at Coedrhiglan near Cardiff in 1899, he depicted the overhanging boughs of a tree hung with white rags marking the prayers of the sick.[35]

At Arfryn, an early Christian cemetery in Anglesey, more than ninety graves were arranged around a central focus marked by a ring of posts surrounding a pebble floor under which lay a single grave. The tombstone of Ercagni, perhaps the founder or leader of the community, was discovered nearby and may originally have stood there as a shrine. The few relics of such individuals which survive do not derive from the earliest period. Nevertheless, bells of iron or bronze such as that of St Gwynhoedl from Llangwnnadl in Llŷn, possibly of ninth-century date and notable for the zoomorphic terminals to its handle, are probably similar to objects of an earlier date which have disappeared. That they existed in Wales is not in doubt, and the Life of St Samson gives a clear insight into the process by which such relics might evolve from a simple beginning – a wooden cross or staff, for instance – into the highly decorated and bejewelled artefacts familiar from the survival of Irish examples made from the ninth to the eleventh centuries. Samson's crosier, 'which was ever wont to be carried before him and which he had blessed', had by the time of the writing of the Life 'been encircled and adorned with lovely things of gold and silver and precious stones'.[36] It was kept in a case to be displayed on special occasions. A poem by Gwynfardd Brycheiniog, written around 1170,

9. The Well of St Seiriol,
Penmon, Anglesey,
date uncertain

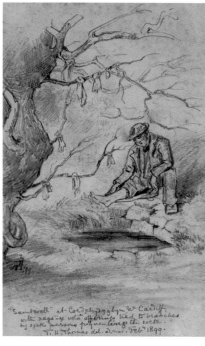

10. T. H. Thomas,
'Saintwell', at
Coedrhydyglyn
nr. Cardiff, 1899,
Pencil, 235 × 140

describes the staff of St David at Llanddewibrefi, enriched 'with a golden head'.[37]
The Life of St Cadog reports that one Gildas, living on the island of Echni
(Flatholm), had a 'parti-coloured bell' and 'wrote a mass book'.[38] Giraldus
Cambrensis noted an object 'completely encased in gold and silver', the top
part in 'the rough shape of a cross' at the Church of St Germanus near Builth.[39]
The frequency of such observations suggests that the visual culture of Wales was
fully integrated into that of western Catholic Christendom. Giraldus Cambrensis
confirms this impression in the most specific terms:

> The common people, and the clergy, too, not only in Ireland and Scotland,
> but also in Wales, have such a reverence for portable bells, staffs crooked at
> the top and encased in gold, silver or bronze, and other similar relics of the
> saints, that they are more afraid of swearing oaths upon them and then
> breaking their word than they are upon the Gospels.[40]

The enrichment of such objects made them vulnerable to theft or vandalism,
since the respect accorded them by the religious community and by local people
did not necessarily extend to raiders from afar. The iconoclasm of the sixteenth
and seventeenth centuries completed the process of destruction so effectively that
it is difficult to determine how many such objects survived even into the later
Middle Ages. However, it is possible to gain an impression of one such decorated
sacred object from Wales – the reliquary of St Winifred.[41] Only a small fragment
of the oak case of the reliquary of St Winifred survives but, fortunately, it was
drawn in a fuller state of preservation by Edward Lhuyd in the late seventeenth
century.[42] Lhuyd's drawing reveals that the object belonged to a group of house-

[40] Ibid., p. 87. Giraldus may well have intended
his comments to present a negative image of the
Welsh Church as a backward-looking institution
in need of reform which he believed himself well-
qualified to implement. However, his descriptions
of devotions are unlikely to have been inventions.

[41] For St Winifred and devotions to other female
Welsh saints, see Jane Cartwright, *Y Forwyn Fair,
Santesau a Lleianod: Agweddau ar Wyryfdod a
Diweirdeb yng Nghymru'r Oesoedd Canol*
(Caerdydd, 1999). For the late devotion of the
saint and the use of her name as a generic name
for a Welsh woman, see Peter Lord, *Words with
Pictures: Welsh Images and Images of Wales in the
Popular Press, 1640–1860* (Aberystwyth, 1995),
p. 51.

[42] Bodleian, Rawlinson MS B.464, f. 29[r].

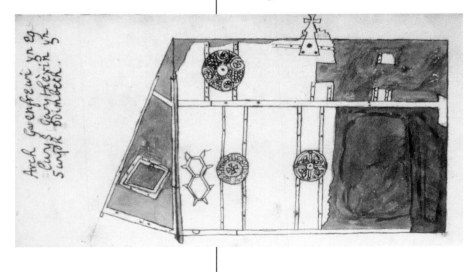

12. Edward Lhuyd, *Arch Gwenfrewi
yn Eglwys Gwytherin yn Swydd Ddimbech*
(The Reliquary of St Winifred), drawn
at the Church of St Winifred, Gwytherin,
Denbighshire, c.1690, Ink

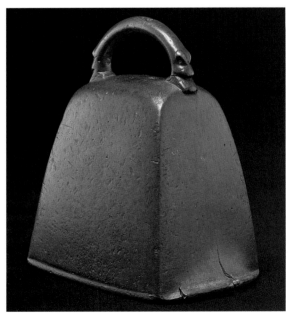

11. The Bell of St Gwynhoedl, found at the
Church of St Gwynhoedl, Llangwnnadl, Caernarfonshire,
9th–11th century, Bronze, ht. 170

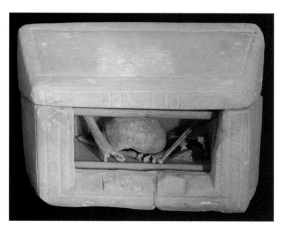

13. Reliquary, found at the old Church
of St Nidan, Llanidan, Anglesey,
date uncertain, Stone, I. 586

[43] The free-standing cross on the roof is a feature not shared with otherwise similar Irish reliquaries, such as that of St Manchan in the church at Boher, Co. Offaly, but which is known from an Anglo-Saxon example at Mortain in Normandy.

[44] For a comparative study of the Lhuyd drawing, see L. Butler and J. Graham-Campbell, 'A Lost Reliquary Casket from North Wales', *The Antiquaries Journal*, LXX, part I (1990), 40–8. The authors disagreed on the likely provenance of the object. Irish reliquaries of the type are discussed in Susan Youngs (ed.), *'The Work of Angels': Masterpieces of Celtic Metalwork 6th–9th Centuries AD* (London, 1989), pp. 134–40.

[45] See below, p. 32. Mark Redknap, 'Breconshire: Llangorse Crannog (SO 129269)', *Archaeology in Wales*, 31 (1991), 38.

[46] John Williams, Ab Ithel (ed.), *Annales Cambriae* (London, 1860), p. 28, 'Sanctum David adiit' and pp. 28–9, 'Archa Sancti David ab ecclesia [sua] furata est, et auro argentoque quibus tegebatur spoliata est.'

[47] James Lydon, 'Christ Church in the later medieval Irish world 1300–1500' in Kenneth Milne (ed.), *Christ Church Cathedral, Dublin: A History* (Dublin, 2000), pp. 93–4.

[48] The reliquary and the history of its discovery in the early eighteenth century, buried under the altar of the old church of Llanidan, is described in Albert Way, 'Alabaster reliquary found in Caldey Island, Pembrokeshire, with notices of an object of the like description existing in Anglesey', *Arch. Camb.*, 4th series, I (1870), 129–34. The eighteenth-century antiquarian Henry Rowlands, perhaps with folkloric sources at his disposal, speculated that it had contained the relics of St Nidan, a shadowy figure. It was believed to have been made in the fourteenth century, but the dating of such an unusual object is speculative, and it may be much earlier.

shaped reliquaries, made from the eighth century onwards. It was possibly clad in metal and was certainly adorned with metal plaques, probably of enamelled and gilt copper alloy, which Lhuyd observed with sufficient care to notice that they carried both interlaced designs and an Anglian-style cross, a feature repeated on the roof.[43] Lhuyd gave no indication of the size of the reliquary but it was probably some fifteen inches in length, and therefore could have contained only a few small bones of the saint, or possibly an artefact associated with her, such as a fragment of cloth. When taken out of the lost shrine to be carried in procession, the reliquary was probably lifted by leather straps attached at each end to metal clasps.[44]

That the design of the reliquary of St Winifred seems to incorporate features characteristic of both Irish and Anglo-Saxon design in the eighth and ninth centuries is unsurprising. It reflects the geographical position of Wales as a crossroads in the complicated interactions of Irish, Norse, Manx, Pictish and Anglo-Saxon traditions in the period. Such objects were manufactured over the whole of the British Isles and there is no reason to doubt that the St Winifred reliquary was one of several made in Wales. Among the objects found at the site of a *llys* at Llangorse in Breconshire was part of a hinge likely to have been from a portable reliquary of this type.[45] At St David's the gold and silver shrine of the patron saint was despoiled and the wording of the description of the event in the *Welsh Annals* under the year 1088 suggests that it was taken away, implying that at least part of it was portable and, therefore, probably a reliquary.[46] A similar fate befell the shrine of St Cybi at Holyhead, though much later. In 1405 raiders from Dublin removed what is described in the records of Christ Church as 'the shrine of St Cubius and placed it in the church of this priory', though what was meant was almost certainly the theft of the relics in their reliquary.[47] Both the Holyhead and St David's reliquaries may have been of the house-shaped type. The tradition of reliquaries manufactured in this form was very persistent. At Llanidan in Anglesey an example carved in stone probably dates from the later Middle Ages.[48]

As a result of the persistent ravishing to which Welsh religious sites were subjected until the late eleventh century, both from local incursions and from sea-borne raiding, few manuscripts survived even into the post-Norman period. The author of the ninth- or tenth-century poem 'Marwnad Cynddylan' was clearly disdainful of those he called 'book-holding monks'.[49] Nevertheless, the written sources make it clear that all religious communities possessed manuscript books and, despite the paucity of survivals, there is reason to suppose that many of them were copied in Wales at an early date. They were broadly of two types – texts of small format for personal study and devotion, sometimes enriched with illumination, and larger illuminated gospel-books for display and communal use, though perhaps only on ceremonial occasions. The most famous of these, held at St Asaph, was still sufficiently impressive to be sent on tour in the late thirteenth century to raise money to rebuild the cathedral.[50] St David's had a 'worm-eaten book covered over with silver plate' as late as 1538, doubtless an early gospel-book,[51]

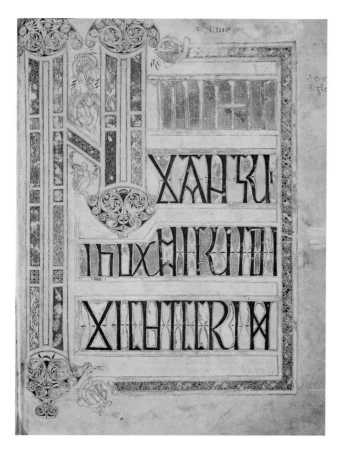

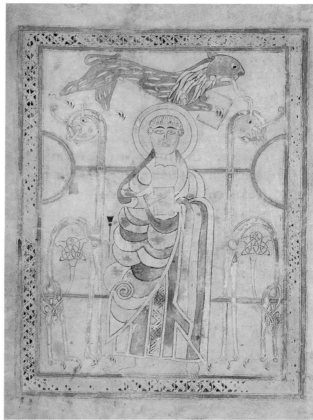

and at Clynnog Fawr the Book of St Beuno, supposedly written by St Twrog and known colloquially as the 'Tiboeth' probably survived until at least 1594. Its fame was sufficient for the poet Iolo Goch to make use of it as a simile in his poem of the late fourteenth century, 'I Ferch' (Description of a Girl) – 'Eye like the jewel of a fine clasp / similar to the Tiboeth stone'[52] – by which the poet probably meant a black jewel stone set into the cover. Unfortunately, he did not elaborate upon the nature of the book, presumably assuming it to be thoroughly familiar to his audience.

Only one large gospel-book from Wales survives. Nevertheless, the Gospels of St Chad is among the masterpieces of Celtic Christian visual culture. It belongs to a group of manuscripts written and illuminated between the late seventh and early ninth centuries. The gospel-book of St Chad was probably made around 730, that is after the Lindisfarne Gospels but before the most famous of the group, the Book of Kells. It derives its name from its later association with Lichfield, where Chad was bishop at his death in 672. The book is incomplete, containing only the gospels of St Matthew, St Mark and a part of St Luke.[53] The text was written by one scribe in a beautiful and regular script, with capitals emphasized by red shading. The initial pages of the three surviving gospels are more intensely illuminated and there are four purely pictorial pages:

[49] 'mynaich llyfyr afael', Gruffydd, 'Marwnad Cynddylan', p. 27, note 57.

[50] Daniel Huws, 'The Medieval Manuscript', in Philip Henry Jones and Eiluned Rees (eds.), *A Nation and its Books* (Aberystwyth, 1998), p. 26.

[51] Ibid.

[52] 'Llygad fel glain caead coeth, / Tebyg i faen y Tiboeth'. The full text and translation are given in Dafydd Johnston, *Iolo Goch: Poems* (Llandysul, 1993), pp. 100–1. The book was referred to in evidence of a court case at Caernarfon in 1537, for which see Edward Owen, 'An Episode in the History of Clynnog Church', *Y Cymmrodor*, XIX (1906), 77, 83, and, according to the dictionary of John Davies, Mallwyd (1632), it was seen by Thomas Wiliems of Trefriw in 1594. Other references to the book are given in D. Rhys Phillips, 'The Twrog MS.', *Journal of the Welsh Bibliographical Society*, 1 (1910–15), 183–7.

[53] The missing part may have survived in a separate binding down to at least 1345. See Douglas Brown, *The Lichfield Gospels* (London, 1982), p. 4, and J. J. G. Alexander, *A Survey of Manuscripts Illuminated in the British Isles: Insular Manuscripts, 6th to the 9th century* (London, 1978), pp. 48–50.

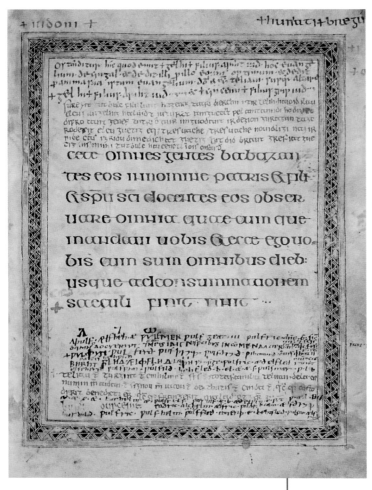

16. Text Page with Welsh 9th-century
Marginalia, from the Gospels of St Chad,
c.730, 308 × 223

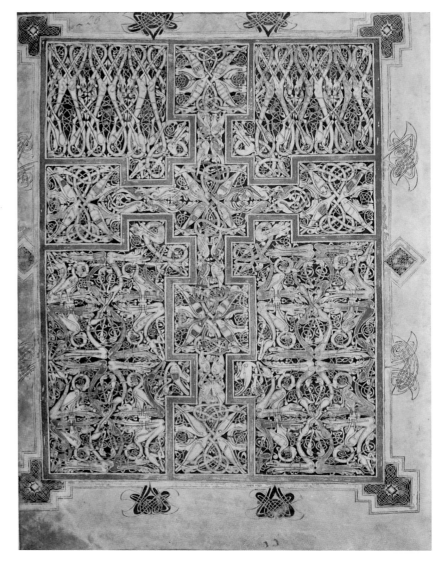

right:

17. Carpet Page, from
the Gospels of St Chad,
c.730, 308 × 223

54 The inscription is transcribed in W. M. Lindsay,
Early Welsh Script (Oxford, 1912), p. 1. Lindsay
assumed that the altar of St Teilo was at Llandaff,
but scholars are now generally agreed that the
Gospels were given to Llandeilo Fawr. See
Dafydd Jenkins and Morfydd E. Owen, 'The
Welsh Marginalia in the Lichfield Gospels, Part I',
Cambridge Medieval Celtic Studies, 5 (Summer
1983), 37–66.

the symbols of the four evangelists; images of St Mark and St Luke; and a carpet
page designed around a Latin cross. Written into the manuscript at a later date are
various notes, some in Welsh in hands probably ranging from early to late ninth
century, and some in Latin with Welsh names. One of them is a deed of gift:

> Here it is shown that Gelhi, son of Arihtiud, bought this Gospel from Cingal,
> and gave him for it his best horse and gave for the sake of his soul this Gospel
> to God and St Teilo upon the altar ...[54]

It seems certain, therefore, that the book was at the monastery of Llandeilo Fawr
within about a hundred years of its creation, and possibly in Wales even earlier.
How it came into the hands of Cingal in the first place and where it was made is a
mystery. The form of the Incarnation Initial in the gospel of St Matthew is strikingly

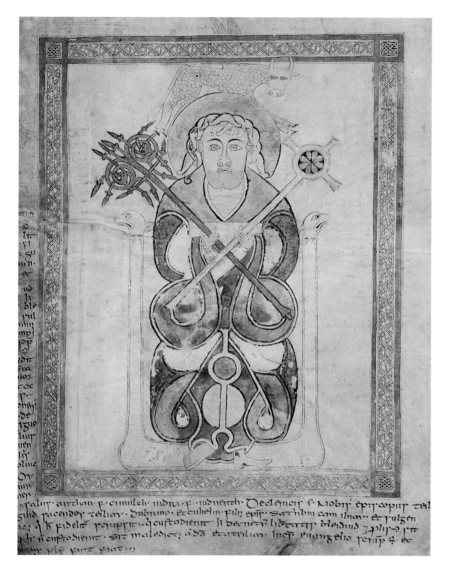

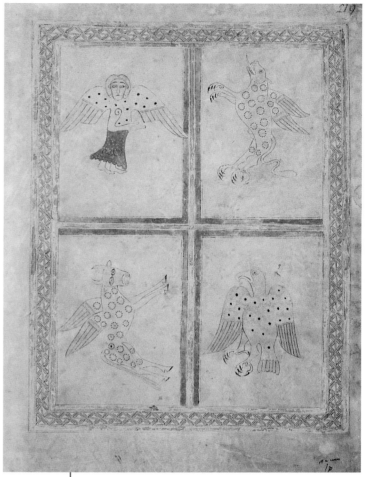

19. The Symbols of the
Four Evangelists, from
the Gospels of St Chad,
c.730, 308 × 223

left:

18. St Luke, Illumination
from the Gospels
of St Chad,
c.730, 308 × 223

close to the corresponding initial in the Lindisfarne Gospels, which is known to
have been written on that island. Similarly, the carpet page is close in conception
to the Lindisfarne work. However, the images of the evangelists St Mark and St
Luke bear little resemblance to the earlier manuscript, the illuminator having taken
the opportunity to transform folds of drapery into two-dimensional patterns,
particularly in the portrait of St Luke. The iconography of this portrait is also
most unusual. The conventional symbol of the saint, the ox, is drawn above his
head but more prominent are the two staffs he holds, crossed one over the other.

Probably around fifty years after the creation of the Gospels of St Chad, a small
gospel-book which now forms part of the ancient library of Hereford Cathedral
was written and illuminated in the same manner as its more celebrated precursor.
Although its precise place of origin in the late eighth or early ninth century has

not been identified, the Hereford Gospels was probably the product of a monastic foundation in Wales. The surviving manuscript contains illuminated initial pages for the gospels of Matthew, Mark and John only, but also several illuminated initials within the text.[55] All appear to be the work of a single scribe, who, unfortunately, did not identify himself.

Enmeshed in the initials of the Hereford Gospels, in the same manner as in the Gospels of St Chad (where they also cover the carpet page from which emerges the outline of the cross) are the interlaced and fret designs so often identified as characteristic of the visual culture of the Christian Celts. In fact, such designs are common to the group of cultures with otherwise distinct languages and social systems – the Celts, the Anglo-Saxons, the Picts and the Norse peoples – whose interactions have already been noted. The pattern of their political and religious contacts in the north-west of Europe is as complicated as the interlace of their manuscripts. There are four basic elements in the visual language, which augment the largely figurative Christian iconography (the symbols of the evangelists, for instance) shared by a much wider group of European cultures in the period. Firstly, there are zoomorphic designs, that is, animal-like heads linked to ribbon-shaped bodies which twine together in rhythmic patterns. Secondly, spirals and various (often tripartite) divisions of the circle, which share with the zoomorphic designs an origin in the visual culture of the pagan Celts.[56] Thirdly, plaits and knots, which echo the weave of textiles and which, in their most refined form, are unending. The plaits are sometimes formed of as many as twenty-four separate bands. Fourthly, fret designs of square, swastika, or triangular shape. Both the interlaced and fret designs were probably developed by the Celts from similar but simpler patterns common in late classical art, though whether they arrived by direct transfer from the Mediterranean area, along the trade and religious routes to the east, or were mediated through Anglo-Saxon artefacts, is unclear.

No contemporary written source interprets the visual culture of the Christian Celts.[57] It is impossible to know, therefore, if the interlaced patterns and animals of the manuscripts represent a symbol system in which particular meanings are associated with particular designs. Even if they do, it is most unlikely that they form a commentary on the narrative of gospel-books. However, the use of zoomorphic designs in manuscripts may be understood in terms of a more general evocation of a belief system for which the supernatural rather than the natural, and the abstract rather than the concrete, form the framework. The frequent transposition into the Lives of the saints of an abundance of serpents, dragons and other disagreeable beasts presumably originating in the oral traditions of Celtic mythology provides a general context for the juxtaposition of pre-Christian and Christian imagery in the illuminated manuscripts. It may well be significant that the characteristic motifs of classical art – leaf and plant forms derived from direct observation of nature – scarcely ever find a place in the gospel-books. Observed animals appear only as the tokens of the evangelists where the conjunction of the figurative and the non-figurative, the natural and the fantastic, indicates the flowering of a conspicuously composite culture.

[55] The Hereford Gospels (Hereford Cathedral Library P.I.2) are described in R. A. B. Mynors and R. M. Thomson, *Catalogue of the Manuscripts of Hereford Cathedral Library* (Hereford, 1993), pp. 65–6. On the subject of their provenance, the authors quote E. A. Lowe, *Codices Latini Antiquiores*, II (rev. ed., Oxford, 1972), no. 157: 'Written in an English scriptorium under Celtic influence, probably near the Welsh border.' This cryptic opinion, based on scholarly reluctance in the period to attribute anything to a Welsh source, is challenged by more recent work. Richard Gameson, 'The Hereford Gospels', in Gerald Aylmer and John Tiller (eds.), *Hereford Cathedral: A History* (London, 2000), pp. 536–43, analyses the textual and structural evidence in detail and concludes that the book was almost certainly made in Wales, with the west of England as a possible, though less likely, source.

[56] Various aspects of the continuity of design elements from pagan to Christian Celtic culture are discussed in Miranda Aldhouse Green, *Celtic Art: Reading the Messages* (London, 1996). Among those regarded as particularly important by Green are the tripartite division of the circle (in particular the triskele, a recurrent motif in La Tène artefacts), animals as facilitators between two worlds, and a general emphasis on the human head.

[57] Giraldus Cambrensis offered some thoughts on the understanding of interlace and zoomorphic patterns, for the interpretation of which see Mary J. Carruthers, *The Book of Memory* (Cambridge, 1992), pp. 254–5. On the difficulties of interpretation presented by the work of both pagan and Christian Celtic culture, Miranda Aldhouse Green pertinently remarks that 'it is as dangerous to see profound meaning in every pattern as it is to under-interpret it'. Green, *Celtic Art*, p. 118.

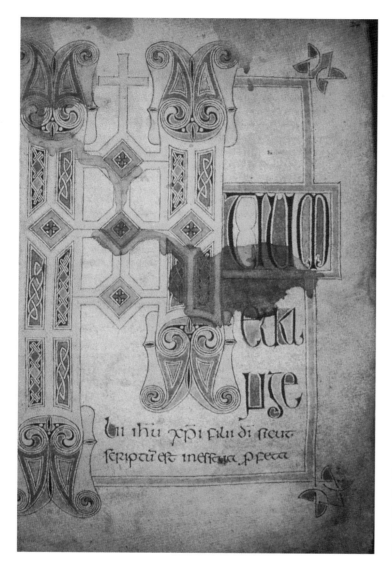

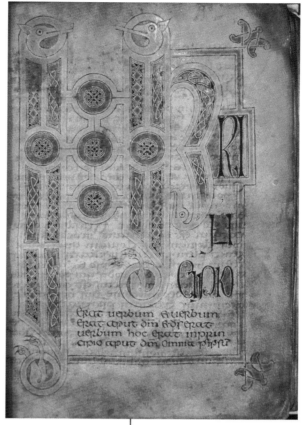

20. Illuminated Initial Page, The Gospel of St Mark, from the Hereford Gospels, late 8th century, 225 × 170

21. Illuminated Initial Page, The Gospel of St John, from the Hereford Gospels, late 8th century, 225 × 170

In a general way, Celtic Christian belief as imaged in the gospel-books may owe much to pre-Christian systems. The presentation of the pagan and the Christian as mutually exclusive is a post-Reformation tendency. Early theologians and hagiographers 'saw the relationship as one of preparation and fulfilment based on the model of Paul's speech in Athens'.[58] In the period in which the gospel-books were written Christians regarded their faith not so much as in conflict with what had preceded it, but rather as the completion of a process which included much, though not all, of that which went before. Attitudes to the natural world – especially such overarching concepts as the tension between the hostile and the benign – may have been subsumed and recontextualized rather than rejected. In this light, the conjunction of imagery representing narratives of human life and of the fantastic seems less perplexing. In the course of time, the range of patterns and fantastic motifs may have become simply a matter of design tradition, largely divested of specificities of meaning.

[58] Thomas O'Loughlin, *St Patrick: The Man and His Works* (London, 1999), p. 33. For Paul's speech, see Acts 17:22–31.

22. D. Farrel,
The Pillar of Eliseg,
1808, Engraving, 211 × 136

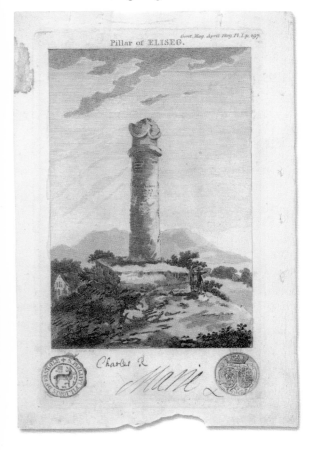

59 Several such memorials carry inscriptions requesting the prayers of the living for the deceased. The suggestion that the later large stone monuments had no liturgical function does not imply that they were not the foci for private prayer. However, as all activity and life was understood as taking place *within* the Christian paradigm, the cross as terminal to such objects, whatever their location and immediate purpose, is natural and should not surprise us.

60 The column was thrown down during the civil wars of the seventeenth century at which time its cross-head was probably destroyed.

61 Nash-Williams, *The Early Christian Monuments of Wales*, pp. 124–5, no. 182.

62 The inscription is given in ibid., p. 123.

Although it cannot be demonstrated that the Gospels of St Chad was made in Wales, the period at which the book was in Llandeilo is of great significance in itself. It coincides with a substantial change in the nature of the stone monuments which form the largest record of the visual culture of the period. In the ninth century the carving in the round of free-standing stone crosses was added to the tradition of the earlier period of incised decoration and inscription on the face of slabs. The use of the word 'cross' to describe the later monuments, though justified in the sense that almost all of them make use of the cross form, may be misleading. It is unlikely that any had a role in worship, in the way that a rood became a focus for devotion in the church buildings of the later Middle Ages. Given the extensive evidence for the veneration of relics in the Lives of the saints, the absence of comment on the large and sophisticated stone monuments of the early medieval period suggests strongly that they were not foci for devotion in the same way. Those monuments which were located in close proximity to churches do not show any consistent spatial relationship to buildings of the kind which might be expected had they been a part of the regular observance of Christian rites. Many of the crosses from a religious context, as sometimes their inscriptions confirm, were probably memorials to notable clerics, but many more were secular memorials, sometimes marking burials.[59] The most remarkable of these is the column of Eliseg near Llangollen, which stands on top of an artificial mound in which a stone coffin was found in 1779. In form, the memorial is similar to an inscribed Roman circular column, though the authority of the Christian faith was probably invoked by a surmounting cross, now lost, to reinforce the dynasty it memorialized.[60] The column carried a long inscription which is now eroded, but most of it was recorded in the late seventeenth century. Its subject was the lineage of the royal house of Powys and, in particular, it celebrated the victories of Eliseg over the English in the mid-eighth century. It was erected by his great-grandson Concenn, who died whilst on pilgrimage in Rome *c.*854. Such direct personal experience of Rome on the part of powerful lay figures, as well as that of ecclesiastics, may explain the apparently classically-derived form of the monument. The Eliseg column is considerably earlier than other insular examples of the form found in coastal Cumberland and the High Peak District of Derbyshire.[61]

The Eliseg column is of importance also for the indication it gives of the process by which such monuments were made. The inscription, which was cut in the half-uncial script of the gospel-books and which echoes their form of words, recorded that 'Conmarch painted this writing at the command of his king Concenn'.[62] Clearly, a royal court of the early ninth century had access to a scribe thoroughly familiar with the written tradition. It would appear that the inscription was painted on the stone by the scribe and then carved by an artisan who may have been illiterate. Alternatively, the scribe may have written on a skin for the carver to copy. The evenness of the inscription on the Eliseg pillar indicates the former

method, but some inscriptions strongly suggest copying from a separate original, perhaps a wax tablet, by an illiterate (and usually right-handed) craftsperson, the letters ascending and becoming larger as they move to the right.

The unusual form and early date of the Eliseg column suggests an isolation which is, perhaps, only apparent. Stone crosses may have been preceded by wooden examples and, indeed, the theory has been advanced that a tendency to avoid horizontals in letter forms cut in stone reflected the experience of masons who also worked in wood and avoided making difficult cuts along the grain.[63] In the absence of surviving examples of letter-cutting on wood, or textual authority for the practice, it is impossible to confirm whether craftspeople in the early medieval period habitually worked in both media, though they may well have done so. Although little evidence of the form, and none of the decoration, of the wooden churches and secular buildings of the period survives, there is no reason to suppose that their structural elements – such as upright posts and lintels – were not carved and painted. Equally, it is possible that churches contained wooden crosses and perhaps carvings on panel. The production of such wood carvings by families or workshops of artisans may have carried forward the traditions manifested in the surviving record only in stone. The visual culture of early medieval Wales would have been most unusual in Europe and also in the broader context of cultures with comparable social organization in other parts of the world had it not included a tradition of wood carving. The loss of such a presumed tradition presents a serious difficulty in understanding the visual culture of the period – both in terms of the date at which the iconography preserved in stone first appeared in Wales, and whether that iconography represents only a small part of the whole, reflecting the limited range of functions of the crosses. It may be, for instance, that wood carving presented much more fully the iconography known from the literary record of the oral culture typified by the praise poetry and the Mabinogion.

In so far as it survives, the carved iconography echoes closely that employed both in metalworking and manuscript illumination. Rivet-like designs and punch marks suggest the transfer of features arising from the necessities of metalworking into the stone-carving tradition, ossified as stylistic conventions. Both metalwork and manuscripts predate the large stone-carved monuments, though the absence of survivals of wood carving makes it impossible to determine whether the time-lag between the use of particular features in two- and three-dimensional work was real or apparent. If there was a process of stylistic transfer, rather than simultaneous development of conventions in lost wood carving, it also involved a transfer of practice because the manuscript tradition was maintained by monks while three-dimensional work was almost certainly the province of professional secular artisans. With some exceptions, notably the column of Eliseg, the new monuments were

[63] The evidence for the practice revealed in stone-carved inscriptions was discussed by Gifford Charles-Edwards in an unpublished paper 'Geometrical Letters' given at the conference 'Early Medieval Sculpture in Wales and her Neighbours', Early Medieval Wales Archaeology Research Group, University of Wales, Cardiff, 11 March 2000.

25. Incised Slab,
Meifod, Montgomeryshire,
late 9th–10th century,
Stone, ht. 1490

[64] For further discussion, see the Appendix.

[65] Nash-Williams, *The Early Christian Monuments of Wales,* p. 179, no. 295, regarded the Meifod slab as particularly important as evidence of the eclecticism of the Welsh material. He believed the object directly reflected 'a group of late Merovingian sculptured grave-lids of the 8th century from the Poitiers district of France'. Furthermore, he believed that Merovingian and Carolingian monuments were the ultimate source of all the Welsh cross-types.

[66] For further discussion, see the Appendix.

[67] The excavation and interpretation of the Llangorse crannog is summarized in Redknap, *The Christian Celts,* pp. 16–25.

[68] See above, p. 24.

below right:

24. Strap Hinge,
found at Llangorse Lake, Breconshire,
late 9th–early 10th century, Copper
alloy and enamel, ht. 54

23. The Crannog,
Llangorse Lake, Breconshire,
late 9th century

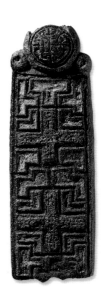

of broadly similar form – slab-like, but usually shaped and decorated on all their surfaces, often in page-like panels. Carved interlace design also remained close to its manuscript source. Carvings were not fully three-dimensional, since one strand did not dive under another. Generally, they remained on the same plane surface and the crossover point was indicated by the convention of a break in the line, as in the drawn interlacings of the manuscripts. The persistence of this convention supports the assumption that the crosses were originally coloured, as was the case in the classical tradition of both carving and letter-cutting.[64]

Very close correspondence with manuscript illustration is also apparent in figurative and zoomorphic imagery, exemplified by the minute designs cut on a roughly formed slab at Meifod, Montgomeryshire, which probably dates from the late ninth century. A crucifixion, enclosed in a wheel cross, surmounts a second cross adorned with interlace. Attenuated serpent-like beasts twist and bite their own tails exactly in the manner of the manuscript tradition. Meifod was an important and large monastic site, and the only one in Wales where the enclosure survives on a scale comparable to that of contemporary Irish monasteries. It contained three churches and was the burial ground of the princes of Powys. The presence of only a single early Christian carving is, therefore, surprising, and we may assume that it once contained a richness of material, including the manuscripts which the sole survivor reflects.[65]

Like the group of manuscripts to which the gospel-book of St Chad belongs, the crosses indicate an extension of the earlier cultural contacts between Wales, Ireland and the south to include Northumbria, where sculptured stone monuments were made before they appeared in Wales. There were also contacts with Mercia and increasingly with the Norse tradition carried by Viking settlements around the coasts of Britain and Ireland and on the Isle of Man.[66] The development of stone carving was probably the result of several factors which encouraged patronage, including changes in political aspirations and, in particular, a general improvement in economic conditions for which there is corroborative evidence. For instance, late in the ninth century the ruler of Brycheiniog, probably Elise ap Tewdwr, built a *llys* on an artificially constructed island in Llangorse lake.[67] The discovery there of the enamelled bronze strap hinge of a reliquary[68] and a remarkable linen textile suggest the employment of craftspeople working to meet demands well beyond those of day-to-day survival.

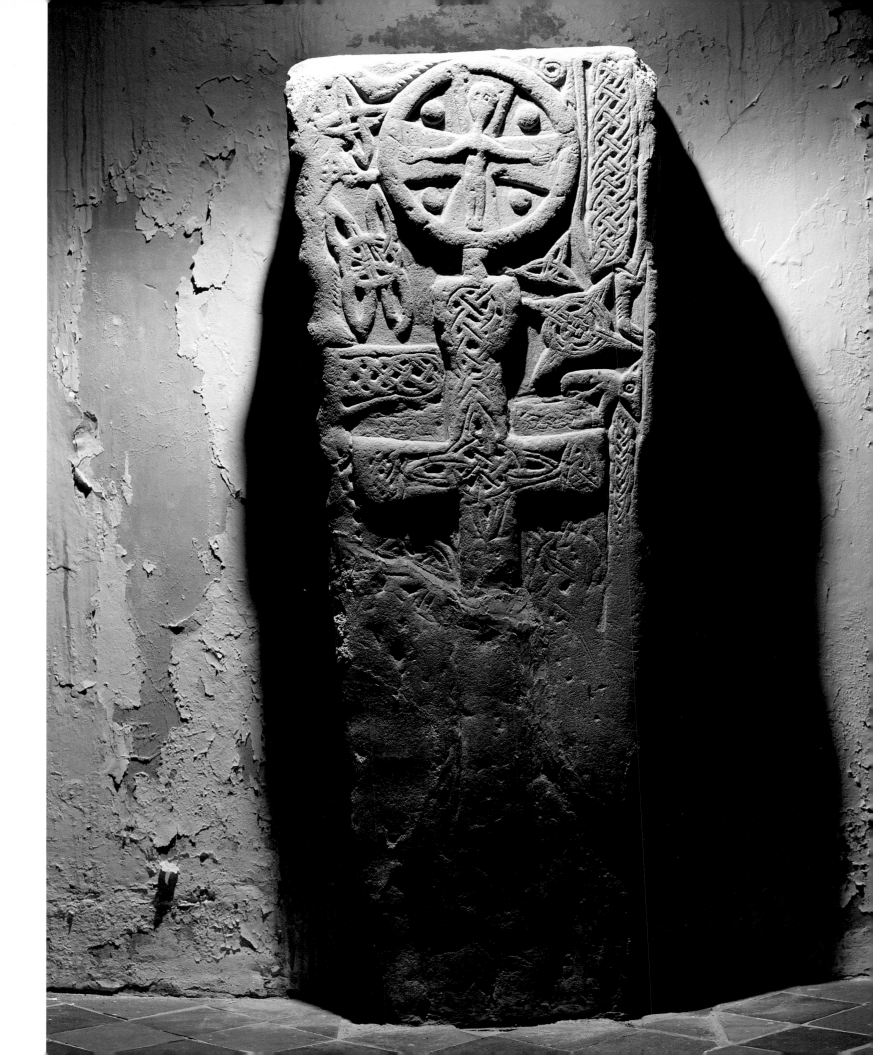

27. Pseudo-penannular Brooch, found at Penycorddyn-mawr, Denbighshire, 8th century, Gilt copper alloy with glass and amber studs, diam. 73

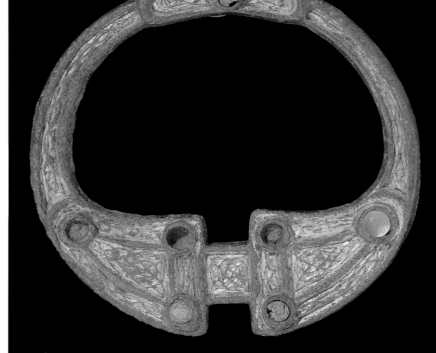

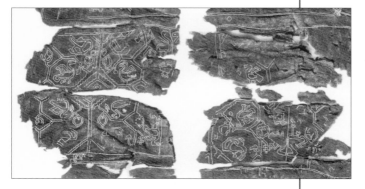

26. Textile, found at Llangorse Lake, Breconshire, late 9th–early 10th century

below:

28. Armlets, found at Llanfihangel Dinsylwy, Anglesey, 10th century, Silver, approx. diam. 70

⁶⁹ A second cross from the area, at Llanddewi'r-cwm, Nash-Williams, *The Early Christian Monuments of Wales*, p. 73, no. 47, though surviving only as a fragment, is clearly of the same type.

⁷⁰ Tree-ring dating indicates that the timber for constructing the site was felled between AD 889 and 893. The Anglo-Saxon Chronicle notes the destruction of the site by a Mercian Army in 916: 'Three days later Æthelflæd sent an army into Wales and stormed *Brecenanmere* [at Llangorse lake, near Brecon], and there captured the wife of the king and thirty-three other persons.' *The Anglo-Saxon Chronicle*, translated by G. N. Garmonsway (London, 1953), p. 100.

⁷¹ As we have seen, it had been attended by St Samson of Dol, and had also numbered among its students St Paul Aurelian, founder of the monastery of St Pol de Leon, and Gildas, author of *De Excidio Britanniae* ('The Ruin of Britain'), a long moral tract in the form of a history, written in the mid-sixth century.

29. The Llanynys Cross,
found at Llanynys, Breconshire,
late 9th–early 10th century, Stone, ht. 1785

The textile, embroidered with silk and wool, was probably a woman's upper garment. The embroidered designs included birds and lions familiar on textiles from the eastern Mediterranean, but made locally. Finds in other parts of Wales, such as the somewhat earlier brooch from Penycorddyn-mawr in Denbighshire and, closely contemporary with the Llangorse *llys*, five particularly fine silver armlets from Llanfihangel Dinsylwy, Anglesey, probably of Viking manufacture, reinforce the picture of developing patronage and trade. Although only in fragmentary form, the metalwork and textiles from Llangorse indicate a level of patronage consistent with the carving of the crosses of the period. Indeed, a particularly elegant example was set up at Llanynys, just a few miles to the north of the *llys* at Llangorse.[69]

The Llangorse *llys* seems only to have survived for some twenty-five years – a reminder that general political stability can by no means be inferred from an increase in patronage.[70] Nevertheless, the period of the crosses, from the mid-ninth to the mid-eleventh century is contiguous with the aspiration of successive regional rulers, beginning with Rhodri Mawr who died in 877, to extend their authority over the whole of Wales. It was Rhodri's grandson, Hywel Dda, who, according to tradition, codified Welsh law in the middle of the tenth century from his power-base in Deheubarth. This attempt to create a common framework for the functioning of civil society is compelling evidence of the aspiration to stability which is also characteristically expressed in the commissioning of public monuments. The stone crosses cannot be forced into a national tradition which reflects a modern understanding of the political aspirations of Hywel Dda, since even when the house of Deheubarth or, later, of Gwynedd dominated the rest of Wales no single seat of power proved sufficiently stable to emerge as a proto-urban focus. Nevertheless, the development of types of cross does hint at the emergence of tradition within regions of Wales which correspond to the larger political divisions of the country. The most suggestive evidence comes from the south, and broadly corresponds with the kingdom of Glywysing, which extended from the Usk in the east to the Tawe in the west. At the centre of this area was the monastery of Llantwit Major which, by the ninth century, must have been an establishment of some size, and which certainly had a distinguished tradition of scholarship.[71] Notwithstanding the secular associations of many of the monuments and the fact that those now gathered together in the church were originally scattered about the locality, their concentration suggests that Llantwit Major was a centre of patronage for carvers over a long period. The occurrence of two particular forms of cross over a larger area confirms that its influence was widespread.

[72] It was suggested by Nash-Williams, *The Early Christian Monuments of Wales*, p. 140, that the decorative style of the carving was close to that on a slab at Tullylease in Co. Cork. Nash-Williams concluded from this that the sculptor of the Welsh crosses was Irish or Irish trained, though logic would suggest the opposite given the existence of a group of such Welsh crosses and a single example in Ireland. Nash-Williams, ibid., p. 33 (d) and plates XXXVII–XXXIX, lists eleven examples in this group.

[73] Ibid., p. 140, no. 220.

[74] For his kingship, see Davies, *Wales in the Early Middle Ages*, p. 102.

[75] The cross, along with several others, is now in the Margam Stones Museum. They were collected in the mid-nineteenth century by C. R. M. Talbot. For the nineteenth-century revival of interest in the crosses and the preservation movement, see Peter Lord, *The Visual Culture of Wales: Medieval Vision* (Cardiff, 2003), CD-ROM, Time Galleries.

[76] Nash-Williams, *The Early Christian Monuments of Wales*, p. 146, no. 231. The use of the word 'fecit' (ENNIAUN P[RO] ANIMA GUORGORET FECIT) seems more conclusive on this point than the more ambiguous 'prepared' on the Cross of Hywel ap Rhys ((H)ANC [CR]UCEM HOUELT PROPE[RA]BIT PRO ANIMA RES), above, ibid., p. 140, no. 220.

30. The Cross of Houelt,
Llantwit Major, Glamorgan,
late 9th century, Stone,
ht. 1835, and detail

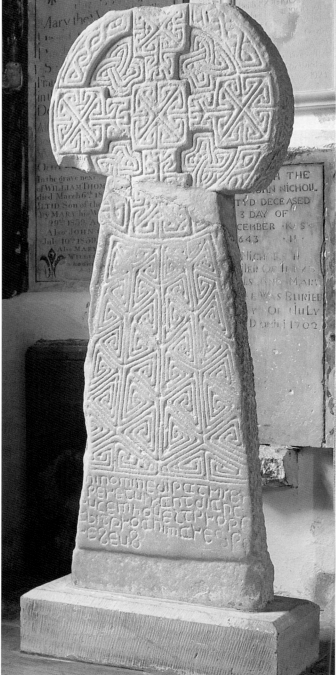

The earlier form of cross is peculiar to Glamorgan, with very few comparable objects identified outside Wales.[72] The example at Llantwit Major itself is of crucial importance because it carries an inscription referring to individuals who can be dated with some certainty: 'This cross Houelt prepared for the soul of Res his father.'[73] Houelt was almost certainly Hywel ap Rhys, who is mentioned in the literary sources as king of Glywysing in the second half of the ninth century.[74] The cross was decorated on both faces and originally also on its edges with a variety of fluid interlacings and angular frets. In the main panel of the Llantwit Major cross they are similar in design to those surrounding St Luke in the Gospels of St Chad, underlining the source of such designs in the calligraphic tradition. The type is also represented at Margam, where a stone of 6 foot in height was cut into the form of a tapering shaft surmounted by a disk onto both faces of which was carved a Greek cross.[75] Like the Llantwit Major cross, that at Margam carries an inscription, and the words 'The Cross of Christ. Enniaun made it for the Soul of Guorgoret' seem to indicate unequivocally the name of the carver.[76] The close similarity in form of the Llantwit Major cross to that at Margam is not reflected in the details of its decoration. The Margam cross has more interlace and less fret. A third cross of the group, though broadly of the same disk-headed type, is more complicated in design and may be of a later date. In common with several later crosses it is constructed from two stones, joined by a mortise and tenon, in this case between the base and the shaft. The patron is named as one Conbelin, but the rest of the inscription has been lost.

The difficulty of transporting monuments of this massive size necessitated a peripatetic practice for carvers. The crosses of the group are cut in different stones, generally quarried near the site at which they were to be erected. This practice does not preclude the location of workshops at Llantwit Major, producing monuments for that locality and also, presumably, a proliferation of lost smaller memorials and utilitarian items such as querns, which could be easily transported. Llantwit Major probably provided a proto-urban setting for commerce in larger memorials – a place to which a patron could go knowing that carvers were to be found and who were available to travel to different localities on commission.

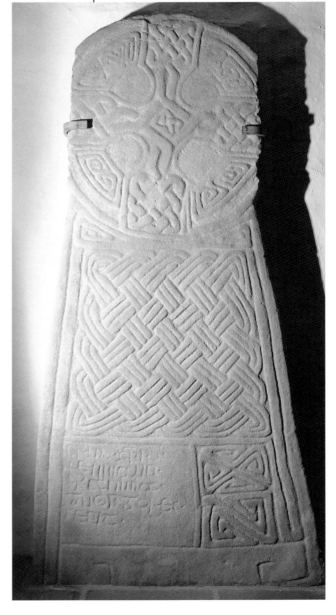

31. Enniaun,
The Cross of Guorgoret,
Margam, Glamorgan,
late 9th–early 10th century,
Stone, ht. 1835

33. Cross Slab,
found at Merthyr Mawr,
Glamorgan, 11th century,
Stone, ht. 2240

32. Sciloc, The Cross of Conbelan,
found at Merthyr Mawr, Glamorgan,
11th century, Stone, ht. 1315

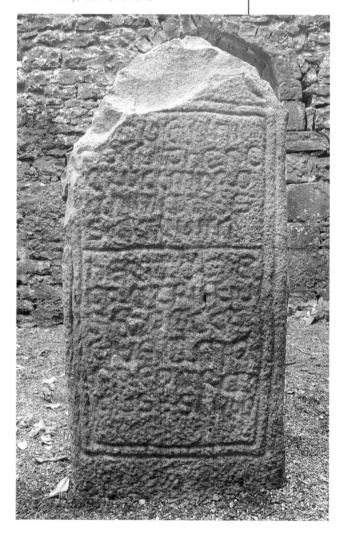

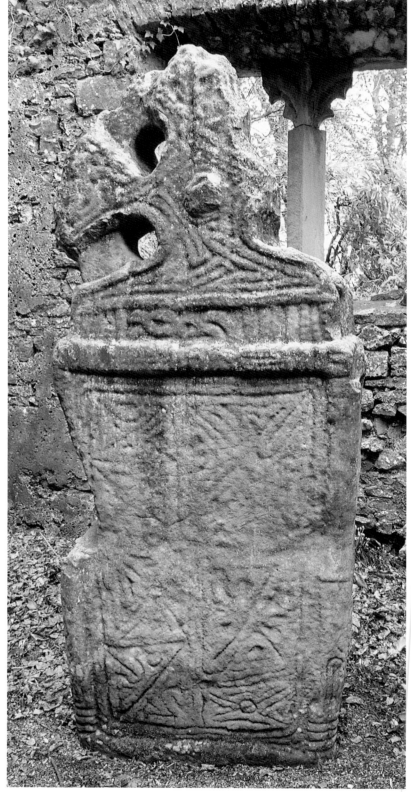

The names of several patrons and carvers are recorded. A mason named Sciloc carved a slab at Merthyr Mawr, now devoid of its cross-head, memorializing a local saint and members of the family of Conbelan, the donor.[77] Its similarity in form to a more mundane tablet recording a deed of transfer, presumably of land, indicates that Sciloc was again responsible. The inscription invokes the authority of the Trinity in this legal matter, and is matched by the form of the tablet, which retains its cross. The charters in the Book of Llandaff record several property grants of this kind, including one at Merthyr Mawr, in the eleventh century, when the carving was made.[78]

Conbelin's cross at Margam is distinguished by figurative carving. On what was presumably the rear of the base is a hunting scene of dogs and horses. From a modern perspective it evokes the pagan world of the Mabinogion, but in that period hunting was a part of the everyday life of the rich and powerful, and it may simply record the patron's prowess in the field.[79] This secular imagery is accompanied on the cross itself, presumably indicating its more important face, by the figures of St John, who holds the book of his gospel, and the Blessed Virgin Mary. They flank the shaft of the cross which stands in place of a figure of Christ. This was the most common convention for the depiction of the Crucifixion in the period and the same arrangement is evident on a slab from Llanhamlach in Breconshire. Other aspects of the Passion were sometimes shown, as on a slab at Llan-gan, Glamorgan, where a figure of Christ within the head of the cross is accompanied by the soldier who carries the sponge laden with vinegar to mock Christ's call 'I thirst' at his death. His companion drives a lance into the side of Christ, who is depicted with a beard, in the tradition of Byzantine rather than Roman imagery, where he is usually beardless. Below the ring of the cross-head stands another figure, possibly a warrior or a huntsman, since he seems to carry a knife or a horn, who may be intended to represent the patron of the work.

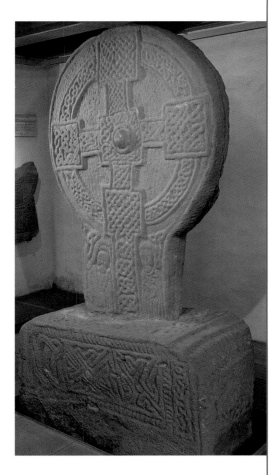

34. The Cross of Conbelin, Margam, Glamorgan, late 10th–11th century, Stone, ht. 1490

[77] Ibid., p. 154, no. 239. 'Conbelan placed this cross for his (own) soul (and for the souls) of Saint Glywys (?), of Nerttan, and of his brother and his father. Prepared by me. Sciloc'. The use of 'preparatus' (… EIUS A ME PREPARATUS + SCILOC) on the Merthyr Mawr monument is somewhat ambiguous, see note 76 above, where Rhys seems more likely to be the patron than the maker. However, the similar usage here is unlikely to indicate the name of a patron since Conbelan is named as such. This memorial was drawn complete with its cross-head by Edward Lhuyd in 1697, when it stood on the river bank at Merthyr Mawr.

[78] Wendy Davies, *An Early Welsh Microcosm* (London, 1978), p. 98. A third tablet, Nash-Williams, *The Early Christian Monuments of Wales*, p. 160, no. 255, from Ogmore, though surviving only as a fragment, also appears to have taken the same form. It celebrates the same saint, Glywys, and one of the individuals, Nertat [*sic*] named in ibid., p. 154, no. 239, from Merthyr Mawr. The Ogmore tablet records the dedication of a field, presumably to a monastery or church.

[79] Less prosaic interpreters of hunting scenes regard them in general as allegories of the search for enlightenment or, in the case of Conbelin's cross, as reflecting Christian symbolism, 'with Christ as the victim represented by the deer, pursued by devils represented by the hounds and riders'. Green, *Celtic Art*, p. 163.

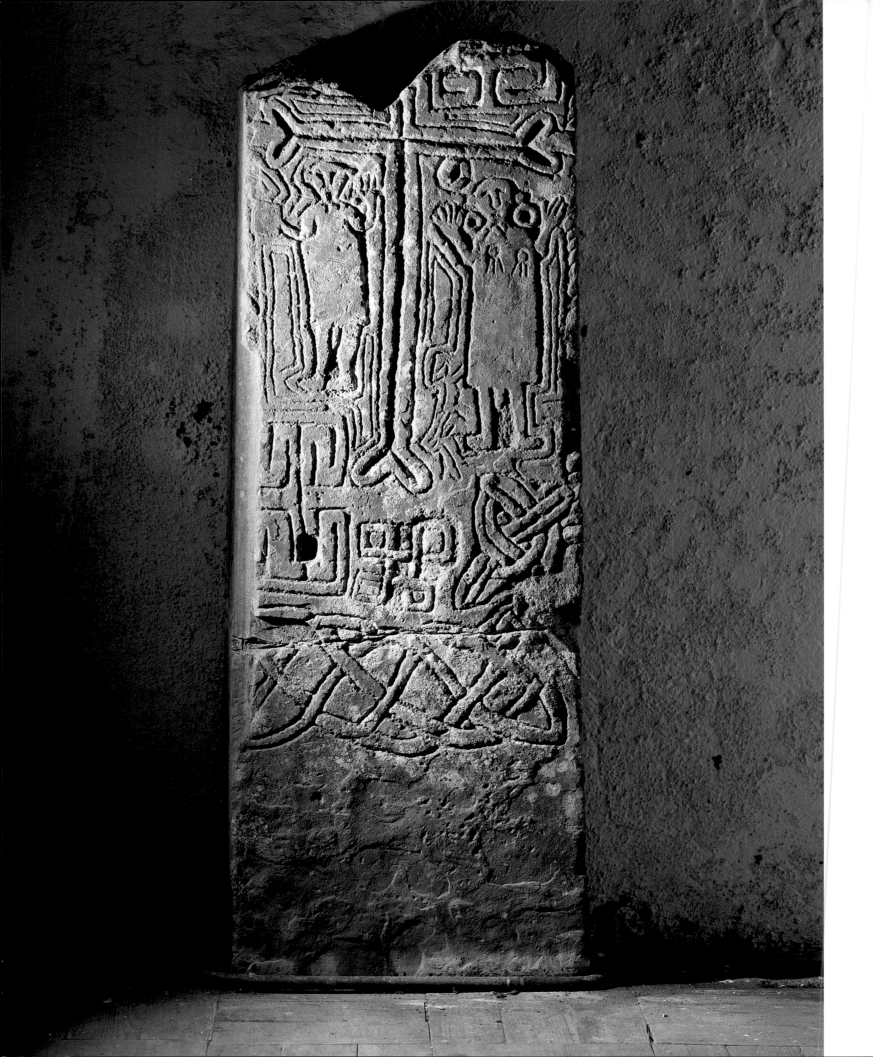

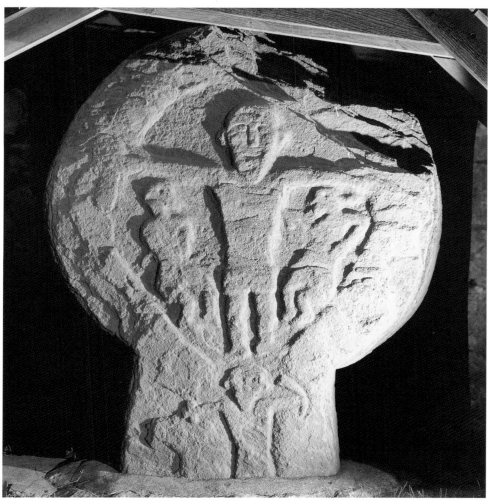

36. The Crucifixion,
Llan-gan, Glamorgan,
10th–11th century,
Stone, ht. 1240

37. The Cross of Briamail Flou,
found at Llandyfaelog-fach,
Breconshire, late 10th century,
Stone, ht. 2300, and detail

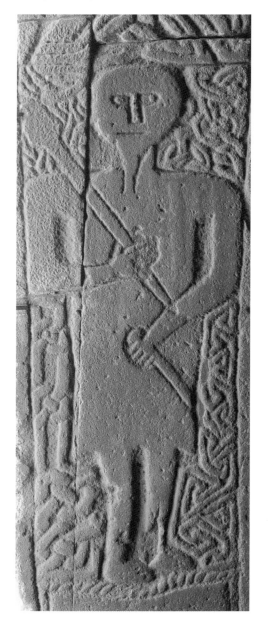

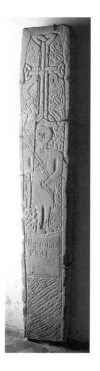

This pattern was also used on a slab at Llandyfaelog-fach in Breconshire, where a standing figure is identified by an inscription as one Briamail Flou.

The remarkable monument at Llandough in Glamorgan, constructed in four pieces, appears to repeat the combination of secular and religious imagery cut on Conbelin's Cross at Margam. The frequency and ease with which images of what seem to the modern mind to be the distinct worlds of belief and everyday experience are brought together is a reminder that the medieval world view encompassed no such divide. Unfortunately, the local stone from which the Llandough

35. The Cross of Moridic,
found at Llanhamlach, Breconshire,
10th–11th century, Stone, ht. 1120

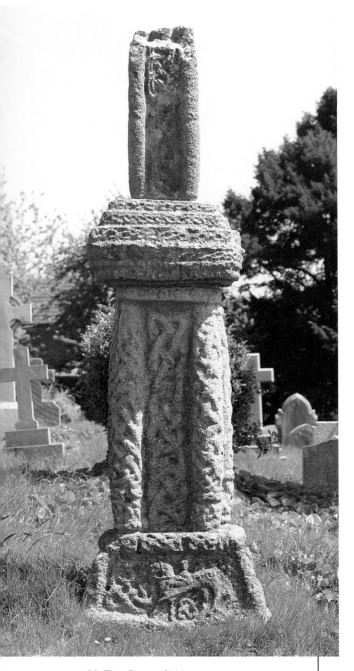

38. The Cross of Irbic,
Llandough-juxta-Cogan,
Glamorgan, late 10th–11th century,
Stone, ht. 2980

right:

39. Slab, found at Cefn Hirfynydd,
Glamorgan, Figure in orans prayer position,
9th–10th century, Stone, ht. 710

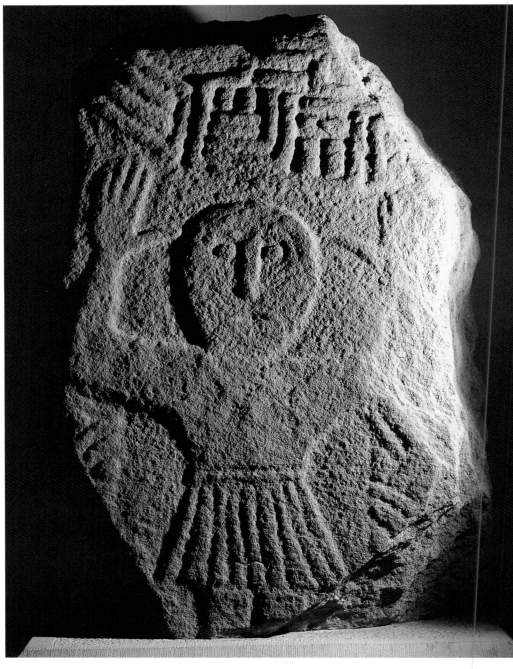

monument was carved has weathered badly, but it is possible to discern a horse and rider on one panel, and a procession or row of five figures, each carrying a cross, on another. The imagined and the tangible formed a single, fluid whole.

The Virgin and St John, attending at the crucifixion on the Llanhamlach cross, are depicted in the orans position – their hands raised, palms facing forward – which was conventional among early Christians at prayer.[80] There are several other depictions in Wales of Christians at prayer in the orans position, notably the Cefn Hirfynydd figure from Seven Sisters. The figure probably occupied the

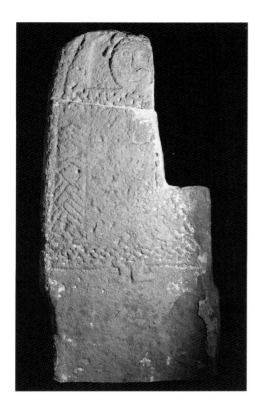

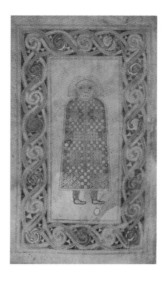

41. The Man, symbol of St Matthew, from the Book of Durrow, TCD MS 57, f.21ᵛ, c.680, 245 × 145

40. Slab, found at Pontardawe, Glamorgan, Figure in orans prayer position, Stone, ht. 1130

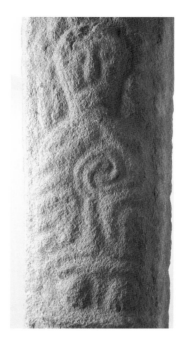

42. The Llanbadarn Fawr Cross, Cardiganshire, late 10th century, Stone, ht. 2730, detail of a cleric, approx. ht. 470

top part of the shaft of a substantial wheel-head cross since the surviving interlace above his head forms the lower part of a circle. He is placed centrally below this circle and therefore probably represents a patron, rather than St John, who would have been set to one side to accommodate a partner figure of the Virgin. On a slab from Pontardawe, the face, hair, and cloak worn by the figure at prayer, beneath which his feet protrude in profile, is reminiscent of the symbolic figure of a man, representing St Matthew, in the Book of Durrow, one of the group of illuminated gospel-books to which the Gospels of St Chad belongs. The fringe of his tunic, though badly worn, carries a fret or interlace design which may have been conflated with an overall pattern on the slab. However, he does not carry a token which might identify him as a saint; nor is he identified as the patron. Such images are never portraits in a modern sense, of course, since figures are not individuated by personal characteristics, but it may well be that images such as the cleric on the high cross at Llanbadarn Fawr in Cardiganshire were intended for historical individuals. The Llanbadarn cleric carries a crosier, the head of which is developed into a spiral in the manner of the Doorty cross in Ireland. Furthermore, his dress is delineated in a manner reminiscent of Irish manuscript illumination[81] and the cross also carries what may be a representation of Jacob wrestling with the Angel, a common motif in contemporary Irish carving. Since few Welsh crosses carry figurative images by comparison to those of the Irish tradition, it is possible that the Llanbadarn cross represents either the first-hand experience of the carver in Ireland or the copying of images from an Irish manuscript held at the monastery. While documentary confirmation of close Irish connections with Llanbadarn is absent in the likely period of the carving of the cross, it is abundant shortly afterwards in the early eleventh century.[82]

[80] The Odes of Solomon, a text probably originally written in Syriac and originating in Syria c.100 AD, describes the orans position as symbolic of the cross. See J. R. Porter, *The Lost Bible: Forgotten Scriptures Revealed* (London, 2001), pp. 114–15.

[81] See, for instance, the St Gall Gospels, Christ on the Cross with Longinus and Stephaton (the iconography of the Llan-gan slab), c.750–60.

[82] The Llanbadarn cross is also of interest because the stone of which it was carved probably originated in the Cadair Idris area, some distance to the north. The transportation of a stone over such a long distance and from such a notable site has given rise to speculation that symbolic importance was attached to it. However, evidence for the use of Preselau stone suggests that the reason may have been more prosaic, see note 85.

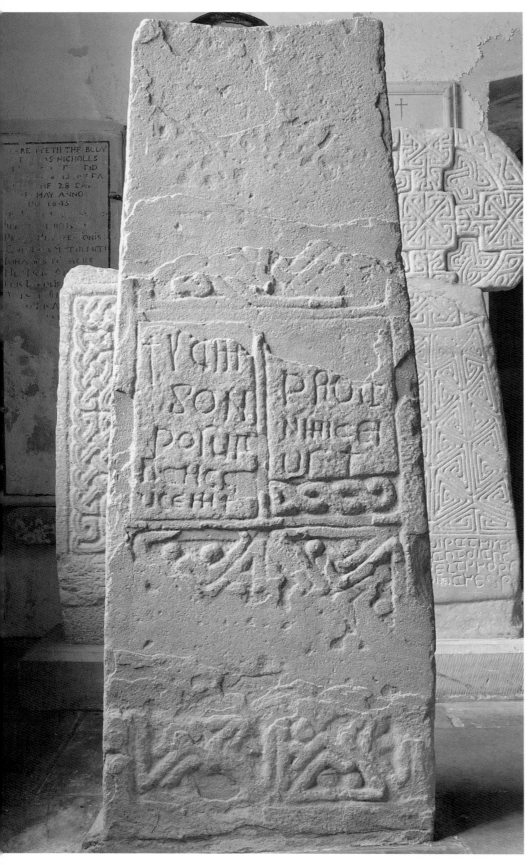

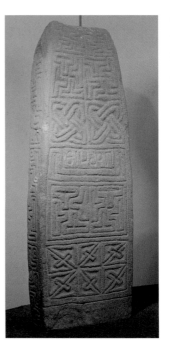

44. The Cross of Eiudon, found at Llanfynydd, Carmarthenshire, 10th century, Stone, ht. 2045

43. The Cross of Samson, Llantwit Major, Glamorgan, late 10th century, Stone, ht. 2170

The probability that the monastery of Llantwit Major, with its religious status reinforced by royal patronage, was a centre from which craftspeople dispersed to work, is confirmed by a second group of crosses of a later date which celebrate secular leaders. The group is more widespread, but unified by massive size, composite construction and inscriptions. At Llantwit Major itself, and at Llanfynydd in Carmarthenshire, only the bodies of the crosses survive. Their decoration, in particular on the edges, is similar enough to suggest a common hand, and their manufacture of local stones confirms the peripatetic nature of the carver's practice. The Llantwit Major inscription is lengthy and informative: 'Samson set up this cross for his (own) soul, (for the soul of) Iltut, of Samson the King, of Samuel, and of Ebisar',[83] but unfortunately not one of the individuals

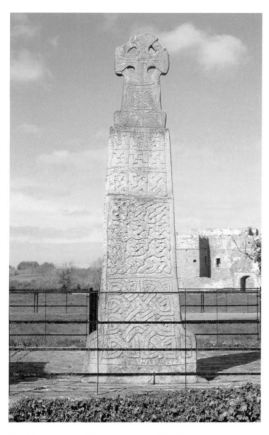

45. The Cross of Maredudd ab Edwin,
Carew, Pembrokeshire,
c.1033–5, Stone, ht. 4130

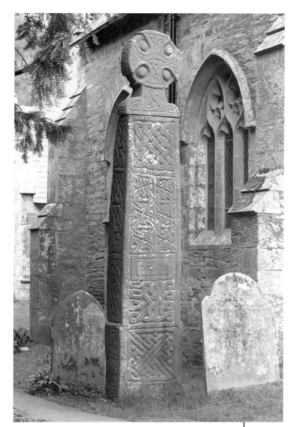

46. The Nevern Cross, Nevern,
Pembrokeshire, early 11th century,
Stone, ht. 3955

named is known from a dated source.[84] A third monument of the same type, with an eclectic array of interlacings and frets, survives complete with its cross-head at Nevern in Pembrokeshire. It carries an inscription which it has not been possible to decipher. However, both the general arrangement and the details of the cross-head are very similar to those cut on the massive monument which survives at Carew. Both crosses are constructed of the same two types of stone, although their arrangement is reversed – the cross-head at Nevern is of the same Preselau stone as the shaft at Carew, while the head at Carew is of the volcanic stone from the Fishguard area from which the mason cut the shaft at Nevern.[85]

The inscription cut on the Carew monument provides the key to dating the whole group. It celebrated Maredudd ab Edwin, the direct descendant of Hywel Dda, who, with his brother, took the kingdom of Deheubarth in the year 1033.[86] Since Maredudd was killed in 1035, it seems likely that the cross dates from that short period of his rule. The patron also apparently had an eye on the future since the carver left an empty panel, clearly in anticipation of cutting a second inscription. The cross was located close to the entrance of a large fortified site of some antiquity, presumably the *llys* of Maredudd himself, and therefore one of the main power centres of the kingdom of Deheubarth.[87]

[83] Nash-Williams, *The Early Christian Monuments of Wales*, p. 142, no. 222.

[84] Ebissar/Ebisar occurs on two crosses at Coychurch, ibid., pp. 130–2, nos. 193, 194, but the style of these suggests a date later in the eleventh or perhaps twelfth century.

[85] The stones were identified by Heather Jackson in a paper, 'The Geology of Inscribed Stones', given at the conference 'Early Medieval Sculpture in Wales and her Neighbours', Early Medieval Wales Archaeology Research Group, University of Wales, Cardiff, 11 March 2000. Jackson showed that the Preselau stone was used in preference to more local stones on several occasions in south-west Wales, thereby necessitating transportation over long distances. However, the reversed order of the usage at Carew and Nevern does not suggest that any symbolic importance was attached to the material from Preselau.

[86] The descent of the royal houses of Wales down to 1400 is given in graphic form in John Davies, *A History of Wales* (London, 1993), pp. 82–3.

[87] The site at Carew seems eventually to have passed to Nest, daughter of Rhys ap Tewdwr of the royal line of Deheubarth. It was rebuilt on an ambitious scale by her husband, Gerald de Windsor, an upwardly mobile Norman. In 1100, following the fall of his own master, Gerald became Henry I's representative in the south-west. Nest had been the king's mistress while at court, a hostage for the good behaviour of her people. Presumably, the survival of the conspicuous monument to the native dynasty was not due to an oversight on the part of Gerald. He may well have considered that the benefit likely to accrue from the local people retaining a sense of loyalty to his wife would have been increased by a show of respect for the monument to her ancestor. Nest would be the aunt of the Lord Rhys and grandmother of Giraldus Cambrensis.

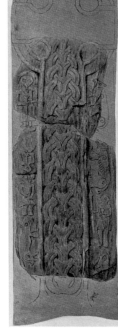

49. After P. M. C. Kermode, Grim's Cross, Michael, Isle of Man, of the early 11th century, 1907, original height of stone approx. 1830

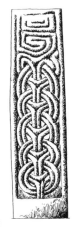

48. Ring-chain pattern from rear elevation of the Cross at Penmon, Anglesey (opposite)

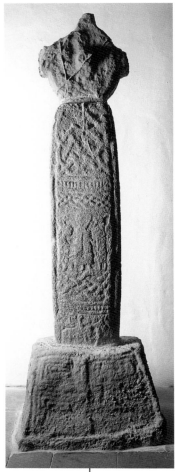

47. Cross, Penmon, Anglesey, late 10th–11th century, Stone, ht. 2165

[88] Grim's Cross to Hromund, at Michael. The hunt motif was also favoured by Pictish carvers, for which see J. R. Allen, *The Early Christian Monuments of Scotland* (Edinburgh, 1903).

[89] The cross at Moone abbey, Co. Kildare, provides a particularly close parallel.

[90] James Graham-Campbell and Dafydd Kidd, *The Vikings* (London, 1980), p. 150, and Cormac Bourke, 'A crozier and bell from Inishmurray and their place in ninth-century Irish archaeology', *Proceedings of the Royal Irish Academy*, 85, section C, no. 5 (1985), 155–6 and plate VII.

[91] Nash-Williams, *The Early Christian Monuments of Wales*, p. 51, no. 1. However, the stone is unusual in carrying decoration on three faces only, suggesting that it was intended to be sited against a wall, rendering one face invisible and casting doubt on the theory that it was used as the base of a cross which had been elaborately carved both back and front. Furthermore, although the stone is large enough to have accepted the cross, it is too small to have provided a stable base. Neither is the stone known for certain to have come from Penmon, since it was found at Beaumaris. The basin which has been cut into the top, presumably for use as a font, may indeed represent its original use.

A group of carvings in Anglesey illustrate both a comparable development of local characteristics to the southern group centred on Llantwit Major, and the cultural interactions which affected iconography in the tenth and early eleventh centuries. Indeed, a cross at the monastic settlement at Penmon provides one example of perhaps the most credible instance of specific artistic influence to be found on any group of Welsh monuments. The rear face of the cross shaft is decorated with a pattern known as ring-chain, which is characteristic of a school of carving on the Isle of Man, and which arose from Viking settlement there. The school is associated in particular with the carver Gaut Björnson who, in the manner of Sciloc at Merthyr Mawr, identified himself on his products. There are eighteen Manx examples of the work of the school, whose starting date is generally agreed to be *c.*950. At least one of them carries the ring-chain pattern in association with a representation of a hunt,[88] which seems also to be the subject on the side panel of the Penmon cross. Viking settlement also resulted in the appearance of Scandinavian characteristics in Irish carving. Notwithstanding the widespread use in monastic contexts of images of St Anthony (since the hermit was generally regarded as the early exemplar of the principle of withdrawal from the world), a scene of the temptation of the saint, flanked by demonic animals, on the front face of the Penmon cross is sufficiently similar to Irish depictions as to suggest continuity in the long-standing close association between Ireland and Anglesey.[89]

Since there is no documented instance of the transmission of a particular image into or out of Wales, speculation must suffice in our attempts to understand the means by which it was effected. The introduction of the Norse ring-chain pattern may have involved either a Welsh carver with experience of working on the Isle of

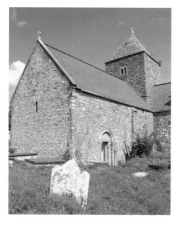

50. The Priory Church
of St Seiriol, Penmon,
Anglesey, c.1140–50

51. Carvers' Trial
Pieces, Dublin,
10th–11th century,
Bone, l. 145 and 160

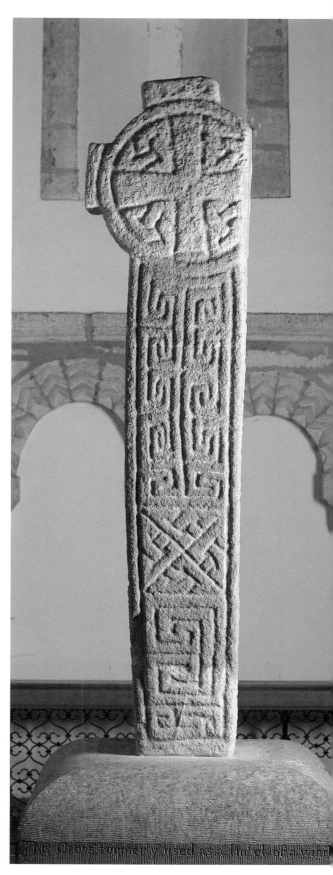

Man, or an Irish or Norse carver visiting Wales. However, there are other possibilities, including a local carver working to the precise instructions of a patron who had travelled outside Wales, or copying from portable patterns. Clearly, manuscripts were a possible source of designs, but fragments of bone or slips of stone, scratched or incised with interlaced designs, which have been found at several sites including Aberglaslyn, Caernarfonshire, suggest that portable pattern pieces may have been commonplace. These artefacts could be either the equivalent of drawings made for a specific task and then discarded or the practice pieces of apprentices, but finds in Dublin of examples deeply cut with a variety of interlacings, including ring-chain, indicate a less ephemeral function.[90]

Viking motifs seem to have impressed the maker of a second cross at Penmon, though the work is more tightly carved and devoid of Manx ring-chain pattern. Two serpent heads act as terminals to runs of fretwork on the side panels. The patterns are similar to those found on a cube-like stone, which it has been suggested may originally have served as its base.[91] The general similarity of these frets and interlaces to those carved on a more widely dispersed group of objects on Anglesey raises particularly important issues, since the objects in question are not crosses but fonts. If, as seems likely, at least some of them are contemporary with the crosses, they demonstrate that the indigenous tradition of stone carving was in a state of evolution into new forms rather than being moribund in the early eleventh century.

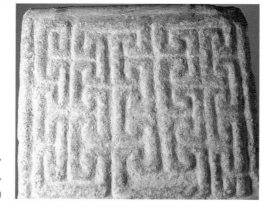

52. Font or Base of a Cross,
found at Beaumaris, Anglesey,
late 10th–11th century, ht. 510

53. Cross, Penmon, Anglesey,
late 10th–11th century,
Stone, ht. 1630

47

54. Utting after E. R. Barnwell,
Old Radnor Font, c.1864

The use of stone for making fonts before the mid-eleventh century is attested in other parts of Wales. The font at Old Radnor was probably made of material taken from a nearby stone circle and was in use perhaps as early as the eighth century. It is remarkably large and was clearly intended for baptism by immersion. A font bowl at Defynnog, Breconshire, which is smaller than the Old Radnor example and ringed by simple carved motifs, is notable for an inscription cut on the top rim. It includes the name SIWVRD GWLMER, presumably a patron, whose name may be related to the one which appears on an inscribed stone from nearby Llangorse.[92] The precise dating of the Defynnog font (and the associated inscribed stone) is disputed, but a similar example at Patricio, Breconshire, can be dated with some confidence to 1060, the year in which the church is believed

55. After Worthington G. Smith,
Bowl of the Font in the Church of St Issui, Patricio,
Breconshire, carved by Menhir *c.*1060, 1892

56. Font, Church of St Cynog,
Defynnog, Breconshire,
11th century

[92] The inscription on the font is often described as runic but appears to be in Lombardic capitals, see Rosamund Moon, 'Viking Runic Inscriptions in Wales', *Arch. Camb.*, CXXVII (1978), 124–6. Moon also discusses the only genuinely runic inscription in Wales, in Corwen churchyard. The Defynnog font bowl now stands on what appears to be the upturned bowl of a second font, and these two in turn on a base which carries a floriate motif at its four corners. Moon describes the Defynnog font loosely as 'Norman'. Nash-Williams, *The Early Christian Monuments of Wales*, p. 76, no. 60, dates the inscribed stone to the eleventh to twelfth century.

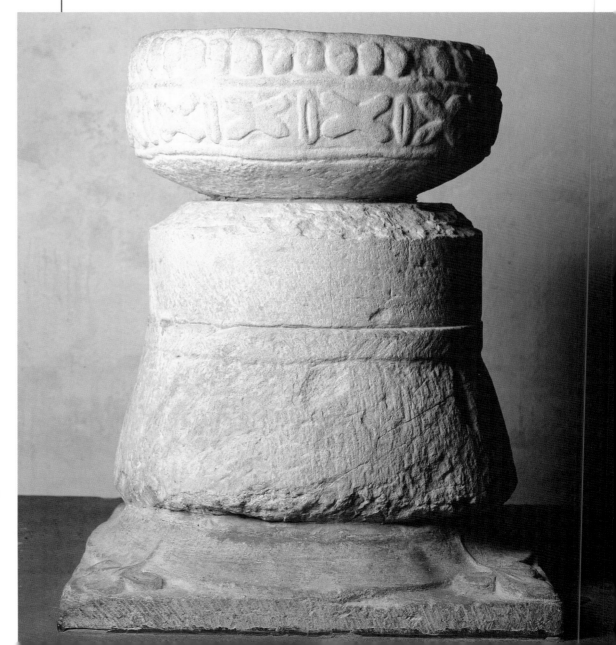

to have been dedicated. The carver is named as Menhir, who worked in the time of Genillin – an individual presumed to be Genyllin Foel, Prince of Powys in the mid-eleventh century.[93]

The twenty idiosyncratic fonts from Anglesey which have been conventionally considered together are not a coherent group, since they are unified primarily by their collective dissimilarity to others. They vary considerably in style and assuredness of design. They do not all appear to have been made at the same workshop and, furthermore, they may represent the product of a long period. Some carry decoration which is little more than incised,[94] while others are deeply cut by confident artisans. Among the latter is the one example which lies outside Anglesey, at Pistyll, on the northern coast of Llŷn, opposite the main group.[95] Its Manx-style ring-chain pattern is continuous, unlike the example at Cerrigceinwen, Anglesey, which, in the manner of many of the crosses, carries a variety of designs cut inside panels. Nevertheless, in general terms both fonts are close enough in general quality, as well as in the depth and size of the detailing, to indicate that they are contemporary with the second Penmon cross, and are possibly products of the same workshop. Indeed, the Cerrigceinwen font carries one interlaced motif which is identical to the central front and rear panel of the cross.

57. Font, Church of St Beuno,
Pistyll, Caernarfonshire,
late 10th–11th century, Stone

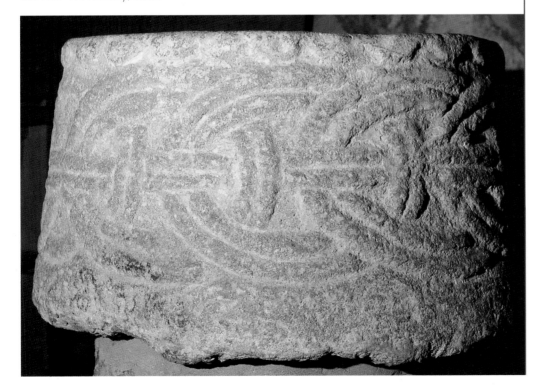

[93] MENHIR ME FECIT I[N] TE[M]PORE GENILLIN. Genyllin Foel was the only son and heir of Rhys Goch. Since the association with Genyllin Foel implied a date about the middle of the eleventh century, J. O. Westwood, 'Inscribed Font at Patrishow, Brecknockshire', *Arch. Camb.*, 3rd series, II (1856), 286–90, made the reasonable assumption that the font was likely to date from the consecration of the church by Herewald, bishop of Llandaff, in 1060. Fonts inscribed with the name of a maker or patron are rare. A third example of an inscribed font, probably of early date, is remarkable because it was made of wood. It appears to carry the name ATHRYWYN and is also unusual in having a double bowl. It was found in a bog near Dinas Mawddwy. For a description and illustration, see E. L. Barnwell, 'Wooden Font, Efenechtyd Church', *Arch. Camb.*, 4th series, III (1872), 258–9, and E. Tyrrell Green, *Baptismal Fonts* (London, 1928), pp. 49, 138–9. Green believed that the smaller bowl was probably intended to hold the holy oil and the spoon used in the chrism or anointing which was part of the sacrament of baptism. The date of the font, at present unlocated, is difficult to determine, as also is whether it represents an otherwise lost group of many carved wooden fonts which may have preceded the stone examples surviving in profusion from the eleventh and twelfth centuries.

[94] For instance, at Llanfair-yn-neubwll, Anglesey.

[95] The Pistyll font is closest in style to that at Llangristiolus, Anglesey, but the comparison is rendered difficult by the fact that the latter font was recut during the Victorian rebuilding of the church.

58. Font, Church of St Ceinwen,
Cerrigceinwen, Anglesey,
late 10th–11th century, Stone

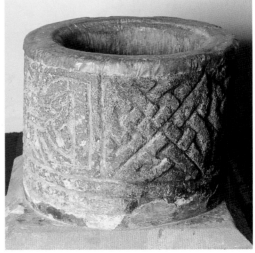

right:

59. Font, Church of St Llwydian,
Heneglwys, Anglesey, late
10th–11th century, Stone

[96] Though of a different design, the font at Newborough was also intended to be sited against a wall. Its front and side panels stand in high relief against a deeply cut ground. The space which would have been occupied by the final panel is cut away to the depth of that ground, again suggesting that the carver knew at the roughing-out stage in the quarry that the font was to be located against a wall, and had decided on a design. The carving of the individual panels is less ordered than that at Cerrigceinwen, but deeply cut and exuberant.

[97] The font at Llaniestyn, Anglesey, carries a very similar vocabulary of images, including a chequerboard design also found at Llanbeulan, but the cutting is less assured and regular.

[98] The capitals on the column arcades of the Llanbeulan font and also that at Llanddeusant, Anglesey, echo those in the Canterbury *Codex Aureus* particularly closely. The Llanddeusant arcaded font has a unique characteristic. It carries a series of dots, placed with sufficient precision to suggest that they are symbols of the Trinity, the Crucifixion and the wounds, for a detailed discussion of which, see below, pp. 177–85.

[99] The late eighth-century closure slabs at Saint-Pierre-en-Citadelle, Metz, are illustrated and discussed in J. Hubert, J. Porcher and W. F. Volbach, *Carolingian Art* (London, 1970), pp. 28–30.

The Cerrigceinwen font also provides some evidence of the working methods employed at the workshop. The largest panel contains an elegant plaited cross. The opposite face is blank, but the incised lines which form the top and bottom borders of the panels continue into the blank space. Nevertheless, they do not join, making it plain that they were not intended to be seen, but rather cut as a guide, probably at the quarry where the stone was roughed out as a blank to make it lighter to transport. Once in situ, against the wall of what was probably a wooden church, the panels were carved in detail, beginning at the front and then proceeding either to the right or left panels, which are of equal size. There remained visible two further small panels before the wall obscured the back face. However, only that on the right was cut, probably because the carver was right-handed, which would have made the use of the chisel or point impossible between the left side panel and the wall.[96]

The second Penmon cross and the Penmon cross-base or font can also be linked by general quality and specific details to fonts at Heneglwys and Llanbeulan, Anglesey, which are clearly the work of the same maker. Notwithstanding a difference of form – the Llanbeulan font is rectangular – they share a T-fret and a diamond pattern of decoration, and an arcade cut in a very similar manner.[97] The T-fret is common also to the Penmon cross-base or font. The head of the Penmon cross is of a similar type to that carved on the Llanbeulan font. It is likely, therefore, that the Penmon artefacts and some of the fonts came from a single workshop and were produced in the first half of the eleventh century.

The arcade motif is carved on several of the Anglesey fonts but not on the crosses, where its horizontal format would have been inappropriate. It has many parallels in both manuscript illumination and carving, dating from well before the Norman period. Several gospel-books, including the Lindisfarne Gospels, divide their canon tables with arcades of closely similar design to the arcades of the Anglesey fonts. In particular the capitals, which are simple slabs or steps, have more in common with the conventions of the manuscript tradition than with architectural practice.[98] However, the most striking parallels for the design appear on carved panels known as closure slabs, which separated the nave from the sanctuary in the early medieval period and which survive in a number of continental churches. Examples from Metz[99] not only display carved arcading but also a Maltese cross of very similar design to that cut on one end of the Llanbeulan font, and a cross-hatch design. The carvers of the slabs frequently made use of interlace, and a further example from Metz also includes a chequer pattern, again closely similar to that evident at Llanbeulan. The later reuse of some continental closure slabs as altar fronts suggests

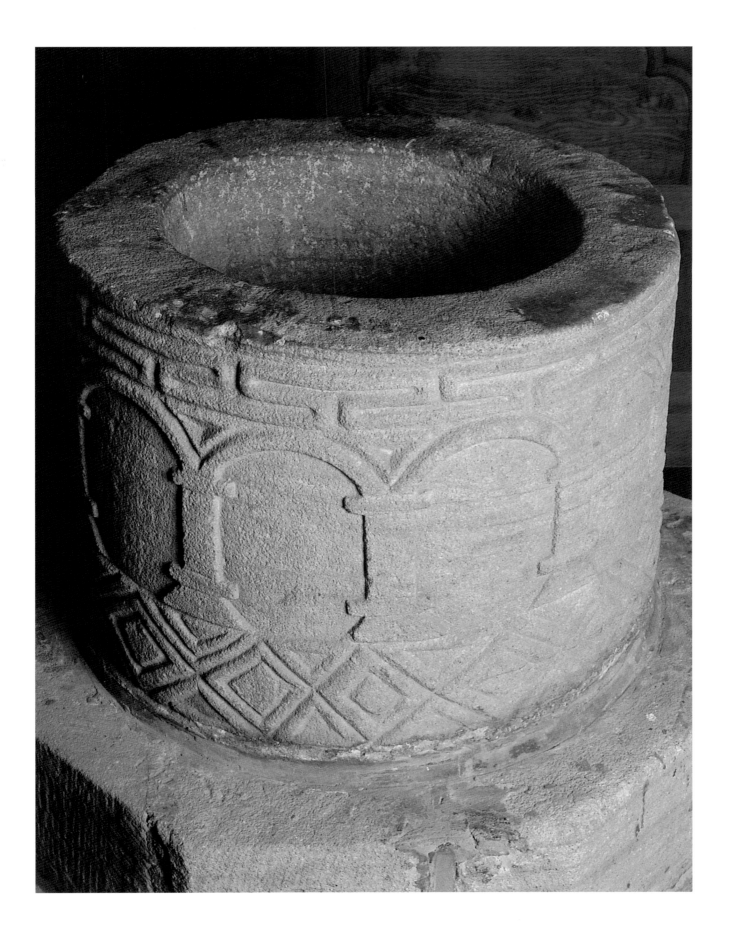

[100] For example, the altar slab from the abbey of Saint-Victor, Marseilles, illustrated in J. Hubert, J. Porcher and W. F. Volbach, *Europe in the Dark Ages* (London, 1969), p. 14.

an answer to the question raised by the unusual form of the Llanbeulan font, which is both much larger than necessary for its function and of a most inappropriate shape. The lack of a terminating feature at the top of the pillars at the four corners and the closeness of the arcading to the rim of the font strongly suggest that the object is incomplete. If the original function of the object had been as an altar (and one of the longer faces is undecorated and was probably therefore located against or close to a wall) it would have been surmounted by a slab, probably with three edges carved and a dished surface as on surviving continental examples.[100] The whole would have been mounted on a low plinth. The space carved within the altar, perhaps subsequently enlarged when its use was changed, would have housed relics. If the Llanbeulan font was, indeed, an altar of the pre-Norman period, it is a unique survivor in Wales and, indeed, in Britain.

60. Closure Slabs,
formerly in the Church of
Saint-Pierre-en-Citadelle, Metz,
late 8th century, Stone

61. Font, Church of St Peulan,
Llanbeulan, Anglesey,
late 10th–11th century, Stone

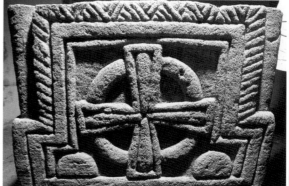

c h a p t e r

t w o

CULTURAL

REORIENTATION

[1] Architectural historians have not used the term 'Romanesque' in a consistent way. Some prefer the term 'proto-Romanesque' to describe the Carolingian and related styles. For a general discussion of the evolution of the Romanesque and interactions with vernacular architectures in northern Europe, see Kenneth J. Conant, *Carolingian and Romanesque Architecture 800–1200* (Harmondsworth, 1973), pp. 1–42. The development of Romanesque in the west was facilitated by a westward migration of builders. For a discussion of this and of artisan practice in general, see David Jacobs, *Master Builders of the Middle Ages* (London, 1970).

[2] For example, in the construction of Westminster Abbey by Edward the Confessor, 1050–65. See Edward Carpenter (ed.), *A House of Kings: The Official History of Westminster Abbey* (London, 1966), pp. 6–8.

[3] The Romanesque tympanum of the Church of St Mary, Portskewett, has been claimed to be of immediate pre-conquest date and carried out under the patronage of Harold Godwinson. The idea is based on the record in the Anglo-Saxon Chronicles that in 1065, 'before Lammas, Harold the Earl ordered a building to be erected at Portskeweth, after he had subdued it', *Arch. Camb.*, 5th series, II (1885), 334. However, Harold's work cannot have proceeded much beyond the foundations, since his workforce was ejected by Caradog within a month. The tympanum consists of a sandstone monolith carved with a single cross and cable moulding, an unusual form. It probably belongs to the original Norman church, perhaps constructed before the end of the eleventh century.

[4] With the exception of the gatehouse, the important castle at Carew, for instance, remained of wooden construction until 1270.

[5] 'The Benedictine Rule was the foundation upon which the entire structure of medieval monasticism in Western Europe was eventually built.' J. Patrick Greene, *Medieval Monasteries* (Leicester, 1992), p. 2.

[6] Ewenni priory is of particular interest since it provides an example of how, in some places, monastic and parochial needs were served by a single new building. The nave of the monastic church was used as the parish church from the outset. Nevertheless, the division between the monastic and the parochial was strongly expressed in the architecture by the construction of a stone screen between the two parts of the church. The case for the construction of Ewenni in a single phase, contrary to prevailing opinion, was made by Malcolm Thurlby, 'The Romanesque Priory Church of St Michael at Ewenny', *Journal of the Society of Architectural Historians*, XLVII (1988), 281–94.

At the end of the eighth century the emergence of the Carolingian Empire in western and northern continental Europe provided the conditions of stability and patronage for a renaissance in the arts. The building methods of the Romans, which had never been lost in the east, re-emerged and developed in the manner known to architectural historians as the Romanesque.[1] Its most splendid manifestations were churches, including the church of the monastery at Aniane built by Charlemagne in 782. The abbot of Aniane was Benedict, whose reform of St Benedict of Nursia's original monastic rule dominated European religious life until the twelfth century and beyond. From the beginning, visual culture was therefore tightly bound into broader realms of thought. The Carolingian renewal of Roman architecture (and of visual culture in general) drew on oriental, Mediterranean and northern sources which were present within its political boundaries and on sources from further afield – including the already interactive Anglo-Saxon, Celtic and Nordic culture groups. Similarly, it influenced their development, so that in England, for instance, by the second half of the tenth century churches such as Winchester Cathedral, constructed by its Benedictine bishop, Ethelwold, were both Romanesque in character and built on a grand scale.

Romanesque was not, therefore, the Norman art which it has often been perceived to be from an insular perspective. Nevertheless, the rapid rise to power of Normandy in the early eleventh century, which included conquests in Sicily and the southern Mediterranean, provided a further stimulus in the north for the evolution of the style. Norman influence was manifested in England even before the conquest of 1066,[2] but it was the new political order resulting from that conquest which provided the channel for the rapid adoption of Romanesque in its most developed form, characterized by semi-circular vaults carried on massive round pillars and reflected in round-arched doorways with concentric rings of rolled moulding.

The earliest manifestations of the Romanesque in Wales of which we have surviving evidence were in the south-east and were the direct consequence of Norman incursion from England.[3] Within a few years of their victory over the English, the Normans had established a foothold at Chepstow. From there they moved west, settling wherever they conquered by carving out a new order of lordships and manors. In parallel with this civil

62. Chepstow Castle, Monmouthshire, begun c.1067–72

order, the Normans imposed a new ecclesiastical organization of dioceses and parishes, and brought new emphases to the liturgy and cults of the Church. These changes had an immediate impact on the material culture in the form of new buildings. At Chepstow the keep of the Norman castle is known to have been built in stone between 1067 and 1072 and, as a result, its features, notably the tympanum, blank arches and herringbone stone-work, are important to architectural historians in dating other buildings whose history is less well documented. Nevertheless, the stone construction at the bridgehead of

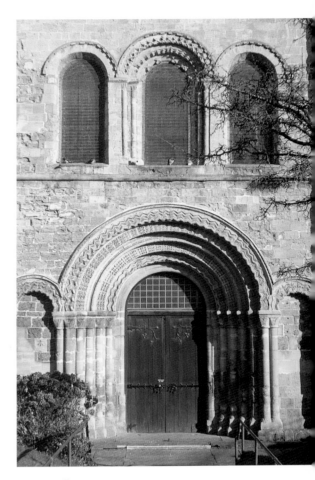

64. West Door,
Priory Church of St Mary,
Chepstow, Monmouthshire,
c.1070

Chepstow was unusual since it is clear that most Norman military buildings were initially constructed of timber. They often remained so for a considerable period,[4] even when substantial resources were being invested by their

owners in the rebuilding in stone of the largely wooden churches which they appropriated and in creating new foundations. This sense of priorities expressed the deeply integrated role of religious life in Norman political and social organization.

Norman domination provided access to Wales for the Benedictine monastic order, resulting in a second level of ecclesiastical reorganization.[5] The Benedictines practised a consistent and profoundly different concept of monasticism from that of the diverse patterns of the Welsh monasteries. The Norman lords donated parcels of the land which they had taken by force to Benedictine communities in Normandy or to their daughter-houses in England, where the order had been well established before the conquest. Consistent with its position as the entry point into Wales for the invaders, the first Benedictine monastery was founded in 1070 at Chepstow. By 1100 Hamelin of Ballon, having established himself as Lord of Abergavenny, had endowed a priory there dedicated to St Mary as a cell of the abbey of St Vincent at Le Mans. At Ewenni, possibly on the site of an earlier church, the local Norman lord, William de Londres, erected a new building between 1116 and 1126, whose architecture is related to that of the Benedictine abbey at Gloucester to whom he gave it. The building changed little subsequently, leaving Ewenni as one of the finest places in Wales where Romanesque building can be appreciated.[6] However, sometimes the high ambitions and consequent slow progress

above left:

63. Thomas Smith, *Chepstow*,
c.1680–90, Oil, 610 × 711,
detail showing the Priory Church

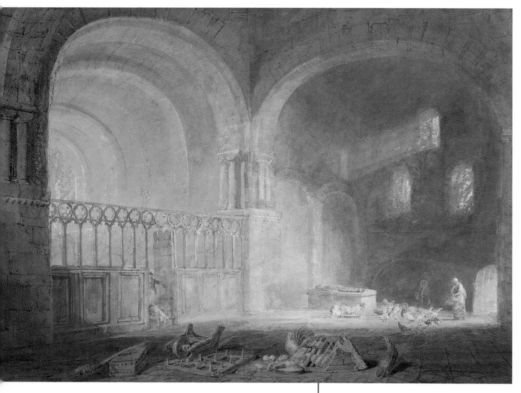

65. J. M. W. Turner,
Trancept of Ewenny Priory,
Glamorganshire, 1797,
Pencil and watercolour,
400 × 559

66. Nave and Aisle Arcades,
St David's Cathedral, Pembrokeshire,
late 12th century, Stone

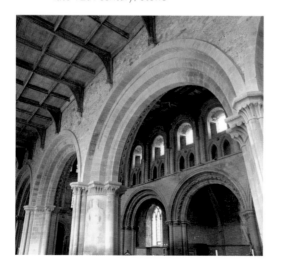

of the initial undertakings, both monastic and parochial, meant that the buildings were overtaken by changes in architectural fashion, even before 1200. The result was a composite style, or sometimes, as in the case of St David's Cathedral, complete renewal within a few generations. The first Norman bishop, Bernard, began to rebuild St David's in 1115, presumably in the Romanesque manner, although nothing of that church survives since, in the later twelfth century, it was again rebuilt by Bishop Peter de Leia.[7] Similarly, the Romanesque priory church at Brecon, built under the patronage of Bernard de Neufmarché by his confessor, Roger, as a cell of Battle abbey in Sussex, was completely replaced, although it lasted rather longer than Bishop Bernard's cathedral at St David's. Brecon probably reached its full extent in the mid-twelfth century, but survived little more than a hundred years.

In the first generation, the establishment of the Romanesque in south Wales was not simply dependent on foreign patronage but probably also on foreign builders. Although the ability to construct masonry with round, weight-bearing arches on a limited scale may have existed in Wales by the mid-eleventh century, Norman Romanesque carried within it an ambition to build not only in the manner of the Romans but on a similarly grand scale, enterprises for which indigenous craftspeople cannot have been prepared.[8] It seems likely that the new lords sent to their patrimonial estates in Normandy for builders to construct the early Welsh churches, rather than attempt to train native craftspeople. No doubt some of them settled in Wales and established workshops, and soon employed and trained local people in the new architecture. Given the substantial amount of building undertaken in the first half of the twelfth century, their culture and language may not have been an impediment to employment when skilled labour must have been at a premium. Unfortunately, there is no documentary evidence for Wales which throws light on the process of acculturation among craftspeople.

Since the Benedictines initially drew most of their monks directly from their mother-houses, skilled masons working in the first wave of the construction of the new monastic churches were, like those working for secular Normans, probably drawn directly or indirectly (that is, through England) from the Continent. The plain detailing (by comparison with their continental cousins) of the new churches of south-east Wales, notably those at Chepstow, Newport, Ewenni and Llandaff, is deceptive, for they were distinguished and substantial works. Surviving evidence

67. Chancel Arch,
Llandaff Cathedral,
Glamorgan, c.1120

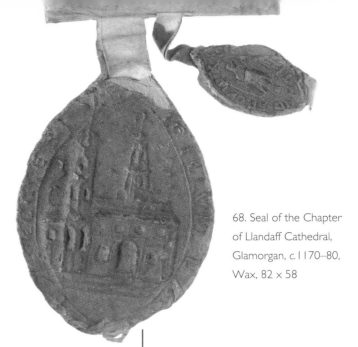

68. Seal of the Chapter
of Llandaff Cathedral,
Glamorgan, c.1170–80,
Wax, 82 × 58

69. Porth Deilo, Llandaff
Cathedral, Glamorgan,
c.1120, Stone, head ht. 210

suggests that adornment was mostly non-figurative, though often of high
quality, exemplified by the finely carved chancel arch at Llandaff, a building
begun by Bishop Urban in about 1120 of which a simple impression can be
gained from its depiction on a seal of *c.*1170–80.[9] Nevertheless, the new architecture
of the twelfth century provides the earliest surviving evidence in Wales of the use
of figurative sculpture integrated with architecture. On the north door at Llandaff
a head, which is clearly intended as a portrait – and tempting, therefore, to visualize
as that of Urban himself – is inserted at the top of the outer moulding of the arch.
Comparison of the weathered image with the fine quality carving of the mouldings
and rosettes of the chancel arch within the church reveals how dramatic the
portrait may once have been.

[7] Bernard's church was dedicated in 1131. In the
long term, Bernard's campaign to have St David
canonized was more important than his building,
since it reinforced the status of the site as a resort
for pilgrims until the Reformation. Although the
evidence for the process of David's canonization
cannot now be traced, in the popular consciousness
he certainly became St David or Dewi Sant.

[8] The extent to which use was made in Wales
by the mid-eleventh century of round-arched
construction is unclear. In principle there is no
reason to suppose that there were not, probably
at major monastic sites, some stone structures in
which round-arched windows and door openings
were employed. For instance, see the reference
in the Life of St Cadog, above, p. 18. Examples of
their use in small-scale church building in the west
of England (such as in the church at Bradford-on-
Avon) must have been known to monastic
communities, as well as the large-scale buildings
seen on continental travels. Unfortunately, the
archaeological record on such matters is so
limited as to be of little use in determining the
nature either of stone or wooden buildings.

[9] It is argued by Roger Stalley, 'A study of the
buildings erected by Roger, Bishop of Salisbury
1102–1139', *Journal of the British Archaeological
Association*, XXXIV (1971), 73, that Llandaff
relates closely to Sarum – an argument made
more credible by the fact that Roger had a
manor at Kidwelly and built the first castle
there. He might have stopped on his visits there
to stay with Bishop Urban and could have been
the contact through whom masons from Salisbury
moved to Llandaff. Such borrowing of masons
was common practice, attested, for instance, by a
letter from Abbot David of St Augustine's abbey,
Bristol, to the Dean of Wells, asking him to lend
his master mason, probably one Adam Lock. See
John Rogan (ed.), *Bristol Cathedral: History and
Architecture* (Stroud, 2000), pp. 21–2.

70. Label-stop,
Priory Church of St Michael,
Ewenni, Glamorgan, c.1120, Stone

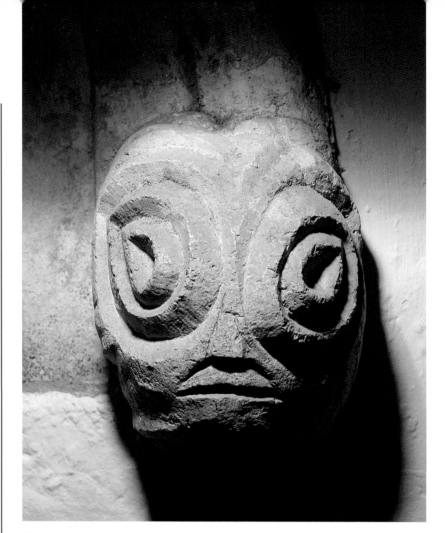

71. Label-stop,
Church of the Holy Trinity, Marcross,
Glamorgan, early 12th century, Stone

[10] The type is manifested most famously by the carving on the Anglo-Saxon church at Deerhurst in Gloucestershire. For this and other Gloucestershire parallels see L. A. S. Butler, 'Medieval Ecclesiastical Architecture in Glamorgan and Gower', in T. B. Pugh (ed.), *Glamorgan County History. Volume III. The Middle Ages* (Cardiff, 1971), p. 382. The most dramatic set of zoomorphic heads in the Scandinavian manner in Wales adorns the corners of the tower of the Church of St Mary, Coety, Glamorgan. They strongly suggest an early post-Norman date, contemporary with the head at Ewenni. However, despite their physical proximity in the Vale of Glamorgan, establishing a link between the two is confounded by the fourteenth-century date of the tower into which the Coety heads are built, though the possibility of their reuse from an earlier structure cannot be discounted.

[11] The Marcross heads seem to have been recut, presumably during the Victorian reconstruction of the church, though they probably reflect closely the original work. At Rhosili, in west Gower, the moulding of a simple Romanesque arch is interrupted at the top and terminated on both sides by heads which, though badly eroded, have some similarity to those at Marcross. The Rhosili arch was almost certainly transferred from the original parish church now buried under sand at the Warren. The precise interpretation of such heads presents considerable difficulties because of the unfamiliarity or loss of the narratives to which they belong, see below, pp. 66–7 and 86–7. For an illustrated discussion of the types, see M. W. Tisdall, *God's Beasts* (Plymouth, 1998).

The rosettes of the chancel arch reappear on a window arch in the south wall of the presbytery at Llandaff, enclosed by a moulding which terminates in an elongated horse-like head, resonant of carving on Scandinavian wooden churches. The carver of the Llandaff head was clearly also employed in the construction of Ewenni priory church, where a closely similar head terminates an arch moulding.[10] Although their subject and scale are different from the Ewenni and Llandaff heads, at the Church of the Holy Trinity, Marcross, only a few miles away, a pair of heads which terminate the mouldings of a Romanesque doorway are carved in a not dissimilar linear manner.[11]

Unlike that of England, the Norman conquest of Wales was a protracted affair of two hundred years, during which power ebbed and flowed between the invaders and the native rulers. Even those areas of the south in which Benedictine houses were rapidly developed under Norman patronage were far from secure in this period – though, surprisingly, their sense of insecurity was not entirely derived from the natural hostility of the conquered. In the 1140s Gilbert Foliot, abbot of Gloucester, wrote to Osbern, prior of either Ewenni or Cardigan:

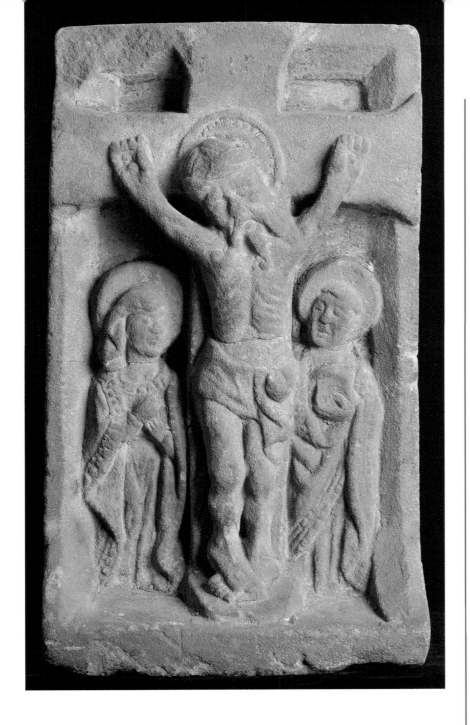

[32] See above, p. 39. The Chepstow crucifixion follows the conventional iconography of the high Middle Ages with the Blessed Virgin at Christ's right hand, whereas Conbelin's Cross reverses this arrangement.

[33] Traces of the original paint survive. For further discussion, see the Appendix.

[34] The compression of this image to little more than a token makes it particularly difficult to interpret. It is possible, for instance, that it represents a local tradition of martyrdom. The inclusion of two animals is, however, consistent with the description of the entry of Christ into Jerusalem in the texts of the period based on the Vulgate text, Matthew 21:1–11, seen as the fulfilment of the prophecy in Zechariah 9:9. Cf. Mark 11:1–10, which only mentions one beast.

[35] There is further evidence in Wales of the extreme compression of an image, though from a later date. At Bosherton in Pembrokeshire a churchyard cross, probably of the thirteenth or fourteenth century, is carved at the intersection of the shaft and arms with a disembodied mask-like head of Christ, in much the same manner as the Ewenni fragment.

Since this New Testament iconography survived the Reformation of the sixteenth century, its general outline is still accessible to the modern Welsh mind. However, even within the context of the biblical narrative, some surviving images are difficult to interpret. A carving at Ewenni priory depicts a horse or donkey with a bearded disembodied head superimposed upon it, which may represent in schematic form the entry of Christ into Jerusalem.[34] The drawing of the image is little different in its simple essentials from the representation of the horseman on the nearby Llandough cross, carved before the arrival of Romanesque architecture. If the image does, indeed, represent the first action of the Passion narrative, according to the Synoptic Gospel texts, it does so with a remarkable degree of compression.[35]

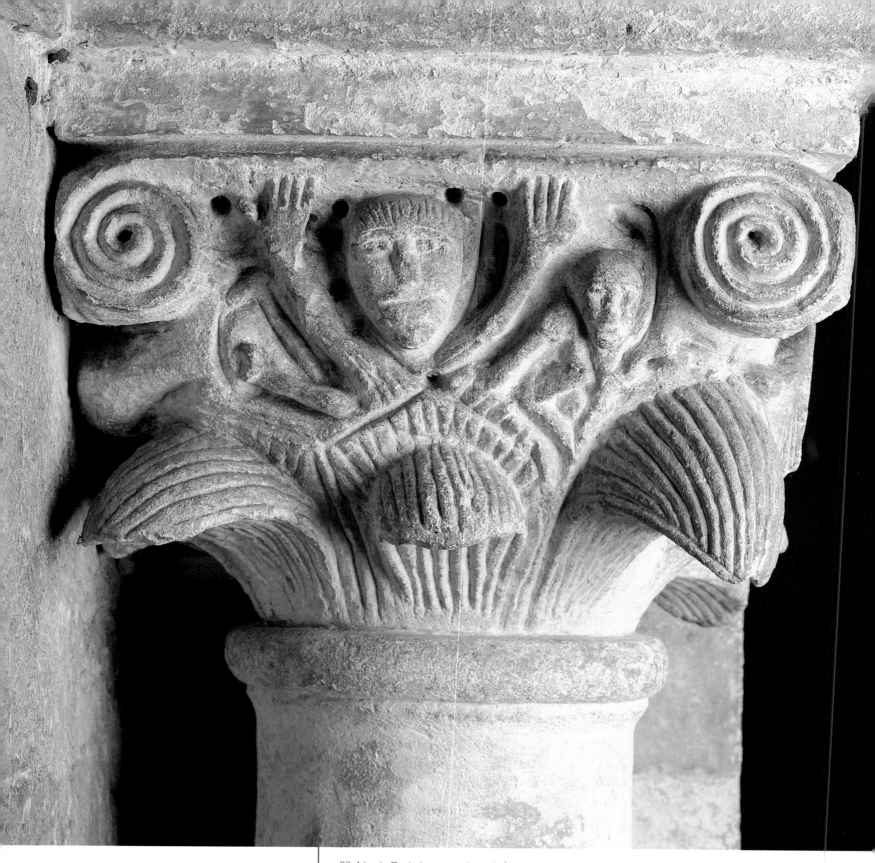

82. North Capital, west and south faces,
of the Arch into the Nave from the Galilee Chapel,
St Woolos' Cathedral, Newport, Monmouthshire,
12th century, Stone, ht. 270

The exuberant carving which adorned the new stone churches of the Romanesque period in northern and western Europe sometimes presents a disconcerting contrast to the stately regularity of the architecture from which it bursts. Its iconography draws on a wide range of sources and, where it departs from obvious biblical inspiration, it is frequently difficult to access. For instance, the interpretation of the animated figures which adorn the carved capitals supporting the arch at the west end of the nave of St Woolos' Cathedral in Newport is far from clear. A standing figure with hands apparently in the orans position appears to represent a continuity of images of individuals at prayer known in Wales from the tenth and eleventh centuries. However, comparison with continental and English examples of figures with arms upraised suggests that the carving at St Woolos' Cathedral is as likely to belong to a widely scattered group which reflect classical capitals carrying images of the god Atlas supporting the world.[36] Nevertheless, if the sculptor intended that we understand the arch which the figure supports as the vault of heaven, it is surprising that he is not reflected on the south capital, whose iconography is even more idiosyncratic and difficult to interpret. A figure with one upraised hand, carrying a wand or a sword, is accompanied by a head and a bird.[37]

However, the carving at St Woolos' Cathedral may suggest how architectural and artistic ideas were transmitted through the network of human relationships which linked the new religious foundations in Wales and those well-established on continental Europe. In form, the carved capitals of the Romanesque arch distantly echo the Corinthian order of classical architecture. Such composite or volute capitals are found in several continental churches, including that of the abbey of Mont St Michel in Normandy. In 1072 William I appointed his chaplain, Serlo, who had been a monk at Mont St Michel, abbot of the Benedictine monastery at Gloucester. During his rule the crypt of Gloucester abbey church was rebuilt and several of the capitals there are of simple composite form.[38] It was also during Serlo's rule that St Woolos' came into the possession of Gloucester and the Romanesque work surviving in the Welsh church probably dates from the later part of his life (he died in 1104) or shortly thereafter. It is likely to have been carried out by masons from Gloucester abbey who, like their patron, may well have been Norman or among the first English craftspeople taught by a Norman master. Serlo provides an example of the kind of link by which particular sculptural forms may have been transmitted from continental abbey churches to Wales.

St Woolos' Cathedral presents evidence of the eclectic nature of much practice and patronage in the first half century of Norman settlement. Its font, animated by feline heads at the corners set against a floriate ground and probably dating from *c*.1120–30, is carved in a quite different style from the column capitals.

[36] See George Zarnecki, *Romanesque Art* (London, 1971), pp. 55–8 and illustration 66 from Dijon. Both in its composite form and in its image of a figure with upraised hands, the carving at St Woolos' Cathedral closely echoes a capital from Lavardin nr. Montoire (Loire et Cher) in France, illustrated in Eric Gethyn-Jones, *The Dymock School of Sculpture* (London and Chichester, 1979), plate 17c, and discussed on p. 10. The Atlas figure is represented in England by a carving in the chapel of Durham Castle, executed around 1072.

[37] C. O. S. Morgan, 'St. Woollos' Church, Newport, Monmouthshire', *Arch. Camb.*, 5th series, II (1885), 286, proposed that the figures represented the Trinity of God as Father, in the act of creation, as Son and as Holy Spirit. However, Morgan also proposed that the capital was adapted from one seen at Caerleon, or indeed possibly taken from there. The examples given by Zarnecki, *Romanesque Art*, demonstrate that this source is most unlikely.

[38] B. J. Ashwell, *The Crypt, Gloucester Cathedral* (Much Wenlock, 1993), p. 3, fig. 2, and Gethyn-Jones, *The Dymock School of Sculpture*, p. 4 and plate 6. Among other Romanesque monastic churches in Wales where, echoing the Corinthian order, volute capitals were carved was St Clears, Carmarthenshire.

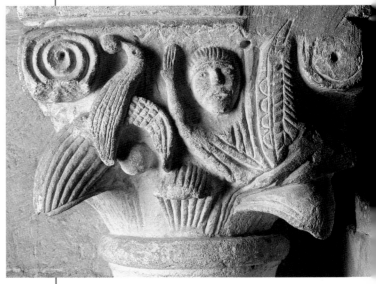

83. Font, St Woolos' Cathedral,
Newport, Monmouthshire,
early 12th century, Stone

[39] Only one 90 degree segment of the original carving survives.

[40] Furthermore, not only in central areas but also, for instance, in Catalonia. See the work of the Master of the lintel of St Génis, illustrated in Christian Zervos (ed.), *Catalan Art from the Ninth to the Fifteenth Centuries* (London and Toronto, 1937), plates VI and VII. The motif also appears at Boyle in Ireland, though in this case it could be argued that it derives from Herefordshire examples as a result of the activities of English-based craftspeople there, for which see below, pp. 92–3.

The heads are bound together by a beaded or studded ribbon entering the mouths of the beasts and leaving through their ears.[39] These ribbons are found widely in continental Europe,[40] but in a regional context they are characteristic of a concentration of sculpture in the west of England, conventionally identified as the Herefordshire school. The patronage which sustained the sculptors was Norman, and the work of the Herefordshire school and the related Dymock school is frequently cited as representing a fusion of Anglo-Saxon and Celtic carving tradition with the imported Romanesque in the first half of the twelfth century. The combination of figurative imagery with fret and interlace was brought to an elaborate climax at the Church of Saints Mary and David, Kilpeck, Herefordshire. As the dedication suggests, the social context in areas like Kilpeck, a few miles from the Welsh border, might seem appropriate for the emergence of schools exhibiting stylistic fusion, and including a Celtic element. Welsh-speaking communities existed inside what

is now England, and the arrival of the Normans added a further layer of language and the culture it carried. However, the characteristics of the resultant society during the late eleventh and twelfth centuries may have been closer to the pluralist model than to that of the melting pot. The introspection of the Benedictine monastic order has already been noted, and although Welsh, Anglo-Saxon, Norman French and Latin were all in adjacent use in their appropriate domains, and individuals, according to need, certainly became multilingual, the process of fusion took place over a long period. Furthermore, in terms of the visual culture, the notion of fusion is dependent on the continuity of pre-conquest architectural stone carving, the evidence for which is scarce in England and absent in Wales. The idea that native masons immediately adopted Romanesque building techniques on the instruction of Norman patrons and combined them with a vibrant indigenous iconography is problematic. There is reason to suppose that carving at Hereford Cathedral, the seminal Romanesque building in the area, may have been carried out under the direction of a continental carver and it is equally possible that the carvers of Kilpeck were also from the Continent, rather than drawn from Anglo-Saxon or Welsh communities in Herefordshire. Figurative imagery combined with interlace was widespread in continental Europe at the time of the conquest.[41] If Anglo-Saxon tradition was, indeed, a source for the Herefordshire school, the fusion is more likely to have occurred as the result of interactions with the Continent as early as the ninth century, especially in the form of manuscript illumination, in which case the twelfth-century carving would represent a reintroduction rather than a revival of native traditions.[42]

In their imposition of a new aesthetic, the Norman rulers did not discriminate between the indigenous cultures of England and Wales, and their patronage of masons and carvers centred in Herefordshire formed an overlay which is indistinguishable from one side of the border to the other. At Monmouth, for instance, a section of what is presumed to have been a tympanum, probably from the castle chapel, depicts two warriors, apparently engaged in combat. The striking similarity of their posture to carvings on a font at Eardisley in Herefordshire, suggests that they were made by the same workshop, although the eroded condition of the Welsh fragment makes its attribution to the same hand and its iconography uncertain. The warriors differ in detail since the Monmouth pair seem to be unarmed.[43]

84. Font,
Church of St Mary Magdalene,
Eardisley, Herefordshire,
12th century, Stone

[41] The characterization of the carving style centred in Herefordshire in the twelfth century as a native revival has been strongly influenced by the efforts of English art historians to construct a national tradition. For continental examples of combinations of imagery and interlace similar to those cited as characteristic of the Herefordshire school, see Zarnecki, *Romanesque Art*, illustration 70 from Quedlinburg Schlosskirche, and from further afield the capitals of the monastic church of St Pere de Roda, Catalonia, and the work of the Master of the lintel of St Génis, illustrated in Zervos (ed.), *Catalan Art*, plates VI, VII and XI.

[42] For further discussion, see the Appendix.

[43] The figures may be tugging each other's beards and, if so, would represent in Wales a small but distinct iconography expressed on column capitals of the same period in Burgundy and northern France, thereby reinforcing the fundamental significance of continental tradition in the evolution of the Herefordshire schools. See, for example, a capital from the Church of St.-Hilaire, Poitiers, reproduced and discussed in Emile Mâle, *Religious Art in France: The Twelfth Century* (Princeton, 1978), p. 17. For further discussion, see the Appendix.

85. Tympanum,
possibly from the Chapel
of Monmouth Castle,
12th century, Stone,
510 × 565

86. Font, Church of
St Thomas, Overmonnow,
Monmouthshire, 12th century,
Stone, bowl diam. 480

87. R. K. Thomas
after G. R. Lewis, *The Fourth Pillar
of the Chancel Arch* [Shobdon], 1851

[44] Monmouth priory was founded
by a Breton, Gwethenoc, in c.1080.
Subsequently, he became a monk and
the lordship of Monmouth devolved
upon William fitzBaderon, who was his
nephew. The history of the priory and
identification of work carried out before
and after the consecration of 1101 or
1102 is discussed by various authors,
*A History of the Benedictine Priory of
the Blessed Virgin Mary and St Florent
at Monmouth* (Monmouth, 2001). The
list of those present at the consecration
suggests that it was considered an event
of some importance. Alongside the
founder and William fitzBaderon were
Abbot William of Saumur, Abbot Serlo
of Gloucester, and several Marcher lords,
including Hamelin de Ballon, the founder
of Abergavenny priory.

[45] Drawings of the interior of the Church
of St Thomas, Overmonnow, by Richard
Colt Hoare (published as an engraving
in William Coxe, *An Historical Tour in
Monmouthshire* (2 vols., London, 1801),
II, facing p. 299) and Charles Landseer
(NLW Department of Pictures and
Maps PE2098) clearly show a simpler,
unadorned font on a much heavier pillar.
It seems unlikely that the present font
was also in the church prior to the 1835
restoration. However, no documentation
has come to light concerning the
whereabouts of the Herefordshire school
font before its installation in St Thomas's.

[46] The bowl of the font at St Thomas,
Overmonnow, stands on a column decorated
with beaded lattice work, which seems too slender
to have been the original support, although the
work is probably contemporary. At the Church
of St Jerome, Llangwm, near Usk, a similar lattice
adorns a fragment of a column which may have
supported an oil lamp. The pristine condition of
the carving at St Thomas, Overmonnow, may
suggest a degree of tidying up of the font during
the nineteenth-century restoration of the church,
similar to that more obviously inflicted on the
font at Llangristiolus in Anglesey, see above,
p. 49, note 95.

[47] The church at Shobdon was destroyed in 1742,
but the chancel arch and the north and south
doorways were preserved in a nearby park as
curiosities. Now largely decayed, they are known
from mid-nineteenth century engravings and
photographs of plaster casts, now also lost.

The work at Monmouth Castle must
have been commissioned by its Norman
builder, William fitzBaderon, who was
probably also the patron of contemporary work at Monmouth priory. The priory
was dedicated in 1101–2 and was a dependency of St Florent, Saumur, into whose
care fitzBaderon subsequently gave his private chapel. At the priory, the design of
two capitals, one with foliate decoration linked by beaded stems, and the other of
a triple scallop design, is closely similar to work at Kilpeck.[44] It seems likely that
the Herefordshire school font now at the Church of St Thomas, Overmonnow,
on the opposite bank of the river from the town of Monmouth, also came originally
from the priory.[45] Whether it was made *in situ* by those at work on the architectural
carving there or was carved in a distant workshop and transported to the site is
unclear, though Anglesey examples demonstrate that it was sometimes the practice
to rough-out the design at source and to complete the carving at the final location.
Although the example at St Thomas, Overmonnow, is smaller than most comparable
fonts, its elegant simplicity has the effect of reinforcing the power of the mask-like
face of an unhappy Eve, tempted by a serpent whose sinister intentions are
expressed with remarkable economy in a single, malicious eye.[46]

92. Tympanum, Priory Church of St Seiriol,
Penmon, Anglesey,
mid-12th century, Stone

93. A Mason, Priory Church
of St Seiriol, Penmon, Anglesey,
12th century, Stone

At Penmon in Anglesey – a major monastic site and well beyond the Herefordshire
sphere of influence – a Romanesque tympanum, decorated with a dog-like animal
who bites his own tail inside a border of interlace, survives complete. Its combination
of figurative and interlace carving poses the question of the precise nature of
continuity, fusion and importation more clearly than any other artefact in Wales.
As we have seen, Penmon and the closely related site of Ynys Seiriol provide
examples both of late tenth- and early eleventh-century interlaced carving and the
early adoption by a native patron of Romanesque. On a historical basis, a search
for a potential site in Wales where the fusion of indigenous and continental styles
might occur would certainly place Penmon among the most likely candidates. The
tympanum at Augustinian Penmon is carved above the original south door of the
nave, which was constructed around 1140–50 in the time of Owain Gwynedd.
Given the connection of the prince, through his father, both with Benedictine
religious houses in England and with royal patrons in Ireland, the work might be
ascribed with equal credibility to an English carver, a continental carver working
in England, an Irish carver, or an indigenous carver receptive to continental ideas.
Although in Wales we know nothing of twelfth-century craftspeople as individuals,
the master who built the nave at Penmon and who perhaps carved the tympanum
(or built the central tower and transepts slightly later) seems to have left an image
of himself for posterity. A stone fragment, probably of twelfth-century date, carries
the portrait of a bearded man with an axe of the type used by medieval masons.

[59] The three heads were crudely reset with the remnants of the arch in the nineteenth-century restoration of the church, but a drawing by the Revd John Skinner, predating the restoration, records them in what was presumably their original context. A fourth head, clearly by the same hand, is set inside the church. A similar arrangement of three heads is evident at Snead, Montgomeryshire, though the carvings themselves are almost certainly Victorian replacements of lost originals.

[60] The fragments at Llangollen, perhaps part of a lost shrine to St Collen of similar form to the Pennant Melangell shrine, are discussed by C. A. Ralegh Radford and W. J. Hemp, 'Pennant Melangell: The Church and the Shrine', *Arch. Camb.*, CVIII (1959), 105.

[61] 'Since the one who led in war has been silent, / One whose rule was like hot fire, a fury in a quarrel, / It has made me very sad to visit Pennant / With its chief having fallen', Nerys Ann Jones and Ann Parry Owen (eds.), *Gwaith Cynddelw Brydydd Mawr I* (Caerdydd, 1991), p. 300. Rhirid Flaidd is an elusive figure and his dates are disputed. See Williams, 'The Literary Tradition to c.1560' in Smith and Smith (eds.), *History of Merioneth II*, p. 529.

[62] Huw Pryce, 'A New Edition of the *Historia Divae Monacellae*', *The Montgomeryshire Collections*, 82 (1994), 39.

No portrait of Owain Gwynedd, probably the patron of Penmon, survives to match that which may represent the Norman Bishop Urban of Llandaff. Nevertheless, further figurative carving, probably contemporary with the construction of the church and which survives in the east wall of the nave above the tower, bridges Welsh and Norman patronage. A double head and two rotund, mask-like faces, represent a type which appears to have been commonly made not only in twelfth-century Wales, but also in Ireland and on the Continent. Heads at Llan-faes and Llanbabo (sufficiently close to those at Penmon to suggest a common hand) are reflected by heads which adorn the east wall of the keep at Monmouth Castle. In most cases the meaning of such heads, which are clearly not portraits, is obscure, but three of the four at Llanbabo are arranged above and on both sides of a Romanesque arch. They are differentiated by size and character, which suggests that they may represent God the Father, Son and Holy Spirit.[59]

All over northern and western Europe regional and local schools, and individual workshops and craftspeople, developed idiosyncratic styles within the broad Romanesque framework. Among the best attested of the Welsh workshops was that which was responsible for carving the shrine of St Melangell at the Church of Pennant Melangell in Montgomeryshire. Fragments of unidentified artefacts carved in the same distinctive style are known from Llanrhaeadr-ym-Mochnant, nearby, and Llangollen and Llanarmon-yn-Iâl, further to the north.[60] The Romanesque capitals, arches and gables at Pennant Melangell suggest that they are contemporary with the construction of a stone church in the early twelfth century, possibly under the native patronage of Rhirid Flaidd, Prince of Powys. Rhirid was associated with Pennant Melangell by the poet Cynddelw Brydydd Mawr in the later twelfth century.[61]

A devotion to Melangell must have been well established (and Pennant a place of pilgrimage of some significance) by the twelfth century to justify the construction of what was certainly a very grand structure. Whether, at that date, she was the 'virgin beautiful in appearance … and given up to divine contemplation',[62] who protected a hare from the hunting dogs of a prince of Powys, is open to question

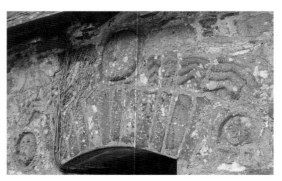

94. Arch with Heads, probably representing the Trinity, Church of St Pabo, Llanbabo, Anglesey, 12th century, Stone, and John Skinner, *Church Door of Llanbabo*, 1802, Watercolour

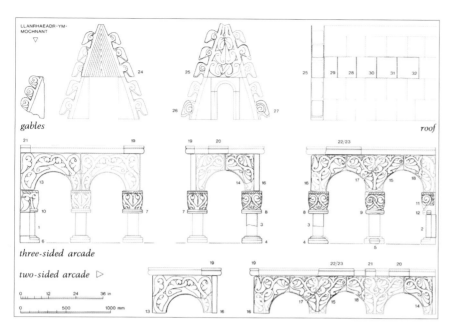

95. The Shrine of St Melangell,
Pennant Melangell, Montgomeryshire,
12th century, Stone, ht. 2230,
and reconstruction drawings

[63] See above, pp. 23–4.

[64] A parallel for such a shrine, located in the apse of a Romanesque church, is Saint-Sylvain, Ahun (Creuse), described by John Crook, *The Architectural Setting of the Cult of Saints in the Early Christian West c.300–1200* (Oxford, 2000), pp. 277–81. On this basis Crook believed that the shrine at Pennant Melangell was reconstructed in the wrong place. Siting the shrine in the apse was considered for the reconstruction at Pennant Melangell but was rejected in favour of the main body of the church, for which see W. J. Britnell and K. Watson, 'Saint Melangell's Shrine, Pennant Melangell', *The Montgomeryshire Collections*, 82 (1994), 147–66. The present reconstruction replaced that designed by Ralegh Radford, for whose pioneering work on the shrine see C. A. R. Radford, 'The native ecclesiastical architecture of Wales (c.1100–1285): the study of a regional style', in I. Ll. Foster and L. Alcock (eds.), *Culture and Environment* (London, 1963), pp. 355–72.

[65] Among the finds made during the restoration at Pennant Melangell was a copper alloy animal head, possibly the foot of a three-legged pricket candlestick. This type of object, placed on each side of a cross on the altar, was in use in the twelfth century.

since surviving redactions of the tale are much later and of a standard hagiographical type. Although it is impossible to determine its precise form or location, the surviving fragments certainly belonged to a house-shaped shrine, reflecting on a large scale the reliquaries of the Christian Celtic period, such as that of St Winifred.[63] The stone church of St Melangell, perhaps replacing an earlier wooden structure, consisted of a single cell with an apse, the access to which was offset, apparently in order to avoid the grave of the saint, which had earlier been demarcated by stone slabs set vertically around the edges. The shrine may have been built over this grave in the apse, or might have stood, as presently reconstructed, in the centre of the main body of the church with the bones translated to the reliquary supported on the pillars.[64] The shrine was constructed of stone from the Montgomeryshire–Shropshire border and was coloured – traces of red paint were found on the fragments at the reconstruction. The capitals, arches, and one of the gables were decorated with floriate patterns of various designs within a common type, some of which were interlaced.[65]

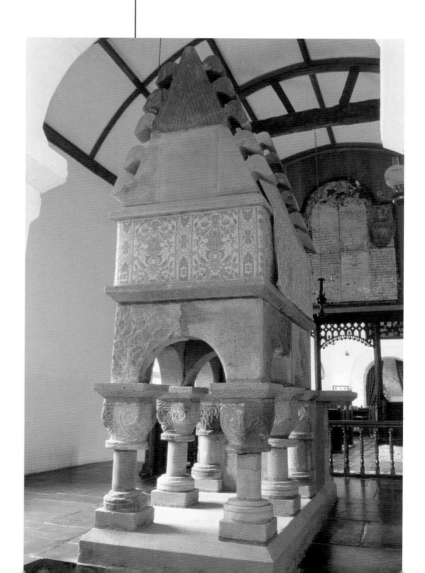

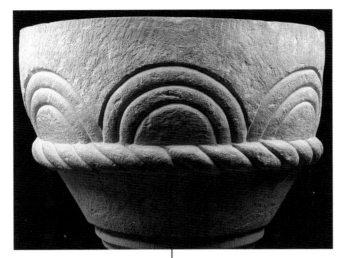

The shrine of St Melangell is a unique survival in Wales. Fonts, however, because of their fundamental theological and liturgical significance, and their status as indicators of the consecration of a church, survive in substantial numbers to represent the non-structural carving of the Romanesque period. Many churches retain undecorated stone examples, probably contemporary with a new building or a rebuilding which occurred in the twelfth century, which are unremarkable in style. However, in various parts

96. Font, Church of St Bride,
Llansantffraed, Monmouthshire,
12th century, Stone, bowl diam. 660

97. Font, Church of St James, Lancaut,
Gloucestershire, 12th century, Lead,
now in Gloucester Cathedral, ht. 335

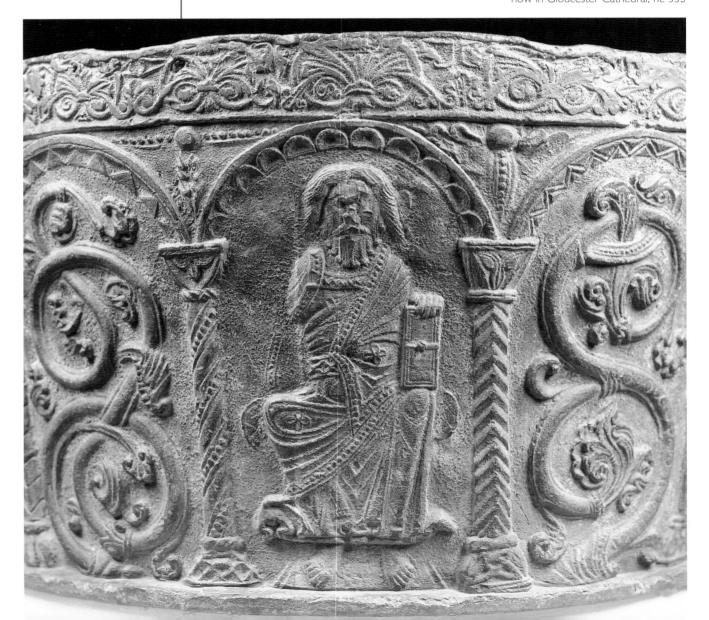

of Wales groups of fonts of distinct design indicate the existence of local workshops. A Monmouthshire workshop produced elegant fonts carved with a design of repeated concentric round arches, echoing Romanesque doorways, for instance. The font at Llansantffraed near Abergavenny, with its twist moulding around the base of the bowl, is characteristic of the group.[66] Other workshops provide evidence of the permeability of the Welsh border in matters of design. At Lancaut (formerly in Monmouthshire, but now in Gloucestershire), the Church of St James housed a magnificent lead font, one of a group of six which were cast from the same mould. They were constructed by soldering together copies of a panel consisting of an arcade of four arches. Under the arches are alternate decorative motifs and figures, probably representing apostles. The particular form of the seated figure of Christ is a common one in the period. It was widespread in French stone carving of the eleventh and twelfth centuries and was also known in England, where the other five fonts of the Lancaut group were located. The craftsman was probably peripatetic, carrying his original carved panels with him, casting from them and assembling them on the site of the commissioning church.[67]

The southern sea coast was no more a barrier to new design than the eastern land border. The continuation of cultural and economic contact with the south-west of England which had existed in the early medieval period assisted penetration by Romanesque styles after the conquest. For instance, the coastal location of the church of Llanfihangel Abercywyn, Carmarthenshire, may explain the presence there of a font which does not seem to belong to a group which would suggest local workmanship. The whole outer surface of the font is decorated with an arcade of elegantly carved interlaced arches. Although widely distributed throughout Europe, the nearest surviving Welsh example of this design is found on the supporting column of the Brecon priory font. On a large scale, interlaced arches of a very similar design were carved at St Augustine's abbey, Bristol,[68] and it seems likely that the Llanfihangel font was imported from one of many workshops in Somerset. It is clear that at least three workshops located in Somerset and north Devon exported to Wales fonts of almost identical design to those made for their local markets.[69] The most productive workshop was located at an undetermined site in north Devon, and supplied fonts of a massive square design cut underneath on each face with triple scallops and mounted on a circular column. Seven examples are

98. Font, Church of St Michael,
Llanfihangel Abercywyn,
Carmarthenshire,
12th century, Stone

[66] The other fonts in this group are at the churches of St Mary, Abergavenny, St Peter, Goetre, and at Betws Newydd. In Anglesey a pair of fonts at the churches of St Nidan, Llanidan and St Ceinwen, Llangeinwen, have a deeply cut floriate design similarly suggestive of a single workshop. In Cardiganshire, at Betws Bledrws and Henfynyw (now at Holy Trinity Church, Aberaeron), the twelfth-century fonts carry an attractive rosette pattern, again suggesting a single workshop.

[67] Lancaut was a Welsh enclave on the eastern bank of the river Wye which, for the most part, formed the border in this area. The Lancaut font is now in Gloucester Cathedral. For a discussion of the lead fonts, see George Zarnecki, *English Romanesque Lead Sculpture* (London, 1957), pp. 10–14. Zarnecki believed that a small, quatrefoil decoration on the seated figures identified the immediate source of the image as a manuscript of the Winchester School, possibly BL Cotton MS Caligula A.14, since it was associated with the west of England.

[68] Now Bristol Cathedral. The interlaced arches are in the chapter house. Rogan (ed.), *Bristol Cathedral: History and Architecture*, pp. 78–84.

[69] The font workshops have been identified by Robert Boak, to whom we are very grateful for allowing us access to his unpublished research.

[70] The Welsh fonts are at Whitson in Monmouthshire, at Oystermouth in west Glamorgan, at Pembrey and St Ishmael in Carmarthenshire, and at Burton, Hayscastle, Manorbier, Penally, St Dogmael's and St Florence in Pembrokeshire. The font at Whitson is enriched with a lattice decoration. Robert Boak suggests that export to Wales of fonts of the north Devon type may have been on a speculative basis, with batches of fonts loaded on to a boat which called at a succession of small harbours along the coast. The survival of fonts of the triple scalloped type at two inland Cardiganshire locations, Llanfihangel Ystrad and Samau, not noted by Boak, may be explained by the third Cardiganshire example at Mwnt, near Cardigan. The port of Cardigan would have been an obvious point of access for the more northerly market.

[71] An unfinished example at Chelwood in Avon tends to confirm the evidence of the earlier font of unrelated design at Cerrigceinwen in Anglesey, which suggests that it was the practice to rough-out the shape and incise the general design at the quarry or central workshop, and carry out the detailed carving at the church. The third workshop, identified as the Ilfracombe workshop, is known by a single font at the Church of Holy Trinity, Ilfracombe (apparently recut in the nineteenth century), and fragments of identical floriate design at the Church of St Mary, Begelly, Pembrokeshire.

known in Devon and Somerset, and ten in Wales, extending from Gwent to Pembrokeshire, with a further three in Cardiganshire.[70] Despite the larger number of Welsh fonts, their distribution at a string of coastal sites, contrasting with the more closely clustered inland sites in England, suggests that the workshop was located in Devon. A second workshop, perhaps located at Hinton Blewitt in Avon, specialized in a more delicate scalloped pattern, enlivened at the corners with a floriate design. The fonts at Hinton Blewitt itself and at Castlemartin in Pembrokeshire are identical.[71]

On the border between Breconshire and Radnorshire, and also in Cardiganshire, a group of churches house fonts characterized by four projecting heads carved at the corners of the original square block from which a circular bowl was cut. The fonts at the churches of St Harmon, St Clement, Rhayader, and St Gwrthwl, Llanwrthwl, vary somewhat in size but are identical in conception. The Llanwrthwl font is notable because the church also has a holy water stoup with a head carved below the bowl, which was clearly the work of the same sculptor and was presumably commissioned at the same time. This combination is echoed by a font and stoup at Pencarreg in Carmarthenshire. The Pencarreg heads are differentiated – one is crowned and another is tonsured, for instance – but their meaning remains obscure.[72]

99. Font, Church of St Michael,
Castlemartin, Pembrokeshire,
12th century, Stone, ht. 880

72 They may represent the four estates of the Crown, the nobility, the Church and the laity. See below, note 74. For further discussion, see the Appendix.

100. Font, Church of St Garmon,
St Harmon, Radnorshire,
12th century, Stone

102. Font, Gross Giewitz, North Germany,
12th–13th century, Stone

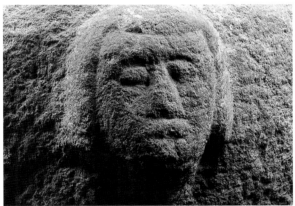

101. Font,
Church of St Clement,
Rhayader, Radnorshire,
12th century, Stone

103. Carved Heads
on the Font at
the Church of
St Patrick, Pencarreg,
Carmarthenshire,
12th century, Stone

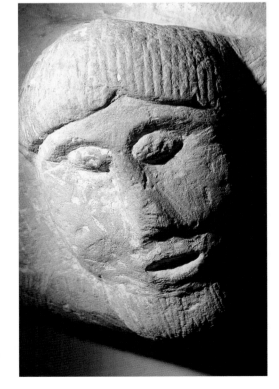

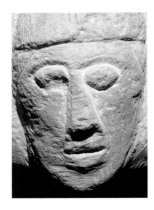
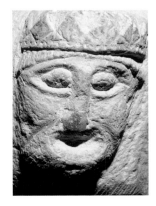
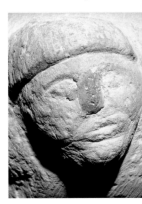

104. Holy Water Stoup,
Church of St Gwrthwl, Llanwrthwl,
Radnorshire, 12th century, Stone

105. Font, Church of
St Gwrthwl, Llanwrthwl,
Radnorshire,
12th century, Stone

106. Quern, reused as a font,
Church of St Mary, Snead, Montgomeryshire,
12th century, Stone, bowl diam. 660

107. Quern, formerly at Popton,
Pembrokeshire, 12th century, Stone, ht. 225

The repetition of the unusual combination of a carved font and stoup, reinforced by the similarity in style between the Pencarreg work and that at Llanwrthwl, suggests that the objects may have been made by the same hand. In that case, the carver worked in two areas which, though not far apart in miles, for reasons of geography probably did not constitute a single community. Ecclesiastical business would be insufficient to support a specialist workshop in one small area. A quern from Popton, near Castlemartin in Pembrokeshire, elaborated with a crowned head of similar character to those at Llanwrthwl and at Pencarreg, is a reminder that workshops were sustained by diverse general practice in more sparsely populated and poorer areas. Although little material evidence of this kind survives, stone-cutters must have been required to meet secular, as well as occasional ecclesiastical needs, and work such as the cutting of millstones and querns presumably provided a regular source of income. Querns were made in a wide range of sizes, and in one case, at Snead, in Montgomeryshire, a particularly large example was re-used as a font in the church. The decorative nature of some querns may indicate that their function, humble in itself, was perceived to have deeper significance.

The Brecon/Radnor and Cardiganshire fonts may be seen as a group on the grounds of their all displaying carved human heads or animals at the corners, and their concentration in a small area.[73] However, within this general scheme they display a wide variety of detail, and they are by no means unique. At Gross Giewitz in the northern lowlands of Germany one of a group of headed fonts bears an uncanny resemblance to the Pencarreg font.[74] The Welsh fonts also bear a general conceptual similarity to a group of more sophisticated fonts in Cornwall,[75] and, within Wales, their iconographies are reflected in several other places. The twelfth-century font at Llanfair-yn-y-cwmwd in Anglesey has heads at its four corners but also, like some of the earlier Anglesey fonts, it is fronted. There is a central mask on one of the four sides adjacent to a cross which, presumably, identifies it as Christ. However, the obvious interpretation of the heads at the four corners as the evangelists is complicated by the presence of serpents, linking the heads on two sides, which suggests that the subject is the tempting of Eve. The story of the Fall was an appropriate image for a font since baptism was believed to restore man to God's grace. The font originally at Llandysiliogogo in Cardiganshire[76] is equally perplexing, but dramatic in the simplicity of its masks. Again, there are five heads, three distributed equally around the font, with two together. The pairing suggests Adam and Eve, an idea reinforced by the sinuous line which circles the font, suggestive of a serpent, as at Llanfair-yn-y-cwmwd, if it is not simply intended for the waters of baptism.

[73] Like the Anglesey group, the Brecon/Radnor and Cardiganshire fonts were brought together in the early twentieth century largely by what was perceived as their collective dissimilarity to prevailing conventions elsewhere. At that time the fonts were identified as two groups, a result of the organization of archaeology along county lines inherited from nineteenth-century Wales. The Cardiganshire fonts, for instance, were described by E. Tyrell Green, 'Cardiganshire Fonts', *Transactions of the Cardiganshire Antiquarian Society*, I, no. 3 (1913), 11–21; ibid., no. 4 (1914), 9–25; ibid., II, no. 1 (1915), 13–31, without reference to those in Breconshire and Radnorshire.

[74] The font is described in C. S. Drake, *The Romanesque Fonts of Northern Europe and Scandinavia* (Woodbridge, 2002), p. 94. The heads are believed to represent a peasant, a king, a bishop and a monk.

[75] The Cornish fonts are in the north-east of the county, perhaps made by a workshop at Launceston. See Alfred Fryer, 'A Group of Transitional Norman Fonts', *Journal of the British Archaeological Association*, VII (1901), 215–18.

[76] It is now at Cenarth. Llandysiliogogo is adjacent to Llanllwchaearn, location of one of the fonts of the four-headed type, though only a single head remains. The font at the Church of St Sulien, Silian, Cardiganshire, is also of the four-headed type.

108. Font, Church of St Mary, Llanfair-yn-y-cwmwd, Anglesey, 12th century, Stone

109. Font, formerly in the Church of St Tysilio, Llandysiliogogo, Cardiganshire, 12th century, Stone

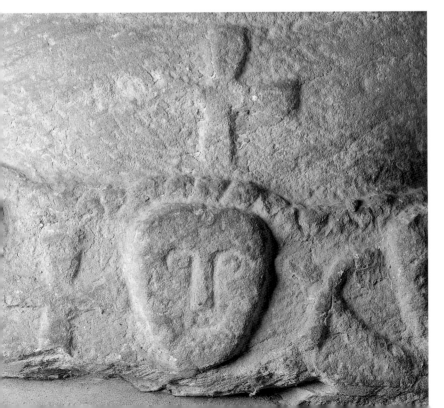

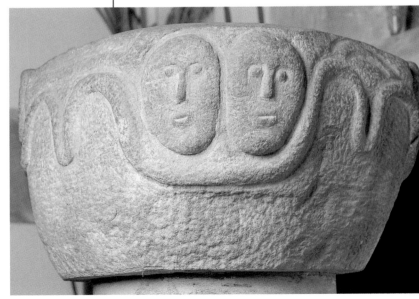

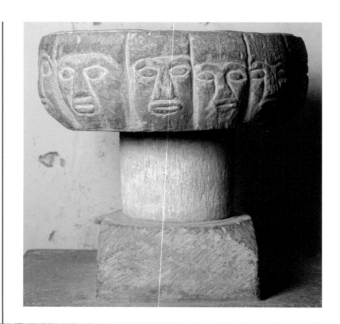

110. Font, Church of St Gwenog,
Llanwenog, Cardiganshire,
12th century, Stone

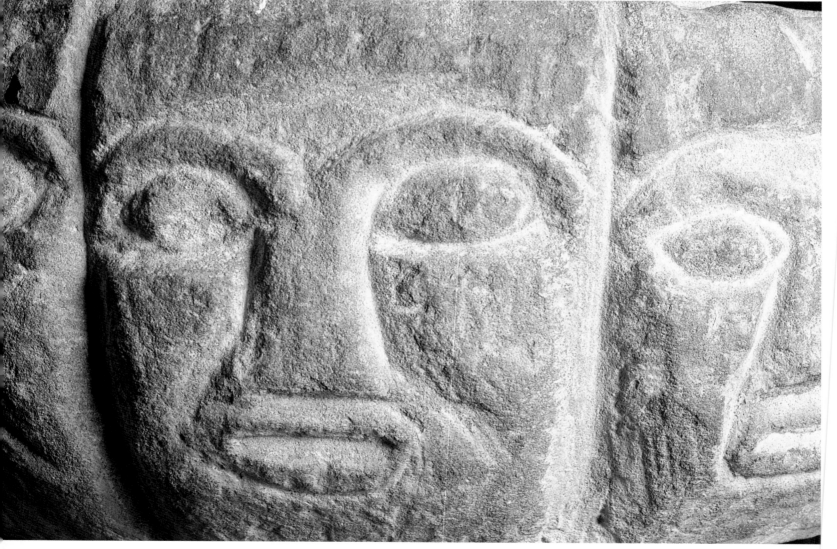

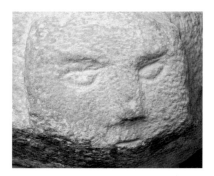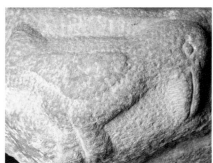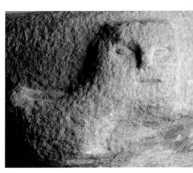

111. The Emblems of
the Four Evangelists on the
Font of the Church of St Mary,
Llanfair Clydogau, Cardiganshire,
12th century, Stone

While the Pencarreg font and stoup may well be the work of the carver of the
Breconshire–Radnorshire border group, only two further Cardiganshire fonts
suggest a common maker – those at Llanwenog and Llanfair Clydogau. The
iconography of the font from Llanfair Clydogau is straightforward, presenting the
four evangelists in the conventional form of the manuscript tradition.[77] However,
the drawing of the symbols suggests that the carver was familiar with the tradition
by oral transmission and had seen few, if any, manuscript examples, unless he
chose to adapt them. The eagle of St John, for instance, was confidently cut in
bold relief, but was clearly based on observation of a crow or raven, rather than
the more exotic bird, which would have had to be copied from a manuscript or
imagined. Such basic Christian iconographies were thoroughly integrated into
popular religion of the Middle Ages, observed and interpreted here by William
Durandus in the thirteenth century:

> Sometimes the four living creatures spoken of in visions of Ezechiel and …
> John are represented: 'the face of a man and the face of a lion on the right
> side, the face of an ox on the left, and the face of an eagle over all the four'.
> These are the four Evangelists …
>
> John has the figure of an eagle because, soaring to the utmost height, he says:
> 'In the beginning was the Word'. This also signifies Christ, 'whose youth is
> renewed like the eagle's' because, rising from the dead, he flourished and
> ascended into heaven …[78]

On the Llanfair Clydogau font the sculptor represented St Matthew according
to this convention simply as a man, but his mask-like form was unusual and
sufficiently similar to the masks which completely ring the remarkable Llanwenog
font as to suggest the same maker. There are twelve heads, presumably intended
for the Apostles of Christ.

[77] The four-headed font in the Church of St Mary,
Maestir, also clearly represents the four evangelists.
It came originally from Lampeter and the more
elaborate nature of its carving, compared to that
of the remainder of the group, may reflect the
position of the town as a regional centre in the
period.

[78] Quoted in John Shinners (ed.), *Medieval Popular
Religion 1000–1500: A Reader* (Peterborough,
Ont., 1997), p. 25. 'Though William Durandus
(c.1230–96) wrote for an educated clerical
audience, his thoughts on the pedagogical value
of art highlight his understanding of the popular
religious mind: what is seen lasts longer than what
is heard', ibid., p. 21. Scholarly minds extended
the basic interpretations of popular religion. For
instance, the four evangelists surrounding the
baptismal water in the font might have been
seen as an aspect of the four winds, spreading the
gospel to the four corners of the earth. See note
72 above. Ultimately the abstract idea of fourness
itself becomes significant in a concept described
as 'unity and quaternity'. For an explication of
this idea, which may well have relevance to
the four-headed font form, see Geoffrey Martin,
'A forgotten early Christian symbol illustrated
by three objects associated with St Cuthbert',
Archaeologia Aeliana, XXVII (1999), 21–3.

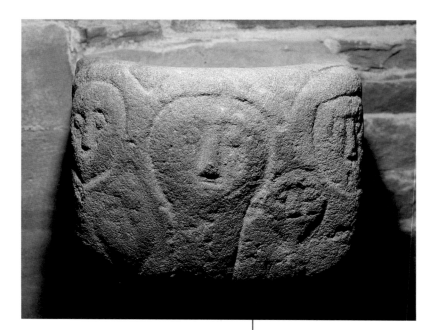

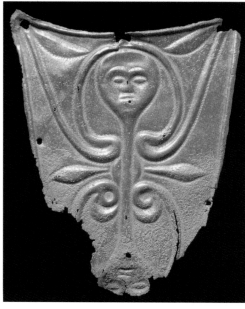

113. Plaque, found at Tal-y-llyn, Merioneth, c.150–50 BC, Copper-zinc alloy, ht. 152

112. Holy Water Stoup, formerly at Capel Madog, Radnorshire, now at the Church of St Bride, Llansanffraid Cwmteuddwr, Radnorshire, 12th century, Stone

[79] For instance, the square cutting of the mouths and the slab-like noses closely reflect figures at Armagh Cathedral, believed to represent Celtic deities. See Robert O'Driscoll (ed.), *The Celtic Consciousness* (Edinburgh, 1982), p. 139, plate 14.

[80] For instance, the stone-carved deity found at Caerwent in 1908, illustrated in *Arch. Camb.*, 6th series, IX (1909), 116–17, and a stone mask found at Llanbryn-mair, probably dating from c.150 BC– AD 50, which bears a striking resemblance to the masks of the Romanesque period at Penmon, above, p. 76. The Llanbryn-mair mask is illustrated in Eric Rowan (ed.), *Art in Wales 2000 BC–AD 1850* (Cardiff, 1978), p. 35.

[81] J. M. C. Toynbee, *Art in Britain under the Romans* (Oxford, 1964), plate XCVIIIc, illustrates a strikingly similar head to those of the Capel Madog stoup, in the form of a pottery antefix of a Celtic goddess, from York. The Capel Madog stoup was moved from a farm near the site of the grange to Dderw, near Rhayader, in the 1860s and at some time after 1911 was built into the south porch of the church at Llansanffraid Cwmteuddwr (Rhayader), where it remains. Little is known of the history of its original location, and, indeed, it is possible that it pre-dates the monastic grange since it was not unknown for older sites to be chosen for new chapels. For Capel Madog, see David H. Williams, *The Welsh Cistercians* (2 vols., Caldey Island, 1984), II, pp. 234–5.

Notwithstanding a certain similarity in carvings of human features carried out by unschooled craftspeople over a wide area and long periods of time, it is difficult to refrain from associating the powerful carving of the mask-like faces of the Llanwenog font with pagan Celtic carvings relating to cults of the head.[79] Stone-carved deities of Welsh provenance survive from the pre-Christian tradition,[80] and more may have been known in the medieval period, providing (in theory) a means of transmission for images. The Llanwenog font is far from unique in having distinct Celtic resonances. A stoup from the chapel of a monastic grange at Capel Madog in the Elan Valley is carved with five paddle-shaped heads. Its architectural context suggests a late twelfth-century date, but the iconography is a mystery and the style of the carving resonates strongly with heads on objects such as a small copper alloy plaque of c.150–50 BC found at Tal-y-llyn.[81] Remnants of oral pagan tradition, including cults of the head and of fertility, were certainly alive and, furthermore, interactive with Christian tradition in the late eleventh or early twelfth century. While almost all of the surviving figurative images of the twelfth century emanate from an ecclesiastical context, in areas such as Ceredigion, which stood remote from the patronage of Benedictine monasteries and Norman cathedral churches, that context would have been closely integrated into the everyday life of the indigenous people and the oral traditions which they maintained. The possible influence of those traditions on religious visual imagery, as they influenced the story-telling tradition, cannot be excluded.[82]

However, this is a highly problematic matter. If the notion of continuity with pre-Christian tradition is accepted (notwithstanding the absence of tangible evidence from visual culture over the whole period of the early Middle Ages), a further difficulty arises as to whether that continuity was represented by fused narratives,

as suggested by the Llanwenog font, or by the co-existence of parallel Christian and pagan narratives when objects from a Christian context but with no apparent biblical reference are considered. At Castlemartin in Pembrokeshire several powerful grimacing faces, clearly the work of the same sculptor, are carved on corbel-stones in the twelfth-century church and, more unusually, also on capitals in the domestic setting of the old rectory. They may be contextualized in connoisseurial terms as early and particularly dramatic examples of a genre of grotesques which become common in both the interior and exterior adornment of churches in the high Middle Ages, but this does nothing to enlighten us about their significance in the mind of their twelfth-century creator and his audience. These objects emanate from the same cultural context as surviving interpretations of biblical subjects which, even in a largely secular twenty-first century Welsh culture, remain internalized. The narratives to which the heads at Castlemartin belong are lost, and are likely to remain so. In the twelfth century, however, we must assume that they formed part of an integrated world view, alongside biblical narratives. Their loss seriously constrains our ability to understand the mind of the period.

[82] The date at which the native tales took the written form in which they are known today as the Mabinogion is a matter of dispute. Proinsias Mac Cana, *The Mabinogi* (Cardiff, 1992), p. 50, believed that they were recorded, perhaps in the twelfth century, by a person who exemplified unhomogenized cultural interactions: 'he strikes one withal as the gifted and learned amateur, selecting and reconstructing and sewing together, yet not somehow as a participator in the integral tradition, whether because the tradition itself had become fragmented or because as a cleric and a Latin scholar (if one may presume as much) he stood outside it, however great his interest in it.'

114. Corbel, Church of St Michael,
Castlemartin, Pembrokeshire,
12th century, Stone, ht. 260

115. Capital, The Old Rectory,
Castlemartin, Pembrokeshire,
12th century, Stone, diam. 260

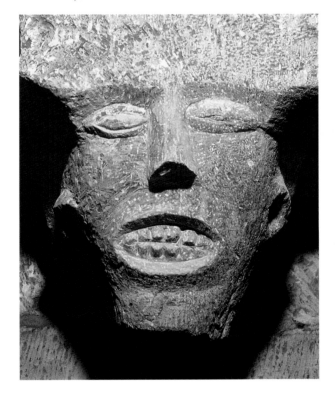

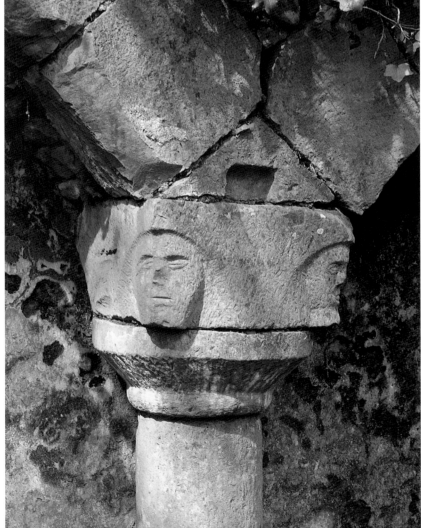

Within the broad category of the imaging of lost narratives in a Christian context, one group of carvings has attracted particular attention for its apparently Celtic resonance. Four Sheela-na-gig figures are known in Wales. The type has been presented as material evidence for the persistence of pagan Celtic tradition in the medieval period. The correspondence between the Castlemartin heads and the Sheela-na-gig from Holy Trinity Church at Llandrindod Wells is particularly close.[83] The Llandrindod figure squats in the birthing position, her hands displaying her genitalia, her face apparently grimacing in distress. This expression is rather different from the leer apparent on the faces of many sheelas which has led to their description as pornographic.[84] The Llandrindod sheela suggests the pain of childbirth. In either case, it seems reasonable to suppose that the figures have some significance in the context of fertility. As we have seen, the acceptability within Christian belief of earlier ideas in precisely such fundamental areas can be attested in writings of the early medieval period. Pagan religions were regarded as incomplete revelations rather than aberrations. But since it is not known to what extent these early sources retained their integrity as distinct narratives, both oral and visual, in the later Middle Ages, attempts to relate visual images to myths current over five centuries before their making are hazardous.[85] This uncertainty has led some observers to propose that the explicit female sexual imagery of the Sheela-na-gig is the outcome of misogyny and concern with sexual immorality in the monastic tradition of the eleventh and twelfth centuries, and to conclude that the Sheela-na-gig figure is a modern image of lust. Any pagan or Celtic association is entirely fanciful.[86]

116. Sheela-na-gig, formerly in the Church of the Holy Trinity, Llandrindod Wells, Radnorshire, probably 12th century, Stone, 600 × 553

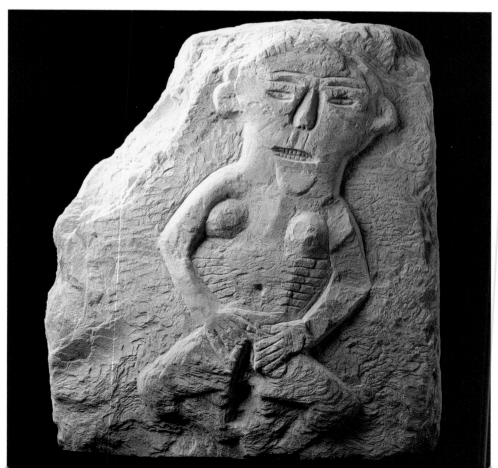

[83] The precise context of the Llandrindod carving is unclear since, unlike most Sheela-na-gig figures, it is not a corbel carved in the round but an incised carving on a flat, square stone. The other Sheela-na-gig figures are at Penmon, Ceredigion Museum (Aberystwyth) and Llanbadarn Fawr (Radnorshire), though since this figure lacks its lower part it is impossible to be certain of its original form. The figure may have been sanitized when it was reset during the Victorian rebuilding of the church, for which, see above, pp. 72–3.

[84] See, for instance, the widely reproduced example at Kilpeck, Herefordshire.

[85] Anne Ross has argued that the Sheela-na-gig figures represented a survival of pagan Celtic iconography associated primarily with the islands of Britain and that 'in their earliest iconographic form they … portray the territorial or war-goddess in her hag-like aspect, with all the strongly sexual characteristics which accompany this guise in the tales'. Furthermore, she believes that 'some of the carvings must date to the earliest centuries of the Christian era'. Anne Ross, 'The divine hag of the pagan Celts', in V. Newall (ed.), The Witch Figure (London, 1974), p. 148. Ross believes that the Sheela-na-gig had both a fertility and an evil-averting significance, which accounted for its subsequent acceptability in Christian churches.

[86] Anthony Weir and James Jerman, Images of Lust: Sexual Carvings on Medieval Churches (London, 1986), pp. 11–22. The authors convincingly demonstrate that there are concentrations of Sheela-na-gig figures in northern France and northern Spain, and that they are not, therefore, peculiar to Celtic Britain. Furthermore, they propose that the Sheela-na-gig figures were an entirely Christian phenomenon, arising no earlier than the eleventh century, and were 'part of an iconography aimed at castigating the sins of the flesh, and that in this they were only one element in the attack on lust, luxury and fornication', pp. 15, 17. Weir and Jerman mention Anne Ross, Margaret Murray and Tom Lethbridge in their attack on the Celticists: 'However interesting and persuasive their evidence may be, it is the overwhelming European [that is, continental] corpus of carvings which dissuades us from "going a-whoring after strange goddesses" in a desperate endeavour to find an insular solution to what is not an insular problem', ibid., p. 18.

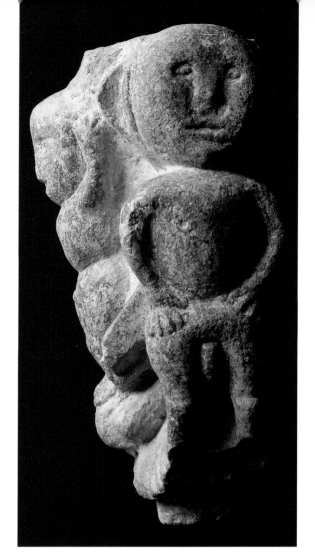
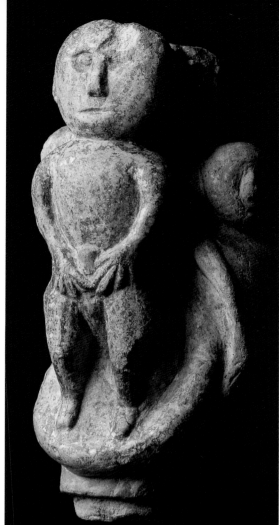

117. The Fall,
formerly at Cynghordy,
Carmarthenshire, 12th century,
Stone, ht. 325

The centrality of the concern with lust certainly extended to twelfth-century Wales, where the Fall is the most common iconography in the surviving figurative sculpture, monastic or otherwise. Two remarkable carvings, probably from the monastic grange of Cynfab at Cynghordy, Carmarthenshire, warn the observer against the sins of the flesh with a concentration on male genitalia which is as explicit as the concentration of the Sheela-na-gig on female sexual organs. The base of the carvings shows that they stood at the head of a pair of columns, but they are too small to be column capitals supporting the roof of a building. Nevertheless, since they are carved fully in the round they must have been part of a free-standing structure of some kind. On one capital Adam is depicted in innocence, with a limp penis, though on his back rides a monkey, symbol of his imminent sin.[87] On the other, he is depicted with Eve and the serpent, and then, in two separate images around the same stone, alone and holding his erect penis. Such explicit depictions of male genitalia are rare in Welsh material, though they may once have been less so. Maen Achwyfan, a late tenth- or early eleventh-century cross from Flintshire, presents the only surviving example certainly of the pre-Romanesque period. The figure standing with a limp penis is apparently holding a shaft or spear.[88]

[87] The monkey symbolizes imminent sin because of the animal's curiosity. In St Bernard's opinion, curiosity was particularly heinous as the first step on the ladder of pride leading to all other vices. See H. W. Janson, *Apes and Ape Lore in the Middle Ages and the Renaissance* (London, 1952), p. 42. A monkey is carved on a capital of the same period at St David's.

[88] A wooden figure originally displaying an erect penis was found at Strata Florida, though its ultimate provenance is uncertain. It is illustrated in *Arch. Camb.*, 6th series, III (1903), 285, but its present whereabouts is unknown. It bears a striking resemblance to a wooden figure from Co. Cavan, Ireland, probably of the first century BC, illustrated in David Bellingham, *An Introduction to Celtic Mythology* (London, 1990), p. 83.

[89] See above, pp. 78–9.

[90] The inscriptions, in lead-filled Lombardic capitals, read: [HIC]]ACET: H[ENRICU]S: [DE]: LANCAUT: QU[ONDAM A]BBAS: DE: VOTO: and HIC: JACE[T: JOHA]NNES: DE: LYUNS. The slab, now in the Sacristy, is very worn and few of the lead-filled letters survive. The best available drawings of it are by John Skinner, BL Add MS 33725, nos. 46 and 60.

[91] See Aelred Squire, *Aelred of Rievaulx. A Study* (London, 1969), p. 21.

[92] Stephen of Lexington, *Letters from Ireland 1228–1229*, translated, with an introduction by Barry W. O'Dwyer (Kalamazoo, 1982), pp. 206–7.

[93] When Samuel and Nathaniel Buck visited the site to make preparatory drawings for their engraving, published in 1741, the south transept was still standing, revealing the scale of the arch above the choir.

[94] The patronage offered by Lord Rhys to the Cistercians extended beyond Strata Florida to its mother-house of Whitland and to Llanllŷr, one of only two Cistercian nunneries in Wales. Furthermore, he was also patron of the Premonstratensian foundation of Talley, whose architectural aspirations were among the greatest of the period. Had the church been completed, it would have rivalled the Norman cathedral of St David's.

[95] For the mobility and social standing of masons in the early medieval and Romanesque periods, see Jacobs, *Master Builders of the Middle Ages*, p. 33 and Phillip Lindley, *Gothic to Renaissance: Essays on Sculpture in England* (Stamford, 1995), pp. 5–6, and the evidence of the Lives of the saints, quoted on pp. 15–16 and 18.

118. Tintern Abbey,

Co. Wexford, Ireland, begun c.1200

Both the Fall from Cynghordy and the stoup from Capel Madog were housed in buildings constructed by the Cistercian monastic order. By 1150 the Cistercians were well established in Wales and their architecture provided yet another framework of continental origin within which the visual culture of Wales evolved. The Cistercians are named after the abbey of Cîteaux in Burgundy, where the reforming order was founded by Robert of Molesme in 1098. They followed the rule of St Benedict but dedicated themselves to stripping away decadent practices which they believed had developed in the established Benedictine order. In particular, the elaboration both of the communal celebration of the divine offices and of visual imagery in the churches were a source of concern. The new order reverted to a life of simplicity at isolated sites, combining manual labour with contemplation and worship in an austere architectural context. A branching tree of reform spread throughout Europe as groups of brothers left Cîteaux to establish new houses, from which sprang third and fourth generations. The Cistercian vocation proved deeply attractive in the twelfth and thirteenth centuries and offered opportunities to men from a wide range of social backgrounds. The wealthy and powerful patronized the order. The educated could become choir monks, whose duties centred on celebration of the divine offices and private prayer and contemplation, while the illiterate might find a place as lay brethren – the *conversi*, who were primarily occupied with manual labour and agriculture. In the abbey churches the *conversi* celebrated divine offices in the nave of the church, separated from the choir monks.

In Wales the appeal of the new movement was as strong as it was elsewhere in Europe. The first Cistercian monks came from L'Aumône, a daughter-house of Cîteaux itself, and established themselves at Tintern on the river Wye in Monmouthshire in 1131. Subsequently, in 1200, Tintern established a daughter-house in Ireland, the abbey of De Voto (Tintern Minor), Co. Wexford. The mobility of ideas through Europe brought about by this organic process (and the potential for the transfer of visual culture) is illustrated by the grave slab of Henry of Lancaut at Tintern. Henry, who may well have been baptized in the fine new lead font of his native parish,[89] crossed the river to enter the monastery. He rose to be appointed abbot of the Irish daughter-house, and finally seems to have returned, probably in old age, to Wales to live the remainder of his life at Tintern. Henry shares a tomb slab with a French monk, one John of Lyons.[90]

The Irish Tintern conveys the original austerity of the Cistercian order. It expresses the concept of humility which occupied a central place in the rule of St Benedict[91] but which was largely lost at the church of the Welsh mother-house when it was rebuilt after 1270. It is easier to imagine the original conception of the reformed order in Wales from the skeletal remains of the monastery at Strata Florida in Cardiganshire. Strata Florida was created by monks belonging to the most dynamic branch

of the Cistercians, led by St Bernard, a monk of Cîteaux who became abbot of the daughter-house of Clairvaux. In 1140 monks from Clairvaux established themselves at Whitland in Carmarthenshire, from where a group of Welsh monasteries sprang which extended also into Ireland. Indeed, the Cistercian monastery at Tracton, Co. Cork, founded from Whitland in 1224, was criticized by Stephen of Lexington, following his tour of inspection in 1228, for its enthusiastic use of the Welsh language.[92] Within Wales, the Whitland group of houses, including Strata Florida, is notable for the close relationship it established with native dynasties. The original patron of Strata Florida was a Norman, Robert Fitz Stephen, but following his capture during the resurgence of Welsh power which reached its peak in 1164, Rhys ap Gruffudd (Lord Rhys), descendant of the ancient line of Deheubarth, took his place. The decision was taken to move to a new site, where the building of the choir and the crossing, with its six chapels, was sufficiently advanced by 1201 for the monks to take possession. Work then proceeded on the nave and was completed in around 1220.[93] Four generations of the descendants of Lord Rhys were buried at the monastery.[94]

The architecture and sculptural elaboration of large-scale buildings in the late twelfth and thirteenth centuries, such as the abbey of Strata Florida, expressed an interaction of forces ranging from those particular to a single project – such as the means and aspirations of a patron – to those collectively affecting a group – such as the early Cistercian commitment to austerity. Furthermore, though general principles of design and the supervision of building at monastic houses were under the control of the monks, the masons whom they employed were free agents who brought to their work expertise often gained over a wide range of building projects.[95] They spanned political boundaries, and in the case of Welsh projects in the early thirteenth century they were intensely interactive with both western England and Ireland.[96] Wales was at the geographical centre of this sphere of activity, reflecting the deep military involvement of Welsh-based Norman landowners during the conquest of Ireland.[97] For instance, William Marshal, earl of Pembroke, founded in Ireland the Cistercian abbeys of Tintern and Graigenamanagh, as well as the most ambitious parish church of the period, St Mary's, New Ross. Both St Mary's and Graigenamanagh were built with stone exported from the Dundry quarries in Somerset through the port of Bristol.[98] Like the stone itself, the architecture and decorative work of the masons who carved it betray their sources in the area around the Bristol channel. From the beginning, Welsh buildings were central to the evolution of Norman Romanesque in south-east Ireland, and their influence had been felt even before the conquest. For instance, it is probable that Ewenni priory was among the most important sources drawn upon by the mason who built Cormac's Chapel at Cashel between 1127 and 1134.[99] Subsequently, the design of Christ Church Cathedral, Dublin,

[96] It has become a commonplace for architectural historians to describe this interactivity as the 'West Country School of Romanesque architecture'. Malcolm Thurlby, 'The Romanesque Priory Church of St. Michael at Ewenny', *Journal of the Society of Architectural Historians*, XLVII (1988), 285, note 21, derives the term from an article written by Harold Brakspear in 1931. The continued use of a term which has clear Anglocentric resonance (since 'West Country' is generally understood as the western counties of England) is misleading, given that the sphere of activity is clearly international.

[97] For the heavy Welsh involvement in the Norman conquest of Ireland, see F. X. Martin, *The Course of Irish History* (Cork, 1994), pp. 123–30.

[98] The imposing Cistercian monastery at Dunbrody was also constructed of imported stone. For the importance of Dundry stone in the building projects of the period, see D. M. Waterman, 'Somersetshire and other foreign building stone in medieval Ireland, c.1175–1400', *Ulster Journal of Archaeology*, 33 (1970), 63–75; T. B. Barry, *The Archaeology of Medieval Ireland* (London, 1987) pp. 113–15. In Wales stone from the Dundry quarries was used as early as the Roman period in the building of Cardiff Castle. It was used at Llandaff c.1170 and, as noted above, p. 79, stone from a range of quarries in Somerset and Devon was used for fonts exported to south Wales. For its use in the manufacture of tomb effigies, see below, pp. 124–30.

[99] For further discussion, see the Appendix.

119. Robert Fitz Stephen,
Illumination from National Library
of Ireland MS 700, late 12th century, detail

120. After Stephen W. Williams, Early 13th-century Capital at Strata Florida Abbey, Cardiganshire, 1889

121. After Harold Graham Leask, Late 12th–early 13th-century Capital at Baltinglass Abbey, Co. Wicklow, Ireland, c.1958

122. Samuel and Nathaniel Buck, *The West View of Stratflour Abby in the County of Cardigan*, 1741, Engraving, 195 x 370

123. After Worthington G. Smith, *Monks' Graves, South East Angle of South Transept, Strata Florida Abbey*, 1888

124. Terminals of the Arch Mouldings on the West Doorway of Strata Florida Abbey, Cardiganshire, early 13th century, Stone

the largest building project of the conquest period, owes something to that of St David's, where certain architectural features which they have in common made their earliest known appearance.[100]

Although in the initial wake of the conquest of Ireland architectural ideas migrated from east to west with the patrons of the buildings in which they are expressed, the pattern of interactions very soon took the nature of a swirling pool rather than a flowing stream. In both Ireland and Wales these interactions are particularly intriguing in the areas on the margins of Norman settlement. Among the capitals from the south transept of the church at Strata Florida is one whose decoration is almost identical to a capital at the abbey church at Baltinglass in Co. Wicklow, erected a little earlier.[101] Baltinglass and Strata Florida also share an unusual architectural feature, a wall of masonry some five feet high which separates the aisles from the nave of the church. It is again to be seen at a west of England Cistercian monastery, Buildwas in Shropshire, which is probably contemporary with Baltinglass. In the absence of documentation[102] it is often impossible to disentangle the order of the events which underlie the appearance of such common features at distant sites. The most pertinent aspect of the many such parallels which may be drawn is the general picture of fluid interactions which they paint.

130. Fish Dish,
formerly at Llanthony Priory,
Monmouthshire, Pottery, 310 × 460

131. Capital,
Strata Florida Abbey,
Cardiganshire, 13th century, Stone

132. Worthington G. Smith,
13th-century Stone Carving of a Monk,
possibly St Bernard, formerly at Strata Florida
Abbey, Cardiganshire, 1888

The elaboration of Cistercian churches in the thirteenth century certainly confirms Giraldus's assertion. At Strata Florida the purity of the main surviving feature, the west doorway, is deceptive, since it was part of a transitional building designed with both the round arches of the Romanesque and the soaring pointed arches of the emerging Gothic style. The new architecture liberated the builders of the thirteenth and fourteenth centuries to penetrate walls with large areas of window, a feature that has seemed to many to be the great glory of the visual culture of the medieval period. Contrary to early practice, at Strata Florida the stone carving of capitals was florid and the structure itself was enlivened by the use of alternate bands of different coloured stone.[4] Rubble walls were plastered and painted with a variety of motifs. There was coloured glass[5] and figurative sculpture, though the interpretation of the only surviving example – a fractured but finely-carved image of a monk, possibly St Bernard – is complicated by the fact that its original location within the abbey complex is unknown. Bernard may also be the subject of a fragment of an incised image of a cleric with a nimbus at Neath abbey.[6] Neath had been endowed in 1130 by a Norman, Richard de Granville, as a Savigniac monastery, but in 1147 that order had been incorporated by the Cistercians, who regarded Bernard with particular reverence. At another Cistercian house, Valle Crucis, founded in 1201 (and deriving ultimately, like Strata Florida,

133. A Cleric with a Nimbus,
Neath Abbey, Glamorgan,
13th century, Stone

[5] Only fragments of early glass (held at Ceredigion Museum, Aberystwyth) were found in the nineteenth-century excavation. The earliest window from a Welsh monastic site whose design can be determined was found in excavations at Carmarthen Greyfriars in 1983. Within a geometric border, the panel carried a heraldic design of birds of prey, presumably the arms of a patron of considerable wealth, since coloured glass would have had to be imported in the late thirteenth century. *ICOM Committee for Conservation*, vol. III (1987), 989–96.

[6] The fragment also carries a small section of an inscription which does not satisfactorily identify the image though, in combination with the fact that it is carved on a thin slab, suggests that it was part of a burial slab. However, since the head is depicted against a nimbus, this is most unlikely.

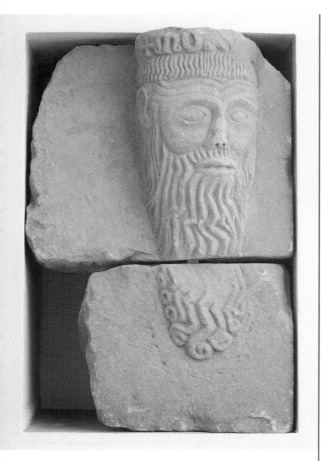

134. Head of Rabanus Maurus (or Morus),
formerly at Valle Crucis Abbey,
Denbighshire, 13th century,
Stone, ht. 343

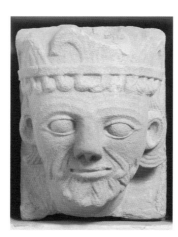

135. Head, possibly
of Llywelyn ab Iorwerth,
formerly at Degannwy,
Caernarfonshire, 13th century,
Stone, ht. 255

from Whitland), rather more figurative carving has survived, including several items which remain *in situ*. A head, identified by a crown-like inscription as Morus, and carved with great authority, was found below the refectory pulpit arch. Presumably not only scripture but the commentaries of Morus on the biblical texts would have been read from there at mealtimes.[7] The distinctive style of the sculpture strongly suggests that it was made by the same carver who produced a head speculatively identified as that of Llywelyn ab Iorwerth which was found at Degannwy, a castle with which the prince was associated.[8] Valle Crucis had been founded by Llywelyn's cousin Madog ap Gruffudd Maelor, prince of Powys Fadog, with whom he was in close alliance at the time of his death in 1236, and the royal patronage of both sites tends to reinforce the attribution of the carvings to the same artisan, exploiting a network of related patrons.[9] The carver may also have been responsible for a head surviving *in situ* in the passage leading from the western porch, though more simply carved details, including a tiny hooded figure, suggest that artisans of varying degrees of sophistication produced figurative work at Valle Crucis.

The support of monastic houses by rich and powerful secular patrons, exemplified by the probable activity of the sculptor of the Valle Crucis head of Morus at a castle of the native princes, created a tension between the demands of austerity and enrichment. The high status of the patrons of the Cistercian houses deriving from Whitland is evident at several sites. Although documentary evidence is lacking to connect Llywelyn ab Iorwerth directly to the abbey at Cwm-hir in Radnorshire, circumstantial evidence might be interpreted as suggesting his involvement there since the church was rebuilt on a massive scale during the twenty-five years of his supremacy in the early thirteenth century.[10] The abbey church was laid out with fourteen bays extending internally to 242 feet, making it by far the largest in Wales and among the largest in Britain.[11] Its pattern of construction was unusual since work proceeded from west to east, though it was never completed beyond the opening into the crossing. While the work was under way an earlier building on a much smaller scale was probably left as the functioning church.[12] A male head, carved on a corbel and found near the site, may be the only relic of that earlier church and, indeed, it seems closer in style to the carving of the nearby Radnorshire/Breconshire font group than to the elaborate floriate carving of the column capitals which adorned its massive but aborted replacement.[13]

[7] Rabanus Maurus (or Morus) (c.776–856) was among the most learned individuals of his time. He wrote on a wide range of subjects, but his commentaries on most of the books of the Old Testament and on the Gospel of St Matthew and the Epistles of St Paul would have made him a particularly appropriate figure for celebration in the refectory at Valle Crucis. The report by L. A. S. Butler, 'Valle Crucis Abbey: An Excavation', *Arch. Camb.*, CXXV (1976), 112–13, failed to identify Rabanus as the subject of the carving, leading to a speculation that the refectory was not its original location. The carving is incorrectly identified on display in the National Museum of Wales.

[8] Leslie Alcock, *Archaeological Journal*, CXXIV (1967), 196–7, excavation report.

147. Francis Chesham
after Samuel Hieronymus Grimm,
*The Inside of the Chapter House
at Margam*, 1780, Engraving,
215 × 154

the direction of Abbot Adam of Carmarthen, whose
efficient if not ruthless management, along with that of
his predecessors, had made it one of the richest monasteries
in Wales.[20] It is indicative of the importance of secular affairs
to such institutions that at Margam, among the closest rivals
of Neath, the most elaborate and refined structure was the
chapter house, the business centre of the abbey.[21]

Taken as a whole, the influence of wealthy secular
patrons on the Cistercian houses is best exemplified by
the reconstruction of Tintern abbey. Redevelopment of the
monastic buildings, begun in the 1220s, seems to have been
associated with the family of William Marshal the Younger,
earl of Pembroke and lord of Chepstow. The church itself
was rebuilt between 1270 and 1301, apparently under the
patronage of Roger Bigod, who had married into the Marshal family and
became earl of Norfolk in the year the work commenced. The interior decoration
included tiles of the Clarendon type, depicting lions and griffins, as well as floriate
patterns echoing the carving of column capitals. However, elaboration continued
after the death of Roger Bigod in 1306, and was most notably expressed by the

148. Samuel and Nathaniel Buck,
*The North East View of Tintern Abby,
in the County of Monmouth*, 1732,
Engraving, 193 × 372

construction of the pulpitum, a
screen of veranda-like form placed
between the monks' choir and the
east end of the nave in which the lay
brothers originally worshipped. By
the late 1320s, the likely period of
its construction, the tradition of lay
brothers was in terminal decline.
The rule which demanded that
the monks work the land themselves
had been increasingly supplanted
by farming through tenants who
paid rents in cash and kind. In
the absence of lay brothers the
significance of the screen had
changed from being a partition to
being a grand point of processional

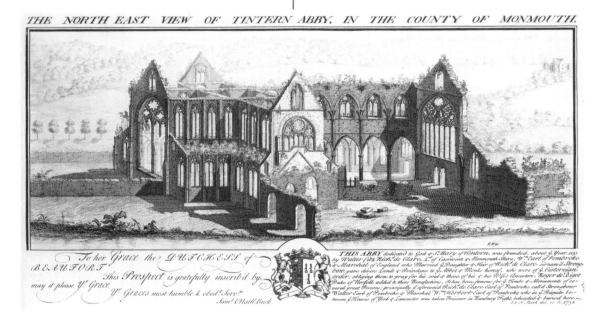

entrance to the most sacred space of the church. The Tintern pulpitum, which survives only as fragments, was probably designed by one of the most celebrated masters of the period, William Joy, who was based at Bristol and was noted for his work on the buildings of south-west England, including the pulpitum at Exeter Cathedral. Whether Joy carried out the practical work at Tintern is uncertain. Almost all of the stone used was quarried and cut locally, and his role may have been mainly supervisory.[22]

The mainstream modernism of Tintern, suggested by the rebuilding begun in the second half of the thirteenth century, is borne out by the survival of a single volume bible from the monastic library. Such bibles were unknown before the thirteenth century but were then produced in large quantities, a development which was related to the rise of university education.[23] The demand for them was so great that production became highly organized and standardized. It was often undertaken at secular workshops, and it cannot be assumed that the two scribes who co-operated to produce the Tintern Bible worked in the scriptorium of the abbey. The bible was of a generally conventional pattern, though there were some minor idiosyncrasies. The illuminations were finely executed but not elaborate, and consistent with the principles of Cistercian moderation which were so dramatically abandoned during the construction of the new building when the bible arrived at Tintern, probably in the third quarter of the thirteenth century.[24]

149. Chris Jones-Jenkins, Tintern Abbey: perspective reconstruction drawing of the pulpitum screen from the south-west, c.1998

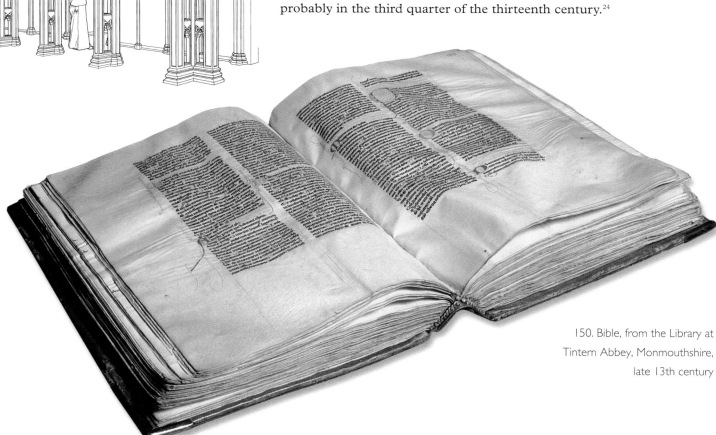

150. Bible, from the Library at Tintern Abbey, Monmouthshire, late 13th century

The elaboration of Cistercian churches was little delayed or moderated by any residual sense of the austerity which marked the birth of the order, and certainly no such constraints hindered the development of secular churches, great and small. Wall painting of the thirteenth century survives at Llantwit Major in the form of a large and elegantly drawn image of Mary Magdalene which adorns the north side of the chancel. Painting from the early to mid-fourteenth century is evident at St David's within the elaborate pulpitum constructed there, which reflected the example at Tintern, although that of the Cistercian foundation was the more *avant-garde* both in terms of design and the fact that it probably predated St David's by a few years. The pulpitum at St David's was constructed by Bishop

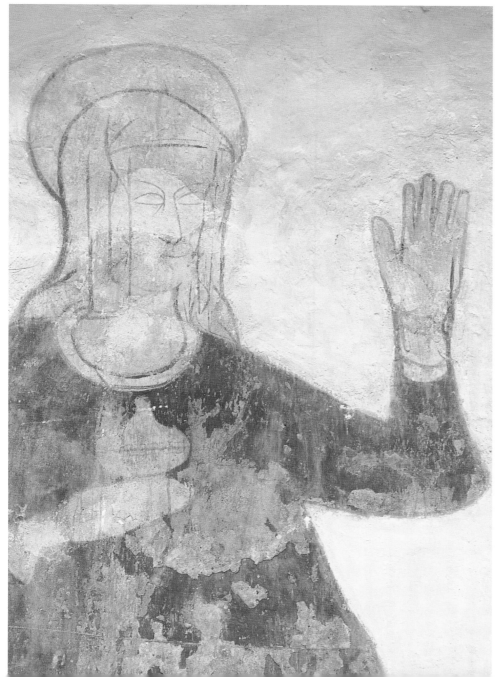

151. St Mary Magdalene, Church of St Illtud, Llantwit Major, Glamorgan, 13th century

[22] The construction of the Tintern pulpitum is discussed in Stuart A. Harrison, Richard K. Morris and David M. Robinson, 'A Fourteenth-Century *Pulpitum* Screen at Tintern Abbey, Monmouthshire', *The Antiquaries Journal*, 78 (1998), 177–268.

[23] The first of the universities to emerge was Paris at the end of the twelfth century, at which period Giraldus Cambrensis was a student there. A hundred years earlier Sulien of Llanbadarn had studied in Scotland and Ireland not as a matter of choice but because the western continental educational centres were yet to develop. For a general discussion of the rise of University education, see Hastings Rashdall, *The Universities of Europe in the Middle Ages* (Oxford, 1987). The only other thirteenth-century bible to survive from Wales (BL Add. MS 54232) was at the Franciscan friary at Llan-faes, founded by Llywelyn ab Iorwerth, though an inscription makes it clear that the Llan-faes community was not its original owner.

[24] Daniel Huws, 'The Tintern Abbey Bible', *Monmouthshire Antiquary*, 6 (1990), 47–54.

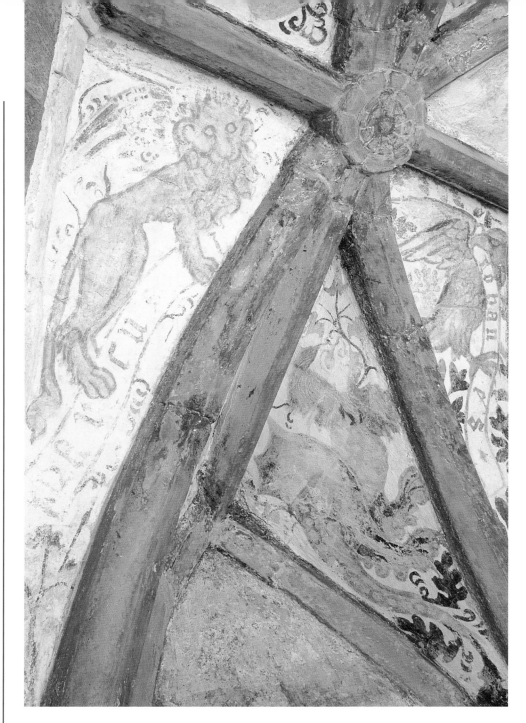

[25] The skeleton vault of the pulpitum is similar to one built by Abbot Knowle for the sacristy at St Augustine's abbey, Bristol (now Bristol Cathedral), which was constructed by the same masons. Their mason marks appear at both sites. Abbot Knowle and Bishop Gower were close friends. G. H. Cook, *Medieval Chantries and Chantry Chapels* (London, 1963), p. 150.

[26] Gower's most audacious plan, to create a stone vault over the cathedral at St David's, was begun by the insertion of the springers from which the arches would rise, but it was not carried forward. He died in 1347.

[27] The sculpture is described in Rick Turner, 'St Davids Bishops' Palace, Pembrokeshire', *The Antiquaries Journal*, 80 (2000), 87–194. Although Gower was the most important figure in the creation of the Bishop's Palace, construction probably began in the late thirteenth century under the direction of his predecessors. See C. A. Ralegh Radford, *The Bishop's Palace, St David's, Pembrokeshire* (London, 1953), pp. 12–13.

152. The Lion, Symbol of St Mark, and an Owl Mobbed by Other Birds, paintings from the ceiling of the pulpitum, St David's Cathedral, Pembrokeshire, second quarter of the 14th century

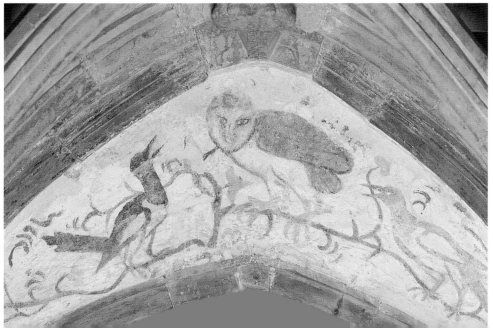

153. Corbel Head,
Bishop's Palace, St David's, Pembrokeshire,
second quarter of the 14th century

Henry de Gower, whose extensive building activities did not rely on negotiation with a secular patron.[25] His reconstruction of the castle at Swansea and the buildings at the bishop's palaces at Lamphey and St David's itself, along with the enrichment of the church, were financed from diocesan income probably supplemented by specific fund-raising activities and his own pocket. Gower's projects were unusual not only for their scale,[26] but also for their distinctive and original style, reflecting a relationship with the masons whom he employed in which he was clearly the dominant partner. Gower was almost certainly a native of the area whose name he bore, but he had spent a quarter of a century at Merton College, Oxford, rising to become Chancellor of the University between 1322 and 1325, when it was a centre of intellectual activity of European importance. His enlargement of the Bishop's Palace at St David's, where his characteristic chequered stonework and parapet arcades were most dramatically displayed, was adorned with the greatest proliferation of figurative sculpture in medieval Wales. The doorway into the Great Hall, at the head of an imposing flight of steps, was surmounted by two large-scale seated figures, traditionally identified as King Edward III and Queen Philippa under whom Gower held offices of state. These monumental sculptures and many of the 170 or more corbels identifiable on the Bishop's Chapel, Solar, Bishop's Hall and Great Chapel are now sadly decayed, though enough survives to indicate the high quality and ambition of this remarkable project.[27]

154. Chequered Stonework,
Bishop's Palace, St David's, Pembrokeshire,
second quarter of the 14th century

155. The Principal Entrance to the Great Hall,
Bishop's Palace, St David's, Pembrokeshire,
second quarter of the 14th century

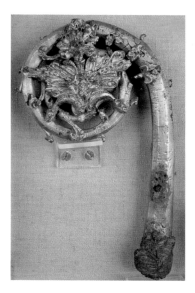

156. The Crosier of Iorwerth, Bishop of
St David's 1215–29, St David's Cathedral,
Pembrokeshire, Gilt copper alloy, ht. 180

[28] Glanmor Williams, 'Henry de Gower
(?1278–1347): Bishop and Builder', *Arch. Camb.*,
CXXX (1981), 9.

[29] J. B. Clear, 'Contents of graves in St. David's
Cathedral', *Arch. Camb.*, 3rd series, XII (1866),
61–3. The chalice is illustrated on p. 198.

[30] The discovery was reported by D. R. Thomas,
History of the Diocese of St Asaph (3 vols., Oswestry,
1908–13), I, pp. 217, 314. Thomas did not give a
source for his report and the floriate cross slab
under which he surmised the grave goods were
found is no longer extant. It is illustrated in *Arch.
Camb.*, 3rd series, XV (1869), 61. Probably
reporting a traditional association, Thomas
speculated that the grave had been that of
Bishop Spridlington (1376–82).

[31] Cyril E. Pocknee, *Liturgical Vesture: Its Origins
and Development* (London, 1960). In their
essentials the vestments were standardized by
the ninth century, and changes in the detail of
design are neither large enough nor consistent
enough to be of use in dating images.

[32] Henry was formerly the prior of the Benedictines
at Abergavenny and is credited with reforming
the Chapter of Llandaff in the modern tradition
of secular cathedrals.

[33] Giraldus Cambrensis, *Speculum ecclesiae* 3.7
(ed. J. S. Brewer in vol. 4 of *Giraldi Cambrensis
Opera*, Rolls Series 21.4 [London, 1873], 161–7).

[34] Joseph Goering and Huw Pryce, 'The *De Modo
Confitendi* of Cadwgan, Bishop of Bangor', *Medieval
Studies*, 62 (Pontifical Institute of Medieval Studies,
2000), pp. 1–27. For a general study of Cadwgan,
see C. H. Talbot, 'Cadwgan of Bangor', *Citeaux in
de Nederlanden*, 9 (1958), 18–40.

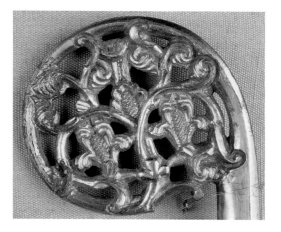

157. The Crosier of Richard de Carew,
Bishop of St David's 1256–80,
St David's Cathedral, Pembrokeshire,
Gilt copper alloy, ht. 75

Henry de Gower has been described as 'a dramatic early example of the
upsurging individualism of the later Middle Ages'.[28] The church over which
he presided provides material evidence of the increasing individuation of the
higher clergy in the century leading to his episcopate, not only in its architectural
embellishment but also in the survival of artefacts relating to the ceremonial in
which the bishop's role was central. At St David's Christian ceremonial artefacts
from the same period can be associated with particular bishops because they were
interred with their owners. In what is probably the grave of Bishop Iorwerth, who
died in 1229, an elaborate crosier was found, and the probable grave of Bishop
Richard de Carew, who died in 1280, revealed both his crosier and his ring. Also
in his grave was found a chalice of the same basic form as that from Cymer abbey,
though the funerary version, not intended to be seen by the public, was a miniature
of simple design.[29] At St Asaph a chalice, probably of rather later date than the
St David's example, was found with a paten in an unidentified burial in the choir.
The paten is of particular interest since it was engraved with a gloved hand in
benediction. This image suggests that the owner was a bishop (since gloves were
a part of the vesture of bishops), though no crosier or ring was found in the grave.[30]

The vestments in which these individuals were interred have not survived, but a
clear impression of their appearance in the thirteenth and early fourteenth centuries
can be gained from depictions in the form of stone carvings, seals, paintings and
manuscript illuminations.[31] At Llandaff the west front of the cathedral, built about
1220, carries on the pendant of the inner round arches of its unusual design an
image of a bishop whose identity is uncertain. It may be a historicist portrait
of St Teilo (though the head is not set against a nimbus) or of Bishop Urban.
However, its enclosure in a mandorla recess recalls the frequent use of this shape
in episcopal seals of the period, and, indeed, the seal of Henry of Abergavenny,
bishop of Llandaff from 1193 to 1218 – that is, in the period of the construction
of the west end of the church – is of precisely that shape.[32] The seal of his near
contemporary at Bangor, Cadwgan, bishop from 1215 to 1235/6, is similar, with
the left hand holding his crosier and the right raised in benediction. Cadwgan was
a Cistercian who, before his elevation to Bangor, had been abbot both of Strata
Florida and Whitland. He became a close associate of Llywelyn ab Iorwerth and

158. Paten, St Asaph Cathedral,
Flintshire, mid-14th century,
Brass, diam. 64

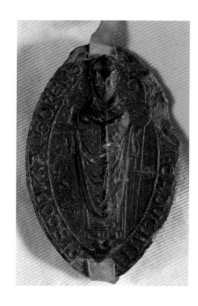

160. Anon., Wooden Tomb Effigy of Cadwgan,
Bishop of Bangor 1215–35/6, at Dore Abbey,
Herefordshire, mid-18th century

159. The Seal of Cadwgan,
Bishop of Bangor 1215–35/6,
Wax, 68 × 42

a figure of sufficient note to be poisonously defamed by Giraldus Cambrensis, whose dislike of him was no doubt fuelled by local rivalry since Cadwgan was born at Lamphey, in close proximity to Gerald's own birthplace at Manorbier.[33] Cadwgan was the author of several treatises, all apparently composed while he was bishop of Bangor, including a work on confession which is notable for its early date.[34] He retired to Dore abbey in Herefordshire, where a wooden tomb effigy was commissioned in his memory some hundred years after his death. The effigy, known only from a drawing, survived until the mid-eighteenth century.[35]

[35] Belmont Abbey, Hill MSS, vol. 3, p. 228. Although the manuscript may slightly predate a description of the memorial published in 1727, which noted that the top of the pastoral staff was broken, the artist has probably imagined the cross drawn in the manuscript. Alfred C. Fryer, *Wooden Monumental Effigies in England and Wales* (new rev. and enlarged ed., London, 1924), p. 86. For other wooden tomb effigies of the early fourteenth century, see below, pp. 125–6. The Hill MSS are no longer at Belmont, and their present whereabouts are not known.

161. Possibly Henry of Abergavenny,
Bishop of Llandaff 1193–1218,
Llandaff Cathedral, Glamorgan, c.1220, Stone

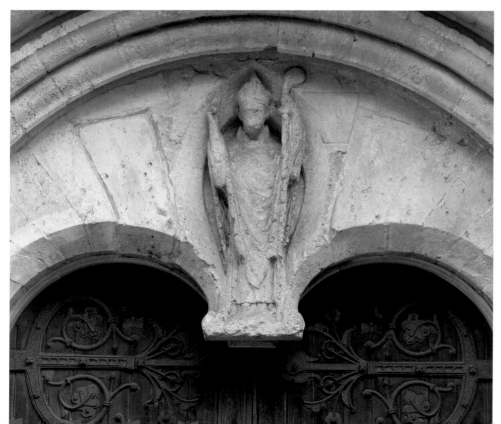

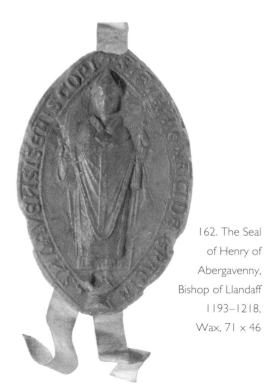

162. The Seal
of Henry of
Abergavenny,
Bishop of Llandaff
1193–1218,
Wax, 71 × 46

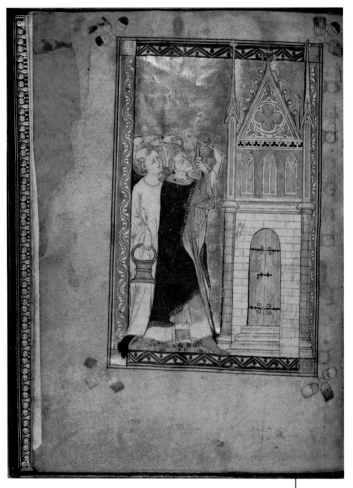

163. Anian II, Bishop of Bangor 1309–28,
Manuscript Illumination from the
Bangor Pontifical, c.1320–8,
Parchment, 258 × 175

164. St Dyfrig,
Manuscript Illumination from
the Warwick Roll,
late 15th century

165. A Bishop,
Church of All Saints,
Llangar, Merioneth,
14th century

36 See the effigy at the Church of St Saeran,
Llanynys, Denbighshire, illustrated in Gresham,
Medieval Stone Carving in North Wales, p. 168, and
the effigy of Dafydd ap Hywel ap Madog at the
Church of Corpus Christi, Tremeirchion, below,
p. 145.

37 The illumination is contained in the Warwick
Roll, made c.1483–5 by Rous, which is held by
the College of Arms, London. Rous, a Warwick
chantry priest, had travelled through north Wales
and Anglesey, examining manuscript collections,
at an earlier date.

At the Church of All Saints, Llangar, in Merioneth an unidentified
bishop forms part of an extensive scheme of wall painting developed over
a long period. The bishop is framed by a fanciful architectural structure.
Although much of his head is lost, the branched pattern of the orphreys on the
pointed chasuble which he wears remains clear, reflecting the pattern depicted on
several stone-carved images of the fourteenth century.[36] Among the manuscript
illuminations of Welsh bishops which survive is a depiction of St Dyfrig. He is
dressed in the vestments of an archbishop of the late fifteenth century, when the
manuscript was made. He wears a plain white alb under a crimson dalmatic which
is largely covered by a chasuble. Over the chasuble St Dyfrig appears to wear the
pallium, signifying his elevated status, though the illustration is not entirely clear
and the golden decoration may simply represent embroidered orphreys. As in the
Llangar wall painting, the archbishop is depicted in a fanciful architectural setting.
He stands in front of his cathedral, holding in his left hand three staffs (repeated
in the arms of Llandaff painted above his head), one of which is surmounted by a
cross signifying his status as an archbishop.[37] The only manuscript illumination of
a bishop with Welsh provenance is that contained in the Bangor Pontifical. The
bishop holds his crosier in his left hand and with his right blesses with holy water
a schematic representation of a church. The image precedes a text of the office
of consecration of an altar. The date of the manuscript is disputed, but it was
probably commissioned from an English scriptorium in the early 1320s by
Bishop Anian II of Bangor.[38]

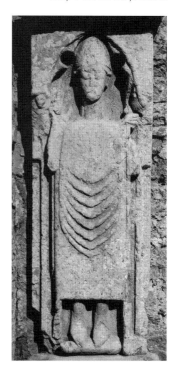

167. Relief Effigy
of an Unknown Bishop,
Kilfenora, Co. Clare, Ireland,
early 14th century, Stone

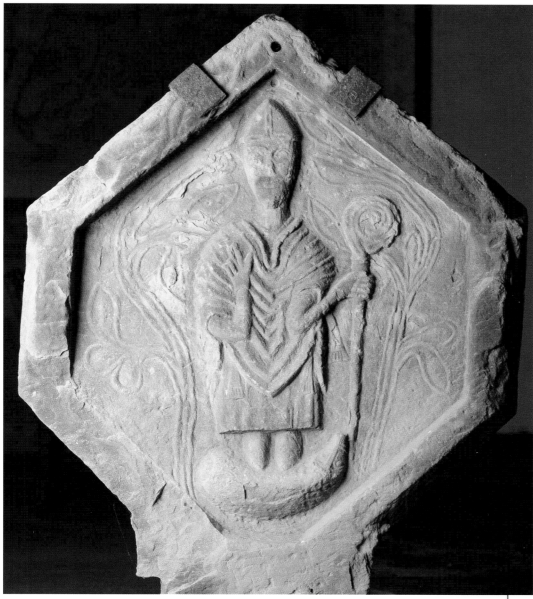

166. Unidentified Bishop,
Church of St Saeran, Llanynys, Denbighshire,
14th century, Stone, ht. 712

Regional variations within the code of episcopal dress were few. A bishop
depicted on a cross from the Church of St Saeran, Llanynys, in Denbighshire
wears a mitre of archaic shape, although its detailing is contemporary with the
probable date of the carving. The bishop is not identified by an inscription, but
bears such a striking resemblance to an image carved on a slab at Kilfenora in
Ireland as to suggest a common maker. The low mitre of the Llanynys bishop
may represent the convention familiar to an Irish carver working abroad rather
than episcopal practice in Wales.[39]

[38] The manuscript is inscribed 'Iste liber est
pontificalis domini aniani bangor episcopi',
and some scholars believe this to refer to
Bishop Anian I, who held office at Bangor
between 1267 and 1305. However, the
recent consensus is for a later date. Michael A.
Michael, 'The Harnhulle Psalter-Hours: an early
fourteenth-century English Illuminated Manuscript
at Downside Abbey', *Journal of the British
Archaeological Association*, CXXXIV (1981), 81–95,
suggests that it may have been made to mark the
beginning of Anian II's episcopacy in 1309, but
Lucy Freeman Sandler, *A Survey of Manuscripts
Illuminated in the British Isles, Vol. 5, Gothic
Manuscripts [1] 1285–1385* (Oxford, 1986),
pp. 77–8, prefers the date 1320–4, by comparison
with the Hours of Alice de Reydon, which she
believes may be the work of the same illuminator.
The two bishops Anian of Bangor are not to be
confused with their near-contemporaries of the
same name who were bishops of St Asaph.

[39] The other side of the cross carries an image
of the Crucifixion, for which see below, p. 155.

168. Henry de Gower,
Bishop of St David's 1328–47,
St David's Cathedral, Pembrokeshire,
Stone, detail

40 See, for instance, an Etruscan tomb in the
Vatican Museum which, in all its essentials, is
identical to those of the high Middle Ages.
The tomb is illustrated in Jacob Neusner, *Jewish
Symbols in the Greco-Roman Period* (Princeton,
1988), p. 67.

41 The tomb effigy of Anna Martel, now much
decayed, is among the earliest representations
of a woman in this form; it was possibly made
before the end of the thirteenth century. The
separate effigy of John, lord of Llanfihangel
Rogiet, husband of Anna, also lies in the church.
See C. J. O. Evans, *Monmouthshire: Its History and
Topography* (Cardiff, 1953), pp. 384–5.

The celebration of power and the sense of individuation expressed in visual culture with unrivalled panache in the early fourteenth century by Henry de Gower culminated in his burial under the canopy of his pulpitum. He was laid to rest in an elaborate sarcophagus surmounted by a fully modelled and painted recumbent effigy. The marking of burials by such images was a practice of the ancient world, which had been gradually reinvented in the Romanesque renaissance.[40] However, the medieval effigy expressed a more complex concept than memorialization, which arose from the belief in the continuity of life after death. The ancient, and indeed modern, sense of memorial is retrospective, but the medieval tomb effigy was also prospective, since earthly life was perceived to be a part of an infinite continuum. The translation from earthly to eternal life required a period of purification in the intermediate state of purgatory, a concept which occupied a central place in the imagination of people in the medieval period. The dead were not cut from the body of the living in the absolute sense which the modern secular mind imagines, but rather were translated to another place within a unified whole, and remained accessible to those left behind. It was believed that prayers and offerings were efficacious in reducing the time spent by the dead in purgatory. Many tomb effigies presented the deceased in the repose of translation from one state to another as a reminder to the living to facilitate the process by prayer. The memorial to Anna Martel at the Church of St Michael, Llanfihangel Rogiet in Monmouthshire, includes an elaborate inscription which not only emphasizes the role of the tomb in securing remission of time in purgatory for the deceased through the interceding power of prayer, but also offered benefits to the living. The central concern of the period with purgatory led to increasingly specific doctrinal pronouncements on the value of prayers of various kinds: 'Anna Martel lies here. God have mercy on her soul. Whosoever will say the paternoster and the Ave Maria for her will receive pardon for forty days. Amen.'[41] In a sense which today may seem paradoxical, the tombs of individuals such as Henry de Gower were simultaneously statements of power and of vulnerability – appeals to the living, however humble, to intercede on behalf of those whose former glory was expressed in their grandiose memorials.

As we have seen, the memorialization of the individual dead had been practised in Celtic Christian society but, as far as is known, not within church buildings, with the exception of those persons regarded as saintly. However, the role of the church building as a social focus clearly encouraged the practice of intramural burial of prominent people, who might in this way increase their access to the power of prayer. Spiritual contagion – the idea that in death physical proximity to holy relics improved one's chances of rapid entry into paradise – provided an

176. After Colin A. Gresham,
Tomb Slab of Gweirca
ferch Owain, 1290,
Valle Crucis Abbey,
Denbighshire, c.1968,
length of stone 1830

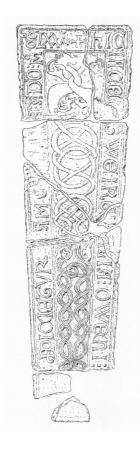

middle right:

177. After Colin A. Gresham,
Tomb Slab, late 13th century,
Valle Crucis Abbey, Denbighshire,
c.1968, length of stone 1449

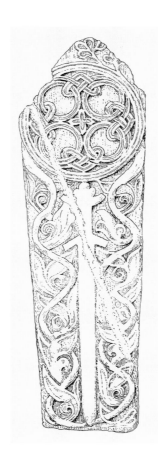

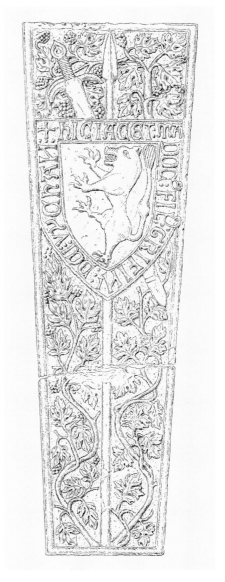

178. After Colin A. Gresham,
Tomb Slab of Madog ap Gruffudd Fychan,
c.1306, Valle Crucis Abbey, Denbighshire,
c.1968, length of stone 2160

dynasty – a piece of symbolism which would have been particularly pointed at her death since it followed closely on the Edwardian conquest. A visual expression of the trauma of the conquest would reflect the poetry sung in the period by *Beirdd y Tywysogion* (the Poets of the Princes), but would have required to be initiated by a sophisticated patron or artisan aware of manuscript or carved sources. On the other hand, this late flourishing of archaic imagery may simply reflect a low level of continuity of which we are unaware (since most of its manifestations have been lost), but which was brought to prominence in the hands of a particularly active artisan or workshop. The most frequently repeated motif was an elegant cross head formed of four interlaced circles which seems to have been a new invention, not based on a pre-Norman model, but both consistent with the principles of the older tradition and distinct from contemporary motifs in use elsewhere.[59]

The several memorials at Valle Crucis to members of the family of Gweirca, descendants of Gruffudd ap Cynan,[60] exemplify a tendency all over Europe to group burials in a favoured church as an expression of dynastic identity. Madog ap Gruffudd Fychan, great-grandson of the founder of the same name (and himself great-grandfather of Owain Glyndŵr), died c.1306 and was buried before the high altar beneath a slab whose design did not repeat the archaism of that of his cousin, Gweirca, but was the source of a group of later memorials which shared a new iconography of a shield laid over a spear and an angled sword.[61]

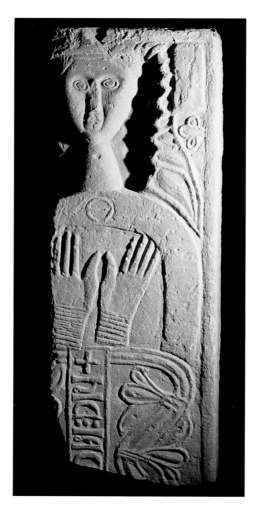

right:

180. After Colin A. Gresham,
Tomb Slab of Dafydd ap Madog,
early 14th century, Church of
St Cynfarch and St Mary,
Llanfair Dyffryn Clwyd,
Denbighshire, c.1968,
length of stone 2045

179. Relief Effigy of
an Unidentified Woman,
Church of St Mary, Cilcain,
Flintshire, early 14th century,
Stone, l. 865

[62] Notwithstanding its general title, in his study *Medieval Stone Carving in North Wales* Colin Gresham considered only the production of funerary memorials and did not attempt to relate them to other stone carving of the period.

[63] For instance, workshops such as those which, when the opportunity for more creative work was presented, produced the font groups of Anglesey and Brecon/Radnor in the eleventh and twelfth centuries. See above pp. 49–52 and 80–2.

[64] The similarity between the two memorials is the more striking because of the considerable physical distance which separates them. The implication must be either that the Joan memorial was widely familiar or that the carver of the Cilcain memorial was peripatetic over an extensive area.

[65] The slab is closely similar to that of Iorwerth Ddu at Cilcain. See Gresham, *Medieval Stone Carving in North Wales*, nos. 129, 130.

[66] The evidence of continuous workshop activity encouraged Colin Gresham to describe the phenomenon as a 'North Wales school of medieval sculpture', *Medieval Stone Carving in North Wales*, p. 1. The appellation is somewhat misleading because although Valle Crucis produced the largest number of surviving memorials in the thirteenth and early fourteenth centuries it was not the only place of production. It was Gresham himself who identified the diversity of local styles and, moreover, divided production into three separate periods. Furthermore, the notion of a north Wales school tends to imply that practice in the north of the country was essentially different from that pertaining elsewhere, whereas it is clear that small workshops or individuals produced groups of works with distinctive characteristics in many parts of the country. The most important general difference which is apparent between the funerary memorials of north and south Wales arises from particular characteristics in the patronage rather than from the production by carvers in the north who shared a common training, as implied by the term 'school'.

The survival of individual memorials of distinctive style, or of small groups such as that which includes the effigy of Joan, tells us little for certain about the practice of stone carving in the period. However, the Joan effigy group was carved at about the same time as the head, perhaps of Llywelyn ab Iorwerth, found at Degannwy and that of Morus from Valle Crucis, both carvings of equal confidence to that of the princess, though directed to such different purposes as to make comparison difficult. Nevertheless, the two heads provide a context for what seems, otherwise, to be a very isolated phenomenon.[62] As we have seen, the workforce employed at major building projects in the twelfth and thirteenth centuries was peripatetic over a wide area. It may be that the possibility of continued patronage encouraged some of them to become resident, perhaps in association with existing practices which produced less prestigious work.[63] The production of figurative carving to decorate the architecture of Valle Crucis and the commencement of production at the same date of a series of tomb slabs which span several generations suggest some degree of interaction between peripatetic architectural masons and resident artisans.

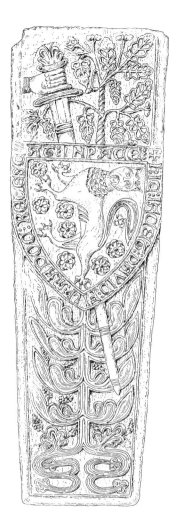

[67] Gresham, *Medieval Stone Carving in North Wales*, p.164, pointed out that if the St Asaph effigy represents Anian II then either it must have been removed, sometime after the dissolution, from the Dominican friary of Rhuddlan (where Anian had directed he be buried), or, if it was originally installed in the cathedral, then it must have surmounted a cenotaph rather than a tomb. Although Anian was a monk, he was depicted as bishop, his episcopal rank taking precedence over his monastic status. An effigy depicting a high-ranking monk of the same period, Abbot Adam of Carmarthen, survives in Neath abbey. Its very poor state of preservation has led to misrepresentation of the iconography in published drawings. Adam's head rests on a pillow, not as illustrated in *Arch. Camb.*, 4th series, VII (1876), 35, against a nimbus. However, this illustration is probably correct in showing a book in the left hand, rather than the model of Neath abbey fancifully interpreted in the illustration published in *Arch. Camb.*, 5th series, III (1886), 333, in the manner of the thirteenth-century tomb of Abbot Serlo in Gloucester Cathedral. The iconography of the effigy of Abbot Adam probably follows that of his seal. See the illustration, p. 102.

There is evidence of continuity of local practice both in the use by carvers of earlier works as models and in a more gradual evolution of stylistic characteristics. For instance, either because of its technical quality or the celebrity of the person depicted, the image of Joan clearly provided the model for the memorial to an unknown woman at the Church of St Mary, Cilcain.[64] The memorial at Valle Crucis to Madog ap Gruffudd Fychan spawned a group of tomb slabs of the same design but with more formalized floriate decoration, notable among which was that of Dafydd ap Madog at Llanfair Dyffryn Clwyd.[65] The evidence of such consistencies of style is reinforced by the use of local stones over a long period, especially from the Llangollen area. However, the precise location of these particular workshops – whether at the quarry, in the precincts of Valle Crucis abbey, or in the settlement of Llangollen itself (where the river would have facilitated transport of both finished memorials and stone), is unknown.[66]

182. Effigy of Anian II, Bishop of St Asaph 1268–93, St Asaph Cathedral, Flintshire, Stone, l. 2250

Notwithstanding idiosyncrasies of local style and regional patronage, the increasingly impressive memorials to the higher clergy of the thirteenth century provide evidence of overall coherence of sculptural forms in Wales. The massive effigy at St David's of Anselm, bishop from 1231 to 1247, lies in deeply carved relief below a trefoil arch surmounted by angels. At the other end of the country, at St Asaph, a more elaborate version of the same form probably represents Bishop Anian II, who died in 1293. Both effigies were designed to surmount free-standing coffins or cenotaphs, which suggests that they originally occupied prominent positions in the body of their respective churches.[67]

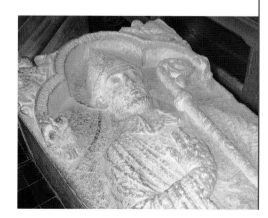

181. Effigy of Anselm, Bishop of St David's 1231–47, St David's Cathedral, Pembrokeshire, Stone, l. 2080

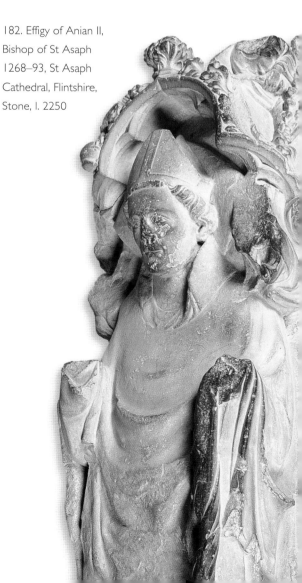

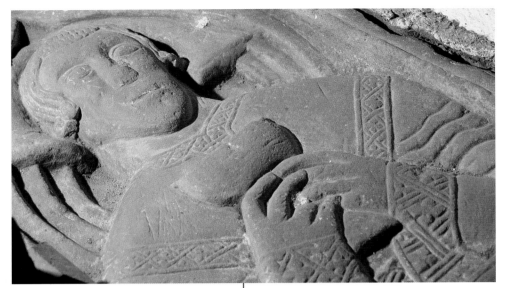

183. Relief Effigy of Iorwerth Sulien, Vicar of Corwen, Church of St Mael and St Sulien, Corwen, Merioneth, c.1340–50, Stone, l. 1881

By the end of the thirteenth century such conspicuous burial of the higher clergy in the great churches was reflected in the marking of burials of ordinary priests with decorated slabs or effigies in parish churches. The effigy of an unnamed priest at the Church of St Cadfan, Tywyn, was apparently of comparable style and elaboration to that of Anian II at St Asaph, probably (like the wall painting of Mary Magdalene at Llantwit Major) reflecting the continuing cachet of the important pre-Norman site.[68] The practice of burying grave goods symbolic of status was also reflected at the lower level of the parish priest. At the Church of St John, Llanblethian in Glamorgan, the priest was interred with his communion chalice placed in a niche in the grave.[69] Although covered with a cross slab rather than an effigy, the ability to pay even for simple carved memorials must have confined the practice of memorialization to those priests who were the sons of wealthy families or held valuable benefices. Unfortunately, nothing is known of the earliest examples since none is identified by a surviving inscription, and the earliest named priest, Iorwerth Sulien, vicar of Corwen, cannot be dated with certainty. In his hands he holds a chalice, his fingers ritually crossed, an iconography which became conventional but not universal for the memorials of priests.[70] The inscription by which he is identified includes an invocation to pray for him.

Both the elongated carving of the face of Iorwerth Sulien and the style of the lettering render it likely that the effigy is the work of the same sculptor who produced an effigy of a secular individual, Meurig ab Ynyr Fychan, at the Church of St Mary, Dolgellau. It belongs to a group of effigies clad in armour which emerge in the early fourteenth century to demonstrate the final decay of the prohibition on secular burials in church in the Welsh-controlled areas. The individuals depicted belonged to the first generation which had not been formed by the Wales of the native princes –

184. After the excavation by Charles B. Fowler, Interment of a Priest at the Church of St John, Llanblethian, Glamorgan, 1897

185. After Colin A. Gresham, Effigy of Meurig ab Ynyr Fychan, c.1345, Church of St Mary, Dolgellau, Merioneth, c.1968, length of stone 2057

[68] The Tywyn effigy is difficult to assess because of its decayed condition. The priest is hooded, an unusual piece of iconography discussed by Gresham, *Medieval Stone Carving in North Wales*, pp. 164–5.

[69] At Highlight (Uchelolau) Church, Glamorgan, the lead chalice and paten of the priest were laid over his pelvis. A small pewter chalice was placed at his feet. The dedication of the church, which was closed c.1570, is unknown. We are grateful to Mr Howard J. Thomas for providing us with details of his excavations at Highlight.

[70] Gresham, *Medieval Stone Carving in North Wales*, p. 159, notes that an earlier example of a priest holding a chalice, at the Church of St James the Apostle, Holywell, was all but destroyed by visitors who, in their enthusiasm for relics associated with St Winifred, chipped pieces away to make into potions. Gresham does not cite the source of this information.

those who jostled with each other to carve out the estates which replaced the tribal pattern of landholding when it finally disintegrated after the conquest of 1282. These people not only patronized sculptors but also the first of a new generation of poets, *Beirdd yr Uchelwyr* (the Poets of the Gentry), whose metrical forms superseded those of the poets who had sung to the princes.[71] Nevertheless, their links to the pre-conquest tradition are evident in the memorial of Gruffudd ap Llywelyn ab Ynyr at the Church of St Garmon, Llanarmon-yn-Iâl, made in around 1320. The tomb was originally at Valle Crucis abbey where it stood with that of his wife, Tangwystl, which, however, took the form of a slab.[72]

[71] See 'Poets of the Gentry' in Meic Stephens (ed.), *The New Companion to the Literature of Wales* (Cardiff, 1998), p. 591. The 'Beirdd yr Uchelwyr' series published by the University of Wales Centre for Advanced Welsh and Celtic Studies is devoted to the works of these poets.

[72] The tomb of Gruffudd ap Llywelyn ab Ynyr was removed to Llanarmon-yn-Iâl after the dissolution and, similarly, that of his wife was taken to the Church of St Tysilio, Bryneglwys. It is apparent that Tangwystl's memorial was carved by the same artisan who made that of Madog ap Gruffudd Fychan. See above, p. 119.

186. Effigy of Gruffudd ap Llywelyn ab Ynyr, Valle Crucis Abbey, now in the Church of St Garmon, Llanarmon-yn-Iâl, Denbighshire, *c.*1320, Stone, l. 2084

187. After Colin A. Gresham, Tomb Slab of Tangwystl, *c.*1310, Valle Crucis Abbey, now in the Church of St Tysilio, Bryneglwys, Denbighshire, *c.*1968, length of stone 2084

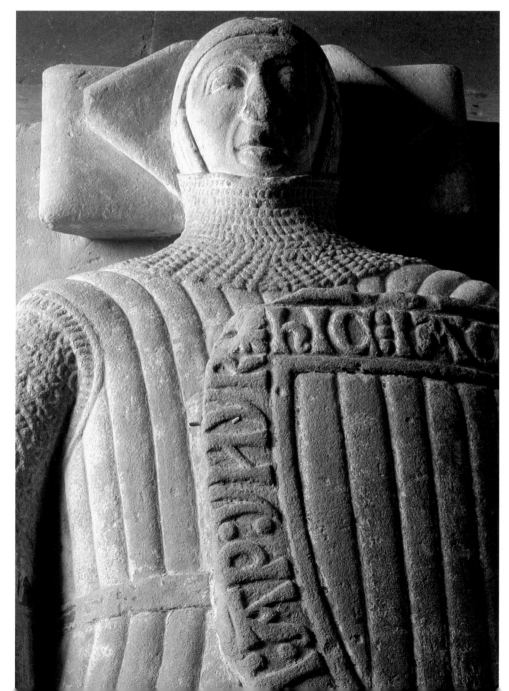

The effigies of the new *uchelwyr* of the north, though made by distinct hands and workshops, share characteristics which distinguish them from those of their longer-established counterparts in south Wales. Most obvious are their straight-legged pose (as distinct from the crossed-legged style of the south),[73] the carving of inscriptions around the shield edge (rather than the edge of the slab), and the undifferentiated heraldry of the shields themselves – most commonly displaying a lion rampant. The difference arises from the domination of the south Wales market, both for reasons of social kinship and geography, by products made in the style of the dynamic quarrying and carving industry of south-west England. Many of the effigies of the southern lords of Norman or mixed lineage, especially those who lived in places accessible by water, were made at Bristol or nearby workshops. Overland transportation of sculpture in the fourteenth century was extremely difficult, even in central England. In 1367 it required seventeen days, ten carts (each drawn by eight horses and driven by two men) and the prodigious expense of £28.6.8d., to transport an alabaster reredos from Nottingham to Windsor.[74] Although they were able to export to north-west England on a small scale,[75] the more difficult conditions in Wales would have inhibited the penetration of the southern market by northern workshops even had the tradition of looking to Bristol not been

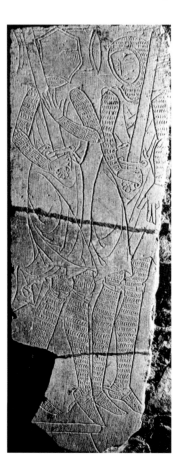

far left:

188. Rubbing of the Incised Stone Effigy of John le Botiler, Church of St Bride, St Brides Major, Glamorgan, c.1285, Stone

189. Incised Effigies known as 'The Brothers', Jerpoint Abbey, Co. Kilkenny, Ireland, late 13th century, Stone

[73] Only one example of a cross-legged effigy of a knight is known from within the area in which the straight-legged effigies produced by the northern workshops dominated. Perhaps significantly, it is believed to be that of an English knight, Sir Robert Pounderling, at Tremeirchion. See Gresham, *Medieval Stone Carving in North Wales*, no. 168.

[74] Pipe Roll 41, Edward III, m.41.

[75] At the church of St Chad, Farndon, Cheshire, pieces of two slabs and one of two Welsh-made effigies, installed in the early fourteenth century, survive, for which see Gresham, *Medieval Stone Carving in North Wales*, nos. 137, 145, 176, 177. The Flintshire carvers of the late fourteenth century, for which see below, pp. 145–6, exported at least one slab and one effigy to Chester itself, ibid., nos. 193, 214.

[76] The effigy is now in the Margam Stones Museum. For the commercial activity of Margam, see Cowley, 'Margam Abbey, 1147–1349', 18. Other monasteries, including Neath, Tintern, Aberconwy and perhaps even inland sites such as Strata Florida, also maintained boats. Margam, Neath, Tintern and Whitland owned property in Bristol to support their trading activities. See Williams, *The Welsh Cistercians*, II, pp. 315–17.

[77] There is no factual basis for the belief that the crossed legs of knightly effigies indicate participation in the crusades. Its origin lies in folkloric attempts to explain the posture, though they have often been repeated in the writing of academic historians. In his chapter 'The Medieval Period' in Eric Rowan (ed.), *Art in Wales 2000 BC–AD 1850* (Cardiff, 1978), p. 86, Glanmor Williams wrote of the effigy at Abergavenny of John, second baron Hastings, that 'The crossed legs resting on a lion signify the knight died "for his magnanimity".' Figures not of the knightly class were sometimes portrayed with crossed legs and the origin of the convention in naturalism is particularly apparent in the unusual image of three women at Cashel in Ireland. An earlier female image depicts Mary Magdalene as *predicatrix* of Christ's resurrection. The twelfth-century MS Wolfenbüttel, Herzog August Bibliothek: Cod. Guelf. 105 Noviss 20. f.171ʳ depicts her standing, cross-legged, in the activity of preaching. The image is reproduced in Katherine Ludwig Jansen, *The Making of the Magdalene: Preaching and Popular Devotion in the Later Middle Ages* (Princeton, 2000), p. 267.

already deeply entrenched. Despite its mutilated and eroded condition, the effigy of a knight at Margam abbey presents important evidence of practice since it was made of stone from the Dundry quarry near Bristol (on which the Somerset workshops relied) around the middle of the thirteenth century. Even in the Cistercian churches of the south the imaging of secular individuals, not born of royal families, began much earlier than in the north, and reflected the influence of the patronage of the Norman lords. At this time Margam abbey was at the peak of its commercial activity, maintaining its own boats which sailed regularly to Bristol with wool, livestock and hides, and returned with English manufactures – including, no doubt, the tomb effigy.[76]

The use of the motif of crossed legs (which was intended to give the appearance of the individual walking out, as in life) was not confined to the carving of effigies in the round.[77] It is also apparent on the only surviving Welsh example of a knightly memorial in the form of an incised slab. The use of this technique enabled the sculptor to reproduce in stone the fluidity of drawing, giving the cross-legged convention an even more naturalistic appearance than was achieved in carving. The memorial at the Church of St Brides Major in Glamorgan to John le Botiler, who died in 1285, is of further interest since it seems to have been made by an artisan who also worked at Jerpoint abbey, Co. Kilkenny. The two slabs may represent another instance of the exploitation of patronage networks by artisans, and an extension of the relationship between Welsh and Irish visual culture evident in the late twelfth century when Norman Romanesque was established in south-east Ireland.[78]

Neither was the carving of cross-legged effigies confined to stone. An effigy believed to be that of John, second baron Hastings, who died in 1325 and was buried at the Priory Church of St Mary, Abergavenny, was carved in oak.[79] The reasons for the choice of wood as a medium are unclear. When coloured, the images would

[78] A branch of the Botiler or Butler family had settled in Ireland. However, the identity of the two knights depicted on the Irish slab remains a mystery. It has been suggested that they represent Walter and Anselm, last surviving sons of William Marshal, earl of Pembroke, who both died in 1245 and were buried at Tintem. The striking stylistic similarity of the Welsh and the Irish slabs suggests a later date. See Peggy Brennan, 'The Brothers', *Irish Arts Review*, 7 (1990–1), 92–5. The incised technique was also used to image civilians, as at Athassel, Co. Tipperary, illustrated in Tadhg O'Keeffe, *Medieval Ireland: An Archaeology* (Stroud, 2000), p. 111, and ecclesiastics as at Neath abbey, above, p. 97.

[79] The effigy was formerly considered to be that of Geoffrey de Canteloupe, an identification challenged by Joseph Bradney, *A History of Monmouthshire* ([London], 1991), I, part 2a, p. 164, who considered it to represent John de Hastings (d. 1313). Both attributions are convincingly challenged by Claude Blair, 'The Wooden Knight at Abergavenny', *Church Monuments. The Journal of the Church Monuments Society*, 9 (1994), 33–52, who considers it to represent the second John de Hastings (d.1325).

190. Effigy of John, second Baron Hastings, Priory Church of St Mary, Abergavenny, Monmouthshire, *c*.1325, Wood, l. 2160

80 The Hastings effigy retains traces of red paint in the folds of the surcoat.

81 The effigy of Walter de Helyon, a country landowner and farmer, living 1357, lies in the Church of St Bartholomew, Much Marcle, Herefordshire, for which see Fryer, *Wooden Monumental Effigies in England and Wales*, p. 87. Fryer described more than a hundred wooden effigies.

82 Edmund Crouchback became Lord of Grosmont in Monmouthshire sometime after 1256. His portrait appears in Bodleian MS. Douce 231, f. 1.

83 Fryer, *Wooden Monumental Effigies in England and Wales*, p. 38. Blair, 'The Wooden Knight at Abergavenny', 33, was of the same opinion, and regarded the Hastings effigy as 'one of the most beautiful pieces of medieval sculpture in Britain'. Curiously, the effigy in Westminster Abbey Church of William de Valence, earl of Pembroke and father of Aymer de Valence, is of wood, though it was almost certainly made at Limoges in France since it is sheathed in enamelled copper plates. Fryer, *Wooden Monumental Effigies in England and Wales*, p. 90. William de Valence was actively engaged in the war against Llywelyn ap Gruffudd in which his son of the same name (brother of Aymer) was killed in 1282 near Llandeilo. This William de Valence was buried in Carmarthen at the Franciscan friary. His grave has been excavated, but no record of the form of his memorial survives. See Terrence James, 'Carmarthen's Religious Houses: a review of recent archaeological work', *The Carmarthenshire Antiquary*, XXXVI (2000), 65. In 1283 William de Valence senior took Castell y Bere.

84 William I intended that his kingdom be divided between his sons. Normandy was granted to Robert and England to William Rufus, but the untimely death of William Rufus allowed a third brother, Henry, speedily to usurp the throne before Robert could assert his prior claim. Since Henry I's position could never be secure with Robert at large, the king had him detained, first at Bristol and subsequently at Cardiff in the charge of his bastard son, Robert Consul. Why Robert of Normandy was buried at Gloucester, rather than at Tewkesbury, the mother church of St Mary in Cardiff, is unclear, except that it was the titular *caput* of his nephew's earldom. The circumstances surrounding the very late commission for the memorial are equally unclear.

191. Tomb of Sir Roger Berkerolles and his Wife, Church of St Tathan, St Athan, Glamorgan, *c*.1350, Stone, l. 1830

have been indistinguishable from their stone-carved equivalents, but the material is unstable.[80] Cost is unlikely to have been a factor since those celebrated in wooden effigies extended to the top of the social order, though they are known also to have been commissioned by individuals below knightly status.[81] Whether the effigies were produced by artisans who carved in both wood and stone or that specialist wood-carving workshops had arisen is also unclear. The particularly distinguished workmanship of the Hastings effigy has meant that it has been associated with the stone effigies of Edmund Crouchback, earl of Lancaster and lord of Grosmont Castle[82] and Aymer de Valence, earl of Pembroke, in Westminster Abbey. The stylistic case is reinforced by the fact that John de Hastings was the nephew of Aymer de Valence, and that he died only two years after his uncle.

192. Tomb of Sir William Berkerolles and his Wife, Church of St Tathan, St Athan, Glamorgan, first half of the 14th century, Stone, detail, ht. 620

On this basis it has been argued that Hastings's effigy was manufactured in London.[83] Nevertheless, it is clear that wooden effigies were also manufactured in Bristol, most notably that of Robert, duke of Normandy, who died in Cardiff in 1134, but whose effigy was probably commissioned for St Peter's abbey, Gloucester, nearly two hundred years after his death.[84] Furthermore, the effigy of John de Hastings probably reclined on a stone chest, part of which survives, made of either Dundry or Beer stone from south-west England.[85]

The tomb chest in Westminster Abbey which carries the effigy of Aymer de Valence, earl of Pembroke, was of particular importance in the early fourteenth century for the influence it exercised on iconography. Figures carved on tomb chests tend to be indiscriminately designated as 'weepers' – that is, figures in mourning for the deceased. The figures surrounding tombs such as that of the earl of Pembroke clearly do not fit this description, since they are often animated and fashionably dressed. They represent the extended family structure of the deceased and the memorials on which they are carved are better described as kinship tombs.[86] Among the knights depicted in life on the earl of Pembroke's tomb may be John de Hastings, whose stone tomb chest is also clearly of the kinship type since the surviving front panel displays eight military figures.[87] Unfortunately, the figures are damaged and stripped of the painted heraldry which originally identified them.

A similar problem of identification affects the interpretation of what appears to be a pair of kinship tombs at St Athan in Glamorgan. One of the tombs was originally free-standing and the other occupies its original position against the wall of the south transept of the church which became, as a result, the mortuary chapel of the family.[88] Sir William Berkerolles and his wife, and his son Sir Roger Berkerolles and his wife, are certainly the individuals represented, and it is likely that Sir Roger is the cross-legged figure depicted in the elegantly designed niche, dominated by a powerfully carved head of God.[89] His tomb chest is elaborated with six kneeling figures, three of whom are knights and almost certainly members of the family. Inscribed on ribbons, two of them carry an invocation to visitors to pray for them – that is, for the extended family depicted as a whole rather than for the individuals represented by the effigies in particular. The two central figures on the front panel of the chest are unusual since they represent monks. While these may be token figures of religious authority it is more likely that they, too, represent family members. The second tomb chest is clearly the work of a different and less sophisticated carver. Nevertheless, it is also of the kinship type, displaying knights and ladies in pairs on opposite sides, with books held open which, presumably, once carried texts.[90]

[85] Blair, 'The Wooden Knight at Abergavenny', 43–4.

[86] The type was identified by Anne McGee Morganstern, *Gothic Tombs of Kinship in France, the Low Countries and England* (Pennsylvania, 2000).

[87] The carved figure on the Westminster tomb of the earl of Pembroke may represent Laurence de Hastings, son of John. If so, Laurence had an unusually extensive iconography since his tomb effigy is at Abergavenny and he also appears among the kinship figures on the tomb of Sir Hugh Hastings (d. 1347) at Elsing in Norfolk.

[88] The family house, East Orchard (now a ruin), contained a chapel. A comparable though larger surviving chapel at Upton Castle housed tomb effigies, see below, pp. 147–8. However, there is no evidence that either pair of Berkerolles effigies was ever located at East Orchard. See G. T. Clark, 'East Orchard Manor House', *Arch. Camb.*, 3rd series, XV (1869), 65. By the late nineteenth century the Berkerolles tombs had been stripped of their paint. Sometime later they were subjected to a second violation by vandals armed with a random selection of house-paints, which has left them in a pitiful condition.

[89] The head of God bears a striking resemblance to a head of king Edward II on an early alabaster effigy at Gloucester Cathedral, much frequented by pilgrims. The St Athan head may simply have been inspired by the other in formal terms but, equally, might be intended as a covert statement of family allegiance to the monarch.

[90] Morganstern, *Gothic Tombs of Kinship in France, the Low Countries and England*, p. 129, regards the segregation of male and female images as characteristic of the development of kinship tombs in the later fourteenth century. The interpretation of the St Athan tombs and their architectural context is particularly difficult. A possible sequence of events is that the effigies of Sir Roger (d.1351) and his wife were created during his lifetime, along with the niche in the south transept. After his death, his son Lawrence may have moved the effigies of his grandfather and grandmother from another part of the church (or possibly from the East Orchard chapel) into the south transept, and commissioned a new free-standing tomb chest to carry them, which would account for the different – and possibly later – hand by which it was made. However, several other sequences are equally plausible.

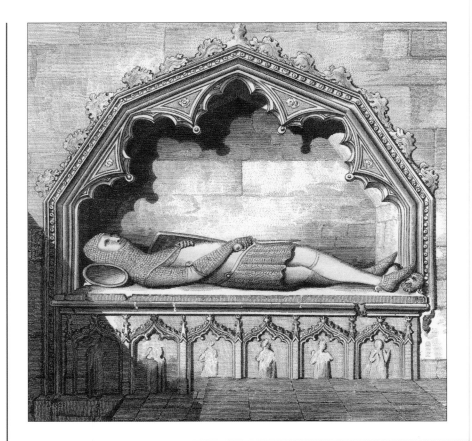

193. James Basire after John Fenton,
Tomb of Elidore de Stackpole ..., 1809,
Engraving, 168 × 162, but
possibly Sir Richard Stackpole

below:

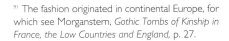

194. Tomb of a Lady, possibly
Lady Margaret Stackpole, Church
of St James and St Elidyr,
Stackpole Elidir, Pembrokeshire,
mid-14th century, Stone, detail

[91] The fashion originated in continental Europe, for which see Morganstern, *Gothic Tombs of Kinship in France, the Low Countries and England,* p. 27.

[92] The figures have been heavily restored by a naïve hand. Those on the female effigy are closer to their original condition, though the effigy itself has undergone a heavier restoration than its male partner.

[93] Sir Roger Berkerolles (whose effigy probably lies on the more sophisticated of the two St Athan tomb chests) married Catherine Turberville, whose sister, Margaret, married Sir Richard Stackpole. There is no indication of the identity of the knight and lady depicted in the Stackpole effigies. However, a date in the mid-fourteenth century, consistent with the style of the carvings, would be correct for memorials to Margaret and Sir Richard Stackpole. The lineage of the two families is given in G. T. Clark, *Limbus Patrum Morganiae et Glamorganiae* (London, 1886), pp. 454–5. In ibid., p. 365, Clark erroneously described Sir Roger Berkerolles as the son of a Sir Laurence Berkerolles. The male tomb effigy seems certain to be resting on its original chest since John Fenton drew them together in 1809, before the Victorian restoration of the church. However, they were in poor condition at that time and may have undergone some later restoration. 'The sides of the tomb are in compartments, each compartment containing a figure, but so disfigured by white-wash ... that nothing of their design or character can be made out.' Richard Fenton, *A Historical Tour through Pembrokeshire* (London, 1811), p. 423. We are grateful to Anne McGee Morganstern for her opinion on the St Athan and Stackpole tombs.

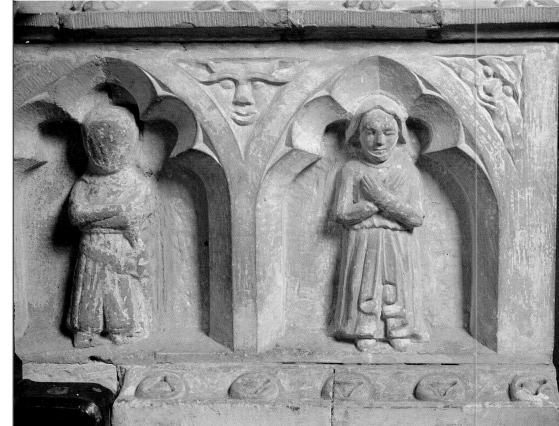

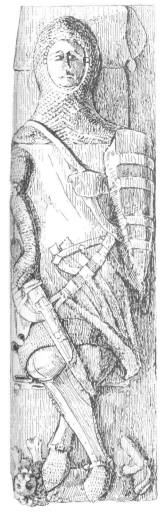

195. After E. H. Edwards,
Effigy of a Figure clad in Mail and Plate,
1911, probably a member of the
de Barri family, first quarter of the
14th century, length of stone 1982

By the middle of the fourteenth century the fashion
for kinship tombs, emanating from London, had
penetrated as far as Pembrokeshire.[91] At Stackpole
Elidir a knight and lady were supported on tomb
chests elaborated with carved figures, clearly not in
attitudes of mourning. The canopied tomb of the
knight includes two women and three armed males,
two of whom carry swords and shields which may
once have identified them by painted heraldry.[92]
The effigies are of Bristol design, but the tomb
chests appear to have been made by a less
sophisticated artisan and bear a resemblance
to that of Sir William Berkerolles at St Athan.
It may be significant that Sir William's son, Roger,
was the brother-in-law of Sir Richard Stackpole,
who is possibly the figure represented by the
Pembrokeshire effigy.[93]

196. After E. H. Edwards,
Effigy of a Mailed Figure in Carew Church,
1911, probably a member of the Carew
family, first quarter of the 14th century,
length of stone 2060

In south-west Wales the practice which created effigies of the cross-legged style like
the knight at Stackpole Elidir is difficult to interpret since much of the work is made
of local stone. Some of the carvings, such as an effigy probably representing a
member of the de Barri family at the Church of St James the Great, Manorbier,
and that of a Carew family member at the Church of St Mary, Carew, have in
common a distinct and energetic style, though they are individuated by their detail.
They were made during the first quarter of the fourteenth century and may be the
product of peripatetic craftspeople called in from Bristol at less expense than would
have been involved in carving an image in the main workshop and its subsequent
transportation to Wales.[94] On the other hand, a local workshop may simply have
copied the Bristol manner and, indeed, it may be that Welsh craftspeople went as
apprentices to Bristol and subsequently rejoined or established workshops in Wales.
Bristol practice had more of the character of a school than did that of north Wales,
a feature which reflected the concentrated nature of its urban base. In either case,

[94] The effigies are treated as a Pembrokeshire
group in a series of articles by E. Laws and E. H.
Edwards in *Arch. Camb.* in 1908–12, though the
county framework conventionally adopted in the
nineteenth and early twentieth centuries is artificial
and, as in the case of the fonts from the Brecon/
Radnorshire border area and Cardiganshire,
discussed above, pp. 80–5, may be misleading.
The de Barri and Carew effigies are discussed in
E. Laws and E. H. Edwards, 'Monumental Effigies,
Pembrokeshire', *Arch. Camb.*, 6th series, XI
(1911), 199–211. The crossed-legged style of
the Bristol workshops was exported and replicated
in the same way in Ireland as it was in Wales.

197. Effigy of Sir William Hastings,
Priory Church of St Mary, Abergavenny,
Monmouthshire, c.1349, Stone, l. 2140

[95] The identification is speculative and was made
by Bradney, *A History of Monmouthshire*, I, part 2a,
p. 164. Sir William was the illegitimate son of John
de Hastings (d.1325), the figure depicted in the
wooden effigy, above, p. 125. For Meurig ab Ynyr
Fychan, see p. 122.

[96] For a map showing the extent of Llywelyn's
holdings, see John Davies, *A History of Wales*
(London, 1994), p. 147. The treaty with the
English crown acknowledged Llywelyn as prince
of Wales and his right to the homage of all the
Welsh lords, bar one: 'the treaty was a recognition
of the fact that Llywelyn had established the basic
constituents of a Welsh polity. Implicit in the status
of prince was the territory, the Principality, and
the Principality's existence was proof that there
were in medieval Wales all the elements necessary
for the growth of statehood.' Ibid., p. 148.

whether by export or by influence, the Bristol workshops dominated carving
in the south well into the period of the production of knightly effigies by the
northern workshops. Sir William Hastings, who died in 1349 and who lies in the
niche designed for his effigy at the Priory Church of St Mary, Abergavenny, was
a contemporary of Meurig ab Ynyr Fychan at Dolgellau.[95] Notwithstanding the
ossification into a convention of the crossed legs, the naturalism of the style in
which the Norman knight was carved contrasts strongly with the formalistic
simplification of his Welsh counterpart.

The ecclesiastical buildings which housed these memorials of prominent
people were constructed against a background of political instability. The
struggle for control between the native dynasty of Gwynedd and the English
crown, accompanied by internal strife and shifting allegiances, was decided by
the demise of Llywelyn ap Gruffudd in 1282, though revolts continued well into
the fourteenth century. The warfare of the period left its own memorial in the
form of the stone castle. In the late twelfth century Lord Rhys of Deheubarth
built an impressive fortress at Dinefwr, but it was during the subsequent period
of the ascendancy of the princes of Gwynedd that most of the castles of the
Welsh rulers were built within the area of their control, whose greatest extent
was marked in 1267 by the Treaty of Montgomery.[96] The stone-carved head

203. Tomb Slab depicting a
Hunting Scene, early 14th century,
Valle Crucis Abbey, Denbighshire,
length of stone 2440, detail

204. Fragment of a
Tomb Slab, possibly depicting
a huntsman, Church of St Peter,
Llanbedr Dyffryn Clwyd,
Denbighshire, early 14th century,
Stone, l. 580

of images of this kind. The illuminations in the lawbook include that of a falconer, with a hawk on one hand and a perch in the other, while a tripartite tile from Neath abbey depicts a huntsman blowing his horn as dogs bring down a stag. Although surviving only as a fragment, a carved slab found at Llanbedr Dyffryn Clwyd may also portray a huntsman, on the basis of comparison with a more complete but worn example at Valle Crucis, almost certainly made by the same carver.[107]

205. Ceramic tiles
depicting a Hunting Scene,
formerly at Neath Abbey,
Glamorgan, c.1340,
130 × 130

The assertiveness of the princes of Gwynedd reinforced the need to consolidate Anglo-Norman fortifications in the south and south-east of Wales.[108] In 1268, at Caerphilly, Gilbert de Clare began to build the largest castle in Wales, which was defended by extensive water works.[109] After the fall of Llywelyn ap Gruffudd, de Clare – who by 1290 had become son-in-law to the king – elaborated the castle by the addition of a sumptuous suite of apartments which expressed the courtly way of life to which such powerful magnates aspired. Nevertheless, visualizing the adornment of the architecture with tapestries, paintings and glass (such as that in Tewkesbury abbey in which de Clare himself was portrayed with other Marcher lords)[110] must remain largely the work of the imagination. Examples are few and confined mainly to small items, especially ceramics and metalwork, such as a bronze tankard from Caerphilly. A ewer, used to hold water for hand-washing at mealtimes, survives from Norman-controlled Gower. Its unidentified owner, one Gilebert, customized his purchase by having his name cast on the side of the pot. Items of this kind may sometimes be the work of craftspeople who also cast church bells in the period, though the centre of excellence for their production was Germany and a more elaborate bronze

206. Caerphilly Castle,
Glamorgan, begun 1268

207. Lords of Glamorgan,
Abbey Church of St Mary,
Tewkesbury, Gloucestershire,
c.1340–4, Painted glass

[108] R. R. Davies, *Conquest, Coexistence and Change: Wales 1063–1415* (Oxford, Cardiff, 1987), pp. 280–1.

[109] Christopher Taylor, 'Medieval Ornamental Landscapes', *Landscapes*, I (2000), 52–3, speculates that, in addition to their military purpose, the water features at Caerphilly may represent an ornamental landscape. For medieval ornamental landscape in Wales in general, see Elizabeth Whittle, *The Historic Gardens of Wales* (London, 1992), pp. 7–15.

[110] The donor of the glass was Eleanor de Clare, though she had died by the time of its manufacture and her wishes were realized by her son, Hugh Despenser. Among the knights depicted were de Clare, Despenser, Zouch and Fitz Hamon, all of whom were lords of Cardiff. See David Verey, *Buildings of England. Gloucestershire: The Vale and the Forest of Dean* (Harmondsworth, 1970), pp. 369–70. The group of chapels around the high altar at Tewkesbury abbey might be considered as a mausoleum of the Norman lords of Glamorgan. On the south side the Trinity Chapel was built by Elizabeth, widow of Edward Despenser, lord of Cardiff (1349–75). On the north side is the chapel of Robert Fitzhamon, lord of Cardiff, standing adjacent to the Warwick Chapel, erected by Lady Isabella Despenser for her first husband Richard Beauchamp, earl of Abergavenny and Worcester and lord of Cardiff in right of his wife (1411–21). Lady Isabella herself was buried in a tomb before the high altar. Her second husband, another Richard Beauchamp, was earl of Warwick and lord of Cardiff (1423–39). The chapels are described in Cook, *Medieval Chantries and Chantry Chapels*, pp. 170–3.

208. The Ewer of Gilebert,

found in the Gower, Glamorgan,

14th century, Bronze, ht. 260

209. Tankard, formerly at Caerphilly Castle,

Glamorgan, mid-14th century, Bronze, ht. 135

210. Aquamanile,
found at Cwm Nantcol,
Merioneth, 13th century,
Bronze, ht. 260

211. Saintonge Jug,
formerly at Caerphilly Castle,
Glamorgan, c.1275–1320,
Pottery, ht. 250

111 The discovery of the Nantcol hoard was made in 1918. See *Proceedings of the Society of Antiquaries*, XXXI (1918–19), 214–16.

112 The vase is described in *Arch. Camb.*, LXXXVII (1932), 193. For the tomb of Edmund Crouchback, see above, p. 126.

113 Such finds confirm the continuing importance for Wales of Atlantic coastal contacts in general and in particular with the Saintonge and the pilgrim route to Santiago de Compostella, which was probably the source of the design of the Romanesque arch at Aberffraw, above, pp. 63–4. For a complete list and distribution map of finds of pottery from western France, see *Arch. Camb.*, CXXIII (1974), 109–12. Other small artefacts illustrative of the way of life of the castles of the thirteenth and early fourteenth centuries include chess pieces from Skenfrith Castle and a flute from White Castle, both in Monmouthshire.

aquamanile in the form of a stag was almost certainly imported from there. The find was made at Cwm Nantcol, Merioneth, in the heartland of the native princes, but it formed part of a group of items which had apparently been collected as scrap by a dealer in the sixteenth or seventeenth century and so its provenance (which may have been secular or ecclesiastical) is uncertain.[111]

The washing of hands at table is believed to have become customary as a result of individuals who had been on crusade observing the practice in the Middle East. The neck of a pottery vase from near Rakka in Syria, found at Grosmont Castle, is a tangible example of contacts between east and west in the thirteenth century. Edmund Crouchback probably brought the vase back in his baggage train from the Holy Land where he was on crusade in 1270–2.[112] A vase from this source is unlikely to have been a commercial import, though many other ceramics of the period certainly were. Jugs for serving wine from the Saintonge area of south-west France, with their characteristic beak-like spouts, have been found both at Norman sites such as Cydweli and Cardiff castles, and at the Welsh sites of Castell y Bere and Cricieth Castle.[113] Such objects would have found their main use in the halls of the castles, but castle chapels were probably the focus for much of the most elaborate decoration and enrichment with artefacts. At Cricieth a figure of the crucified Christ was found, badly burned, in the rubble of what had presumably been the castle chapel in the inner gatehouse. The nature of

217. Unidentified Effigy of an Ecclesiastic,
Priory Church of St John the Evangelist,
Brecon, 14th century, Stone, l. 1930

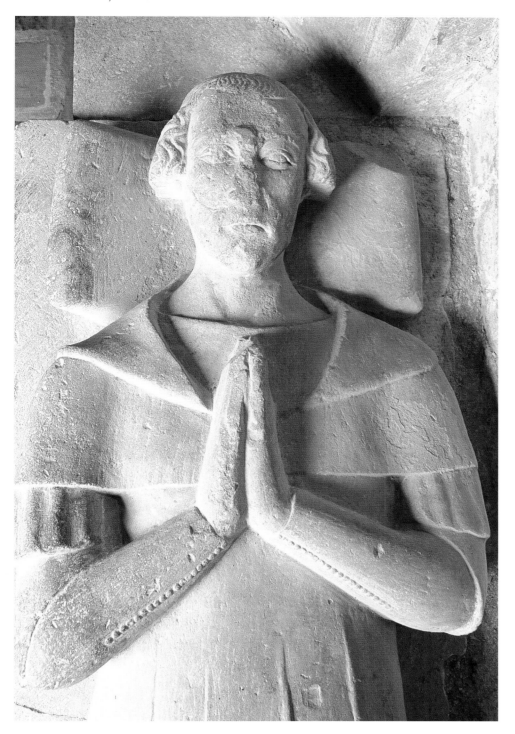

[127] The importance of medieval Cardiff as a trading centre, especially with Bristol, is discussed in Edgar L. Chappell, *History of the Port of Cardiff* (Cardiff, 1994), pp. 14–18. Chappell noted that a document of 1315, the period of the civilian effigies, described Cardiff as 'villa mercatoria' – a trading town. Ibid., p. 15. For the borough, its guilds and charters, see William Rees, *Cardiff: A History of the City* (Cardiff, 1962), pp. 47–58. The individuals depicted at St Hilary and Llantwit Major may have been associated with the smaller towns of Cowbridge and Llantwit itself. Nevertheless, the identification of the effigies as tradesmen must remain tentative. At Much Marcle, Herefordshire, a fourteenth-century civilian effigy represents a country gentleman and landowner, Walter de Helyon. No Welsh civilian effigies have been identified as representing individuals of this class, though the image of a hunting dog on the effigy of the unidentified individual at Llantriddyd, Glamorgan, might be interpreted as suggesting that he was not of the mercantile class.

[128] Heart burials survive at several locations in Wales. Perhaps the most unusual is that illustrated in *Arch. Camb.*, 5th series, XI (1894), 137, in the churchyard at Chirk, where a civilian figure of about two feet in height is carved in the conventional posture, but with his feet resting on the head of a second individual.

218. Unidentified Effigy, Church of St Illtud,
Llantwit Major, Glamorgan, 14th century,
Stone, l. 2060, detail

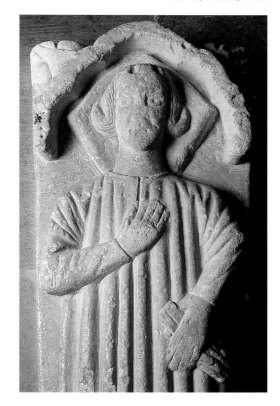

219. Roof boss representing
Oceanus or Bacchus,
Chepstow, Monmouthshire,
14th century, Stone

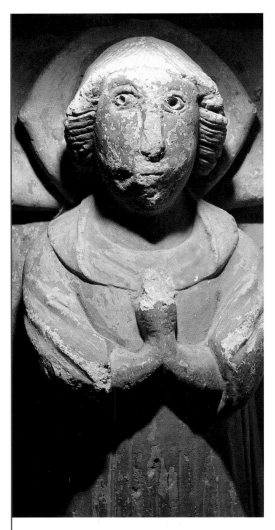

220. Unidentified Effigy,
Church of St Mary, Coety,
Glamorgan, 14th century, Stone

[129] Given the simplicity of the dress customarily depicted on civilian memorials, it is possible that the Coety examples were made to cover the burial of children, though this seems unlikely.

[130] The individual is associated by tradition with the rebuilding of the nave of the cathedral in the first half of the fourteenth century.

[131] For the medieval wine trade in Chepstow, see Ivor Waters, *The Port of Chepstow* (Chepstow, 1977), pp. 5–15.

[132] For further discussion, see the Appendix.

[133] The effigy does not follow the ubiquitous cross-legged pattern of the period, again suggesting a later date. The death of Laurence de Hastings in the plague was noted in the *Abergavenny Chronicle*, translated and discussed by E. St John Brooks, 'The Piers Ploughman Manuscripts in Trinity College, Dublin', *The Library*, 5th series, 6 (1951), 144–51.

[134] The recovery is evident not only in the renewed commissioning of effigies but in large-scale building work which, for instance, had certainly commenced at St Asaph Cathedral by 1375. The precise location of the Flintshire quarry or quarries has not been identified.

[135] See above, p. 112.

[136] The effigy is linked by tradition to the poet Dafydd Ddu of Hiraddug, an important figure in the development of Welsh poetry and the editor of a grammar written by Einion Offeiriad. He held various offices at St Asaph Cathedral, and if the effigy is not his its elaboration certainly suggests a figure of equally high status. For further discussion, see the Appendix.

the unusual depth of his slab and the elaboration of its sides (where a dog is again carved) give it the appearance of a sarcophagus. A pair of civilian memorials at Coety, also in the Vale of Glamorgan, are true miniatures.[129]

No evidence survives to suggest the level of involvement of the mercantile classes in the visual elaboration of their houses, but some traces of collective patronage through the guild system which regulated trade in medieval towns have survived. The guild chapel of the Corvisers at the Priory Church of St John the Evangelist, Brecon, is stripped of the painting and other elaboration which it once probably contained, with an iconography specific to the shoemaker's trade. However, a tomb effigy survives under an elegant canopy which is presumably the memorial of a prominent guild member, perhaps the chaplain or priest-warden, since he is tonsured.[130] At Chepstow, more direct evidence of guild iconography is evident in the early fourteenth-century vaulted ceiling of a secular building believed to have been the property of traders involved in the import of wine.[131] Two of the three bosses of the undercroft vaulting are figurative, the central one apparently representing either Oceanus or Bacchus. Either image would have been appropriate for the location – Oceanus, the father of all rivers because Chepstow was an inland port with access to the seas over which trade was conducted, or Bacchus as a more straightforward symbol of the wine trade.[132]

In the mid-fourteenth century, economic expansion, which was already slowing, was halted by the Black Death. The massive loss of life had disruptive effects which were felt for a generation. Between a quarter and a third of the people died, leaving Wales by the end of the fourteenth century with a population little in excess of 200,000. Among those it carried off was Laurence de Hastings, whose effigy lies in the Priory Church of St Mary, Abergavenny, though whether Hastings's effigy was carved immediately after his death must be open to doubt, since both patronage

and production were severely curtailed by the cataclysmic events of the period.[133] In the north the fact that not a single tomb effigy can be dated to the period 1350–75 demonstrates that all parts of Wales were affected by both the collapse of patronage and deaths among craftspeople. When production recommenced in the north in the final quarter of the fourteenth century, it did so from a new centre in Flintshire, which made use of a fine-grained local stone, excellent for carving.[134] On those memorials cut from this material which retain their inscriptions, the text was always introduced by a cross of distinct form. It seems certain, therefore, that all the memorials were made at a single workshop, and that it was a particularly successful enterprise because it exported its products as far as Anglesey. For instance, the effigy of Matheus ap Elye, chaplain of St Mary, in Newborough was depicted with the conventional priestly iconography of the chalice and was accompanied by an appeal for prayers encouraged by the promise of an indulgence from Rome. During the course of the fourteenth century, between the carving of the effigy of Anna Martel[135] and that of Matheus, the value attached to the performance of this service had inflated from 40 to 120 days.

At Tremeirchion another Flintshire-made image of a priest, Dafydd ap Hywel ap Madog, survives in excellent condition in its original niche as the most complete example of the workshop style.[136] The chest on which the effigy lies displays seven shields, the central one probably displaying the arms of Dafydd himself and those

221. Effigy of Matheus ap Ælye, Church of St Peter, Newborough, Anglesey, late 14th century, Stone, l. 1805, detail

222. Tomb of Dafydd ap Hywel ap Madog, Church of Corpus Christi, Tremeirchion, Flintshire, late 14th century, l. 1894, and detail of label-stop

145

137 Gresham, *Medieval Stone Carving in North Wales*, p. 226, cites later comparisons. The family arms have not been identified.

138 The slab was discovered in Bangor Cathedral in 1879, buried under the floor of the chapter house.

223. Relief Effigy of Eva,

Bangor Cathedral, Caernarfonshire,

c.1380, Stone, width 560,

original length 1830

to the right the arms of his family. The family arms are balanced to the left by three shields bearing 'sacred heraldry'. The outer two display the instruments of the Passion of Christ – the nails, the hammer, the pincers and the scourge, the reed with the sponge and the crown of thorns. Between them are the symbols of the Virgin Mary – a heart carried on wings symbolic of the Annunciation. Because of its similarity to other examples of sculpture from the Flintshire workshop, the tomb can be dated with certainty to the late fourteenth century, and it therefore figures among the earliest surviving examples of this iconography.137 In addition to fully three-dimensional effigies, the Flintshire workshop also produced three remarkable low-relief images, probably all for the same patron, Gruffudd ap Gwilym of Llaniestyn, Anglesey. Gruffudd was the son of Eva, who was depicted on one of them in around 1380.138 The image of Eva is sprinkled with quatrefoil flowers identical to those prominent on the tomb of Dafydd ap Hywel ap Madog. Although the form of the two memorials is different, beneath the superficial elaboration of the image of Dafydd lies a monumental quality which is echoed in the memorial to Eva. This quality, reinforced by the characteristic cross before the inscription and the liberal scattering of flowers, strongly suggest that the two carvings were the work of the same sculptor.139

Eva's hands are held, palms outward, in the manner of the effigy of Joan, and she carries prayer beads. No doubt among the other accoutrements of her faith would have been a devotional book of some kind. One such work, a book of hours, survives from the period, which seems to have been the property of a woman who lived in the same part of Wales as Eva. The Gwynedd provenance of the manuscript is clear since the calendar of saints' days includes St Deiniol of Bangor and St Peblig of Caernarfon, as well as St David. The manuscript was probably written in England, though whether the illuminations were added there or in Wales is less clear. The subjects are not all clearly identifiable, but it is possible that the picture of a bishop represents St Peblig, given his appearance in the list of the feast days of the saints included in the psalter. It may be, therefore, that a picture of an unidentified king is that of his father, Magnus Maximus.140

Unfortunately, other than the appearance in the manuscript of the name Isabella Godynogh and a note that she died in 1413, little is known of the presumed owner and it is difficult to determine the social context in which she moved.141 If Isabella was of the mercantile or the professional class, one room of her town house probably had a place set aside for a prayer desk on which the book was placed before an image in the form of painting or sculpture of Christ or the Virgin Mary. If she was particularly wealthy her house might have contained a small oratory or chapel, but this would be more likely had she been of the landowning or knightly class and occupying a substantial country house. The best example from the fourteenth century of such a

chapel is at Upton Castle in Pembrokeshire. Although it is devoid of the books and other artefacts which it probably once contained, and also stripped of colour, the tomb effigies of the Malefaunt family which survive there give a sense of its original importance both as a focus for private and household devotions, and as a mausoleum. The chapel is a free-standing building with a nave and chancel. It contains a font and among the memorials is the effigy of a priest who presumably officiated there in the fourteenth-century. The effigy is in poor condition, but that of another Pembrokeshire priest of the period which lies in the Church of St Mary, Carew Cheriton, may give a good – though monochromatic – impression of its general appearance.[142] In addition to baptism, priestly duties at the Upton Castle chapel would have included the saying of prayers and Masses for the repose of the soul of an unidentified knight, next to whose effigy is set a chantry light in the form of a clenched fist, projecting from the wall so as to hold

[139] The other carvings attributed to the same hand, images of Pabo and Iestyn, are considered below, pp. 216–17.

[140] NLW MS 17520A is described in G. F. Warner, *Descriptive Catalogue of Illuminated MSS of C. W. Dyson Perrins*, (2 vols., Oxford, 1920), I, p. 59. If the figures depicted in the illuminations have been correctly identified, they would provide strong evidence that the legend of Magnus Maximus was part of a living tradition in the area in the late fourteenth century and, therefore, that the meaning of the image Caernarfon Castle, created by Edward I a hundred years earlier, remained clear.

[141] Isabella was married to William Godynogh, who is associated with Conwy. See Daniel Huws, *Medieval Welsh Manuscripts* (Cardiff and Aberystwyth, 2000), p. 19.

[142] The Carew Cheriton effigy covers a heart burial. The identity of the priest has not been established.

224. St Peblig, Manuscript Illumination from the Llanbeblig Book of Hours, late 14th–early 15th century, 175 × 120

225. Magnus Maximus, Manuscript Illumination from the Llanbeblig Book of Hours, late 14th–early 15th century, 175 × 120

226. Effigy of a Priest,
Church of St Mary,
Carew Cheriton,
Pembrokeshire,
14th century, Stone

227. Anon., 14th-century
Stone Chantry Light,
Upton Castle Chapel,
Pembrokeshire, c.1881

a candle. The effigy is unusual in the context of images of knights from surrounding churches in that it was not carved in the cross-legged style of the Bristol workshops, and this may indicate a date late in the fourteenth century. His niche is ornate, containing carved figures under canopies, and the tomb chest itself may well have been elaborated with painted figures or heraldry.[143]

228. Tomb of a
Member of the Malefaunt
Family, Upton Castle Chapel,
Pembrokeshire, 14th century,
Stone, and detail from niche

[143] The chapel also contains an unidentified female effigy in an elaborate niche, and a massive cross-legged knight originally placed in the Church of St Mary, Nash, Pembrokeshire.

[144] Theophilus Jones, *A History of the County of Brecknock* (4 vols., Brecon, 1909–30), II, p. 93, dated the memorial to 1312, though the inscription on which this assertion was presumably based has subsequently disappeared. Jones's description was illustrated with a drawing by Thomas Price (Carnhuanawc), pl. II, fig. 7, which, though inaccurate in some respects, shows more of the top of the memorial than that which survives, including two angels hovering above the crucifixion.

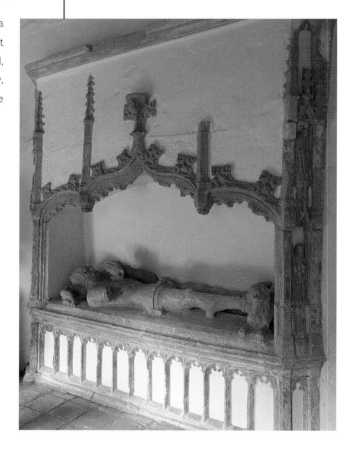

The book of hours of Isabella Godynogh and the memorials to the Malefaunt family in their private chapel provide evidence of the increasing concern with the salvation of individual souls which has already been noted as a characteristic of the fourteenth century. The growing awareness among wealthy secular people of their individual relationship with God and their personal responsibility for salvation reflects an evolution of religious doctrine moved by the philosophical disputes among the intellectual elite in the European universities. The concept of Nominalism, crystallized in the works of the English thinker William of Ockham and his followers had a profound impact on theology, inverting the world view of the dominant earlier figures, Bonaventure and Thomas Aquinas, who regarded the universe from God downwards. Ockham took the human mind as his starting point, and in so doing foreshadowed the fundamental shift of perceptions which would characterize the fifteenth-century Renaissance.

As we have seen, the sense of the individual's relationship with God, expressed in private devotional artefacts and chapels, also lay behind the very public proliferation of memorials, effigies and chantries in the great churches. Among the most moving manifestations in Wales of this public display of secular piety is the tomb slab of Walter and Christina Awbrey in Brecon priory, which dates from the early fourteenth century.[144] It is remarkable in several respects, not least of which is that man and wife are depicted lying together, rather than on separate but adjacent memorials.[145] It is likely, therefore, that the carving was prepared during the lifetime of one, if not both, the partners. It was originally located in the Dominican friary to which the estates of Walter Awbrey were adjacent, and of which he may have been founder.[146] At his chest Awbrey holds a crucifix, presumably representing an object of personal devotion which he owned and which would have found its place in the space in his home set aside for prayer.[147] However, between

[145] On the monument to Sir Roger Berkerolles and his wife at St Athan, described above, pp. 126–7, the effigies are carved separately for the shared tomb. They turn slightly to face each other.

[146] The memorial was probably removed to the former priory church at Brecon in 1660 as a result of the desecration of the church in that year, for which see Gwenllian E. F. Morgan, 'The Vanished Tombs of Brecon Cathedral', *Arch. Camb.*, LXXX (1925), 271–3. Morgan argued that since the images of Christ on the tomb had not been defaced, it cannot have been removed to the cathedral at the dissolution. Had it been there in the early years of the civil wars, they would have been obliterated by the Parliamentarian soldiers who so effectively destroyed all other images of Christ in the cathedral.

[147] Images of the Crucifixion were worn around the neck in the position depicted on the effigy, but this example, both by virtue of its size and the fact that it is mounted on a panel, appears to represent a sculpture which was hung on a wall.

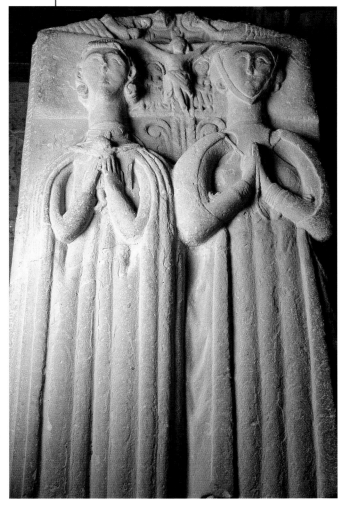

230. Effigies of Walter and Christina Awbrey, Priory Church of St John the Evangelist, Brecon, early 14th century, Stone, l. 2350

229. Hugh Thomas *The Collegiate Church of Brecon* (formerly the Dominican friary church), BL Harleian MS 3538, f. 80, late 17th–early 18th century, Ink

husband and wife a second depiction of the Crucifixion occupies a place in a different kind of reality. The heads of St John and the Virgin Mary, present at the Crucifixion, touch those of the fourteenth-century Walter and Christina Awbrey to suggest their own presence at the event in a metaphysical sense.[148] The carving images the way in which the Crucifixion was a present reality of imaginative experience for the pious of the Middle Ages. This sense of the life and passion of Christ as a present reality in the world through the progress of the individual towards salvation animated all the layered and resonant portrayals of the life of Christ, the apostles and the saints, which form the great bulk of surviving visual imagery from medieval Wales.

231. The Crucifixion, detail from the tomb slab of Walter and Christina Awbrey, Priory Church of St John the Evangelist, Brecon, early 14th century, Stone

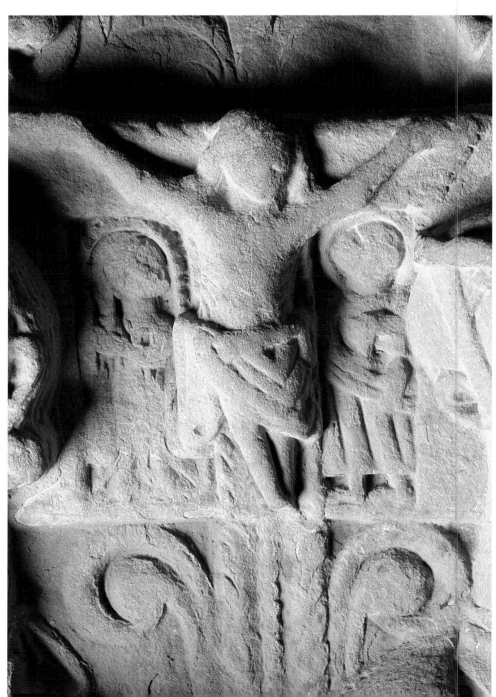

[148] For an iconographic parallel, see the double tomb slab with Crucifixion at Kells, Co. Meath, Ireland, illustrated in John Hunt, *Irish Medieval Figure Sculpture 1200–1600* (2 vols., Dublin, 1974), II, plate 33.

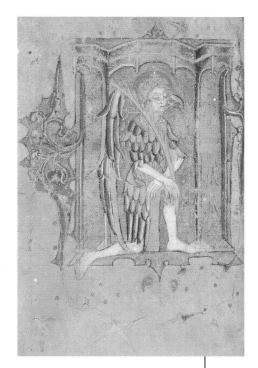

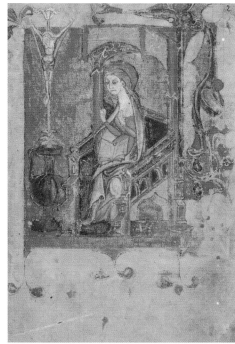

human sin.[14] Furthermore, there was a popular belief in the medieval period that 25 March was the date both of the Annunciation and of the Crucifixion.[15] The collect for that day illustrates the link between the two events in the words 'that, as we have known the incarnation of thy Son Jesus Christ by the message of an angel, so by his cross and passion we may be brought unto the glory of his resurrection'.[16] It may be that the lily crucifixion in the Llanbeblig Book of Hours is both unique as a manuscript miniature and also the earliest of some fifteen documented examples of the iconography which have been noted.[17] To these may probably be added the image carved on one face of the churchyard cross preserved at the Church of St Saeran, Llanynys, Denbighshire, which may also date from the second half of the fourteenth century. Christ's body is set directly against a flowing image of a tripartite plant which springs from the ground at his feet.[18]

234. The Annunciation to the Virgin Mary with Lily Crucifixion, Illumination from the Llanbeblig Book of Hours, late 14th–early 15th century, 175 × 120

235. Lily Crucifixion, Church of St Saeran, Llanynys, Denbighshire, 14th century, Stone, ht. 712

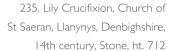

[14] A sophisticated development of the projection forward from events in the life of the Virgin to those in the life of Christ is found in the fifteenth-century Pembroke Hours. A long succession of images of the Virgin and of Christ are placed on facing pages, the event depicted in the one predicting or representing the 'type' of the event in the other. For the Pembroke Hours, see below, pp. 260–2.

[15] See W. L. Hildburgh, 'An Alabaster Table of the Annunciation with the Crucifix: a Study in English Iconography', *Archaeologia*, LXXIV (1923–4), 205–6, for this popular belief and its application to the lily crucifixion.

[16] A collect is a short prayer appointed for a particular day or season. That quoted here from the Book of Common Prayer is of considerable antiquity. It is to be found in the *Sacramentary of Hadrian* and probably dates from the eighth century.

[17] The surviving lily crucifixions are described in Hildburgh, 'An Alabaster Table of the Annunciation with the Crucifix'.

[18] For a general discussion of the cross, see above, p. 111.

[19] 'And it came to pass, while they were there, the days were fulfilled that she should be delivered. And she brought forth her first-born son; and she wrapped him in swaddling clothes, and laid him in a manger, because there was no room for them in the inn', Luke 2:6–7.

[20] For the apocryphal Gospels, see Cartlidge and Elliott, *Art and the Christian Apocrypha*, pp. 3–7, and for apocryphal accounts of the Nativity, ibid., pp. 88–94. For the Old Testament and the concept of typology, see Beryl Smalley, *The Study of the Bible in the Middle Ages* (3rd ed., Oxford, 1983).

[21] The image of the ox and the ass was inspired by an Old Testament text, Isaiah 1:3.

[22] Henrik Cornell, *The Iconography of the Nativity of Christ* (Uppsala, 1924), p. 12. Bridget of Sweden, c.1303–73, left her native land for Rome, where she lived for 23 years. On pilgrimage to the Holy Land, Mary revealed to Bridget the details of the nativity of Christ, which she recorded in her *Revelations*.

[23] See below, pp. 252ff.

[24] The sacrificial iconography of the Nativity was established by the twelfth century when a painted glass panel of the subject was commissioned for Chartres Cathedral. The panel is illustrated in Henry Icraus, *The Living Theatre of Medieval Art* (Pennsylvania, 1967), p. 48. The St David's example has been erroneously described as a depiction of the birth of the Virgin in Mary Wight, *Pilgrim's Guide to St David's Cathedral* (St Davids, n.d.), p. 40, and Eric Hunt, *History and Description of St David's Cathedral* (London, 1961), p. 31. The carving is one of three fragments which survive from an unidentified object, perhaps a reredos. They were built into a new altar in Holy Trinity chapel by the architect W. D. Caroe during a restoration in the 1920s.

[25] NLW MS Peniarth 23C. The older iconography also persisted into the fifteenth century in Brittany. The *calvaire* at Tronven includes a Nativity, the iconography of which is similar in some respects to that of the Welsh manuscript. The Virgin is bare-breasted, and Joseph is depicted as an old man with a crutch.

[26] See Dylan Foster Evans (ed.), *Gwaith Hywel Swrdwal a'i Deulu* (Aberystwyth, 2000), p. 124. This poem by Ieuan ap Hywel Swrdwal is curious for its use of Welsh orthography in the English language.

Like that of the Annunciation, the iconography of the birth of Christ came to include elements not present in the biblical account.[19] The descriptions given in the early Christian texts now known as the Apocrypha of the New Testament (which were excluded from the canonical scriptures), in addition to texts from the Old Testament which were perceived as prophetic, contributed to a process of accretion of events, which were reflected in visual representations.[20] The folkloric forms of storytelling and drama reinforced the hold on the popular imagination of images such as the ox and the ass in the stable where Christ was born.[21] Images of the nativity of Christ also exemplify the effect of changes in theological emphases on iconography. Until the end of the fourteenth century depictions of the Nativity were essentially naturalistic, showing the Virgin in childbed. As a result of the description given by Bridget of Sweden, to whom it was revealed in a vision that the birth occurred instantaneously and painlessly while Mary knelt at prayer, the baby appearing 'pure from any kind of soil and impurity', the iconography changed.[22] Subsequently, nativity scenes took the form in which they persist in popular tradition, with Mary kneeling and the child in a manger or crib. The new iconography had spread from Italy to northern Europe by the third decade of the fifteenth century and is evident in manuscripts commissioned by Welsh patrons from Burgundian artists.[23] However, no example survives in Wales in the form of carving, wall painting or glass, and depictions of the Nativity according to the old iconography are also remarkably rare. At St David's Cathedral a defaced carving presents the essential elements of Mary in bed with the baby lying beyond her on a structure whose altar-like form prefigures the eventual sacrifice of Christ.[24] The old iconography of the Virgin in childbed, along with a dozing Joseph and the ox and ass, also appears as a manuscript illumination probably made as late as the end of the fifteenth century.[25] The Virgin is shown with bare breasts, an image echoed in the poetry of the period:

> On iwr paps had swking …
>
> Kwin od off owr God, owr geiding – mwdyr
> Maedyn notwythstanding.[26]

237. The Nativity,
St David's Cathedral,
Pembrokeshire,
14th–15th century,
Stone, ht. 425

236. The Nativity,
Illumination from
NLW MS Peniarth 23,
c.1500, 222 × 162

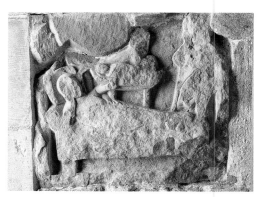

Underlying the naturalistic emphasis of this depiction of maternity was the intention to dramatize by contrast the dual nature of Christ, who was believed to be both human and divine. The Virgin was also depicted with bare breasts and holding the infant Jesus, as in the book of hours of Isabella Godynogh, though here the image was not simply naturalistic. The Virgin was depicted crowned and enthroned as the queen of heaven, projecting forward to the conclusion of the cycle of her own life. Similarly, depictions of Christ simply held in the arms of Mary also frequently showed her in majesty. At the Church of St Illtud, Llantwit Major, the Virgin is seated and crowned, while her right hand and the right hand of Christ support an orb. However, at Grosmont, Monmouthshire, a carved image of the Virgin and child, probably a churchyard cross, depicts Mary simply as mother.[27] The plain style of the carving seems particularly appropriate for this more humble image

of the Virgin, and was probably the work of a local artisan, unlike the many cross-heads of the fifteenth century which were produced in English workshops and exported to Wales.[28] The Grosmont Mary has loose hair covered by a scarf or veil to signify her virginity. She is seated on a bench. The infant Christ stares directly at the observer, with his right arm extended in the gesture of benediction.[29]

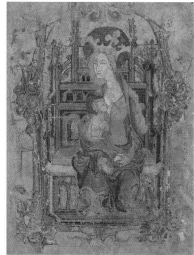

238. The Virgin Mary Suckling Jesus, Illumination from the Llanbeblig Book of Hours, late 14th–early 15th century, 175 × 120

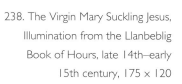
240. The Virgin and Child, Church of St Nicholas, Grosmont, Monmouthshire, 14th–15th century, Stone

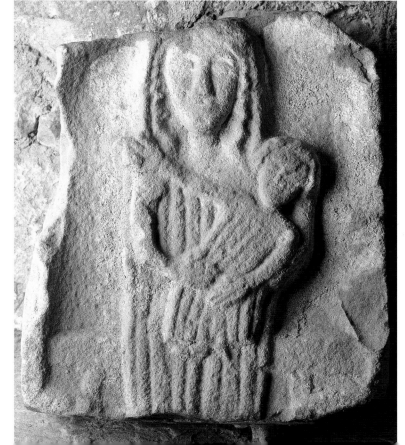

[27] The image was common on churchyard crosses. See, for example, the churchyard cross from Denbigh illustrated in *Arch. Camb.*, 5th series, II (1885), 158. A more unusual vehicle for the image of the Virgin and child was a cast plaque on the church bell originally at Llanfihangel Ysgeifiog, Anglesey, but which subsequently moved to Caerwen. The Virgin is crowned and carries a sceptre, and both Virgin and child are depicted against a nimbus. The plaque and its associated inscription were drawn by Harold Hughes and reproduced in *Arch. Camb.*, 6th series, XIII (1913), 443 and 444.

239. The Virgin and Child, Church of St Illtud, Llantwit Major, Glamorgan, 14th century, Stone, ht. 350

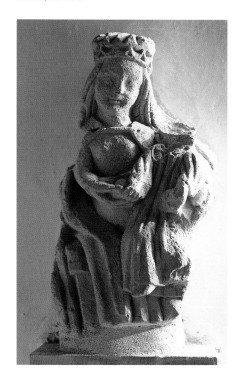

[28] For instance, the shaft of the churchyard cross at St Donat's, Glamorgan, was made from local stone, whereas the head was of stone from south-west England, and was almost certainly carved in a workshop there.

[29] At the Church of St Lucy, Llanwnnen, Cardiganshire, a very worn sculpture survives which almost certainly represents the Virgin and child. It is located on the outside of a tower of the fifteenth century, but it may be older and have been relocated there. Like the Grosmont Virgin, the figure appears to be veiled rather than crowned. Images of the Virgin also survive on the seals of several Welsh monasteries. In the fourteenth century both royal statute and papal dictate required all monasteries to present such an image on their seals.

Few images of the events of the childhood and early manhood of Christ have survived in Wales. A carving at St David's Cathedral probably depicts the Flight into Egypt, with Jesus carried on the shoulders of Joseph, who follows Mary.[30] The fragment almost certainly came from the same defaced object as that depicting the Nativity. The fifteenth-century churchyard cross at Hanmer, Flintshire, appears to carry an allusive iconography of the presentation of Christ in the Temple, though the decayed condition of the cross makes precise interpretation difficult. An apparently conventional image of the Virgin in majesty, carrying Jesus, is complicated by the fact that Christ appears to gesture towards a sword which pierces the side of Mary. One of a pair of angels reaches up towards the sword. The reference is to a verse in the Gospel of St Luke which describes the Presentation:

> And Simeon blessed them, and said unto Mary his mother, Behold, this child is set for the falling and rising up of many in Israel; and for a sign which is spoken against; yea and a sword shall pierce through thine own soul; that thoughts out of many hearts may be revealed.[31]

Images of the baptism of Christ – the event which immediately preceded the beginning of his ministry[32] – are similarly scarce. In common with most images of the subject, the seal of the Augustinian priory of Llanthony compressed the narrative sequence of the biblical accounts into a single scene:

[30] 'Now when they were departed, behold, an angel of the Lord appeareth to Joseph in a dream, saying, Arise and take the young child and his mother, and flee into Egypt, and be thou there until I tell thee: for Herod will seek the young child to destroy him. And he arose and took the young child and his mother by night, and departed into Egypt …', Matthew 2:13–14. The event is more commonly imaged by Mary and Jesus riding on an ass. See Cartlidge and Elliott, *Art and the Christian Apocrypha*, p. 98. Alternatively, the fragment may represent the presentation of Christ in the Temple, described in Luke 2:22.

[31] Luke 2:34–5. The sword pierces Mary's side in the place in which the spear would penetrate the side of Jesus at the Crucifixion.

[32] According to Luke 3:23, Christ's ministry began when he was aged around thirty.

[33] Matthew 3:16–17; Mark 1:10–11.

[34] L. A. S. Butler et al., 'Valle Crucis Abbey: An Excavation in 1970', *Arch. Camb.*, CXXV (1976), 110, speculated that the object (found in 1851) may have been mounted above a rood beam or the pulpitum, or placed over a portable Easter Sepulchre. A font from Valle Crucis is preserved in an eighteenth-century picturesque grotto at Plas Newydd, Llangollen.

[35] John 1:29. The reference to Christ as the Lamb of God is also taken up in 1 Peter 1:19, and frequently in the Revelation of St John the Divine.

[36] The *Agnus Dei* has a wider symbolism than the Baptism. The image represents in a general sense the 'mystic lamb' with the emphasis upon sacrifice and the association of Easter with the Jewish festival of Passover. For the tiles, see p. 101. The animals which (with heraldic shields) surround the central image of the tiles are the peacock, which 'signifies the Gentiles, coming from the ends of the earth to Christ'; the leopard (or panther), representing Jesus; and the dragon, the enemy of the leopard, representing the Devil. See Richard Barber (trans.), *Bestiary: Being an English Version of the Bodleian Library, Oxford MS. Bodley 764* (Woodbridge, 1999), pp. 30–3, 170, 183. Bodleian MS 764 contains excerpts from a treatise on beasts which forms part of Rabanus Maurus's *On the Nature of Things*, and stories taken from Giraldus Cambrensis's *Topography of Ireland*. It was probably written at a cathedral or a monastic scriptorium in the Welsh Marches, and it is richly illuminated.

241. The Flight into Egypt, St David's Cathedral, Pembrokeshire, 14th–15th century, Stone, ht. 580

242. After J. Romilly Allen, *Hanmer Churchyard Cross, East Face*, 1876, Cross head, *c.*1500, Stone, ht. 620

243. The Seal of Llanthony Priory, depicting the Baptism of Christ, 1316, Wax, 70 × 50

244. The Holy Spirit in the form of a Dove, formerly at Valle Crucis Abbey, Denbighshire, late 15th century, Gilt lead, width 150

And Jesus, when he was baptized, went up straightway from the water, and lo, the heavens were opened unto him, and he saw the Spirit of God descending as a dove, and coming upon him; and lo, a voice out of the heavens, saying, This is my beloved Son, in whom I am well pleased.[33]

Christ was depicted in the waters of the river Jordan flanked by an angel and John, who baptized him, while at the same time the Holy Spirit was shown descending on him in the form of a dove. At the Cistercian monastery of Valle Crucis a gilt lead dove of around six inches in span was probably associated with the descent of the Holy Spirit at the Baptism. The dove was clearly designed to be hung on a chain and was probably located over the font.[34]

At the Baptism John exclaimed, 'Behold, the Lamb of God, which taketh away the sin of the world',[35] and so the event was also frequently depicted in the medieval period in the symbolic image of Christ as a lamb – though in a somewhat more oblique way and within a nexus of other symbols. For instance, *Agnus Dei* images, such as the tiles from Whitland abbey which we have already noted, also project forward to the events of the Crucifixion by presenting the image of the lamb holding a cross united with a banner to symbolize victory over death in the resurrection of Christ.[36]

Representations of the subsequent events in the life of Christ, prior to the Passion, are extremely rare. There is no surviving depiction in a church of a miracle, for instance, though the frequency of references to the miracles of Christ in the works of the poets makes it clear that they were an important part of the framework of popular religion. In an elegy to his five-year-old son, Siôn y Glyn, written in the second half of the fifteenth century, Lewys Glyn Cothi bemoaned the fact that he, like Lazarus, might not be raised:

Ah that Siôn, pure and gentle,
Cannot be a Lazarus![37]

A lost manuscript written in the same period by the poet and antiquarian Gutun Owain contained a drawing of the miracle of the raising of Lazarus, which was copied by Richard Langford sometime before 1564.[38] Gutun Owain is known to

[37] Dafydd Johnston (ed.), *Gwaith Lewys Glyn Cothi* (Caerdydd, 1995), p. 512. For the translation, see Joseph P. Clancy, *Medieval Welsh Lyrics* (London, 1965), p. 190. The poet also recalls that St Beuno had raised the dead.

[38] The Langford manuscript is NLW MS 732B. Langford (sometimes Longford) also included two illuminations, a Crucifixion and a Man of Sorrows, in his copy of the Chester Chronicle, Chester County Archives MS D2093. However, these do not appear to have been copied by him. They are on folded folios, which suggest that they were salvaged from another source, perhaps a prayer book. Given that Langford was Welsh and his interests were primarily in Wales and the Welsh language, that source may have been Welsh, but the illuminations themselves carry no indication of their place of origin. For the Langford manuscripts, see Daniel Huws, 'Yr Hen Risiart Langfford' in Morfydd E. Owen and Brynley F. Roberts (eds.), *Beirdd a Thywysogion: Barddoniaeth Llys yng Nghymru, Iwerddon a'r Alban* (Caerdydd, 1996), pp. 302–25.

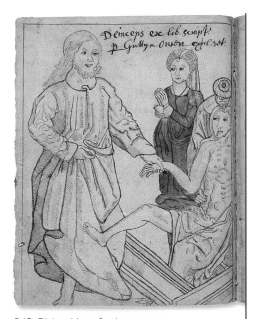

245. Richard Langford,

The Raising of Lazarus,

Illumination from NLW MS 732,

mid-16th century, 205 × 155

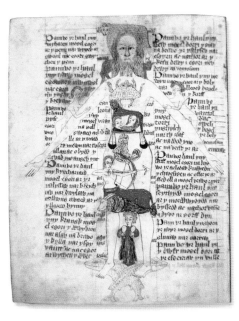

246. Gutun Owain,

Man with the Signs of the Zodiac,

Illumination from NLW MS Mostyn 88,

second half of the 15th century, 232 × 171

have produced medical drawings[39] and may have been the artist of the original, or perhaps he obtained the drawing from another source to include in his work.

As we have seen, a mysterious fragment of stone carving from Ewenni priory may depict Christ's entry into Jerusalem,[40] but no image survives of an event central to Christian belief – the last supper of Christ with his disciples. The events in the garden of Gethsemane on the Mount of Olives, to which Christ repaired after the Last Supper, are represented only in pictures made for Welsh patrons by artists working outside Wales. For instance, a book of hours, commissioned between 1465 and 1469 by William Herbert, earl of Pembroke, contains a representation of Peter striking off the ear of Malchus, the servant of the high priest, who came to the garden to take Christ for trial. The ear was reputedly kept in Bangor diocese and such an important relic, associated directly with the events of the Passion, attracted many pilgrims.[41] However, none of the literary references to the relic make mention of any visual imagery in the form of painting or glass which may have reinforced the devotion.[42]

[39] NLW MS Mostyn 88.

[40] Above, p. 65.

[41] John 18:10. Luke 22:50–1 also describes the incident, but also the miraculous restoration of the ear by Christ. The guardians of the relic in Bangor diocese clearly exercised a degree of selectivity in their use of scripture.

[42] A roof boss at Norwich Cathedral carries a carving of the event.

[43] Mark 14:65.

[44] The tormentors wear medieval clothes. From a twenty-first century perspective, this anachronism intensifies the contrast between good and evil, though it is difficult to say whether it would have had a similar resonance in the Middle Ages, when it reflected a widespread convention for the depiction of those who witnessed the life of Christ. The image of spitting heads became familiar as a shorthand iconography for the Passion. For its use in popular iconography, see Eamon Duffy, *The Stripping of the Altars: Traditional Religion in England c.1400–c.1580* (New Haven and London, 1992), p. 239. On a late fifteenth or early sixteenth-century doorframe at Rhyd Owen, a house owned by Sir Rhys ap Thomas, two spitting heads are divided by foliate carving rather than an image of Christ, but the reference is almost certainly to the Mocking.

In contrast to the paucity of surviving depictions of the early life of Christ, the central events of the Passion are conveyed by many images, generally representative of the mainstream of European iconography of the subject. Examined by the priests and the council, Jesus acknowledged that he was the 'Christ, the Son of the Blessed', and was thus condemned:

And some began to spit on him, and to cover his face, and to buffet him, and to say unto him, Prophesy: and the officers received him with blows of their hands.[43]

At the Church of St Teilo at Llandeilo Tal-y-bont in Glamorgan the humiliation of Christ was represented by an image whose drama reflected the theological and devotional importance which this brief biblical text came to assume. Its depiction of the contrast between human violence and Christ's submissive response prefigured the Crucifixion itself. The complexity of Jesus's situation as the sinless incarnate son of God living among sinful people was conveyed by the device of contrasting

the calm symmetry of his full-face depiction with the grotesque asymmetry of the spitting profile faces of his tormentors.[44] The image itself and the understanding of some of those who viewed it (and many others like it depicting the events of the Passion) might be informed by their experience of popular drama. The depiction retained much of the immediacy of the plays in which the events of the Passion were enacted in the streets of towns and some villages, and the painter's ability must have conveyed a sense of their energy even to those among the audience who had not witnessed them at first hand. In the plays the story of the Passion was revealed as a series of tableaux linked by narrative and dialogue, and similarly the paintings at Llandeilo Tal-y-bont probably presented a redaction of the whole sequence. However, individual incidents, depicted in a variety of media, were also used independently within churches.

Following the Mocking, Christ was taken before the civil authority of Pontius Pilate, the Roman governor, who judged him blameless but nonetheless scourged him, presented him to the mob with the words *ecce homo* ('behold the man') and, at their insistence, delivered him for crucifixion. The Scourging provided the subject for a carving on the pulpit of the Church of St John the Baptist at Newton Nottage, Glamorgan. The biblical account of the event is brief and lacks the descriptive detail which accrued from other sources and which became an essential element in the elaborate popular iconography of the plays. Even the single surviving Welsh Passion play which, in general, remained faithful to the biblical texts, dwelt on the barbarity of the scene. Pilate commands:

> Ye knights of cruelty
> take Jesus [and deal according] to your wisdom,
> and bind him fast to a post,
> and with scourges scourge him.

The Fourth Knight responds:

> Scourge him, with mockery,
> and fear not to wound his flesh,
> I am full of joy
> to see him so tormented.[45]

As in the depiction of the mocking of Christ at Llandeilo Tal-y-bont, the carver of the Newton Nottage pulpit adopted the device of standing a serene and full-faced Christ between two violent and agitated individuals, dressed as knights or soldiers.[46] Christ stands against the pillar, which became the identifying symbol of the incident. At least two sculptures of the Scourging in north Wales were regarded sufficiently important to attract the praise of late fifteenth-century poets, who were possibly engaged by the institutions which owned them to publicize the cults and maintain income from pilgrims. Indeed, the image owned by the Dominican friars at Bangor was regarded as 'the holiest relic in all North Wales'

45 Anon., 'The Passion', lines 165–8, 185–8, in Gwenan Jones, *A Study of Three Welsh Religious Plays* (Bala, 1939), p. 169.

46 The pulpit was severely mutilated during a restoration carried out in 1826. It originally had straight side panels so that it protruded some five feet in all into the nave. The alterations are described in detail in D. C. Davies, *The Church of St John the Baptist, Newton, Porthcawl* (Cowbridge, 1938), pp. 17–18. It was also, presumably, at this time that the pulpit (and the lintel) was thoroughly scoured in order to remove not only all traces of the paint which once intensified and detailed the image, but probably also some of the carved surface itself.

247. The Mocking of Jesus, formerly at the Church of St Teilo, Llandeilo Tal-y-bont, Glamorgan, 15th century

248. The Scourging of Jesus, Church of St John the Baptist, Newton Nottage, Glamorgan, 15th century, Stone

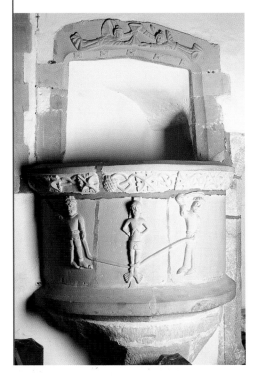

47 *Letters and Papers, Foreign and Domestic, of the reign of Henry VIII*, XIII, Part II (London, 1893), no. 200. Ingworth did not specify the nature of the other image. The high status accorded the image of the Scourging at the Dominican priory is of particular interest because of the presence of the ear of Malchus in Bangor diocese. See above, p. 160. Since this relic had a direct association with the Passion it might be expected that it would be accorded higher status than that of the sculpture. It may be that the sculpture incorporated a similar relic of the Passion, though neither Ingworth nor Llywelyn ap Gwilym ap Rhys mention it.

48 NLW MS 3048D, p. 72, NLW MS 21248D, p. 67. We are grateful to Mr Paul Bryant-Quinn for his edited text and translation of this poem and other quotations in this chapter. For further discussion, see the Appendix.

49 John 19:17. The other Gospels report that the cross was carried for Christ by Simon of Cyrene.

50 'Here is the land where Christendom dwells. Here, the true road where our Faith is. By way of the sea to the land's roads, I enter into the city of Rome ... for my efforts, I shall receive the Pope's grace and his true welcome. A curate and a vicar, Jude's name is in my heart. May blessed Peter help the soul; in time of need, he is the best of gifts. When the time comes for me to lay my body down, and I a pilgrim, will not Paul give in return for the honours done to him? The best of graces a man has received is to have seen Christ our Judge's vernacle', 'The Relics in Rome', Leslie Harries (ed.), *Gwaith Huw Cae Llwyd ac Eraill* (Caerdydd, 1953), p. 83, lines 1–4, 9–18. The popularization of the Veronica or vernacle is described in Gabriele Finaldi et al., *The Image of Christ* (London, 2000), pp. 75–93.

51 D. H. Williams, 'The White Monks in Powys I', *Cistercian Studies*, XI, part 2 (1976), 86. For an apocryphal elaboration of the story of the Veronica, see Cartlidge and Elliott, *Art and the Christian Apocrypha*, p. 50.

52 Finaldi et al., *The Image of Christ*, pp. 98–100. The relic was housed at Constantinople from 944 to 1203.

249. Head of Christ, Church of St Dochdwy, Llandough-juxta-Cowbridge, Glamorgan, 15th century, Wood

by Richard Ingworth, who, although he was a Dominican, was charged at the dissolution of the monasteries with the removal of objects regarded as idolatrous. Ingworth reported that 'No man may kiss it but he must kneel as soon as he sees it and he must kiss every stone of it and afterwards pay a met of corn or a cheese or a groat or 4d. It was worth to the friars of Bangor, with another image which the writer has also closed up, 20 marks a year.'[47] Ingworth's reference to 'kissing every stone of it' may refer simply to the plinth on which a wood-carved image was placed, especially since the poet Llywelyn ap Gwilym ap Rhys refers to it as being gilt:

> Let us hasten to the golden image, there for all to see, in the blessed church of fair Bangor, [...] of the Lord of greatest valour, crucified for the sake of the world's Five Ages [...]. All will tell what a grace it is to see [the image] of the true Jesus, shown as he, the Prophesied One, was on [that] Friday: bound before Pilate of the harsh judgement, in the presence of all the Jews, [before being led to be scourged] at the pillar. For all [Pilate's] malice, Jesus [rose] after his Passion (how sweet [this thought] is!). See His own image in Bangor, in the splendid choir, in the Friars' court [...] in good Bangor [...] [we come] to find healing.[48]

The account of the journey of Christ to Calvary carrying the cross on which he was to be hung became much elaborated from the simple biblical statements to include a series of events, each of which evolved a particular iconography.[49] On the road to Calvary – the *Via Dolorosa* – a cloth offered to Christ by St Veronica to wipe his face was believed to have retained an image of the face miraculously imprinted upon it. The cloth, which became known simply as the Veronica, was first described in the eleventh century and was the most famous relic kept in Rome. The poet Huw Cae Llwyd described seeing the Veronica among other relics there in 1475.[50] Its particular appeal was that it purported to present a true likeness of Christ and, indeed, the Veronica became one of the two sources from which were derived most medieval representations of his physiognomy. The mocked Christ at Llandeilo Tal-y-bont exemplified the type, and a 'famed picture of Jesus', an object of pilgrimage to the abbey at Cwm-hir – perhaps a panel painting – may also have depended on the Veronica as its ultimate source.[51] A similar narrative supported the claim of the Mandylion of Edessa to be the true image of Christ. The Mandylion purported to be the imprint left upon a towel used by Christ to wash his face.[52] Among the surviving images of Christ most closely derived from this source are a carved head on a roof boss in the Church of St Dochdwy at Llandough, near Cowbridge, in Glamorgan. It is distinguished from images derived from the Veronica by depicting Christ with parted hair and forked beard, and without a crown of thorns.[53]

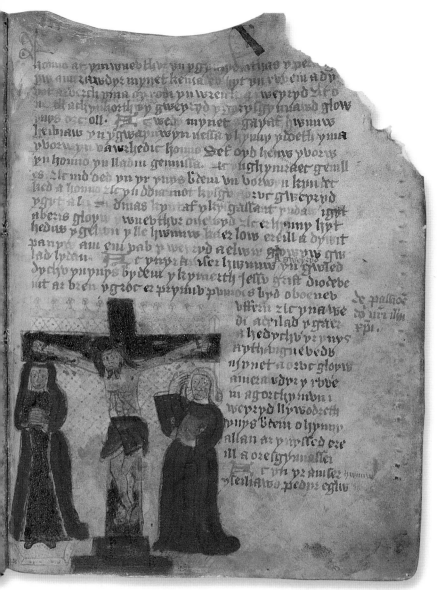

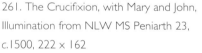

261. The Crucifixion, with Mary and John,
Illumination from NLW MS Peniarth 23,
c.1500, 222 × 162

262. The Crucifixion, with Mary,
John, Angels and Supporting
Figures, Priory Church of
St John the Evangelist, Brecon,
14th–15th century, Stone,
ht. 2100

[74] This poem, possibly by Hywel
ap Dafydd ab Ieuan ap Rhys
(Hywel Dafi), is attributed to
several late fifteenth-century
poets. The (slightly emended)
text offered here is taken from
Henry Lewis, Thomas Roberts
and Ifor Williams (eds.),
Cywyddau Iolo Goch ac Eraill (1st
ed., Bangor, 1925), pp. 230–2; cf.
also the diplomatic text given in
G. Hartwell Jones, 'Celtic Britain
and the Pilgrim Movement',
Y Cymmrodor, XXIII (1912),
303–5. The rood at Brecon
was celebrated by several poets,
notably Ieuan Brydydd Hir, for
whose 'Y grog yn Aberhonddu'
see M. Paul Bryant-Quinn (ed.),
Gwaith Ieuan Brydydd Hir
(Aberystwyth, 2000), pp. 65–70
and 157–65; for a translation, see
J. P. Clancy, *Medieval Welsh Lyrics*
(London, 1965), pp. 240–2,
where the poem is attributed to
Huw Cae Llwyd.

[75] See above, p. 54, note 6, and pp. 56, 90.

[76] Although the painting at Llanbedr Ystrad Yw is
a repeat design, it was not stencilled. Each of the
repeated elements was drawn freehand. Since
such patterns lacked iconography which might
be considered idolatrous they may have been
repainted or, indeed, new designs created after
the Reformation, which makes extant examples
like that at Llanbedr Ystrad Yw difficult to date.
For example, the refined rose ceiling of the chancel
at the Church of St Mary, Tal-y-llyn, Merioneth,
has been dated as late as *c.*1600, see RCAHM,
*An Inventory of the Ancient Monuments in Wales
and Monmouthshire VI: The County of Merioneth*
(London, 1921), p. 164, no. 524.

[77] For the speculative reconstruction of the Brecon
rood on the basis of the archaeological and literary
evidence, see D. M. Gwynne-Jones, 'Brecon
Cathedral *c.*1093–1537: The Church of the Holy
Rood', *Brycheiniog*, 24 (1990–2), 26–37. Gwynne-
Jones suggested that the *ensemble* may have stood
under a canopy of honour on which the saints, the
'cloud of witnesses' were depicted. The canopy
of honour at the Church of St Benedict, Gyffin,
exemplifies the arrangement, for which see
below, pp. 211–12.

263. Background to the Rood,
Church of St Peter, Llanbedr Ystrad Yw,
Breconshire, late 15th–early 16th century

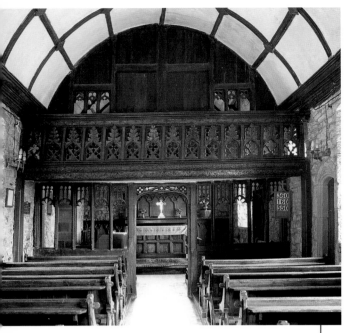

264. Rood Loft and Screen,
Betws Newydd Church (dedication
unknown), Monmouthshire,
late 15th century, Wood

so that the congregation might glimpse the celebration of the Mass by the priest. Of the roods themselves, none survived the iconoclasm of the sixteenth and seventeenth centuries. However, at the Church of Llanelieu in Breconshire, where a substantial part of the medieval screen remains, the surmounting gallery is backed with panelling which forms a tympanum upon which is the

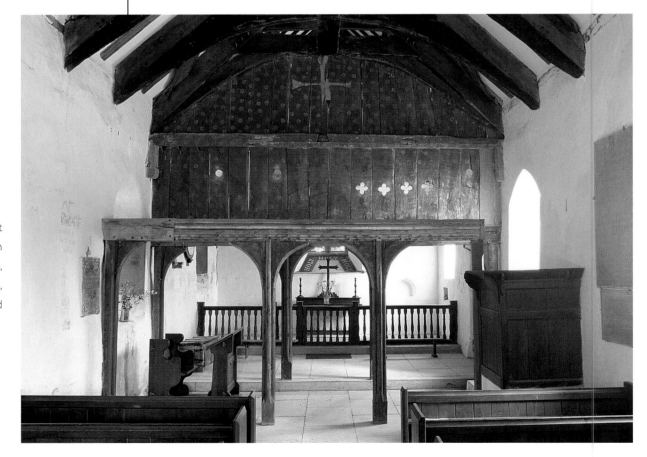

265. Rood Loft
and Screen, Church
of St Ellyw, Llanelieu,
Breconshire,
15th century, Wood

ghostly image of the rood it once carried. Probably in the second half of the fifteenth century the screen was repainted in red with a pattern of white roses without removing the crucifixion mounted upon it. When the rood was torn down, a negative image was revealed which provides perhaps the best surviving impression in Wales of the focal point of the late medieval church.

Remains of the figurative carving of the rood survive from the Church of All Saints, Kemeys Inferior, Monmouthshire, and the Church of All Saints, Mochdre, Montgomeryshire.[78] The skeletal form and contorted pose of the figures of Christ from both Kemeys and Mochdre exemplify the most fundamental evolution of the understanding of the Crucifixion to affect its imaging between the fifth and the sixteenth centuries. The shift in theological emphasis was fuelled by monastic piety. The writings of St Bernard and subsequently St Francis contributed to a process of change in the perception of the balance between the two natures of Christ. From a transcendent Christ, presented in images as a figure of power and authority beyond the reach of the humiliation and physical suffering of the Passion, the emphasis shifted towards a Christ who fully entered into human experience by, as it were, emptying himself of the knowledge that he was God. This change

[78] The Church of All Saints, Kemeys Inferior, is now demolished. The Mochdre figures were found concealed on the top of a wall below the roof during the almost complete renewal of the church in 1867. See Mark Redknap, 'The Medieval Wooden Crucifix Figure from Kemeys Inferior, and its Church', *Monmouthshire Antiquary*, 16 (2000), 11–43.

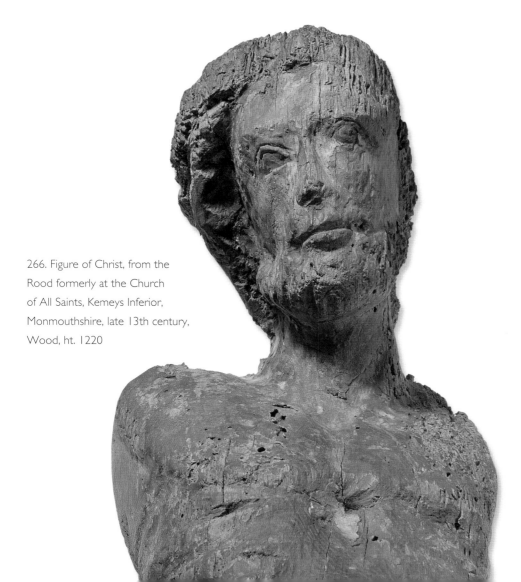

266. Figure of Christ, from the Rood formerly at the Church of All Saints, Kemeys Inferior, Monmouthshire, late 13th century, Wood, ht. 1220

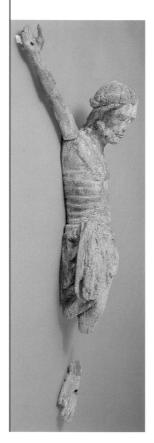

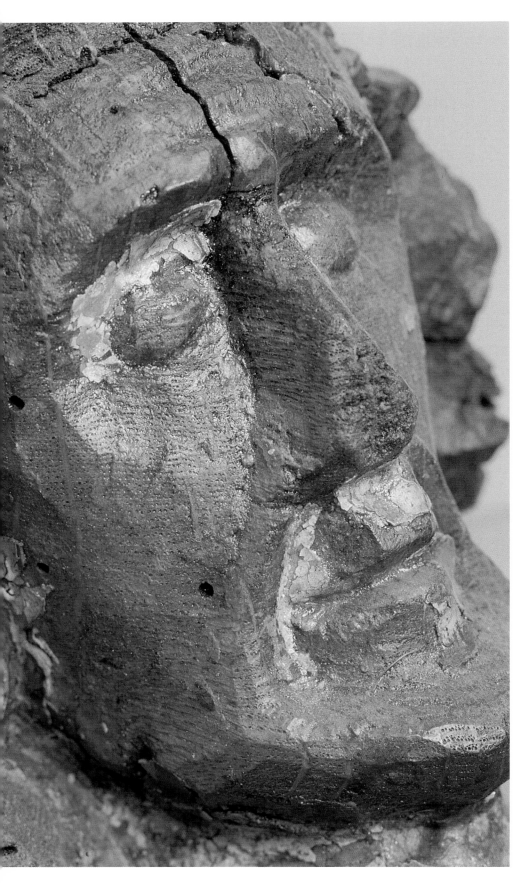

in emphasis was perceived as facilitating the efforts of the devout to empathize with Christ and, therefore, strengthen their faith. Latin texts on the subject written by scholars such as St Bonaventure became familiar in vernacular translations throughout Europe and were reflected in the popular writings of others in prose and poetry.[79]

Anguished visual images of Christ on the cross began to reflect the change in theological emphasis in the twelfth century and became widespread in the thirteenth century. An illumination which closes a redaction of the Welsh law, possibly made in the mid-thirteenth century, is representative of the development and illustrates that it became part of Welsh thought and imagery at the same time as it did so in other parts of Europe.[80] Christ is depicted with his knees drawn up in pain, with

267. Figures of Christ and the Virgin Mary, from the Rood formerly at the Church of All Saints, Mochdre, Montgomeryshire, second half of the 14th century, Wood, ht. 460 and 425

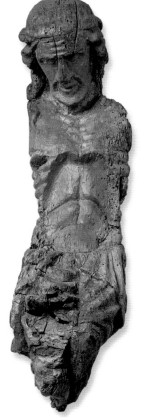
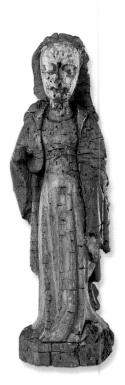

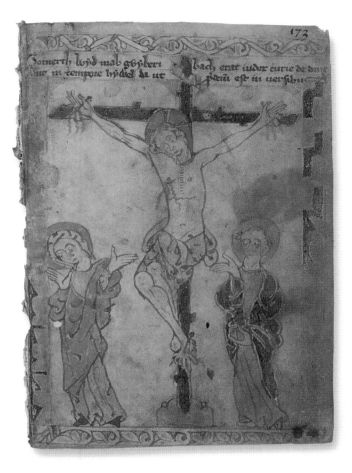

269. Emily Hewlett Edwards,
A 13th-century Mural
Painting of the Crucifixion,
Church of St Mary, Tenby,
Pembrokeshire, c.1900

268. The Crucifixion, with Mary
and John, Illumination from
Bodleian Library, Oxford, MS
Rawlinson C.821, 13th century

[79] In the mid-fourteenth century a Carthusian monk, Ludolf of Saxony, wrote a particularly influential life of Christ in which the tendency to give priority to his humanity was expressed: 'I know not for sure, I am not able fully to understand, how it is that you are sweeter in the heart of one who loves you in the form of flesh than as the word, sweeter in that which is humble than in that which is exalted … It is sweeter to view you as dying before the Jews on the tree, than as holding sway over the angels in Heaven; to see you as a man bearing every aspect of human nature to the end, than as God manifesting divine nature, to see you as the dying Redeemer than as the invisible Creator', C. A. Conway, 'The *Vita Christi* of Ludolph of Saxony … a descriptive analysis', *Analecta Cartusiana*, no. 34 (1976), 56, quoted in Duffy, *The Stripping of the Altars*, p. 237. In a *cywydd* to the rood at Llangynwyd, the poet Tomas ab Ieuan ap Rhys emphasized both the intense suffering of Christ and his status, with his disciples, as a 'social outcast': 'The golden and grievous effigy of God, we call upon you; the holy Cross at Llangynwyd, you are gory, fine and fair your craftsmanship. The image of the Blessed Son, fresh his wound, in the manner that he was when full of pain. Look, by means of this representation, how Jesus suffered during his passion. Let us meditate upon his suffering: our belief is that we perceive his pain. God of the Jews – son of the breast – was unnecessarily afraid; he and his virgin mother, he upon a cross, flinching from the grievous lance. Christ – a tall, blessed and handsome man – and his twelve disciples roamed in exile …', BL Add MS 31109, f. 347 and NLW MS 13127A, p. 125, transcribed in Jones, 'Celtic Britain and the Pilgrim Movement', p. 302.

[80] Bodleian Library, Oxford, MS Rawlinson C.821, f. 173ʳ.

[81] For the mural, see Edward Laws and Emily Hewlett Edwards, *Church Book of St Mary the Virgin, Tenby* (Tenby, 1907), pp. 151–2.

blood flowing from the wounds. Mary turns away from the sight of her son's agony with her hands held in a gesture of despair. John, holding the book by which he was conventionally identified, gestures towards Christ but his eyes look down. The depiction of the cross itself as a roughly trimmed tree deepens the realism of the agony of crucifixion. A second image of this 'rugged cross' survived the Reformation at the Church of St Mary, Tenby. A wall painting with similar iconography and of around the same date as the manuscript was recorded in the early twentieth century, when it was briefly uncovered.[81]

Nevertheless, although the continental trend towards the explicit depiction of Christ's suffering is evident in Welsh imagery at an early date, it did not entirely displace more conservative and hieratic images. Depictions of Christ on the cross in which the arms extend horizontally so that the body seems weightless, accompanied by an upright head and a calm facial expression, did not disappear from the repertoire of image-makers. The high cross in the churchyard at Newmarket, Flintshire, for instance, presented such an image of Christ and was probably made in the late fourteenth century. The Newmarket cross may have

270. Anon.,
*Cross in Newmarket Churchyard,
Flintshire*, 1891

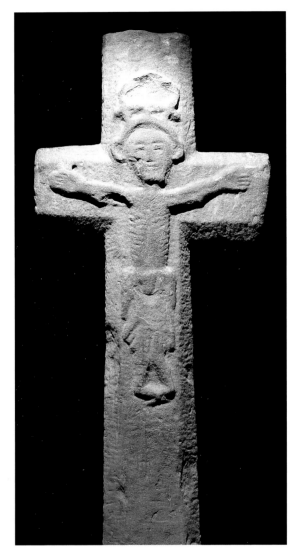

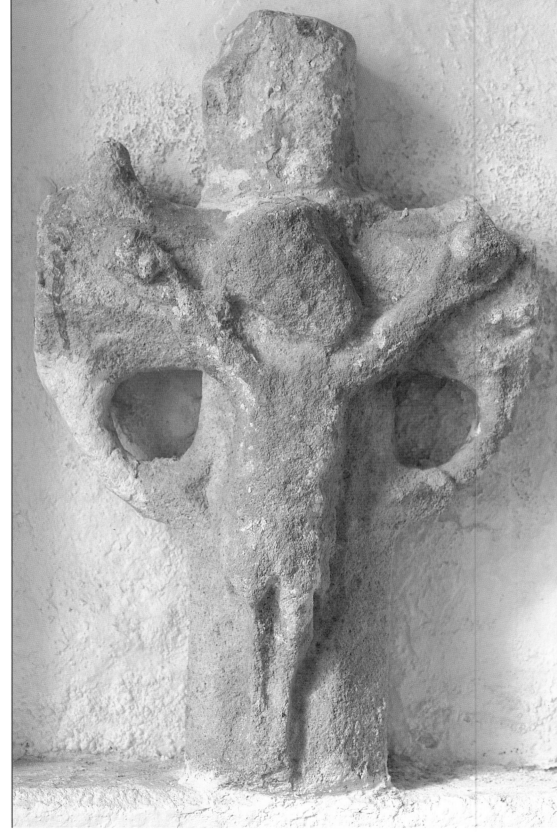

[82] The cross is now much decayed, but the illustration published in *Arch. Camb.*, 5th series, VIII (1891), 73, clearly shows a quatrefoil pattern at the corner closely similar to that characteristic of the Flintshire workshop. See above, pp. 145–6.

[83] Heather A. King, 'Late Medieval Crosses in County Meath c.1470–1635', *Proceedings of the Royal Irish Academy*, 84 (1984), sect. C, 2, plate XVIII, the churchyard cross from Kilmore. For further discussion, see the Appendix.

far left:

271. Churchyard Cross, Church of St Martin,
Cwm-iou, Monmouthshire, probably 13th century,
Stone, ht. 1160

left:

272. Churchyard Cross, Church of St Eugrad,
Llaneugrad, Anglesey, probably 13th century,
Stone, ht. 1410

been produced in the Flintshire workshop at which many memorial effigies and slabs were made,[82] but the image also persisted in the simple style of occasional works made by individual carvers. The small cross from the Church of St Martin, Cwm-iou, Monmouthshire, represented Christ according to the older perception and wearing an unusual crown, perhaps of the type worn by Holy Roman Emperors, although identification is difficult because of the poor condition of the cross and the loss of its colour. Such simple artefacts are particularly difficult to assign to a period, but the evidence of the older iconography cannot be taken as necessarily indicating that they are of an early date. The Cwm-iou cross displays striking formal similarities to Irish crosses known to have been made in the second half of the sixteenth century.[83] Equally, it is clear that minor patrons or carvers working for a local market were not necessarily theologically conservative, and some were ready to adopt the iconography of the human Jesus at an early date. At Llaneugrad, Anglesey, a figure of Christ is clearly of this type, but the wheel-headed cross on which it hangs represents the persistence of a pre-Norman design.

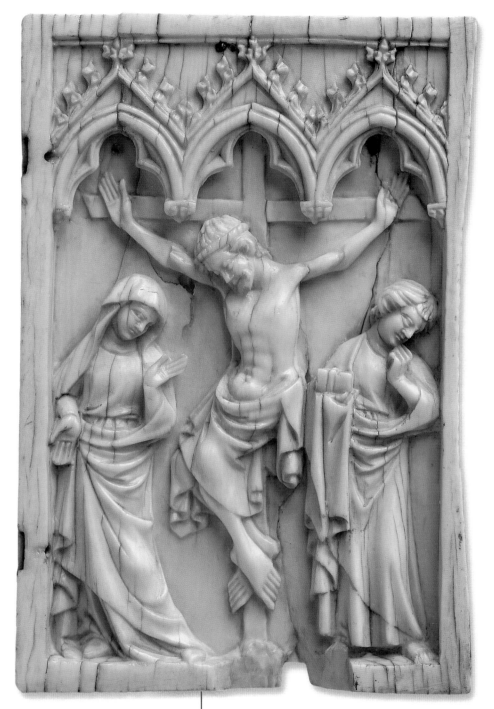

273. The Crucifixion,
with Mary and John,
14th century,
Ivory, 108 x 71

In general, however, representations of Christ's suffering became increasingly intense, and were revealed in particular by contorted postures of the body. The homogeneity of the iconography throughout western Christendom was continually reinforced by trade in objects such as the panel known as the Llandaff Ivory, part of a diptych or a pax probably made in France in the fourteenth century. Yet the

175

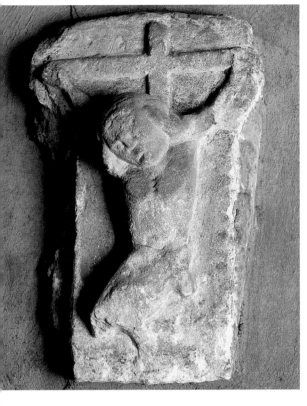

top left:

274. The Crucifixion, Bangor Cathedral,
Caernarfonshire, late 14th–15th century, Stone

276. The Crucifixion, Church of St Cadwaladr,
Llangadwaladr, Anglesey, c.1500, Painted glass

275. Wayside Cross,
Newport, Monmouthshire,
late 14th–15th century,
Stone, ht. 520

same intense tokens of Christ's agony, in particular the drawn-up knees, are evident on a small stone-carved panel at Bangor and a larger fragment of stone carving from Newport, both of which were made locally or within the region. Since it is not carved on the back the fragment from Newport may well have been part of a wayside cross located on the river bridge in the town. However, perhaps the most remarkable expression of the intensification of the image of the suffering of Christ on the cross takes the form of stained glass. In a window commissioned in the late fifteenth century for the Church of St Cadwaladr at Llangadwaladr in Anglesey, the skeleton of Christ appears as a shadowy image beneath his tortured flesh. The artist has striven to express both the fact and the symbolic meaning of the statement in the Gospel of St John that, at the Crucifixion, 'A bone of him shall not be broken'.[84]

The Llangadwaladr crucifixion, in common with many other painted glass images of the subject, stressed the significance of the wounds inflicted on Christ's body through the depiction of angels who collect the blood which flows from them. Throughout the fifteenth century devotion directed to the wounds of Jesus intensified. Votive masses of the five wounds became popular in response to the legend that the archangel Gabriel had appeared to Pope Boniface I and promised deliverance from earthly evil to those who celebrated such a Mass, and deliverance from purgatory for the soul of those for whom five such masses were said. Some practised individual devotions associated with each of the wounds.[85] In the Llangadwaladr glass there are four angels, one of whom holds two chalices which, as elsewhere, take the form of the chalices used in the celebration of the Mass. It is Catholic doctrine that the bread and wine, taken by the celebrant during this central sacrament of the church, are transubstantiated into the body and blood of Christ. The moment at which the priest elevated the host and at which this transubstantiation was believed to take place became, therefore, the focus of devotion and the imaging of the wounds assumed a particular significance.[86] The direct relationship between the wine and the blood of Christ was emphasized in the silver chalice at the Church of St Elian, Llaneilian-yn-Rhos, Denbighshire. The foot of this finely-made artefact, directly at the eye-level of the priest at the moment of elevation, was engraved with an image of the Crucifixion.[87]

[84] John 19:36. The Gospel passage represents the fulfilment of the ordinance of the Jewish feast of the Passover that no bones of the sacrificed lamb shall be broken, Exodus 12:46. In this way the artist of the Llangadwaladr crucifixion shows Christ not only at the moment of death but as the Paschal Lamb. The Resurrection scene at the apex of the window is drawn in the same way.

[85] See Duffy, *The Stripping of the Altars*, pp. 238–45.

[86] For the place of the Mass in popular religion in the fifteenth and early sixteenth centuries, see ibid., pp. 91–130, and Miri Rubin, *Corpus Christi: The Eucharist in Late Medieval Culture* (Cambridge, 1991).

[87] A second fifteenth-century silver chalice, once probably in use in Wales, survives at the Church of St Faith, Bacton, Herefordshire, which belonged to Llanthony priory. The chalice seems to have been the gift of one John Capulle, mayor of Gloucester, to Llanthony Secunda, from where it was transferred to Llanthony Prima. At the dissolution it found its way to Bacton, perhaps for safekeeping. E. W. Colt [Williams], 'Notes on the Bacton Chalice', *Transactions of the Woolhope Naturalists' Field Club 1886–9* (1892), 230–3.

277. Chalice, Church of St Elian,
Llaneilian-yn-Rhos, Denbighshire,
late 15th–early 16th century,
Silver gilt, ht. 172

278. The Crucifixion with the
'Angel of the Abyss', and the Virgin
and Child, Church of St Ust and St Dyfnig,
Llanwrin, Montgomeryshire, c.1461–83,
Painted glass

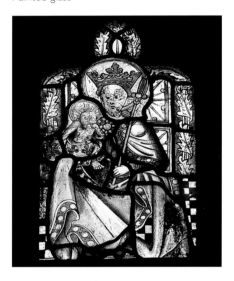

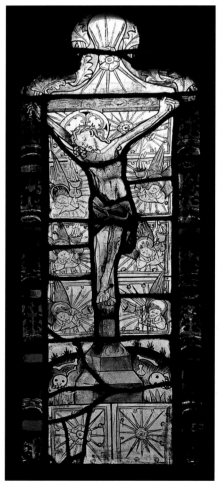

As with other aspects of crucifixion imagery, the depiction of the collection of the blood from the wounds provided scope for a range of iconographic variants, reflecting theological fashions or the taste of individual patrons. Above an arch in the wall of the nave of the Church of St John the Baptist at Newton Nottage, through which access to the pulpit is gained, two carved angels hold a single chalice.[88] Here there is no image of the Crucifixion itself (unless a painted image has been lost) and the five wounds of Christ are indicated by five floriate carvings underneath the figurative work. In contrast to this spare and symbolic language[89] a window at the Church of St Ust and St Dyfnig at Llanwrin, Montgomeryshire, presents a rich and explicit image of the blood flowing from the wounds. However, its apparently conventional iconography of angels collecting the blood from the wounds is deceptive, because one of them is demarcated by a black halo.[90] This image, like that of the crucified Christ at Llangadwaladr, reflects considerable theological sophistication in either the artist or the patron. The dark halo indicates the 'angel of the abyss', the servant of Satan whose words are a deceit.[91] The blood which fills the chalice of the angel of the abyss flows from no wound on the body of Christ.[92] At the head of the window is a depiction of the Virgin and Child, remarkable for the drawing of the faces of Christ and his mother.

279. The Crucifixion and Panels from the
Seven Sacraments Sequence, Church of St Tymog,
Llandyrnog, Denbighshire, c. 1500, Painted glass

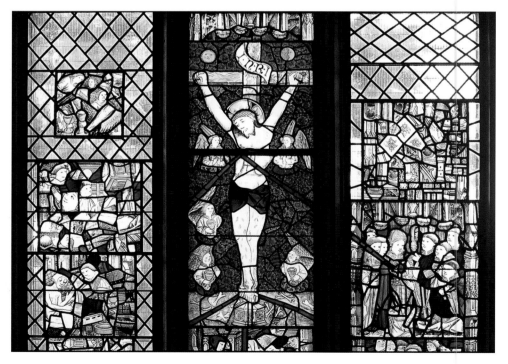

of St Michael, Trefeglwys, Montgomeryshire, where it probably formed part of the roof.[106] A similar image carved by a more sophisticated artisan serves as a corbel stone at Llandaff Cathedral. It resolves the ambiguity of the forms emanating from the necks of the Trefeglwys heads in terms of two sprays of foliage. However, the survival of a seven-headed example of the same motif, originally in the chapter house at Haverfordwest priory, suggests that the identification of the triple heads as images of the Christian Trinity is problematic.[107]

According to the Gospel accounts, Pilate granted the body of Christ to one of his followers, Joseph of Arimathea:

And he bought a linen cloth, and taking him down, wound him in the linen cloth, and laid him in a tomb which had been hewn out of a rock; and he rolled a stone against the door of the tomb. And Mary Magdalene and Mary the mother of Joses beheld where he was laid.[108]

The Gospels vary in their accounts of those present at the deposition of the body of Christ from the cross and its laying in the tomb. St John noted the presence of Nicodemus, who brought spices to anoint the body and a conflation of accounts appears to be the source for an alabaster panel at the Church of St Bride, Llansantffraed in Monmouthshire. Joseph and Nicodemus are at the head and foot of the body of Christ, which is depicted wrapped in the cloth. A jar of spices stands on the rough-hewn floor of the tomb by Mary Magdalene.[109] She is distinguished from the Virgin Mary, the central figure of the upper group in the panel, by her uncovered head and hanging hair – to the contemporary mind a symbol of a loose woman or a prostitute. A third female figure may represent Mary, the mother of James, or Salome who, in the account of St Mark, accompanied Mary Magdalene to the tomb to anoint the body of Christ on Easter morning. The conflation of the Gospel accounts and the accretion of features from non-biblical sources contributed to the development of a particularly complicated iconography of the events surrounding the Deposition and the discovery of the empty tomb. Indeed, the individual identities of the women involved, three of them called Mary, became confused. Furthermore, between the Crucifixion and the laying in the tomb, a tableau was inserted which provided a source for some of the most powerful visual imagery of the whole Passion Cycle. None of the biblical accounts mentions the moment at which the body of Christ was laid in the lap of his distressed mother, but the increasing emphasis by the pious on the empathetic experience of the Passion gave the *pietà* particular intensity. Like other

[106] The carving is now at the Church of St Llonio, Llandinam, Montgomeryshire.

[107] Nevertheless, the central head of the Haverfordwest example closely reflects images of Christ derived from the Veronica.

[108] Mark 15:46–7.

[109] The conventional attribute of Mary Magdalene is the 'alabaster cruse of exceeding precious ointment', with which she anointed the feet of Christ in the house of Simon the Leper, Matthew 26:6–13. Nevertheless, the jar in the Llansantffraed alabaster no doubt does service both as that which contained the spices brought by Nicodemus and as a device to emphasize the identification of the female figure as Mary Magdalene. The seal of Goldcliff priory, in use in the mid-fourteenth century, similarly identifies Mary Magdalene by a jar of ointment at the moment at which the risen Christ revealed himself to her: 'Jesus saith unto her, Woman, why weepest thou? Whom seekest thou? She, supposing him to be the gardener, saith unto him, Sir, if thou hast borne him hence, tell me where thou hast laid him, and I will take him away. Jesus saith unto her, Mary. She turneth herself, and saith unto him in Hebrew, Rabboni; which is to say, Master', John 20:15–16. Goldcliff priory was dedicated to Mary Magdalene. The seal is illustrated in Williams, *History of Wales through Seals*, p. 29. The mural painting of Mary Magdalene at the Church of St Illtud, Llantwit Major, Glamorgan (see p. 105), also identifies her by means of the jar of ointment, though in this case it is depicted in an idiosyncratic manner, which suggests an association with the Botiler family of St Brides. The heraldic identification of John le Botiler by three closed cups on his memorial at the Church of St Brides Major, is close in style to that of the jar held by the Magdalene at Llantwit Major. Since both works are of the thirteenth century, John or one of his immediate ancestors or descendants may have been the patron of the wall painting. For the Botiler memorial, see pp. 124–5.

288. *Pietà*, Church of St Canna,
Llan-gan, Glamorgan, 15th century,
Stone, ht. 880

moments in the Passion Cycle, it placed the Virgin Mary at the centre of events, interlocked with the cycle of her own life, and provided an occasion for transcending linear time. The conventional disposition of the figures resonates with images of the infant Christ in his mother's arms. Although severely weathered, the churchyard cross at Llan-gan in Glamorgan clearly reveals the formal arrangement characteristic of the *pietà* throughout Europe. At Llan-gan the image was carved on one of the two larger faces of the cross, opposite a conventional depiction of the Crucifixion and accompanied by a wealth of other images, including a Virgin and Child.

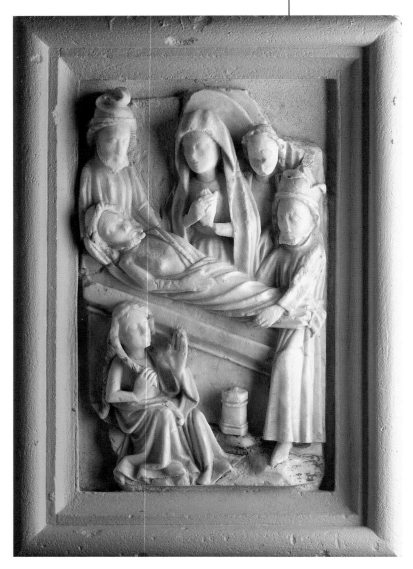

289. The Deposition, Church of St Bride,
Llansantffraed, Monmouthshire,
15th century, Alabaster, 410 × 260

290. The Resurrection, Church of St Bride, Llansantffraed,
Monmouthshire, 15th century, Alabaster, 410 × 260

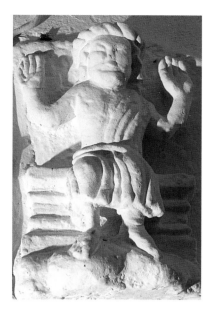

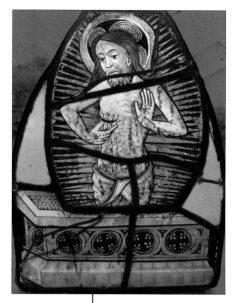

291. The Resurrection,
Church of St Decumanus,
Rhoscrowther, Pembrokeshire,
possibly 14th century, Stone

292. The Resurrection
from the Vision of
St Gregory, formerly
at the Church of
St Cystennin,
Llangystennin,
Caernarfonshire,
c.1500, Painted glass

The Gospel of St Matthew states that Pilate set a guard over the tomb in order to prevent the body of Christ being removed by his disciples and hidden, so that they might claim that he had risen from the dead, as he had predicted.[110] Since the resurrection of Christ in this world was the reality of transformation promised to all those of faith, it was widely imaged. The panel which formed the partner to that depicting the Deposition at Llansantffraed displayed the conventional iconography in its most developed form.[111] Christ rises from the tomb – usually depicted in the form of a stone tomb chest of the Middle Ages – and steps over the sleeping soldiers. With his right hand he makes a sign of benediction and in his left he carries the cross-headed staff which was the symbol of his victory over death.[112] Condensed depictions of the Resurrection might omit the multifarious details of the narrative as it came to be elaborated in the Passion plays in order to concentrate upon the central image of Christ stepping from the tomb. At the Church of St Decumanus, Rhoscrowther in Pembrokeshire, a tiny stone carving omits the soldiers but retains a reference either to the rocky site of the cave or to the boulder used by Joseph of Arimathea to close its mouth. Christ appears to step with vigour from the tomb chest onto rocky ground with his hands raised in the orans position, symbolizing both the sacrifice of the cross and his triumph over suffering and death. However, the precise nature of the iconography has been obscured by the application of successive coats of limewash. It is possible that Christ is shown sitting on the side of the tomb and that his arms are raised to display his wounds, in which case the image is not a resurrection in the strict sense but a variant depiction of a vision seen by St Gregory while celebrating Mass in Rome and which became widely celebrated in the fourteenth and fifteenth centuries. A fragment of glass from a window originally at the Church of St Cystennin, Llangystennin in Caernarfonshire, is unequivocally of this type.[113]

[110] Matthew 27:62–6.

[111] The original location of the panels at Llansantffraed is uncertain. They may have belonged to a reredos, but more likely to a tomb chest. Such 'before and after' imagery was considered particularly appropriate for the tomb chest, exemplified by that of Bishop Bromfield at Llandaff, which displays paired images of the Resurrection and Christ as judge. See below, pp. 188–9. There is no reason to suppose that the panels were not originally commissioned for the church, possibly as a memorial to Philip ap Thomas (d. 1460), elder brother of Sir William ap Thomas of Raglan.

[112] At the Church of St Mary, Swansea, the brass memorial to Sir Hugh and Lady Maude Johnys c.1510 presents the same elements, though Christ has been given a nimbus. The brass is illustrated in Lewis, *Welsh Monumental Brasses*, pp. 42–3, which also provides a biography of the patrons. In the same church a fragment of fifteenth-century painted glass presents the standard iconography of the Resurrection, with Christ stepping from the tomb, cross in hand, over the sleeping soldiers.

[113] See Gray, *Images of Piety*, p. 43. The Llangystennin tomb chest, from which Christ rises, is of the type used to inter Llywelyn ab Iorwerth, for which see pp. 116–17. Although the image survives with several other fragments, it is not possible to determine the original arrangement. The fragments are described in Lewis, *Stained Glass in North Wales*, pp. 66–7. Gray noted that Lewis misread the depiction of Christ rising from the tomb chest as a conventional Resurrection image.

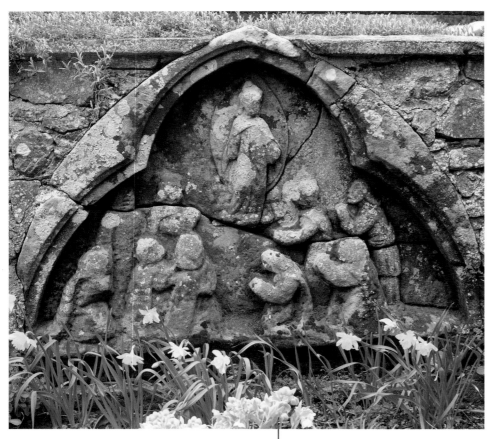

293. The Ascension,
Cwm-hir Abbey, Radnorshire,
13th century, Stone

Only a single representation of the Ascension of Christ into heaven survives, though it is unlikely that its rarity indicates that the depiction of the culmination of the salvation cycle was less common in Wales than in other parts of Europe. The badly weathered stone-carved tympanum from the abbey at Cwm-hir may, perhaps, have originally been located above the south processional door of the nave, leading from the cloister into the incomplete church.[114] Although the New Testament descriptions of the Ascension are spare, a conventional iconography arose around depictions of the event in the Middle Ages, some of which are discernible in the carving at the abbey of Cwm-hir.[115] A robed Christ is set against a mandorla, rather than supported by angels, as he was often depicted, and his left arm inclines down towards a group of disciples and the Virgin Mary, who kneels in prayer, clearly demarcated from the figures about her.[116]

[114] For the architectural context of the sculpture, see above, pp. 98–100.

[115] Luke 24:50 notes that the Ascension took place from among the disciples at Bethany. Acts 1:9 describes how Christ 'was taken up; and a cloud received him out of their sight'. In Acts 1:12, the event is declared to have taken place 'from the mount called Olivet'. The carving was incorrectly identified as the Assumption of the Virgin in David H. Williams, *The Welsh Cistercians* (2 vols., Caldey Island, 1983), I, plate 14.

The cumulative meaning of the salvation cycle was expressed in the image of Christ in heaven, victorious over death. The effigy of Bishop Edmund Bromfield of Llandaff, carved in a workshop in the west of England around 1393, is presented in a memorial which carries images of both the risen and the triumphant Christ as the promise and prefiguring of his own resurrection. Beneath the canopy, an unadorned image of Christ rising from his tomb and displaying the marks of his suffering at human hand was placed so that, in a metaphorical sense, the cleric would see it on first opening his eyes at the moment of his judgement. On the front face of the tomb an equally simple image of Christ in heaven, robed and enthroned, pronounces a benediction.

According to St Mark, Christ took the place of honour in heaven 'at the right hand of God',[117] but depictions of the Majestas figure, such as that carved for Bishop Bromfield, do not commonly reflect this dual gospel image of the deity. Rather, they follow the vision recorded in the Revelation of St John the Divine:

Straightway I was in the Spirit: and behold, there was a throne set in heaven, and one sitting upon the throne; and he that sat was to look upon like a jasper stone and a sardius: and there was a rainbow round about the throne, like an emerald to look upon ...[118]

A gilt bronze image of the Majestas, which now adorns the binding of the Book of Llandaff, has Christ seated on a rainbow, showing no signs of his earthly suffering. The casting was probably made in the third quarter of the thirteenth century and perhaps originally formed part of a reliquary.[119]

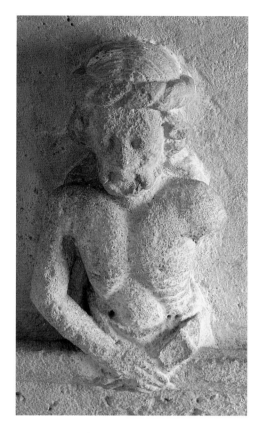

294. The Tomb of Bishop Edmund Bromfield, with the Resurrection and Christ in Glory, Llandaff Cathedral, Glamorgan, c.1393

[116] Mark 16:14 states that eleven disciples were present at the Ascension and does not mention the presence of the Virgin Mary. However, the carving at Cwm-hir abbey is characteristic of visual tradition throughout Europe in its variation from the Gospel account. In particular, the Virgin Mary is almost always depicted, though more commonly in the orans position than kneeling as at Cwm-hir. See Cartlidge and Elliott, *Art and the Christian Apocrypha*, pp. 42, 133. In early Christian tradition the mandorla shape, against which Christ is set, evoked the idea of divine protection, but by the later Middle Ages it had become simply a symbol of the deity. The design of the carving would have permitted the inclusion of angels supporting Christ, painted on the background.

[117] Mark 16:19.

[118] Revelation 4:2–3.

[119] For the history of the binding, see E. D. Jones, 'The Book of Llandaff', *National Library of Wales Journal*, IV (1945–6), 125–6, and Daniel Huws, *Medieval Welsh Manuscripts* (Cardiff and Aberystwyth, 2000), pp. 124–5. For the sculpture, see Jonathan Alexander and Paul Binski (eds.), *Age of Chivalry* (London, 1987), pp. 308–9. It is not clear at what date the figure was attached to the book cover. Alexander and Binski suggest it may have been as early as the fifteenth century, though the Reformation would have provided a more compelling reason for the removal of the sculpture from its original context. The large and projecting head of the figure suggests strongly that it was designed to be seen from below. It may, therefore, have been mounted on the gable-end of a house-shaped portable reliquary, which was normally displayed on top of a shrine. By the seventeenth century the figure was believed locally to be an image of St Teilo, a confusion which might be explained by it having originally formed a part of the shrine of the saint at Llandaff. Alexander and Binski, *Age of Chivalry*, p. 309, describe it as 'a unique survival of major English bronze casting'.

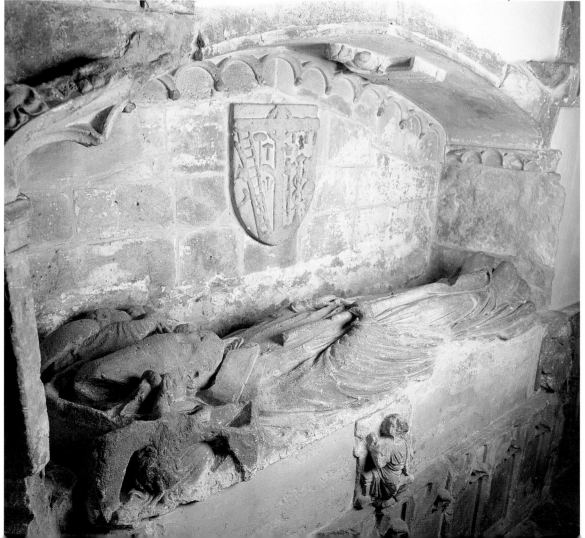

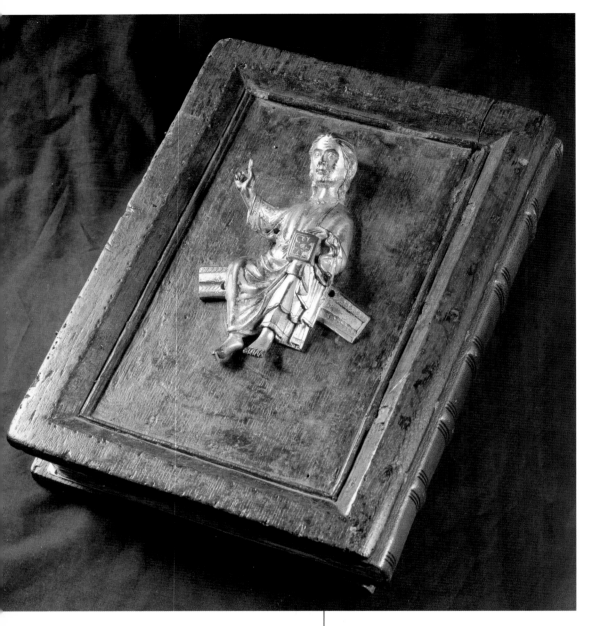

295. Christ in Glory,
1250–65, Gilt copper alloy,
ht. 171, attached to the
binding of the Book
of Llandaff

The rainbow is suggestive of God's continuing love and fidelity to his people, notwithstanding his wrath at their sinfulness.[120] In his left hand Christ holds a book, which is a common feature in Majestas images and is generally associated with the Book of Life described in the Revelation of St John the Divine.[121] It also appears in a thirteenth-century enamel from Penmon priory which, unlike the gilt casting, probably originally adorned a book. The Limoges enamel has the head of Christ set against a nimbus and, in its original context, the head of the Book of Llandaff figure may well have been similarly portrayed. The nimbus would have been carved, engraved or painted on the panel to which it was attached, which may also have carried a framing mandorla.[122] A monumental stone-carved Majestas from Llandaff Cathedral depicts Christ seated on a throne of classical form. The original location of the figure, still powerful despite weathering and deliberate defacement, is uncertain, though it is generally believed to have occupied a niche at the apex of the western gable of the nave. The lost right arm of the figure of Christ was probably raised in benediction.[123]

[120] In medieval iconography both God the Father and God the Son are depicted with a rainbow. See Walter Cahn, *Romanesque Bible Illumination* (Cornell, 1982), pp. 114–17 for illustrations and explication.

[121] St John is specific that the book was held in the right hand, but the change in the image is probably a matter of artistic necessity rather than of theological significance, given the need to portray the right hand of Christ in benediction. The image encapsulates a reference to the apotheosis of the Lamb, though the complexity of the Revelation of St John on which it depends makes interpretation a difficult matter. See Margaret Barker, *The Revelation of Jesus Christ* (Edinburgh, 2000), especially chapter 8.

296. Christ in Glory,
Priory Church of
St Seiriol, Penmon,
Anglesey, 13th century,
Champlevé enamel

297. Christ in Glory,
Llandaff Cathedral,
Glamorgan,
13th century,
Stone, ht. 1380

The essential work of the church, which began at the moment of the descent of the Holy Spirit onto the disciples of Christ at the feast of Pentecost,[124] was the preparation of the individual for judgement with a view to the salvation of the soul. The depiction of Christ enthroned, himself triumphant over death, was therefore closely related to the imaging of Christ as judge. The popular iconography of judgement frequently combined the Majestas figure with the visualization of judgement as the weighing of souls in a balance held by St Michael, the archangel. At the Church of St Elian, Llaneilian-yn-Rhos, Denbighshire, a series of panel paintings, probably originally part of the rood loft, have as their central focus a figure of Christ in Majesty. The panels were heavily overpainted in 1874, but probably retain their original iconography.[125] Christ is seated upon a rainbow and gives a sign of benediction. In so doing he reveals the wounds on his hands, a sign reinforced by the opening of his robe to reveal the wound in his side. He is flanked by angels holding Instruments of the Passion. Beyond them, on the right hand of Christ, three panels depict St Michael holding the scales of judgement while the Devil and the Virgin Mary contest the ownership of the souls in the balance.

The belief that Mary was able to intercede at the Judgement on behalf of the individual was a compelling factor in the popularity of her cult. At Llaneilian her influence was symbolized by the depiction of her casting rosary beads into the balance, apparently to good effect since the scales tip down on her side. The symbol was particularly popular in England[126] and the frequency of its use in Welsh poetry suggests that the Llaneilian painting may be the sole survivor of many in Wales:

[122] The mandorla shape is suggested by the angle at which the ends of the rainbow are cut.

[123] A similar figure, though a modern replacement, can be seen at Wells Cathedral, Somerset.

[124] Acts 1:2–4.

[125] The manner of the painting of the Llaneilian panel can be judged only by comparison with the canopy of honour in the church and that at the Church of St Benedict, Gyffin, which were probably the work of the same artist. See below, pp. 208, 211–12.

[126] It is sometimes regarded as 'a motif unique to Britain'. Andrew Breeze, 'The Virgin's Rosary and St Michael's Scales', *Studia Celtica*, XXIV/XXV (1989–90), 97, note 2.

When he comes to his judgement, O Michael,
Let them give it to weigh the soul!
May nothing stop the weights on one side, with Jesu's help,
Because his Passion and Mary's rosary
Can forgive all his sins.
Mother of her father, you are a nurse, Mary;
Stand by fair Morys,
Have him weighed with a faithful finger,
And be it, on a rosary's weight, as it may be![127]

298. St Michael the Archangel Weighing Souls, and Christ in Glory, Painted panels probably from a rood screen, Church of St Elian, Llaneilian-yn-Rhos, Denbighshire, 15th century

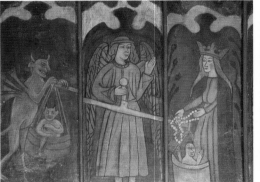

[127] T. Gwynn Jones (ed.), *Gwaith Tudur Aled* (2 vols., Caerdydd, 1926), I, pp. 323–4, lines 87–96. The poem is an elegy to Morys ab Ieuan ap Hywel of Llangedwyn (c.1465–c.1525). Along with other examples associating the rosary of the Blessed Virgin and the scales of judgement, it is given in Breeze, 'The Virgin's Rosary and St Michael's Scales', pp. 91–2.

[128] I Kings 3:16–18. Elias Owen, *Old Stone Crosses of the Vale of Clwyd and Neighbouring Parishes* (new ed., Mold, 1995), p. 36, reported the interpretation of the panel as the Judgement of Solomon as a conventional wisdom, but suggested that it was more likely to represent an elaborate Virgin and Child group. However, given the presence on another face of what is certainly a Virgin and Child, the repetition of the subject seems unlikely. The cross was already in poor condition when Owen inspected it in the 1880s, having suffered from the attentions of iconoclasts as well as natural erosion.

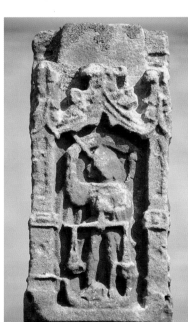

299. St Michael the Archangel Weighing Souls, Church of St Mary, Derwen, Denbighshire, mid–late 15th century, Stone

St Michael is depicted with the scales on an end face of a cross outside the Church of St Mary at Derwen in Denbighshire, an image probably made in the second half of the fifteenth century. Unfortunately it is too badly weathered to determine with certainty the details of iconography which may once have elaborated the basic image. Michael appears to hold a sword and trumpet and to stand on a curved surface perhaps representing the globe of the world. Mary's rosary does not seem to feature, but the importance of the Virgin Mary in the later Middle Ages in the context of the idea of the general resurrection at the last day is apparent from her presence in the carving of at least two of the remaining faces, a Crucifixion and a Virgin and Child. Such a grouping of images is typical of the iconography of the churchyard crosses of the period. However, the Derwen cross is unusual in that one face is carved with a group of figures which may represent the Judgement of Solomon, an Old Testament type of the Last Judgement.[128]

Individual images concerned with the conception of Christ in Majesty and as judge were brought together in depictions of the Last Judgement, often known as 'Dooms', which were conventionally painted above the chancel arch, the most visible section of a wall inside a church. The sole surviving painting of this kind in Wales is on a large scale at the Church of St Giles, Wrexham. Its central feature is of Christ in Majesty, seated on a rainbow and showing his

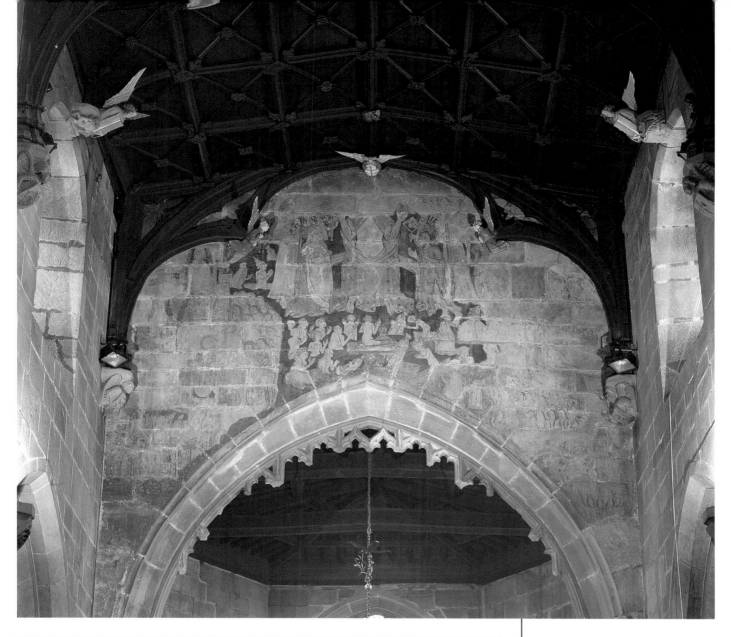

300. The Doom,
Church of St Giles, Wrexham,
Denbighshire, 15th century

301. The Apparition of the Cross before Judgement, Church of St Mary, Tenby, Pembrokeshire, late 15th century, Wood

[129] For Tudur Aled, c.1465–c.1525, see Jones (ed.), *Gwaith Tudur Aled*. The imaging of the Doom by late medieval poets provides particularly striking examples of the symbiotic relationship which existed between literature and visual culture (as well as the mimetic arts and music) in the period. In the context of the Wrexham Doom, see, for instance, the *cywydd* 'I'r Farn Fawr' (To the Great Judgement) by Siôn Cent, which includes a description of the separation of the damned and the saved: 'There, they shall be separated; the devil shall take the doers of evil to his land. There, when the earth quakes, shall they as one cry out. Fearsome indeed is that parting; sorrow, Oh, for the world that was! ... Those who have done good shall as one family be caught up to heaven in an instant. That heaven is full of bliss eternally, a blessing to many', Henry Lewis, Thomas Roberts and Ifor Williams (eds.), *Cywyddau Iolo Goch ac Eraill* (Caerdydd, 1937), p. 283, lines 1–6, 19–22. The relationship between imaging in literature and the visual culture in Wales is discussed in John Morgan-Guy, *What Did the Poets See? A Theological and Philosophical Reflection* (Aberystwyth, 2002). In c.1871 a figure of Christ in majesty was revealed on a wall above the rood screen at the Church of St Jerome, Llangwm Uchaf, Monmouthshire. It may have formed part of a Doom into which were integrated the three-dimensional figures of the rood. See Fred H. Crossley, 'Screens, Lofts, and Stalls Situated in Wales and Monmouthshire', *Arch. Camb.*, CVIII (1959), 19–20, 54.

wounds. The Crucifixion is symbolized by angels holding the Instruments of the Passion. Below the Majestas the dead rise from their tombs and are either dispatched to hell on the left hand of Christ or accepted into heaven on his right. Those judged are of every station – common people, clerics, kings and queens. A pope, identified by his triple crown, is among the saved. Below him, the new Jerusalem is built. Christ is flanked by the figures of John the Baptist and the Virgin Mary, who has bared breasts. As the poet Tudur Aled suggested, the maternity of the Virgin in this context symbolized her appeal to her child to show mercy on the humanity among whom he was himself born.[129]

In the roof of the Church of St Mary, Tenby, a quartet of angels surround a figure of Christ, who carries an empty cross before him. The image is known as 'the Apparition of the Cross before Judgement' and originates in the work of the

Archdeacon Peter Conwey,[151] though not by the same artisan as the Jesse window at the Church of St Dyfnog, Llanrhaeadr-yng-Nghinmeirch, Denbighshire, despite the fact that it was made in the same year. The drawing of the faces at Diserth is more severe and intense than that at Llanrhaeadr where, remarkably, the window survives largely intact.[152] It is divided into five

319. Figure of Jesse, 1498, Woodcut, printed in Paris by Jean Pigouchet

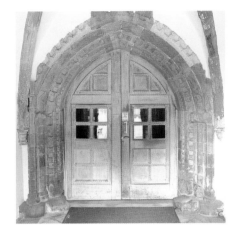

320. The Tree of Jesse on the south-west doorway of St David's Cathedral, Pembrokeshire, 14th century, and detail of King David

lights, and the central place – above Jesse and below the Virgin – is accorded to King David, founder of the dynasty fundamental to Jewish tradition. The depiction of Jesse, which clearly derives from a French woodcut in a printed book of hours, illustrates the important role of the new technology in the dissemination of images throughout Europe.[153] Above the Virgin herself is the pelican whose chicks feed on blood from their mother's breast, the symbol of the sacrifice of Christ on the cross and especially of the mass, when the faithful were fed by the body and blood of their Saviour.

The tree of Jesse was sometimes used as a framing device, which required that the descent of Christ be split into two strands, as at the Church of St Illtud, Llantwit Major. The niche created may have housed a painting or – since the carving of Jesse himself protrudes to form a plinth – more likely a sculpture, perhaps of the Virgin and Child. At St David's Cathedral the use of the image to frame the south-west door to the nave necessitated the unusual device of showing the descent from two figures of Jesse, one each side, the branches coming together at the apex of the pointed arch of the frame. The carving is much decayed, but the figure of King David with his harp remains clearly discernible. The importance of the image in the later Middle Ages can be gauged from the massive size of the Tree of Jesse carved in wood for the Priory Church of St Mary, Abergavenny. Only the once-coloured and bejewelled Jesse himself remains, his head supported by an angel, but the size of the figure suggests that the complete object must have ascended to a great height. Where it was located in the church and how it was supported is unknown, though it seems likely to have occupied the whole wall of a chapel.[154]

[153] See Bernard Rackham and C. W. Baty, 'The Jesse Window at Llanrhaiadr, Denbighshire I', *Burlington Magazine*, LXXX, no. 468 (1942), 65.

[154] At the abbey church in Dorchester-on-Thames a large-scale Jesse was carved in relief in stone, the branches forming the lights of a window. The antecedents of Christ are depicted both in the form of further stone carvings and painted glass. The Dorchester-on-Thames window gives an impression of the likely scale and complexity of the Abergavenny Jesse. For the artist who created the Abergavenny Jesse, see below, p. 215, note 175.

321. Jesse Niche,
Church of St Illtud, Llantwit Major,
Glamorgan, early 13th century,
Stone, ht. 2480, and detail

322. Sleeping Jesse,
Priory Church of St Mary,
Abergavenny, Monmouthshire,
early 15th century, Wood, l. 2940

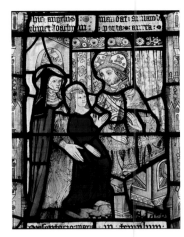

323. St Anne and St Joachim, the Birth of the Virgin Mary, and Mary received into the Temple, Church of All Saints, Gresford, Denbighshire, 1498, Painted glass

[155] In particular the *Protevangelium Jacobi, The Gospel of the Nativity of Mary* and *The Gospel of the Pseudo-Matthew*, for which see Cartlidge and Elliott, *Art and the Christian Apocrypha*, pp. 21–46.

[156] The Welsh iconography of St Anne is discussed in Gray, *Images of Piety*, pp. 18–21.

[157] Fragments of glass of similar date suggest that another cycle may once have existed in the Church of St Cyngar at Hope in Flintshire, and also possibly at the Church of Corpus Christi, Tremeirchion, where a head of St Anne remains. Mostyn Lewis identified the glass at Tremeirchion as being derived from earlier examples at York, possibly by a York master 'using local assistants'. Lewis, *Stained Glass in North Wales*, plates 6 and 7.

The parentage and early history of the Virgin Mary are described in detail in the New Testament Apocrypha.[155] The special status of Mary, bestowed on her by her virginal conception of Jesus, was reinforced by the story of her own immaculate conception in the body of her mother, Anne.[156] Images of Anne and her aged husband Joachim appear in the only surviving cycle of the life of the Virgin in Wales, made in glass for the Church of All Saints, Gresford, in 1498. The cycle includes the birth of the Virgin and scenes of her early life, such as her being taken to the Temple by her mother.[157] The 'canopy of honour' over the altar at the Church of St Elian at Llaneilian-yn-Rhos contains a scene of St Anne teaching the Virgin to read, but the faded condition of the paintings makes it difficult to determine whether the image was accompanied by others from the cycle.[158] The concentration of these images of the Virgin, all of which date from the late fifteenth century and from north-east Wales, reflects patterns of patronage and the accident of survival rather than a peculiarity in the intensity of devotion towards her in that area at that time. For instance, at the Church of St Mary, Treuddyn, in Flintshire, an image of the Virgin painted on glass, possibly from an Annunciation scene, probably dates from the late fourteenth century.[159] The equal popularity of the cycle of the Life of the Virgin in south Wales is attested by poems written for patrons there. One work, composed by Hywel Swrdwal on the subject of Anne and Joachim, makes reference to a shrine of the Virgin at St David's, known from another source to have included an image not only of Mary but also of her parents.[160]

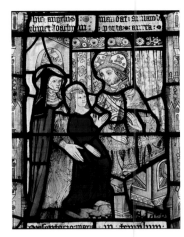

324. St Anne Teaching the Virgin Mary to Read, Church of St Elian, Llaneilian-yn-Rhos, Denbighshire, 15th century, Panel painting

325. The Virgin Mary, probably part of a depiction of the Annunciation, Church of St Mary, Treuddyn, Flintshire, late 14th century, Painted glass

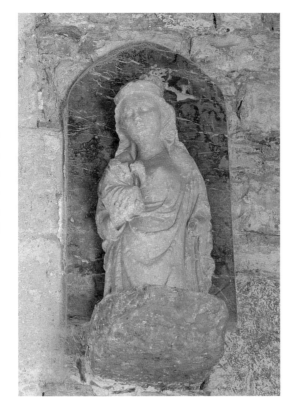

326. The Virgin and Child, Priory Church of St Mary, Cydweli, Carmarthenshire, 14th century, Stone, originally full length, approx. ht. 1500

327. The Seal of the Cistercian Abbey of Margam, depicting the Virgin and Child, 1530, Wax, 58 x 39

As we have seen, the commonplace iconography of the Virgin did not strictly reflect the narrative sequence of the events of her life. Depictions such as that at Cydweli combined the image of Mary as mother of Christ, with the infant in her arms, and the image of Mary crowned and sometimes enthroned as the Queen of Heaven.[161] Several of the surviving seals of Cistercian monasteries which, by a statute of the fourteenth century, were required to image the Virgin Mary, also follow this iconography. The Church of St Mary, Cilcain, Flintshire, possesses the only surviving example in Wales of the Virgin in tears, an iconographic variant well known elsewhere in Europe. The three central figures of the Cilcain crucifixion remain in their correct relationship one to another, but the flanking figures of St Michael and St Peter must originally have been elsewhere since the landscape background of Golgotha, liberally sprinkled with bones, is discontinuous.

[158] For the iconography of St Anne teaching the Virgin to read and its implications for the understanding of female literacy in the Middle Ages, see Pamela Sheingorn, '"The Wise Mother": The Image of St Anne Teaching the Virgin Mary', *Gesta*, XXXII/1 (1993), 69–80.

[159] For the dating of the Treuddyn glass, see Lewis, *Stained Glass in North Wales*, pp. 90–2.

[160] 'No maiden was ever so fair as Our Lady of Monmouth; she is my health to me', Evans (ed.), *Gwaith Hywel Swrdwal a'i Deulu*, p. 86, lines 61–2, and pp. 190–1. Glanmor Williams, *The Welsh Church from Conquest to Reformation* (rev. ed., Cardiff, 1976), p. 493, refers to a shrine of the Virgin at St David's, 'presumably in the chapel of St Mary mentioned in Bishop Edward Vaughan's will'.

[161] The Cydweli Virgin and Child had an unusually troubled history. The sculpture was presumably concealed at the time of the dissolution, but was eventually recovered and found a place above the porch of what had become the parish church. It remained there until at least 1846, but shortly thereafter was taken down and buried by a zealous incumbent who took exception to the devotion with which it was regarded by his parishioners. The statue was exhumed in 1875 but kept from public view until c.1922 when it was reinstated in the body of the church. D. Ambrose Jones, 'Figure of the Blessed Virgin at Kidwelly', *Arch. Camb.*, 7th series, II (1922), 415. The sculpture as now displayed omits fragments from the lower part, which make it clear that the Virgin was depicted standing rather than enthroned. See D. Daven Jones, *A History of Kidwelly* (Carmarthen, 1908), plate XV.

328. The Crucifixion, with St John and the Virgin Mary in tears, Church of St Mary, Cilcain, Flintshire, early 16th century, Painted glass

329. The Assumption of the Virgin, from the throne of Bishop John Marshall, Llandaff Cathedral, Glamorgan, late 15th century, Painted panel, 1500 × 1440

The imaging of the Assumption of the Virgin into heaven is represented by a panel painting which originally formed the back of the throne of Bishop John Marshall of Llandaff. It was commissioned in 1485 and well illustrates not only the widespread conventions of the iconography of the scene but also the close identification of individual patrons with the subject. Bishop Marshall is portrayed standing in adoration as the red-robed Virgin is carried into heaven by angels.[162]

[162] Another image of the Assumption, which is also closely associated with the devotion of an individual donor, survives as part of the tomb of Richard Herbert of Ewias. See below, pp. 247–8.

[163] The interpretation of these paintings as representing events connected with the life of St Nicholas is not universally accepted. See Geoffrey R. Orrin, *Medieval Churches of the Vale of Glamorgan* (Cowbridge, 1988), p. 123.

[164] Thirty niches in the tower originally contained sculpture. The central statue in the group on the western face is a Virgin and Child. The patron saint of the Wrexham church, St Giles, is depicted with his tokens, a deer and an arrow, on the central boss of the vaulted porch. The design of the tower has been attributed to William Hort. See Edward Hubbard, *The Buildings of Wales: Clwyd (Denbighshire and Flintshire)* (Harmondsworth and Cardiff, 1986), p. 300.

[165] Hebrews 12:1.

[166] For an earlier painted group of the evangelists at St David's Cathedral, where they are represented symbolically, see above, p. 106.

The weaving into the liturgical year of the festivals of the saints is reflected in the numerous iconic representations which remain in churches, carved on tombs and painted on glass, walls and panels. Depictions of complete cycles of the lives of saints were probably largely confined to those churches to whom they were dedicated, though at the Church of St Michael, Colwinston, in the Vale of Glamorgan, a painting around a niche at the side of the chancel arch may depict two events connected with the life of St Nicholas. Against it and below the rood screen probably stood an altar dedicated to the saint. An image of the consecration of St Nicholas and the miracle he wrought by saving a child which had been left by his mother in a bath while she was at church probably represent the survivors of what was once a more extensive cycle.[163] Such visual narratives of the lives of saints probably existed in other churches but were destroyed at the Reformation, though single depictions of individuals would always have been more common. As the serried ranks of saints on the tower of the Church of St Giles at Wrexham indicate, they were often assembled together in groups.

The late medieval date of the Yale Tower at Wrexham, the construction of which probably began in 1506 but continued until at least 1520, demonstrates the vigour of the devotion to the saints by wealthy patrons on the eve of the Reformation.[164] Similar groups of saints were frequently contrived on features inside churches

330. John Boydell, *The North-East View of Wrexham Church in the County of Denbigh*, 1748, Engraving, 394 × 522, detail

331. Scenes from the Life of St Nicholas, Church of St Michael, Colwinston, Glamorgan, 14th century, Wall painting

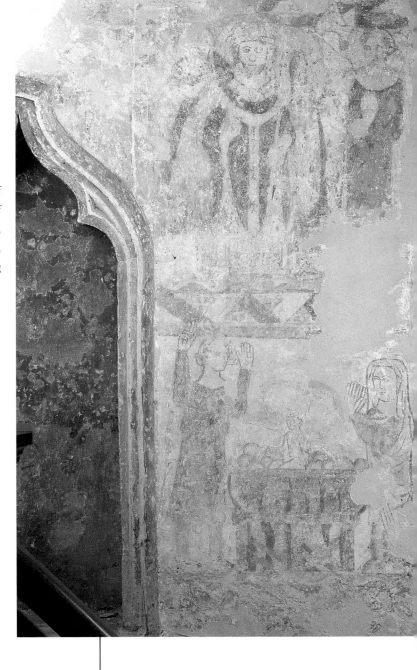

within the period. At the Church of St Benedict, Gyffin, near Conwy, sixteen panels form a semi-circular canopy of honour over the altar. The canopy served both to celebrate the Apostles and saints by placing them as a 'cloud of witnesses'[165] in proximity to the most sacred part of the building and also to reinforce the sense of communion with the saints felt by the devout as they witnessed the sacrifice of Christ at the mass. The panoply of saints included the four evangelists, identified by their symbols and placed centrally in a group directly over the altar.[166] Beside them, on the upper row, stand the Virgin Mary and St Mary Magdalene. On the other side of the evangelists are the monastic saints, Bernard and Benedict (the patron saint of the church), whose presence is attributable to the fact that the church was the possession of the Cistercian monastery of Maenan.[167] The lower row, on both sides, consists of apostles and saints, including St Jude, who is identified by a boat, and St James the Less, who holds a fuller's bat, since he was believed to have been martyred by being clubbed to death. Canopies of honour were a feature of many churches by the end of the fifteenth century. The style of the example at Gyffin is sufficiently close to that of the less well-preserved canopy at the Church of St Elian, Llaneilian-yn-Rhos, to suggest that they may be the work of the same painter.

332. Canopy of Honour, Church of St Benedict, Gyffin, Conwy, Caernarfonshire, 15th century, Panel paintings

[167] The centrality of the group of the evangelists and the presence of two female saints and two monastic saints suggests that a symmetrical scheme was planned, but the images do not reflect one another from side to side. However, when the two sides of the scheme are drawn out on paper and compared, their plans are identical and perhaps represent the painter's intention. The north side plan in the upper row is, left to right: Mary Magdalene, St John, St Luke and (probably) St Benedict. The south side plan is: the Blessed Virgin, St Mark, St Matthew and St Bernard.

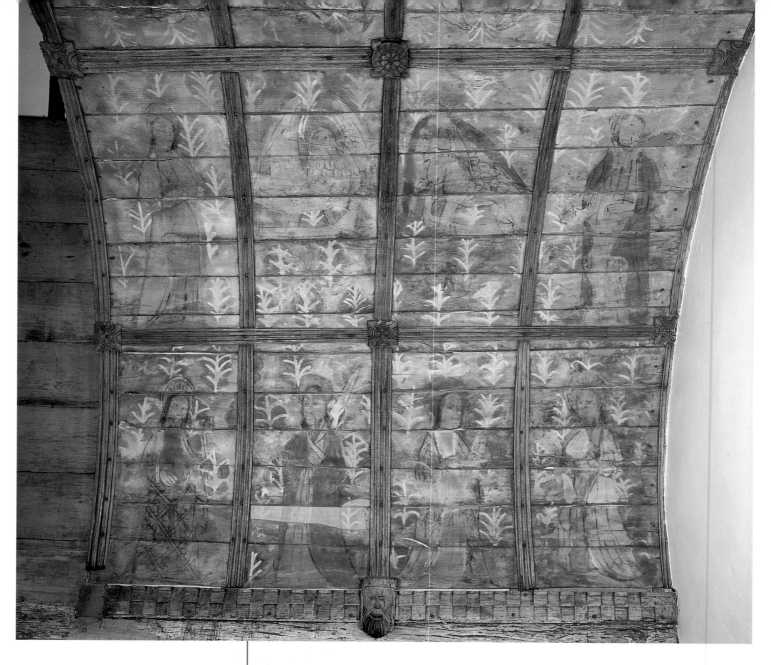

333. Canopy of Honour,
Church of St Benedict,
Gyffin, Conwy, Caernarfonshire,
15th century, Panel paintings

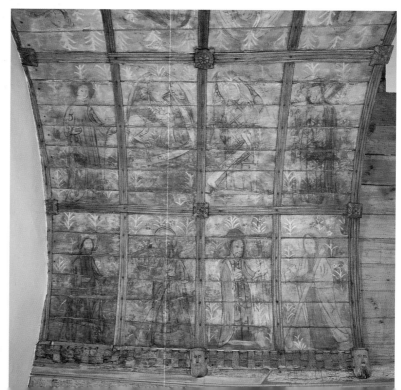

334. St Catherine of Alexandria,
Church of St Stephen,
Old Radnor, Radnorshire,
c.1461–83, Painted glass

335. St Christopher,
Priory Church of St Seiriol, Penmon,
Anglesey, late 15th century, Painted glass,
with 19th-century figure of St Seiriol

The wide distribution and frequency of the imaging of certain saints indicates the existence of a hierarchy of popularity. Female saints and martyrs came high on the list, and among them St Catherine of Alexandria was frequently depicted.[168] Her story was told in the Golden Legend, one of the most widely read devotional books of the later Middle Ages. It was composed around 1260 and some of the Lives which it contained were available in Welsh very soon thereafter.[169] In visual images Catherine was identified by the bladed wheel on which the emperor Maximus had intended to put her to death. She was spared that fate by divine intervention, only to be beheaded. The fifteenth-century glass at the Church of St Stephen, Old Radnor, depicts the saint carrying the wheel, but the image survives only as a fragment and she may well originally have been accompanied by other female saints and martyrs in the manner of the east window at Gresford.[170]

Perhaps the most dramatic representations of the saints, however, are to be found among images of St Christopher. His legend described him as a giant who, under his original name of Offerus, was charged with carrying travellers over a river. One night in a storm he carried a child, who subsequently identified himself as Jesus, and so he became Christopher – the Christ-carrier.[171] At the priory church at Penmon in Anglesey a bearded face, turned to look back over his shoulder and carrying a staff, is clearly a remnant of a St Christopher.[172] At the Church of St

[168] See Eamon Duffy, 'Holy Maydens, Holy Wyfes: The Cult of Women Saints in Fifteenth and Sixteenth Century England', *Studies in Church History*, XXIII (1990), 175–96. For St Catherine, see Katherine J. Lewis, *The Cult of St Katherine of Alexandria in Late Medieval England: An Introduction* (Woodbridge, 2000). Lewis argues that St Catherine was considered the primary female saint in late medieval England.

[169] The *Legenda Aurea* was composed by Jacobus de Voragine, but drew heavily on the apocryphal Gospels. Jacobus de Voragine, *The Golden Legend*, ed. William Granger Ryan (Princeton, 1993). The oldest surviving redaction in a Welsh-language manuscript, NLW Peniarth 5, dates from c.1350, but the translation is believed to date from c.1265–82, possibly the work of a monk at Llanbadarn Fawr or Strata Florida. J. E. Caerwyn Williams, 'Buchedd Catrin Sant', *Bulletin of the Board of Celtic Studies*, XXV, part 3 (1973), 248–9. For the manuscript as a whole, its date and patronage, see Huws, *Medieval Welsh Manuscripts*, pp. 227–68.

[170] Mostyn Lewis associated the Old Radnor glass with that at Llanwrin, above, pp. 178–9, both by virtue of its style and the presence of a rose motif associated with Edward IV, which would date the work to 1461–83. Lewis, *Stained Glass in North Wales*, pp. 5, 78. For a list of surviving depictions and a discussion of the imaging of female saints and martyrs, see Gray, *Images of Piety*, pp. 27–30.

[171] For further discussion, see the Appendix.

[172] In 1855 the image of St Christopher was reconstructed along conventional lines, which probably reflected the original. However, the construction of a second fragment of a hand holding a staff into an adjacent image of St Seiriol is speculative. Nevertheless, the association is an interesting one since Seiriol's monastery on Puffin Island was approached by means of wading over a tidal causeway from the mainland. A further example is to be seen at the Church of St Cyngar, Hope, Flintshire, though restoration of the window has jumbled the parts.

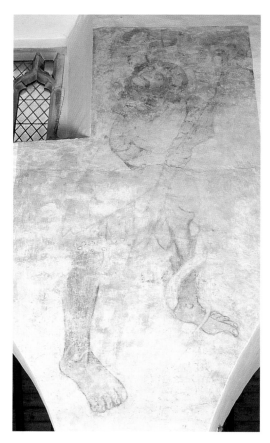

336. St Christopher,
Church of St Illtud, Llantwit Major,
Glamorgan, 15th century,
Wall painting, ht. 2440

337. St Christopher,
Church of St Saeran, Llanynys,
Denbighshire, 15th century,
Wall painting, ht. 3660

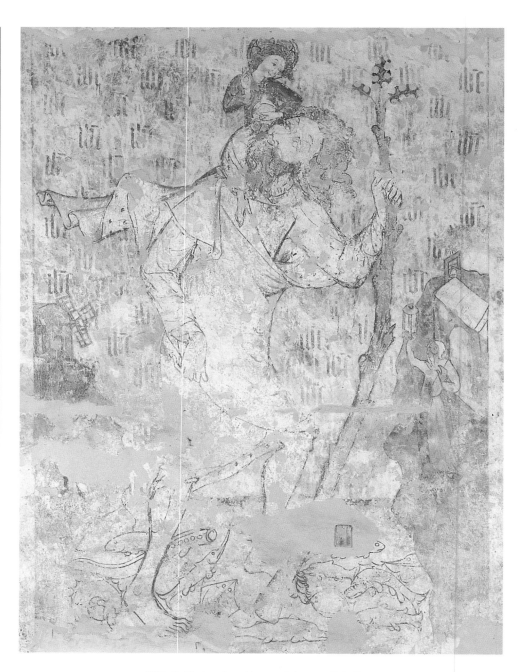

338. St Christopher, Norton Priory,
Cheshire, early 15th century,
Stone, ht. 3370, detail

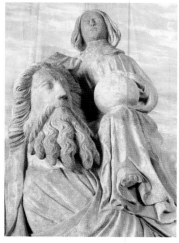

173 John Salmon, 'St Christopher in English Medieval Art and Life', *Journal of the British Archaeological Association*, 61 (1936), 76–115. The popularity of the saint was initially greater in continental Europe than in England. Most English images date from the second half of the fifteenth century or later. Images painted on glass suggest that this pattern of late popularity applied also in Wales.

174 His protective reputation also lies behind his talismanic depiction on a bronze belt fitting, dating from c.1400, found at Cydweli Castle.

Illtud, Llantwit Major, his image was painted high on the north wall of the nave, probably in the late fifteenth century, when the popularity of the saint reached its peak.[173] Since prayers to the saint were believed to give protection for the day, his image was commonly placed facing the door by which the devout left the church to face the

church (which at that time was located in Flintshire), her uncle witnessed the unfortunate event, restored her head to its proper position and disposed of Caradoc. On the departure of Beuno for Clynnog Fawr, Winifred became a nun and eventually an abbess at Gwytherin, and it was there that her cult first developed. Such was her popularity that her relics were removed to Shrewsbury abbey in 1138, but devotion to her persisted in Wales and the focus transferred to the site of her martyrdom. Holywell attracted pilgrims not only from within Wales but also in large numbers from England and overseas. The well was covered by a lavish structure on two levels – the chapel above and the vaulted well chamber below. It was adorned with sculpture depicting the lives of St Winifred and St Beuno carved on the ceiling bosses, which included elaborate cylindrical pendant bosses over the well itself.[187]

It is likely that there was also a large-scale image of St Winifred at Holywell.[188] However, so thoroughly were they sought out and destroyed at the Reformation that little remains of images and reliquaries which were the focus of the pilgrim's devotion, save for allusions to them in the poems of the fifteenth and

347. Roof boss with scenes from the Lives of St Winifred and St Beuno, Holywell, Flintshire, late 15th century, Stone

348. Anon., *St Winefreds Well, usually called Holy Well, near Flint in north Wales,* mid-18th century, Engraving, 229 × 392

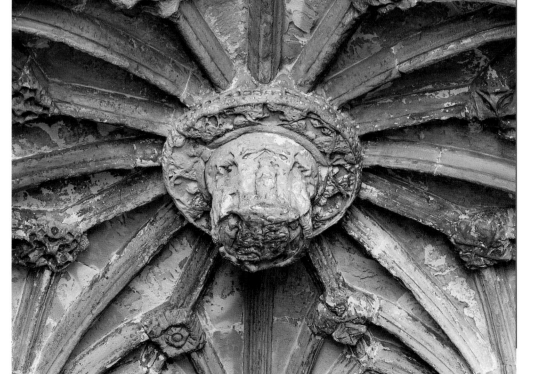

[184] The indulgence is described in detail in Edward Owen, 'Strata Marcella Abbey immediately before and after its Dissolution', *Y Cymmrodor*, XXIX (1919), 1–18.

[185] The window carried an inscription, subsequently rewritten, naming a priest, Robert Jones, as the donor, though whether Jones paid for the window or was instrumental in financing it is unclear. See Matthews, *The Llanrhaeadr Jesse Window*, p. 11.

[186] The church is known to have had medieval painted glass with subjects from the life of St Aelhaearn, St Beuno, and St Winifred. The glass was recorded in 1723. See RCAHM, *An Inventory of the Ancient Monuments in Caernarvonshire* (3 vols., London, 1956–64), II, p. 42, note 29.

[187] William Caxton printed a Life of St Winefride in English in 1485; it was possibly sponsored by Margaret Beaufort. See M. J. C. Lowry, 'Caxton, St Winifred and the Lady Margaret Beaufort', *The Library*, 6th series, 5 (1983), 101–17. However, Michael K. Jones and Malcolm G. Underwood, *The King's Mother: Lady Margaret Beaufort, Countess of Richmond and Derby* (Cambridge, 1992), p. 150, warn against the tradition of attributing patronage of St Winifred to Margaret Beaufort since there is no written or iconographic evidence. So well-known was the cult to the English that Winifred became a generic name for a Welsh woman. See Peter Lord, *Words with Pictures: Welsh Images and Images of Wales in the Popular Press, 1640–1860* (Aberystwyth, 1995), pp. 50–1.

[188] It was possibly located in the niche now occupied by the statue made in 1888.

349. Stag, Part of the Shrine of St Derfel, Church of St Derfel, Llandderfel, Merioneth, probably 15th century, Wood

[189] Williams, *The Welsh Church from Conquest to Reformation*, pp. 492–4 gives the location of many Marian shrines.

[190] For further discussion, see the Appendix.

[191] A *cywydd* by Rhisiart ap Rhys suggests that water from the well may have flowed through the Virgin's breasts, as at St Anne's well at Llanmihangel in Glamorgan, but the allusion may be figurative: '... [like] milk flowing from thy breasts, O wise and fair Virgin'. The poems in praise of the Virgin at Pen-rhys are discussed by Christine James, 'Penrhys: Mecca'r Genedl', in Hywel Teifi Edwards (ed.), *Cwm Rhondda* (Llandysul, 1995), pp. 27–71. T. Charles Edwards, 'Pen-rhys, y cefndir hanesyddol: 1179–1538', *Efrydiau Catholig*, V (1951), 24–45, gives the historical background and six of the poems in full, including that by Rhisiart ap Rhys, 43. For further discussion, see the Appendix.

[192] Letter to Thomas Cromwell, quoted in W. Gareth Evans, 'Derfel Gadarn: A Celebrated Victim of the Reformation', *Journal of the Merioneth Historical and Record Society*, XI, part 2 (1991), 143–4.

[193] The fact that fifteenth-century rebuildings were uncommon in Merioneth reinforces the significance of the income derived from pilgrimage in this case. Andrew Davidson, 'Parish Churches' in J. Beverley Smith and Llinos Beverley Smith (eds.), *History of Merioneth. Volume II: The Middle Ages* (Cardiff, 2001), p. 345.

[194] The fact that Price, who was not renowned for observing high ethical standards as a public servant, refused a bribe of £40 has led some commentators to question the reliability of his account of affairs at Llandderfel. Huw Pryce, 'The Medieval Church' in ibid., pp. 295–6, 345. For further discussion, see the Appendix.

[195] Since the Reformation the carving has been popularly known as 'Derfel Gadarn's Horse', probably because it carried the image of the saint or the reliquary on its back, but this identification is most unlikely. The stag or deer is a particularly suitable image as a focus for pilgrimage. See Barber, *Bestiary*, pp. 51–2, and Raymond P. Scheindlin, *The Gazelle: Medieval Hebrew Poems on God, Israel and the Soul* (Oxford, 1999), pp. 3–29. For further discussion, see the Appendix.

early sixteenth centuries. Judging by the volume of poetry, the statue of the Virgin at Pen-rhys in Glamorgan was among the most celebrated in Wales.[189] It was probably erected in the first half of the fifteenth century, at which point what seems to have been simply one of many wells associated with the Virgin began to assume greater importance.[190]

The evidence of the poems suggests that the statue was a crowned Virgin and Child, standing and perhaps with the head of Mary inclined towards Jesus. The figures, brightly coloured and gilt, were encrusted with jewels and elaborately robed.[191]

Dr Elis Price ('Y Doctor Coch'), the government's commissary general for the diocese of St Asaph, testified to the popularity of the shrines of local saints into the sixteenth century. Charged with their destruction, Price reported in April 1538 that:

> there ys an image of Darvelgadarn within the saide diosece, in whome the people have so great confidence, hope, and truste, that they cumme dayly a pilgramage unto hym, somme with kyne, other with oxen or horsis, and the reste withe money: in so muche there was fyve or syxe hundrethe pilgrames, to a mans estimacion, that offered to the saide Image the fifth daie of this presente monethe of Aprill.[192]

Llandderfel was yet another of those many churches rebuilt in the fifteenth century with the profits of pilgrimage on this substantial scale.[193] The parishioners were prepared to offer £40 to Price to spare the statue of St Derfel – 'Derfel Gadarn' – but the commissary persisted and arranged for its dispatch to London.[194] However, a part of the shrine, the wooden image of a stag at rest, was left in the church. It may have stood before or beneath the statue of the saint. A rectangular depression cut in the back of the animal suggests that it supported the reliquary or the image of the saint.[195]

All over Wales celebrations of local saints' days, like that of St Derfel, would have drawn crowds from some miles away, as the *pardons* of Brittany do to this day, by combining religious observance with the celebration of a sense of place and the simple indulgence of a holiday. But travelling to a major shrine within Wales or England[196] was a more serious undertaking, and travel overseas required particular determination, which was recognized by the church and the community it served. Pilgrims travelling great distances might engage in a public ritual of departure involving blessing and the exchange of their everyday clothes for a garb which, from the end of the eleventh century onwards, distinguished them almost as if they were a religious order:

351. St James as a Pilgrim, St David's Cathedral, Pembrokeshire, probably late 14th century, Stone, ht. 430

When the debts be thus paid and the meine is thus set in governance the pilgrim shall array himself. And then he oweth first to make himself be marked with a cross, as men be wont to do that shall pass to the Holy Land ... Afterwards the pilgrim shall have a staff, a sclavein, and a scrip.[197]

Among the most important destinations for Welsh pilgrims was Santiago de Compostella in Spain, the reputed burial place of St James the Apostle, who was conventionally depicted dressed as a pilgrim in a sclavein, a long cloak of coarse material, and carrying a staff and a scrip to hold food and money. A flowing cloak and the base of a staff on an elegant fragment of carving from Llanthony priory are sufficient to identify the subject as St James. These practical accoutrements were invested with symbolic significance in the manner characteristic of a period in which every aspect of the material world carried spiritual resonance. For instance, the pilgrim's staff was able to ward off marauding wild beasts, which were the agents of the Devil: 'the staff is the pilgrim's third leg, and three is the number of the Trinity; the staff therefore stands for the conflict of the Holy Trinity with the forces of evil'.[198]

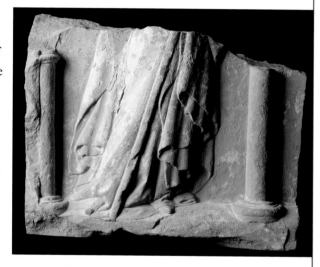

350. St James the Apostle, found at Llanthony Priory, Monmouthshire, late 15th century, Stone, ht. 240

[196] For example, that of St Wulfstan at Worcester, which attracted considerable numbers of Welsh pilgrims. See Emma Mason, *St Wulfstan of Worcester c.1008–1095* (Oxford, 1990), p. 249.

[197] Richard Alkerton, 1406, quoted in Jonathan Sumption, *Pilgrimage: An Image of Mediaeval Religion* (London, 1975), p. 171.

[198] Ibid., p. 173.

354. Pilgrim Ampullae in the form of scallop shells, St David's Cathedral, Pembrokeshire, 14th–15th century, Lead, ht. 40

352, Effigy of a Pilgrim, Church of St Tyfodwg, Llandyfodwg, Glamorgan, probably 14th century, Stone, l. 1900

centre right:
353. Effigy of a Pilgrim, Church of St Mary, Haverfordwest, Pembrokeshire, mid-15th century, Stone, l. 2100, detail of scrip

355. Pilgrim's Cap Badge from Rome with St Peter and St Paul, 14th–15th century, found at Laugharne, Carmarthenshire, Lacquered, 38 × 35

[199] See above, p. 114, note 45.

[200] John and Rees, *Pilgrimage: A Welsh Perspective*, p. 31.

[201] For the wider importance of this route, see above, p. 64.

[202] The similarity and proximity of these images suggests that the same carvers may have been at work. Among their repertoire of images were many animals, including an elephant. The Church of St Mary, Mold, has similar external decoration and may also be linked to Holywell by the patronage of Thomas Stanley. A very similar carving survives at Worcester Cathedral, which was originally associated with the shrine of St Wulfstan, to which Welsh pilgrims often travelled.

356. Misericord, perhaps depicting St Govan, St David's Cathedral, Pembrokeshire, 1470, Wood

Those who had journeyed to one of the major destinations sometimes chose to be memorialized as pilgrims on their burial slabs. The garb of unknown individuals buried at the Church of St Mary, Haverfordwest, and the Church of St Tyfodwg, Llandyfodwg, Glamorgan, displays scallop shells which indicate that they had visited Santiago de Compostella. By the end of the twelfth century it was no longer necessary for pilgrims to collect their own shells from the coast before departure because badges cast in lead were on sale at the shrine.[199] The providers of this service were regulated by the church authorities, who took a percentage of their sales. A further development was the ampulla, a phial for carrying blessed oil or holy water and cast in the shape of the scallop shell. Those who had ventured to Rome were identified by images of the Apostles Peter and Paul, both of whom were believed to be buried there. The cap badge of a pilgrim who had visited the city was found at Laugharne, perhaps near his or her place of landing on return. Among the many visitors staying at the English College in Rome at Easter 1507 were thirty-six laymen, five women and three priests representing all four of the Welsh dioceses.[200] They may have travelled in groups, which were sometimes blessed communally before departure at a large church, such as St Mary's, Tenby, where scallop shells are carved among the roof bosses. Tenby was probably a popular point of departure for a voyage to south-western France, where Welsh pilgrims joined others travelling the land routes to Santiago de Compostella which began at Paris, Vezelay and Trier.[201]

Towards the end of the Middle Ages carvers occasionally presented images of the common people who formed the bulk of those who

went on pilgrimage to sites both near and far. At Holywell a sick person is depicted being carried to St Winifred's well on the back of another. A similar image is to be found among the rich adornments of the

358. Sick Pilgrim and Porter, Church of St Chad, Hanmer, Flintshire, late 15th century, Stone

357. Sick Pilgrim and Porter, Holywell, Flintshire, late 15th century, Stone

exterior of the Church of St Chad at Hanmer, also in Flintshire.[202] St David's Cathedral has a set of twenty-eight misericords carved in 1470, among which is an image of four people in a boat. One of them has not travelled well. He is traditionally regarded as St Govan, depicted on his return from pilgrimage to Rome, though since neither he nor his companions are identified as pilgrims by their accoutrements, it may be that the image simply represents the discomfort of travel by sea. On such fittings as misericords and in architectural detail images of the common people certainly increased in number through the fifteenth century, within the broader array of kings, queens, saints and Gospel narratives. We have noted the realistic representations of ordinary people in marriage and death in the glass of the Church of St Tyrnog, Llandyrnog, made at the end of the fifteenth century, and in the same way the column capitals at the contemporary Church of St Mary,

359. Human Faces from capitals and arches, Church of St Mary, Haverfordwest, Pembrokeshire, 14th century, Stone

360. Meurig ap Llywelyn ap Hwlcyn and his wife, Marged ferch Ifan Fychan, and Owain ap Meurig and his wife, Elin ferch Robert, Church of St Cadwaladr, Llangadwaladr, Anglesey, c.1500, Painted glass

[203] Similarly, puritan opinion was also inclined to regard the enthusiasm of the common people for pilgrimage as the gratification of the desire for secular entertainment rather than as a sign of piety. Those depicted at prayer in the Llangadwaladr glass are Meurig ap Llywelyn ap Hwlcyn and his wife Marged ferch Ifan Fychan, and Owain ap Meurig and his wife Elin ferch Robert. Following the conventional self-identification with the historical witnesses at the Crucifixion also seen in the Aubrey tomb at Brecon Cathedral and the Church of St Dyfnan, Llanddyfnan, Meurig and Marged kneel under the Virgin Mary and Owain and Elin kneel under St John. Between them King Cadwaladr is enthroned beneath the Crucifixion. The glass dates from 1490–5. The figures of Meurig and Elin, and the head of Cadwaladr, include nineteenth-century restoration. For a detailed analysis of the window, see Richard B. White, 'The Llangadwaladr East Window: An Examination of the Inscription and its Personae', *Anglesey Antiquarian Society and Field Club Transactions* (1969–70), 80–110.

Haverfordwest, display many faces which are clearly individuated. Nevertheless, images of the common people were outnumbered by those of the wealthy, whether individuated or as types. Moreover, with increasing frequency, the wealthy had themselves portrayed within the works they commissioned to adorn rebuilt churches undertaken in this period.

The motivation of patrons such as the two couples depicted in the east window of the Church of St Cadwaladr at Llangadwaladr, Anglesey, at the end of the fifteenth century was regarded with suspicion by some contemporaries. They felt that ostentation of this kind reflected self-aggrandizement in this world rather more than care for the soul in the next.[203] When political circumstances and such a radical critique came into alignment in the third decade of the following century, many if not most of these images were swept away. A longer perspective suggests that worldly and pietistic motives were not necessarily in conflict in the patronage of the wealthy in this period. What is certain is that throughout the fifteenth century many more patrons than in the past had emerged from the shadows of medieval anonymity. Their ambition and increasing self-confidence was reflected in a flowering of patronage, both public and private, both religious and secular, which characterized Wales during the hundred years before the Reformation.

Indeed, the poet Dafydd ab Edmwnd, one of the most important figures in the evolution of the bardic tradition, was himself a Hanmer and flourished probably in the period of the rebuilding of the church.[8] However, such comprehensive literary and visual patronage must have been less common than the presentation of individual items to enrich existing churches such as a brass lectern, formed by the back and wings of an elegant eagle, at the Church of St Giles, Wrexham.[9] Among the most distinguished of such gifts in the form of metalwork were the chandeliers in the churches of St Garmon, Llanarmon-yn-Iâl and St Tegla, Llandegla, Denbighshire. The serpentine branches of both chandeliers enclose images of the crowned Virgin. The Llanarmon-yn-Iâl example is the more elaborate, but the proximity of such rare survivals in neighbouring churches strongly suggests

366. Detail of a Lectern, Church of St Giles, Wrexham, Denbighshire, c.1524, Brass

[6] Thomas Dineley, *The Account of the Official Progress of His Grace Henry the First Duke of Beaufort through Wales in 1684* (London, 1888), pp. 98–9, described the church and noted in particular 'Sr John Hanmere's Chancell window' and imagery in several others. The church was destroyed by fire in 1889.

[7] M. H. Lee, 'Calvary Cross in Hanmer Churchyard', *Arch. Camb.*, 4th series, VII (1876), 210, identified the arms as those of the Lestrange family of Knockin. M. P. Siddons, *The Development of Welsh Heraldry* (3 vols., Aberystwyth, 1991–3), II, p. 534, gives the Lestrange (or Strange) arms as Gules, two lions passant Argent or Gules, lions passant gardant. The Hanmer arms are Argent, two lions passant gardant Azure, ibid., I, p. 177; II, pp. 217–18. Given the already decayed and colourless condition of the cross when it was described and drawn in 1876, the identification of the arms on the cross at Hanmer as those of the Lestrange family seems perverse.

[8] For Dafydd ab Edmund, *fl.* 1450–97, see Meic Stephens (ed.), *The New Companion to the Literature of Wales* (Cardiff, 1998), pp. 143–4.

[9] The lectern from which the Gospels were read was often given the form of an eagle with wings spread in flight. The bird symbolizes the Resurrection – the idea of new life in Christ – and, by extension, the inspiration of the Gospels. See Psalm 103:5 and for the Old Testament typology, Isaiah 40:31.

367. Angel, Church of St Idloes, Llanidloes, Montgomeryshire, 1542, Wood

368. Angel, Church of All Saints, Gresford, Denbighshire, late 15th century, Wood

369. Revd John Parker, *Side View of Corbels in Llanidloes Church*, 1828, Pen and wash, 160 × 115, Corbels, Wood, 1542

[10] According to T. W. Pritchard, *The Parish Church of St Garmon, Llanarmon yn Iâl, Clwyd* (Wrexham, n.d.), pp. 29–30, only six chandeliers of pre-Reformation date survive in Britain. Pritchard suggested that Sir Evan Lloyd (d. 1586) might have been the patron on the basis of his having been in the Low Countries. However, he would have been most unlikely to install images of the Virgin in parish churches in the second half of the sixteenth century even if he had Catholic sympathies, as is sometimes suggested.

[11] See above, pp. 208 and 215.

[12] The nearest large church destroyed at the dissolution was Basingwerk, but there is no evidence of the removal of the roof from the monastery.

that they were both the gift of a local gentry family, perhaps the Lloyds of Bodidris. The chandeliers were made in the Low Countries – the source, as we shall see, of many of the most expensive and sophisticated items which attracted the wealthiest Welsh patrons of the second half of the fifteenth century.[10]

The concentration of examples in the north-east of Wales, at churches such as St Chad, Hanmer, and most importantly All Saints, Gresford (where Thomas, Lord Stanley, was again a benefactor), indicates that glass was particularly favoured by the new patrons, as was woodwork. Indeed, the rebuilt church at Gresford provides examples of both, for in addition to its celebrated glass[11] the roof is an elaborate structure of square panels, enlivened by heraldic motifs and supported by the flying angels which are characteristic of several contemporary rebuildings. The large size of the angels which mask the ends of the hammerbeams at the Church of St Mary, Cilcain, and the massive structure of the roof in what is a relatively small church have led some to believe that the timbers and carving were taken from a dissolved monastery.[12] The roof at Cilcain is further elaborated by

carved plates at the bases of the simple trusses which alternate with the hammerbeams in the elaborate structure. Similar traditions concern the impressive roofs at the Church of St Idloes, Llanidloes, and the Church of St Collen at Llangollen, but they are almost certainly spurious. As we have seen, the stone arcade at Llanidloes was taken from the abbey at Cwm-hir, but dendrochronological tests show that the timbers were cut in 1537/8 and cannot therefore have come from the abbey.[13] The roof was made especially to cover the reused arcade and was completed in 1542. Patrons even of parish churches of moderate size sometimes expressed grand aspirations in their commissions. The framing of the panels in the roof at Llangollen (and some of the infill) displays an extraordinary

[13] We are grateful to Richard Suggett of the Royal Commission on the Ancient and Historical Monuments of Wales for this information. The fact that the roof at Llanidloes did not come from the abbey at Cwm-hir reinforces the belief that the abbey was burnt by Glyndŵr, though there is no contemporary written evidence bearing on the matter. See J. F. O'Sullivan, *Cistercian Settlements in Wales and Monmouthshire, 1140–1540* (New York, 1947), pp. 108–9.

370. The Roof of the Church of St Mary, Cilcain, Flintshire, late 15th–early 16th century, Wood, and details

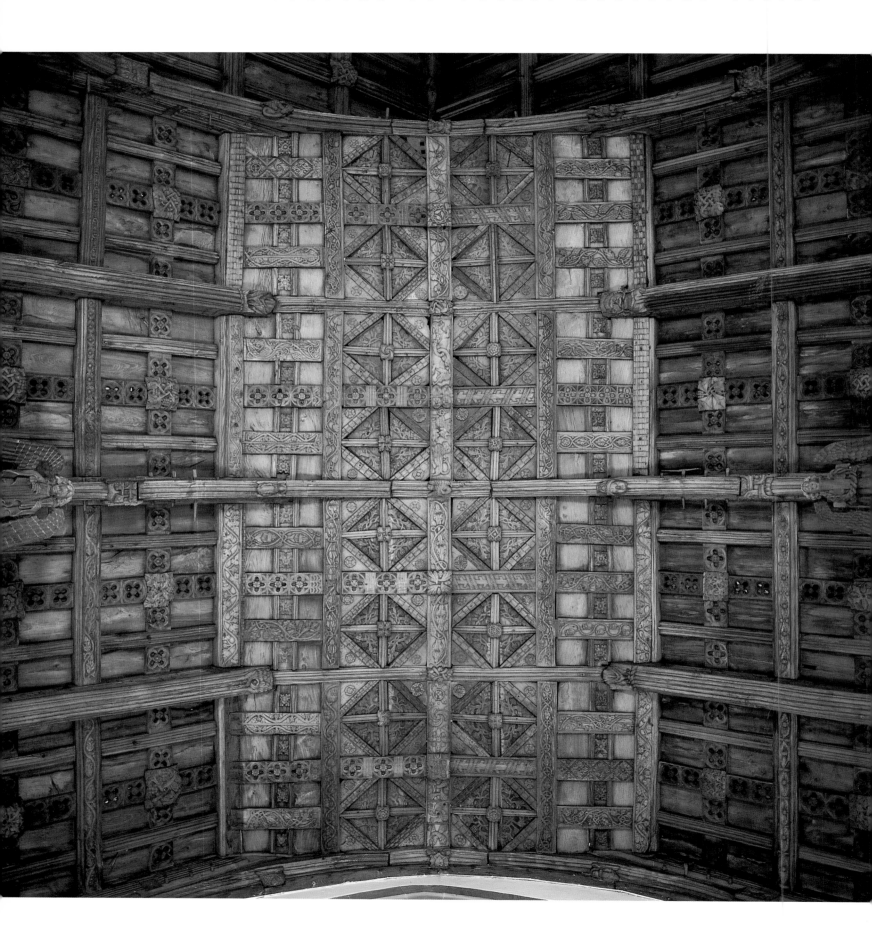

repertoire of figurative, heraldic and decorative designs, among which are unusual interlace patterns which are of particular interest in the context of the late manifestation of such motifs on memorial slabs at the abbey of Valle Crucis nearby.[14]

The sophistication of wood carving throughout Wales is particularly evident in choir stalls and their misericords.[15] Carvers seem to have felt free when making misericords to draw on a particularly extensive range of images, including scenes of everyday life, animals taken from the bestiaries, heraldry, biblical and apocryphal subjects. Little attempt was made to achieve overall coherence, though the set of twenty misericords at the Church of St Mary, Beaumaris, is bound together with unusual discipline by a common format.[16] All display heads or busts, which act as supporters to winged angels carrying shields. One pair seems to be taken from life since it depicts people in late fifteenth-century dress. A woman carries on her head two flagons tied by a rope and another bears a sheaf of corn. A second pair probably represent a bejewelled Solomon and the Queen of Sheba, who wears her crown.[17] At St David's the Tudor imagery of the stalls, and in particular the carving of pomegranates on two bench ends and running along the bressumer – suggest that their construction may have coincided with the marriage of Prince Arthur, eldest son of Henry VII, to Catherine of Aragon in 1501. Catherine's emblem was the pomegranate. Furthermore, a date of between 1497, when the treaty of marriage was ratified, and 1501, when the ceremony took place, would date the stalls to the episcopacy of Bishop John Morgan,

[14] See above, pp. 118–19.

[15] For misericords in general, see M. D. Anderson, 'The Iconography of British Misericords' in G. L. Remnant, *A Catalogue of Misericords in Great Britain* (Oxford, 1998), pp. xxiii–xl. The catalogue lists all those extant in Wales, pp. 201–8, including examples such as those from Bangor Cathedral which have been removed from their original location, p. 203.

[16] Ibid., pp. 201–2.

[17] I Kings 10:1–13 and 2 Chronicles 9:1–12. The theme is wisdom, judgement and justice.

371. The Roof of the Church of St Collen, Llangollen, Denbighshire, late 15th century, Wood, and detail

372. Misericords, Church of St Mary, Beaumaris, Anglesey, c.1500, Wood

373. Misericord, St David's Cathedral,
Pembrokeshire, late 15th–early 16th century, Wood

[18] For the dating of the stalls, see Wyn Evans, 'St Davids Cathedral: The Forgotten Centuries', *Journal of Welsh Ecclesiastical History*, 3 (1986), 73–92 and idem, 'The Reformation and St Davids Cathedral', ibid., 7 (1990), 1–16. For colour illustrations of all the misericords, see Nona Rees, *The Misericords of St Davids Cathedral, Pembrokeshire* (rev. ed., St David's, 1997). The bressumer is the high horizontal beam, often elaborately decorated, which links the stalls. The term is also used to describe the similar transverse beam of a rood screen.

[19] Anderson in Remnant, *A Catalogue of Misericords in Great Britain*, p. xxxvii, suggests that the owl, sometimes mobbed by small birds, was used in the Middle Ages to symbolize the Jewish people because they were associated with darkness. However, she also cautions against understanding every image from the period in terms of a symbolic sub-text, ibid., p. xxvii, and indeed the benign naturalism of the St David's owl does not immediately suggest complex meaning. Rees, *The Misericords of St Davids Cathedral*, p. 12, states that the image may refer to the belief that owls were the only birds which would nest in ivy. Since ivy was the plant associated with Bacchus, the allusion was to drunkenness. A Green Man is also carved on the Romanesque capitals of the nave at St David's – possibly the earliest occurrence of the image in Wales, ibid., p. 13. For the Green Man, see Fran and Geoff Doel, *The Green Man in Britain* (Stroud, 2001).

whose patron was Henry VII.[18] The imagery of the misericords is more characteristically varied and ranges from scenes of human activity, such as boat-building, and scenes from nature, such as an owl sitting on a branch of ivy, to fabulous beasts and grotesques, including a Green Man.[19]

The south choir stalls at Abergavenny priory, broadly of the same date, are similarly rich in Tudor imagery. Surmounting the ends of the stalls are a group of beasts, probably inspired by the 'king's beasts' which are displayed prominently at St George's Chapel at Windsor Castle, the intended burial place of Henry VII.[20] The lion, the mastiff and the unicorn also appear among the six misericords which survive from a set of twenty-two stalls carved for the Dominican friary at Brecon, alongside a cadaver image.[21] However, the carving is less sophisticated than that found on misericords in most other Welsh churches. They were probably made *c.*1525–35 and reflect a renewal of conventual life and corporate worship for which

374. Misericords,
Chapel of Christ College,
Brecon, *c.*1525–35

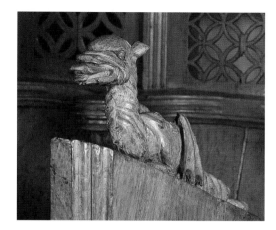

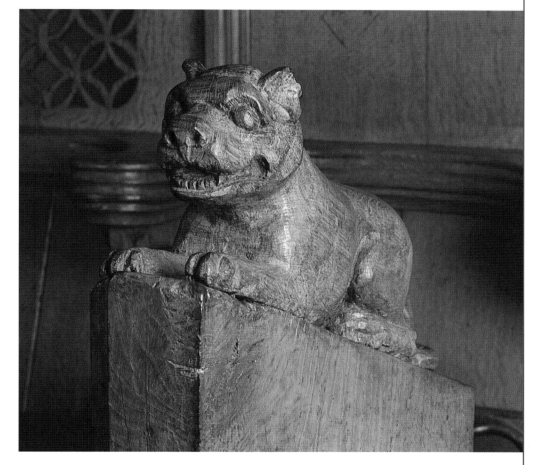

375. The King's Beasts,
Priory Church of St Mary,
Abergavenny, Monmouthshire,
late 15th–early 16th century,
Wood, approx. l. 500

[20] In the event, Henry VII was buried at
Westminster. The stalls on the north and south
sides of the Priory Church of St Mary, Abergavenny,
were carved at different dates and the misericords
were reorganized at an early stage. See Fred H.
Crossley, 'Screens, Lofts, and Stalls Situated in
Wales and Monmouthshire', *Arch. Camb.*, CVIII
(1959), 20–8. On the south side a stall-end carries
the name Wynchester, the prior from 1493 to
1516. One of the misericords carries a crowned
Tudor rose, perhaps to commemorate the marriage
of Prince Arthur in 1501, but it may have been
carved after the others. The king's beasts were
derived from the heraldic supporters of shields of
arms which proclaimed the descent of the Tudor
dynasty from Edward III, and thus its legitimacy.

[21] For cadaver images, see above, p. 195. The
remains of the friary church are now incorporated
in the chapel of Christ College, Brecon.

[22] The inventories compiled by the bishop of
Dover in 1538 with reference to the dissolution
of the Welsh friaries refer to 'new stalls' at Brecon,
Bangor, Rhuddlan and Haverfordwest, all of which
were Dominican houses.

there is evidence in several Welsh Dominican communities on the eve of the
Reformation.[22] The simplicity of the carving reflects that at another small institution,
the Cistercian nunnery at Llanllugan, Montgomeryshire. An idiosyncratic panel
of a hunting scene, a dragon and a crucifixion, which presumably represent a lost
narrative, survives in a private house but almost certainly came from the nunnery.
It is less clear whether an adjacent roof boss depicting an owl is from the same

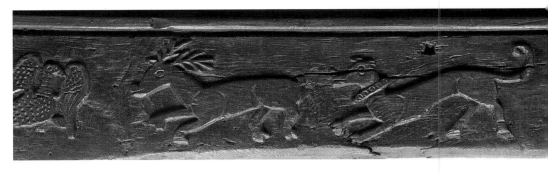

376. Carved Panel, probably
from the Cistercian Nunnery
at Llanllugan, Montgomeryshire,
late 15th–early 16th century,
Wood, l. 3070

23 For other fragments of the glass and for the
foundation of the nunnery, see above, pp. 166–7.
Richard Plantagenet, the duke of York, was Lord
of Cedewain. He was a man of immense wealth
and a noted patron of painted glass, as was his
wife. At Oddingley in Worcestershire she
commissioned glass comparable with that at
Llanllugan. It probably came from the workshop
of Richard Twygge and Thomas Wodshawe, who
were active in the West Midlands in the second
half of the fifteenth century.

24 D. R. Thomas, *The History of the Diocese of
St Asaph* (3 vols., Oswestry, 1908–13), II, p. 336.

377. An Abbess,
from the Cistercian
Nunnery at Llanllugan,
Montgomeryshire,
mid-15th century,
Painted glass

source, but its striking similarity to the
stalls at the Dominican friary in Brecon
is scarce and noteworthy testimony to the
coherence over a wide area of artisan practice
which must have met many secular as well as religious needs. The carving may be
a little later than the more sophisticated painted glass commissioned in 1453 by
Richard, duke of York, father of Edward IV. Fragments from several windows in
the convent church survive, gathered together in the east window, including the
achievement of arms which identifies the donor. Among other fragments is the
image of an abbess, kneeling in prayer, probably the convent superior at the time
of the commission.[23]

378. Carved Boss,
possibly from the Cistercian
Nunnery at Llanllugan,
Montgomeryshire,
early 16th century, Wood

As we have noted, the Glyndŵr rebellion did not mark
the end of the depredations of the fifteenth century.
William Herbert, earl of Pembroke, a partisan of the Yorkist
cause in the Wars of the Roses, burnt Llanrwst in 1468
and among the casualties was presumably the woodwork
of the Church of St Grwst. The work of replacement was
apparently underway soon after 1470 and the new rood
screen was among the most elaborate and finely carved in
Wales.[24] Substantial parts survived the Reformation, including
the rood itself, which was glimpsed by Thomas Dineley
in 1684 when he accompanied Henry Somerset, William
Herbert's direct descendant, on a progress through Wales:

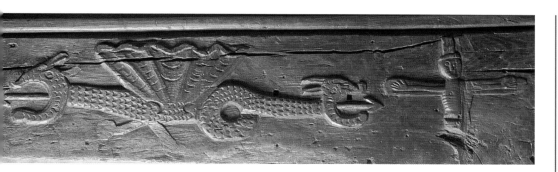

379. Revd John Parker, *Tracery at Llanrwst,*
Denbighshire, c.1830, Pen and wash,
110 × 225, Screen of late 15th century

Over the Timber Arch of the Chancell neer the Rood Loft, lieth hid the
ancient figure of the Crucifixion as bigg as the life. This I suppose is shewn
to none but the curious, and rarely to them.[25]

The rood was subsequently lost, but the screen on which it was mounted
retains its vaulted loft with canopied niches for other figures, along with the
elaborate horizontal traceries of the bressumer and the elaborations of the
heads of the arches of the partition itself.[26] Such an elaborate screen would have
been expensive to commission and no evidence has come to light regarding the
identity of the patron. The reconstruction of the church may represent the efforts
of a group of townspeople. The carving of the screen is elaborate and largely
decorative although, as we have seen, it includes the Instruments of the Passion

[25] Dineley, *The Account of the Official Progress of
His Grace Henry the First Duke of Beaufort through
Wales,* p. 147. Crossley, 'Screens, Lofts, and Stalls',
Arch. Camb., XCIX (1946), 36, supposed the figure
seen by Dineley was the Mostyn Christ, for which,
see above, pp. 163–4. However, this seems
unlikely given that Dineley specifically described
the sculpture as a crucifixion, and it is reasonable
to suppose that he was, indeed, shown the rood.
Crossley correctly refuted the idea that the Mostyn
Christ had been part of the rood at Llanrwst. For
further comments by Dineley and others on the
depredations and survivals of the Reformation and
the civil wars, see Peter Lord, *The Visual Culture of
Wales: Imaging the Nation* (Cardiff, 2000), pp. 54–6.

[26] The reputation of the screen was sufficient to
inspire the poet Ieuan Llwyd Brydydd, who was
blind by the time he wrote, to meditate upon its
meaning. See M. Paul Bryant-Quinn (ed.), *Gwaith
Ieuan ap Llywelyn Fychan, Ieuan Llwyd Brydydd a
Lewys Aled* (Aberystwyth, 2003), pp. 111–13,
151–5.

380. Revd John Parker,
*The Legend of St Monacella,
at Pennant Melangell,
Montgomeryshire*, 1837,
Watercolour, 115 × 240,
Screen of late 15th–early
16th century

381. Details of a Sedile,
Church of St Mary, Nercwys,
Flintshire, constructed from
parts of a screen of late
15th–early 16th century

382. Screen, Church of
St Mary and All Saints,
Conwy, Caernarfonshire,
c.1497–1501, Wood

and an *Agnus Dei*.[27] Its local identity may have been expressed more clearly
in the lost figures from the niches. It was common practice to include saints
directly related to the church or to the locality in the way that some screens carried
narratives, carved lineally on the bressumer, which were specific to their location.
At Pennant Melangell, for instance, the myth of the local saint, Melangell, was
depicted, confirming the continuing attraction of the ancient shrine to devotees.[28]

Many screens of the period survive only as fragments. Sometimes they were
reconstructed into other forms, as at the Church of St Mary, Nercwys, Flintshire,
where some of the parts were rebuilt as a seat or sedile. The surviving elements
at Nercwys suggest an unusual example even when considered in terms of the
considerable variation which is evident in both design and construction methods
throughout the country.[29] Regional patterns have been discerned in various parts
of Wales, but these were sometimes interrupted by screens constructed in remote
workshops or by craftsmen imported from outside at the behest of an individual
patron. The screen at the Church of St Mary and All Saints, Conwy, is one of
a small group whose design suggests that they were prefabricated in English
workshops or constructed on site by English craftspeople.[30] Among the carvings on
the screen at Conwy is a red eagle's claw grasping a fish, the emblem of Sir Richard
Pole, who was constable of Conwy Castle and presumably the patron. Prominently
displayed Tudor roses and the pomegranates of Catherine of Aragon suggest

[27] See above, pp. 164–5.

[28] See above, pp. 76–7.

[29] Fred H. Crossley, 'Screens, Lofts, and Stalls
Situated in Wales and Monmouthshire', *Arch.
Camb.*, XCVIII (1945), 190–2. Crossley was
unable to match the elements 'by any other
remains within the Principality'. He believed that
the modern colouring was based on the original
scheme.

[30] Other screens which Crossley suggested were
of English workmanship include those at Clynnog
Fawr, New Radnor, Gresford and Usk. Ibid., 81.

383. Inscription from a Fragment of
the Screen, Church of St Mary, Llanfair
Waterdine, Shropshire, late 15th–early
16th century, Wood

31 The period extending from the treaty of
marriage of Catherine to Prince Arthur and
the marriage ceremony.

32 Sir Richard Pole was a member of Prince
Arthur's household which was based at Ludlow
and related by marriage to the queen. Crossley,
'Screens, Lofts, and Stalls', *Arch. Camb.*, XCVIII
(1945), 83.

33 Attempts to interpret the notation began with
Samuel Rush Meyrick, whose paper on the matter,
originally delivered in London to the Society of
Antiquaries, was published some four years later.
Samuel R. Meyrick, 'Inscription at Llanvair
Waterdine, Shropshire', *Arch. Camb.*, 1st series, II
(1847), 298–314.

34 Mike Salter, *The Old Parish Churches of Shropshire*
(Wolverhampton, 1988), p. 46. Salter does not
give a source for the transliteration or a text.

that the screen was made in the period between 1497 and 1501.[31]
The screen design is notable for the wooden vaulting carrying the
gallery, the style of which has been related to the work of craftspeople
from the Ludlow area.[32] The less grandiose aspirations of most patrons
are represented by the surviving fragments of the screen from the
Church of St Mary, Llanfair Waterdine, on the border between Montgomeryshire
and Shropshire, which is probably not the work of a specialist carver. The images
include animals which may have formed a narrative particular to the place (as at
Pennant Melangell), though the standing figures represent characters in the dress
of the period. The most remarkable feature of the screen is its inscription, which
early investigators understood as musical notation.[33] Subsequently it has been
transliterated and shown to be a commemoration in the Welsh language of the
donors, Sir Matthew Pichgar, rector of the mother church at Clun between 1485
and 1520, and his brother Meyrick. Why they chose to be memorialized in such
an idiosyncratic fashion is a mystery.[34]

As we have seen in the case of stone-carved fonts and effigies, regional or
workshop styles were not confined to Wales. In the borders many screens share
the characteristics of those produced in Herefordshire and Gloucestershire.

384. Screen, Church of St Jerome,
Llangwm Uchaf, Monmouthshire,
15th–early 16th century, and detail

Among the screens from the eastern counties of Wales, that in the Church of St Jerome, Llangwm Uchaf, Monmouthshire, though much restored, gives an impression of the great elaboration of the woodwork which might be found even in a small church.[35] Similarly, the south coast was affected by interaction with the south-western counties of England, as it had been since the early Middle Ages. Trading patterns exerted their influence in both directions. When new pews and a pulpit were commissioned for the Church of St Petroc at Bodmin in Cornwall in 1491, the timber was imported from Wales and prominent among the patrons was one John Glyn.[36]

The repertoire of decoration and imagery used by the carvers of church screens was also carried into domestic commissions. At Glasbury the roof timbers of the fifteenth-century vicarage were elaborated with a grotesque, a head of a woman in contemporary dress, and a bishop, all in a manner familiar to church carving of the same period.[37] Surviving examples from entirely secular buildings are uncommon, though their scarcity probably reflects the particular vulnerability of such buildings (especially in urban locations) to redevelopment rather than their rarity in the fifteenth and sixteenth centuries. The exterior of the Old Hand Inn at Wrexham, for instance, displayed standing figures like those at Llanfair Waterdine, vine

385. Head of a Woman, Glasbury Old Vicarage, Radnorshire, early 15th century, Wood

386. Edward Meredith Jones, Carving of the late 15th–early 16th century from the exterior of the Old Hand Inn, Wrexham, Denbighshire, c.1899

[35] The neighbouring church at Llangwm Isaf appears to have had a similarly elaborate screen. See Crossley, 'Screens, Lofts, and Stalls', *Arch. Camb.*, CVIII (1959), 49. For the restoration of the Llangwm Uchaf screen by Seddon in 1871, see ibid., 49–54.

[36] Cornwall Record Office, The Bodmin Register, B/BOD/245. £4 was paid in advance for the timber and a further £4 on delivery. The contract sets out the requirements of the group of patrons in terms of a comparison with woodwork already made for another church, at Moretonhampstead in Devon. The new pulpit was to be of the same standard 'or better'. Although the example is from England, both the commission from a group of patrons and their use of work in another place with which they were familiar to define their requirements probably reflects common practice in Wales.

[37] Many more such carvings probably elaborated the building as constructed. The date of the building and almost certainly of the carvings (since they adorn structural members) may be as early as c.1400.

387. Heads from the Prior's Lodgings,
Monmouth, late 15th–early 16th century,
Stone, ht. 450 and 400

[38] For example, a carving of two rabbits who share three ears, a motif also to be found at St David's Cathedral and in several churches in Devon. The Old Hand Inn was demolished in 1899. Its woodwork was described and illustrated in Alfred Neobard Palmer, 'A Destroyed Tudor Building in Wrexham', *Arch. Camb.*, 6th series, I (1901), 173–8.

[39] The carvings survive in the Church of St Thomas, Overmonnow, and seem to be either the originals of two similar carvings which remain *in situ* at the prior's house or additional images which have been removed. Keith Kissack, *Monmouth: The Making of a County Town* (London and Chichester, 1975), p. 4, describes the *in situ* sculptures as a knight and a miller. An angel also survives.

[40] For instance, the painted portrait of Bishop John Marshall of Llandaff, above p. 210, or the four donors of the Llangadwaladr glass, above p. 224.

[41] Welsh portrait paintings of the sixteenth century are discussed in Peter Lord, *The Visual Culture of Wales: Imaging the Nation* (Cardiff, 2000), pp. 22–31.

[42] There is no heraldic confirmation for the traditional belief that the double portrait represents Thomas Stanley and Margaret Beaufort. See above, p. 227, note 5. However, the portrait formerly thought to have been of Sir William is now known to have been a misattribution.

scrolls, heraldic beasts and motifs like those at Conwy, and animals with mythological associations as at Pennant Melangell.[38] Similarly, surviving examples of stone-carved images from secular urban settings are scarce. Like the Glasbury wood carvings, two heads at Monmouth come from a building with religious connections, in this case the Prior's Lodgings.[39] Many more buildings, especially those of a corporate nature, such as market and guild halls, may have displayed similar imagery in the fifteenth and early sixteenth centuries.

388. Roof boss,
possibly depicting Sir William Stanley
and Elizabeth Hopton, Holywell,
Flintshire, late 15th century, Stone

Scarcity does not afflict the visual record of the secular patrons and their spiritual counterparts who commissioned such works. As we have seen, painted donor portraits in glass, on panel and in miniature, were all familiar by the end of the fifteenth century.[40] Memorial portraits in brass had increased in popularity by the beginning of the sixteenth century and were soon followed by portraits of the living on panel or canvas which were commissioned to hang in frames in the new and rebuilt houses of those made wealthy by the acquisition of land or by trade.[41] Sir William Stanley, who rebuilt the Church of St Chad at Holt with its ostentatious font, commissioned a portrait before his premature demise in 1495, as did his elder brother Thomas. He may also be imaged on a boss at the well of St Winifred, Holywell, where he faces his wife Elizabeth.[42]

The earliest surviving portrait brass in Wales dates from the early fifteenth century. It depicts Wenllian Walsche of Llandough, near Cowbridge, Glamorgan, who died in 1427, and it was probably made, like most of its contemporaries, in London, the centre of the engravers' craft in England.[43] The origins of the brass to Richard Foxwist in the Church of St Peblig, Llanbeblig, are less certain. Foxwist was depicted on his deathbed in 1500 holding a shield with a symbolic representation

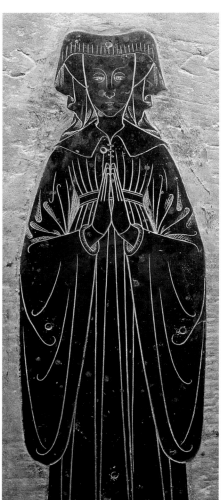

389. Memorial to
Wenllian Walsche,
Church of St Dochdwy,
Llandough-juxta-Cowbridge,
Glamorgan, c.1427,
Brass, ht. 775

of the Five Wounds. At his side an ink container and a bundle of quill pens symbolize his profession of notary.[44] However, the most obvious manifestation of the desire of the wealthy of all classes to be imaged for posterity remained the tomb effigy. The essentials of the form remained unchanged from those of the fourteenth century: effigies lay on chests lined with the images of family members or religious subjects, and were either free-standing or recessed into a wall. However, the high Gothic arches of niches such as that enclosing the tomb of Sir Roger Berkerolles and his wife at St Athan[45] descended into the compressed ogee arches of the Tudor period, often accompanied by columns and pedestals which reflect the renaissance of interest in the classical world which was changing the architecture of the period. The tomb of John Butler and Jane Bassett at the Church of St Brides Major, Glamorgan, characterizes the form as it had evolved by the Reformation. John Butler died in 1540, though his tomb may be earlier, since, as we have seen, it was by no means uncommon for patrons to commission their memorials during their own lifetime. The modernity of the tomb is compromised by one curious detail – John Butler is depicted cross-legged, in the style of the Bristol workshops of the fourteenth century. Conservatism on the part of a local craftsperson is unlikely to explain such an anachronism. For instance, not far away in Gower, the effigies of Sir John Penrice and his wife Margaret Fleming were certainly of local manufacture and had dispensed with crossed legs a hundred years earlier. Not that the Penrice tomb and an elegant

390. Memorial to Richard Foxwist,
Church of St Peblig, Llanbeblig,
Caernarfonshire, c.1500, Brass,
190 × 240, detail

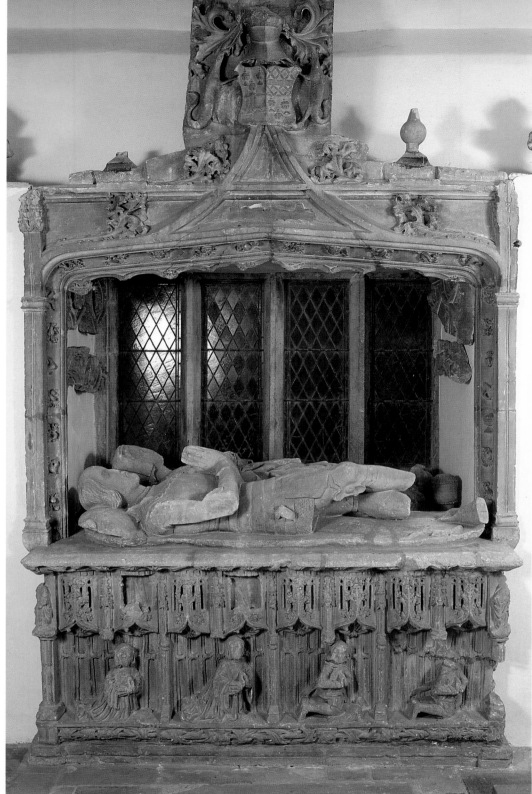

391. Tomb of John Butler and Jane Bassett, Church of St Bride, St Brides Major, Glamorgan, c.1540, Stone

head from their castle at nearby Oxwich were entirely commonplace. Most unusually they were carved from a composite material manufactured using local sand.[46] Perhaps the active, cross-legged posture of John Butler, incongruously combined with the repose of the rest of his body, his hands held together in prayer, is a reference to the incised tomb slab of his ancestor, John le Botiler, nearby.[47] In all other respects his tomb is thoroughly modern.

[43] J. M. Lewis, Welsh Monumental Brasses: A Guide (Cardiff, 1974), pp. 36–7. Since brass sheet had to be imported and the trade was carried through London, engravers were concentrated there. See ibid., p. 9. On p. 35 Lewis illustrates a rubbing of the only known Welsh brass of an earlier date, a half effigy of a priest. Made c.1370, it was formerly at St Non's Chapel, St David's, but is now lost.

[44] For details of the career of Foxwist, see ibid., p. 40.

[45] See above, p. 126.

[46] The identification of the effigies is discussed by Edward A. Martin, 'The Doolamur and the Dolly Mare: two medieval effigies', Gower, 30 (1979), 27–35. Geoffrey R. Orrin, The Gower Churches: A Survey of the Churches in the Rural Deanery of West Gower (Swansea, 1979) begs to differ, but Martin's argument that they represent Sir John Penrice and Margaret Fleming is convincing. Sir John had been captured by Owain Glyndŵr in December 1403 and remained a prisoner until 1408. He died two years later.

[47] See above, p. 124.

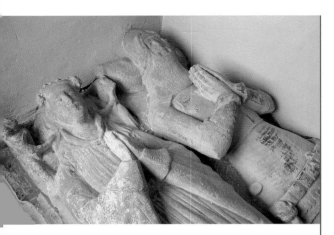

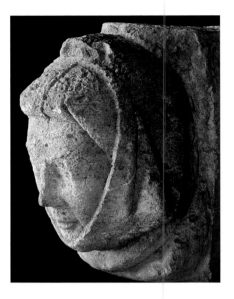

The Butler tomb is elaborated with secular imagery only, though avant-garde patrons who chose to do so could also manifest their awareness of contemporary good taste with religious subjects. One such patron was the well-connected Bishop John Morgan of St David's during whose episcopate, as we have seen, the choir stalls were commissioned and the elaborate bishop's throne, built in the mid-fourteenth century, was restored and emblazoned with his arms and devices.[48] The end panel of the bishop's tomb depicts the Resurrection in the Renaissance manner of images transmitted northward from the Continent through the medium of woodcuts.[49] The prints had a particularly strong influence on the alabaster carvers in England, who manufactured tombs like that of John Morgan, along with reredos and also panels for display as framed single items. His choice of subject for the panel at his feet set Morgan firmly in the mainstream, since the Resurrection is the most common image among those carved alabasters which have survived the Reformation.[50]

392. Effigies of John Penrice and Margaret Fleming, Church of St Illtud, Oxwich, Glamorgan, early 15th century, Composite material, l. 1890

393. Head, formerly at Oxwich Castle, Glamorgan, late 14th–early 15th century, Composite material on limestone block, ht. 314

[48] Notwithstanding its manufacture in the mid-fourteenth century, the throne almost certainly post-dates the patronage of Bishop Gower, who died in 1347. Charles Tracy, 'The St David's Cathedral Bishop's Throne and its Relationship to Contemporary Fourteenth-century Ecclesiastical Furniture in England', *Arch. Camb.*, CXXXVII (1988), 113–18.

[49] Wyn Evans and Roger Worsley, *St Davids Cathedral 1181–1981* (St David's, 1981), p. 68.

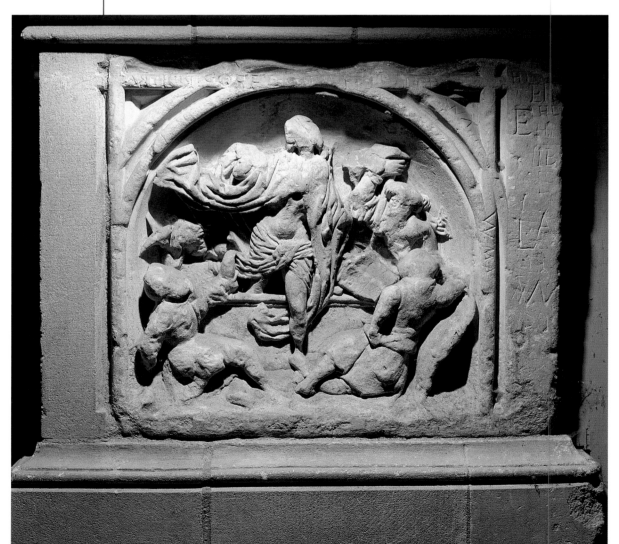

394. The Resurrection, from the Tomb of Bishop Morgan, St David's Cathedral, Pembrokeshire, c.1504, Alabaster, 560 × 630

Alabaster was generally the material of choice for the effigies of all but the wealthiest of fifteenth- and early sixteenth-century patrons. Only bronze was more prestigious. Effigies were made either in small workshops in Nottinghamshire and Derbyshire, near the quarries, or in London, though the precise origin of a tomb is difficult to determine without documentary evidence.[51] However, the hand of an individual or workshop can sometimes be detected in several commissions. The splendid tomb of Sir Richard Herbert of Ewias at the Priory Church of St Mary, Abergavenny, is

395. Sleeping Beadsman, from the Tomb
of Sir William Matthew and his wife Janet,
Llandaff Cathedral, Glamorgan, before 1530,
Alabaster, ht. 210

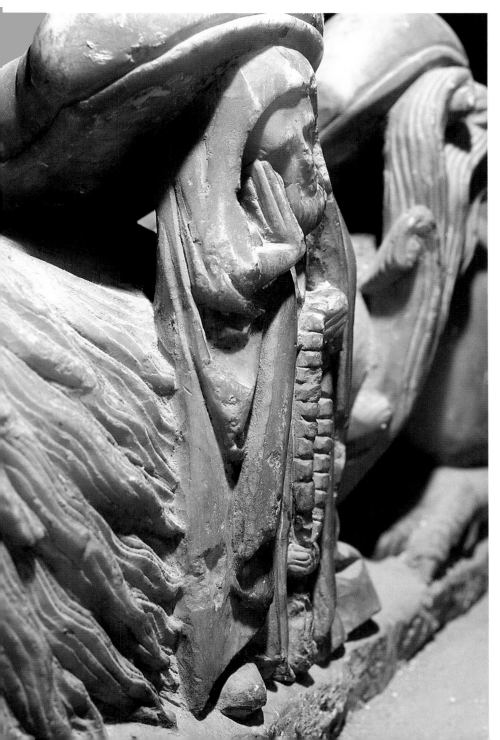

[50] 144 images are known to survive. See the catalogue of the exhibition, Francis Cheetham, *The Alabaster Men: Sacred Images from Medieval England* (London, 2001), p. 14. The emblem of the Resurrection also appears above the figures of Sir Hugh Johnys and his wife Maude on a distinguished brass made for the Church of St Mary, Swansea, c.1510. See Lewis, *Welsh Monumental Brasses*, pp. 42–3.

[51] Phillip Lindley, *Gothic to Renaissance: Essays on Sculpture in England* (Stamford, 1995), pp. 23–9, provides an introduction with further references to the practice of alabaster carvers in England. Although alabaster was probably used originally as a substitute for expensive white marble from the Continent, it eventually became an important English export, especially to Normandy, as both carved and raw material.

396. Sleeping Beadsman,
Church of St Saeran,
Llanynys, Denbighshire,
late 15th century, Wood

397. The Assumption of the
Virgin Mary, from the Tomb of
Sir Richard Herbert of Ewias,
Priory Church of St Mary,
Abergavenny, Monmouthshire,
c.1510, Alabaster, ht. 900

notable for a panel of the Assumption, before which he lies, in which a dramatic lateral compression emphasized the verticality of the motif. Remarkably, the post-Reformation desecration of the tomb was concentrated on the faces of the patrons, rather than on that of the Virgin, which survives intact. By means of a humorous but discreet feature the tomb can be linked to commissions from at least one other Welsh family. Beneath the foot of Sir Richard, and hidden within the niche in which he lies, is carved a sleeping beadsman – a monk paid to pray for the soul of the deceased. The image probably represents the trade mark of a particular carver or workshop since it is to be found, similarly placed, on two tombs of the Matthew family at Llandaff Cathedral.[52] The sleeping beadsman

[52] The carver may have worked at Chellaston in Derbyshire. The same image is to be found on several tombs in England, including that of Sir Ralph Fitzherbert (d. 1483) at Norbury, Derbyshire.

[53] Nevertheless, there may be a specific sculptural inspiration for the caricatures made by the Derbyshire carver. Among the most famous of the early alabaster effigies was that of William of Wykeham at Winchester Cathedral. At his feet sit three monks, alert at prayer. The image is illustrated in Wim Swaan, *The Late Middle Ages: Art and Architecture from 1350 to the Advent of the Renaissance* (London, 1977), p. 33.

[54] For a description of the tombs, see Edward Laws and Emily Hewlett Edwards, *Church Book of St Mary the Virgin, Tenby* (Tenby, 1907), pp. 71–6.

398. Charles Norris,
The House of the White Family of Tenby,
c.1812, Watercolour, 124 × 161

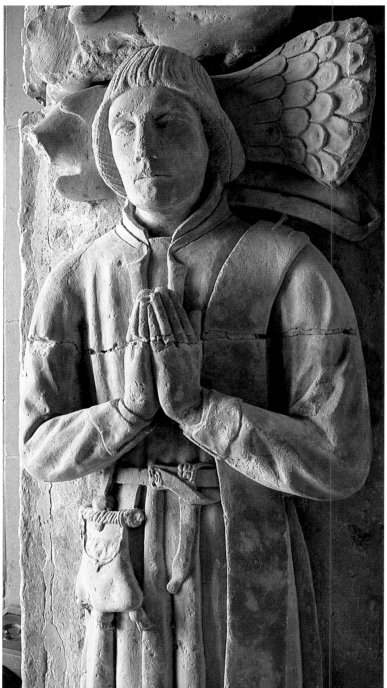

was clearly a well-known figure of fun in the late fifteenth and early sixteenth centuries. He is also depicted in a wood carving on the contemporary roof of the Church of St Saeran, Llanynys, Denbighshire.[53]

The choice of alabaster for memorials reflected the wealth and power of the patron rather than gentry status. In the Church of St Mary, Tenby, lie the alabaster tombs of Thomas White, 'formerly merchant and Mayor of this town', and his son, John, who owned houses nearby.[54] The tombs stand in line – an unusual arrangement – with the son's head at his father's feet. They were probably commissioned *c*.1490, during John's lifetime but following the demise of Thomas in 1482. The inscriptions

399. Tomb and detail of the Effigy of Thomas White, Church of St Mary, Tenby, Pembrokeshire, late 15th century, Alabaster, l. 1830

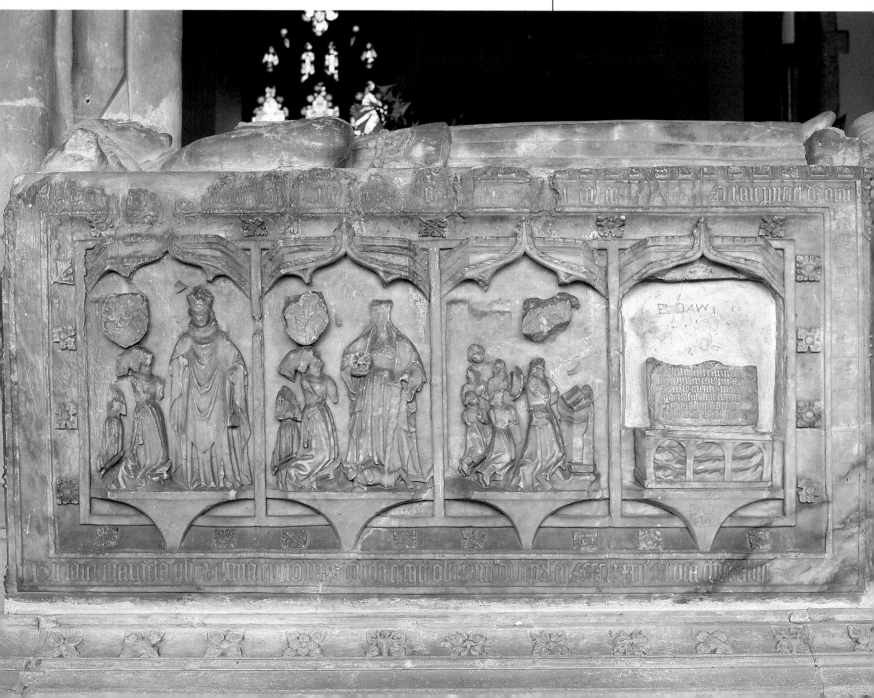

remind visitors of their own mortality and invite prayers for the souls of the deceased, who include the women of the family – Joan Howel and Isabella Butler, wives of Thomas, and Margareta Phillips and Christina Eynon, wives of John. St Catherine, St Thomas, St John the Evangelist and St John the Baptist are depicted below.[55] The power and distinction of the family did not rest entirely on their commercial success. In 1471 Thomas White had provided the boat in which Jasper Tudor, earl of Pembroke, and his nephew Henry Tudor, escaped together to Brittany following the battle of Tewkesbury. The reward for this service came after the return of Henry to Pembrokeshire, from where he marched to success at Bosworth Field. Thomas White did not live to see the day of his victory, but his son was granted the lease of all the new king's lands in the area.[56]

[55] St Thomas appears on the tomb of John White, while the two saints John appear on the tomb of Thomas, giving rise to the suspicion that the chests had at some time been taken apart, resulting in the jumbling of the panels. It is possible that the two tombs were originally one, with the effigies located side by side, though sited, perhaps, in a different part of the church.

[56] George Owen of Henllys provides this information, quoted in Laws and Edwards, *Church Book of St Mary the Virgin, Tenby*, pp. 13–14.

[57] The Free Library of Philadelphia, Rare Book Department, MS Lewis E 201. The manuscript is described in James R. Tanis (ed.), *Leaves of Gold: Manuscript Illumination from Philadelphia Collections* (Philadelphia, 2001), pp. 228–32. The other streams of the descent of Edward IV were the earls of Clare and Mortimer, the kings of France, the kings of England and the dukes of Normandy.

[58] NLW MS Peniarth 23C may be of the same period as the pedigree roll of Edward IV, but is more likely to be somewhat later, *c*.1500. See J. Gwenogvryn Evans, *Report on Manuscripts in the Welsh Language* (2 vols., London, 1898–1902), I, pp. 349–50. It is a redaction of Geoffrey of Monmouth's *History of the Kings of Britain*, probably a transcript of NLW MS Peniarth 21, written in the first half of the fourteenth century. An image of the Crucifixion from the manuscript is described and reproduced above, pp. 168–9.

[59] Other treasures of the princes were simply regarded as liquid assets. For instance, the seal matrices of Llywelyn ap Gruffudd, Dafydd and Princess Eleanor were transformed into a chalice for the abbey of Vale Royal. It has been unconvincingly suggested by A. J. Taylor, 'A fragment of a *Dona* account of 1284', *Bulletin of the Board of Celtic Studies*, XXVII, part 2 (1977), 253–62, that this chalice is to be identified with the Dolgellau chalice, above, pp. 100–1.

[60] Beauchamp was Master and Surveyor of the Works from 1472 until his death in 1481. The stone vaulting of the aisle in which the boss is incorporated was under construction by 1482. The boss probably dates, therefore, from the preparatory work done in the last year of the bishop's life, unless it is to be considered a *post mortem* memorial.

400. The Edward IV Roll, *c*.1461–4, Vellum, 4778 × 460, detail showing the descent of the Welsh kings

401. King Arthur, Illumination
from NLW MS Peniarth 23,
c.1500, 222 × 162

Although their service had been crucial at one stage, the White family was touched only at the periphery of the state by the long tentacles of patronage which extended outward from the monarch and by means of which government was effected. However, throughout the second half of the fifteenth century some Welsh individuals and families moved very close to the centre. The loyalty of Wales remained of great importance to the insecure English Crown and those willing to guarantee it were in a strong position. As we shall see, Henry VII's use of his paternal ancestry to exploit Welsh sentiment was abundantly manifested in his patronage, but his Yorkist predecessor, Edward IV, had also been aware of the potential of Welsh family connections. Following his coronation in 1461 a pedigree roll was commissioned which traced his descent (and thereby his legitimacy as monarch) through five streams. The primary stream, delineated in the left-hand column, described his descent from the ancient British kings in the tradition defined in the first half of the twelfth century by Geoffrey of Monmouth's *Historia Regum Britanniae*.[57] The currency of Geoffrey's work in the fifteenth century is evident in the substantial number of manuscript copies produced. Among them were Welsh-language redactions, one of which portrayed, in the manner of the painters of the pedigree rolls, several of the kings from Aeneas to Cadwaladr.[58] In 1475, four years after his restoration to the throne, Edward IV began the rebuilding of St George's Chapel at Windsor Castle as a grand statement of his power and authority and as a dynastic mausoleum. At three places in the building were carved representations of its most celebrated relic, the Croes Naid, a reliquary containing a fragment of the True Cross once owned by the princes of Gwynedd. After the death of Llywelyn ap Gruffudd it was taken by some of his erstwhile supporters and presented to Edward I at Conwy in 1283. Like the Stone of Scone, appropriated in Scotland by Edward, the transfer of the Croes Naid to London was a powerful symbol of conquest – of the removal of the divine source of the empowerment of the native dynasty.[59] No doubt it was as a symbol of the purported continuity of that dynasty in his own person that Edward IV gave it such prominence in his new chapel. The reliquary was represented on two roof bosses and, held by an angel, at the east window. In one of the bosses the cross is flanked by the figures of Edward and Bishop Richard Beauchamp, who kneel in adoration.[60] To what extent the bejewelled ring-headed cross depicted there, set on a stepped base, reflects the design of the object when it belonged to

402. Roof boss depicting the Croes Naid,
St George's Chapel, Windsor Castle,
Berkshire, c.1480–1, Stone

Llywelyn ap Gruffudd is impossible to say. It had certainly been substantially elaborated in 1352, probably to mark its installation in the predecessor to Edward IV's building, begun by Edward III in 1348.[61]

It is among those Welsh people who associated themselves closely with the Crown and became the direct agents of royal authority that we find the most extravagant patrons of visual culture. Being a great-grandson of Owain Glyndŵr was perhaps not the most promising starting point for a rise to power close to the English Crown, but John Dwnn of Cydweli proved to be a great survivor. He fought in the French wars, eventually in the service of Richard, duke of York, and in 1461 he participated in the battle of Mortimer's Cross by which Richard's son, Edward IV, came to the throne. He was rewarded with numerous positions and lands in south-west Wales, and the grant for life the office of Serjeant of the Armoury of the Tower. By 1466–7 his wife, Elizabeth Hastings, sister of the king's close friend Lord Hastings, was one of the queen's ladies-in-waiting. In 1471 he was knighted after the battle of Tewkesbury, which confirmed the restoration of Edward IV, who had been deposed the previous year. It was probably during Edward IV's brief exile, which he spent at the Hague and at Bruges, that the king acquired a taste for illuminated manuscripts. Subsequently he bought them in impressive numbers,[62] and Sir John Dwnn, the king's servant, followed his master's example in this prestigious and expensive activity. In the age of the printed book, the medieval tradition of calligraphy and illumination flourished as an art form rather than as a practical necessity for the transmission of texts and images. It rose to new heights of sophistication in Flanders, where John Dwnn had abundant opportunity to inspect and commission works from the hands of the best craftspeople. In 1472, 1477 and 1478 he negotiated on the king's behalf at the Burgundian and French courts.[63] Whether or not he had already begun his collection, the sumptuous gift of an elaborate copy of Vasco Fernandes de Lucena's translation of Quintus Curtius Rufus's history of the exploits of Alexander the Great must certainly have provided a considerable stimulus.[64] The gift, made by Margaret, duchess of Burgundy, whose husband, Charles the Bold, is depicted receiving the text in the opening miniature, indicates the proximity of Dwnn to the centre of power and to the intellectual life of the northern Renaissance.[65] Margaret was the sister of Edward IV and Dwnn, who had helped to negotiate, and subsequently attended, her wedding, probably received the book in recognition of his role in the negotiations for the marriage of Margaret's stepdaughter, Mary, in 1477. Both women inscribed the gift: 'For yet not har that ys on of yor treu frendes Margarete of Yorke' and '[P]renez moy ajames pour v[ost]re bonne amie Marie D. bourgne'.[66] The manuscript contains forty-nine miniatures, many of them accurately observed scenes of warfare enclosed

[61] The documents relating to the history of the Croes Naid are discussed in Winifred Coombe Tennant, 'Croes Naid', *National Library of Wales Journal*, VII (1951), 102–15 (originally published in the *Report* of the Society of the Friends of St George's Chapel, Windsor, 1943).

[62] See Janet Backhouse, 'Founders of the Royal Library: Edward IV and Henry VII as Collectors of Illuminated Manuscripts' in Daniel Williams (ed.), *England in the Fifteenth Century: Proceedings of the 1986 Harlaxton Symposium* (Woodbridge, 1987), pp. 23–41. At Bruges Edward stayed at the palace of Louis of Bruges, Lord of Gruuthuuse, a notable book lover at the court of Charles the Bold, ibid., pp. 25–6.

[63] Sir John Dwnn's career is summarized in Ralph A. Griffiths, *The Principality of Wales in the Later Middle Ages: The Structure and Personnel of Government, I, South Wales 1277–1536* (Cardiff, 1972), pp. 187–8. Griffiths mistakenly identified William, Lord Hastings, as Dwnn's father-in-law.

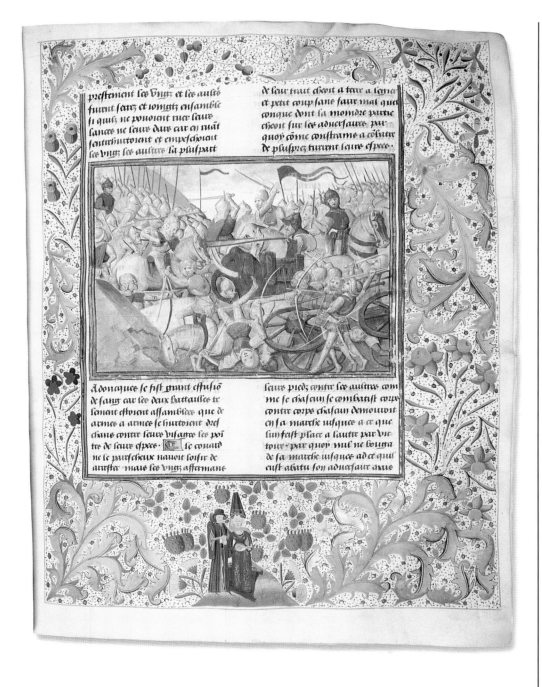

403. The Passage of
the Oxus; and The Battle
of Issus, Illuminations
from BL MS Royal 15D iv,
'Quinte Curse Ruffe des
faiz du grant Alexandre',
c.1467–77, 432 × 331

[64] BL MS Royal 15 D. iv. Vasco de Lucena
translated Quintus Curtius Rufus's text, *Res gesta
Alexandri Magni*, into French and enlarged upon it.
The French version is known as *Faiz du grant
Alexandre*.

[65] Charles the Bold's taste for classical culture was
reflected in that of many of the courtiers around
him. See Otto Cartellieri, *The Court of Burgundy:
Studies in the History of Civilization* (London, 1929,
repr. 1972), pp. 172–6. In the visual culture his
interest was expressed not only through the
medium of manuscript books but also in the
commissioning of tapestries on classical subjects
such as Hannibal, Alexander the Great and the
destruction of Troy.

[66] Janet Backhouse, 'Sir John Donne's Flemish
Manuscripts' in Peter Rolfe Monks and D. D. R.
Owen (eds.), *Medieval Codicology, Iconography,
Literature, and Translation: Studies for Keith Val
Sinclair* (Leiden, New York and Köln, 1994), p. 49.

[67] *The Catalogue of Royal Manuscripts* lists the
miniatures. The arms of Dwnn, obscured by an
erasure, had not been identified at the time of
writing the catalogue.

[68] The statues were, of course, largely denuded
of their original colour.

[69] BL MS Royal 16 F. v. For Dwnn's manuscript
collection, see Backhouse, 'Sir John Donne's
Flemish Manuscripts', pp. 48–53.

within elaborate floriated borders and occupying a whole page.[67] They were
painted in tones of grey, enlivened by tiny details of brilliant colour. The technique,
known as *grisaille*, was probably made fashionable as a result of the increasing
interest in the recovery of classical statues in Italy.[68]

Dwnn owned at least four Flemish illuminated manuscripts, one of which may
have been commissioned by him as a gift to Edward IV.[69] Like the Alexander the
Great manuscript, its opening miniature portrays the presentation of the book to

a king. However, Dwnn's arms are painted below the illumination, probably identifying him as the donor and Edward IV as the recipient. The texts are the Romance of Sydrac and Boctus,[70] followed by a theological work on the subject of the Revelation of St John. The latter is introduced by an illumination depicting the saint writing his text on the island of Patmos. St John was probably Dwnn's patron saint since he is also the subject of one of the illuminations to a manuscript

404. St Michael the Archangel overcoming the Devil; Sir John Dwnn and a Guardian Angel; and The Annunciation to the Virgin Mary, with a Portrait of Sir John Dwnn, Illuminations from the Louthe Hours, before 1483

[70] The work is a catechism of the medieval sciences in the form of a dialogue between an astronomer, Sydrac, and Boctus, king of the Bactrians. It was a popular work, of which Sir John Dwnn's copy is a late example in manuscript form. The work was available in print by 1486.

[71] BL MS Royal 20 B. ii.

[72] The manuscript, held at the Catholic University of Louvain, MS A2, is known as the Louthe Hours, after Thomas Louthe, previously and incorrectly identified as the patron.

405. Probably Sir John Dwnn
presenting a book to King Edward IV,
Illumination from BL MS Royal 16F v,
before 1483, 363 × 255

containing four saints' lives, in which Dwnn is again identified as the owner by his arms on the first folio.[71] However, the most explicit assertion of his patronage of the painters of illuminated manuscripts is the two portraits to be found among the many pictures and decorated borders of a book of hours, which is among the most elaborate and finely made Flemish works of the period.[72] The patron appears both in a border, as an observer of the Annunciation, and later as the subject of a framed illumination. He kneels before an altar at which a guardian angel appears to him in a vision. In both cases Dwnn is identified by his arms, and his physical appearance confirms that he was indeed the donor depicted in the Romance of Sydrac and Boctus.

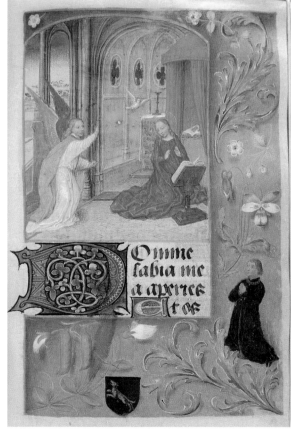

406. St John the Evangelist on Patmos; and The Assumption of the Virgin Mary, Illuminations from BL MS Royal 20B ii, before 1483, 300 × 172

[73] The manuscript, BL Add. MS 54782, is discussed in Janet Backhouse, *The Hastings Hours* (London, n.d.). The change in the iconography of St David may reflect an intention to present the manuscript to the young prince.

[74] The altarpiece and its patronage are discussed at length by Lorne Campbell, *National Gallery Catalogues: The Fifteenth Century Netherlandish Schools* (London, 1998), pp. 374–91. The conventional dating of the work is c.1479–80, on the basis of its similarity to the triptych known as 'The Mystic Marriage of St Catherine', completed in 1479. In support of an earlier date Lorne Campbell points to the evidence of the year 1478 inscribed on a copy of the donor portraits it contains. Dwnn is known to have been on the Continent in 1477 and 1478.

[75] Edward IV had been the earl of March.

Dwnn's patronage of the finest manuscript illuminators of northern Europe placed him among a small élite of powerful and wealthy patrons. His brother-in-law and close friend, William Hastings, was also counted among them. The most celebrated of his manuscripts is a book of hours which carries his name, and which has some importance in Welsh terms. The Hastings Hours opens with images of four saints of particular significance to the owner, among whom is St David. Hastings served Edward IV as Constable of Beaumaris Castle and Chamberlain of north Wales. The image is an unusual representation of the saint and seems to have been altered at some point. David was originally to be portrayed in the conventional manner as a bishop, but was subsequently transformed into a prince, reflecting the tradition of his royal birth. The change may reflect Hastings's loyalty to Edward IV's son, who was created prince of Wales in infancy – a loyalty which cost the patron his life when the throne was usurped by Richard III in 1483.[73]

Probably in 1478 or 1479 Sir John Dwnn widened the range of his patronage with a commission to Hans Memling of Bruges to paint the altarpiece known as the *Virgin and Child with Saints and Donors*. Memling was at the height of his career and among the most celebrated painters of his day.[74] At the centre of the work the Virgin Mary sits enthroned in a loggia above an extensive landscape. John Dwnn kneels to her right, with St Catherine behind. Elizabeth Dwnn, accompanied by her daughter, kneels to the left of the Virgin, with St Barbara. The patrons wear collars of suns and roses from which hang the emblem of the Lion of March – all symbols of their allegiance to Edward IV.[75] Further behind

407. St David as a
Prince, Illumination
from the Hastings
Hours, before 1483

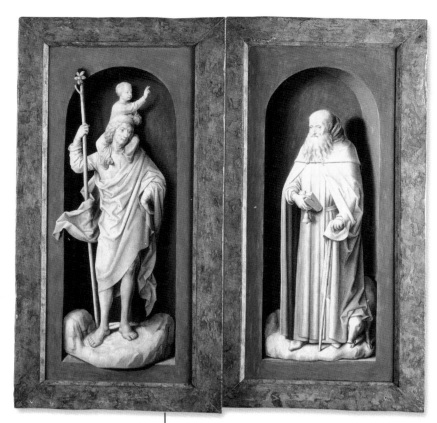

408. Hans Memling,
*The Virgin and Child with Saints
and Donors*, c.1479, Oil on panel,
centre 710 × 703, wings 710 × 305

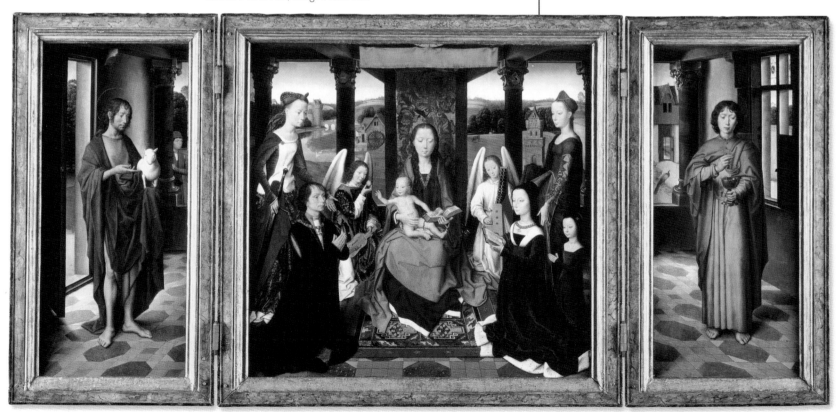

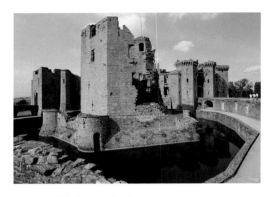

409. Raglan Castle,
Monmouthshire,
begun c.1432

right:

410. Tomb of
Sir William ap Thomas
and Gwladys, Priory Church
of St Mary, Abergavenny,
Monmouthshire,
mid-15th century,
Alabaster, l. 2800

[76] See above, p. 181.

[77] In 1443 his father, Griffith Dwnn, had obtained the necessary papal permission to maintain a portable altar. J. A. Twemlow (ed.), *Calendar of Entries in the Papal Registers relating to Great Britain and Ireland: Papal Letters. Vol. IX, 1431–1447* (London, 1912), p. 369.

[78] Griffiths, *The Principality of Wales in the Later Middle Ages*, p. 188.

[79] No trace of the chapel survives and although sixteenth-century sources confirm its existence, none describes its appearance. See Campbell, *National Gallery Catalogues*, p. 387.

[80] Letter from Jasper Tudor to Roger Puleston, quoted in H. T. Evans, *Wales and the Wars of the Roses* (new ed., Stroud, 1995), p. 84.

[81] Ibid., p. 88.

[82] Sir William died in 1445. He lies at the side of his second wife, Gwladys, daughter of Sir Dafydd Gam and mother of William Herbert. Their tomb bears a strong resemblance to that of Sir Ralph and Lady Greene at Lowick in Northamptonshire, which is of importance because its makers are known. A contract, dated 1415, names Thomas Prentys and Robert Sutton of Chellaston. The price was £40. It is likely that the tomb of William ap Thomas came from the same workshop.

Dwnn, in the side panel of the triptych, is St John the Baptist, and behind him – outside the loggia – an unidentified bystander peers towards the central scene. In the opposite side panel stands St John the Evangelist, who holds the poisoned chalice represented, a little later, in the memorial brass to Richard and Elizabeth Bulkeley at the Church of St Mary, Beaumaris. In Memling's painting the serpent from whose poison John was miraculously preserved is inside the cup.[76] When the wings of the triptych were closed, as they would have been during Lent, they displayed portraits painted in *grisaille* of St Christopher and St Anthony.

Dwnn's movements as an ambassador were so frequent that his altarpiece is unlikely to have travelled with him.[77] He probably kept it at his house in Calais rather than in Wales. Later, the triptych may have adorned an altar at a house on the estates in Buckinghamshire, which he purchased in 1480 and which became the family's main home. Although he survived the dynastic transition of 1485, so that by 1487 Henry VII was describing him as 'our trusty and well beloved counsellor' on embassy in France,[78] the manuscripts of which we have knowledge and the Memling triptych probably all belong to the period before the death of Edward IV in 1483. His allegiance to that royal patron was steadfast. Dwnn chose to be buried in his own chapel in the north aisle of St George's, Windsor, close to Edward and to William Hastings, his brother-in-law and the king's confidant.[79]

As we have seen, the turning-point in Dwnn's career was his involvement in the battle of Mortimer's Cross in 1461. His ally there was William Herbert of Raglan, the man whose wealth and power had largely raised the Yorkist army. The defeated Jasper Tudor attributed his reverse that day to 'March, Herbert, and Dwnns'[80] and lost not only the battle, but also his nephew, Henry Tudor, who was taken into Herbert's care.[81] The accession of Edward IV accelerated the rise of Herbert to a position of unrivalled power in which he acted much as the king's viceroy in Wales. He became Chamberlain of South Wales, a Knight of the Garter and, in 1467, Chief Justice of North Wales. In 1468 he laid siege to Harlech, the last Lancastrian stronghold, and on its fall the humiliation of Jasper Tudor was completed when his earldom of Pembroke was transferred to Herbert by the king.

William Herbert's castle of Raglan, to which the four-year-old Henry Tudor was probably taken after Mortimer's Cross, was under redevelopment on a grand scale. The work had begun in the 1430s under Herbert's father, Sir William ap Thomas, with the construction of the moated inner fortress known as the Great Tower, though he may also have conceived some of the more palatial aspects of the design later executed by his son. William ap Thomas's alabaster tomb at Abergavenny, perhaps designed in his own lifetime, certainly demonstrates the refined taste of the period.[82] By the end of the 1460s Raglan was home to a magnificent Renaissance

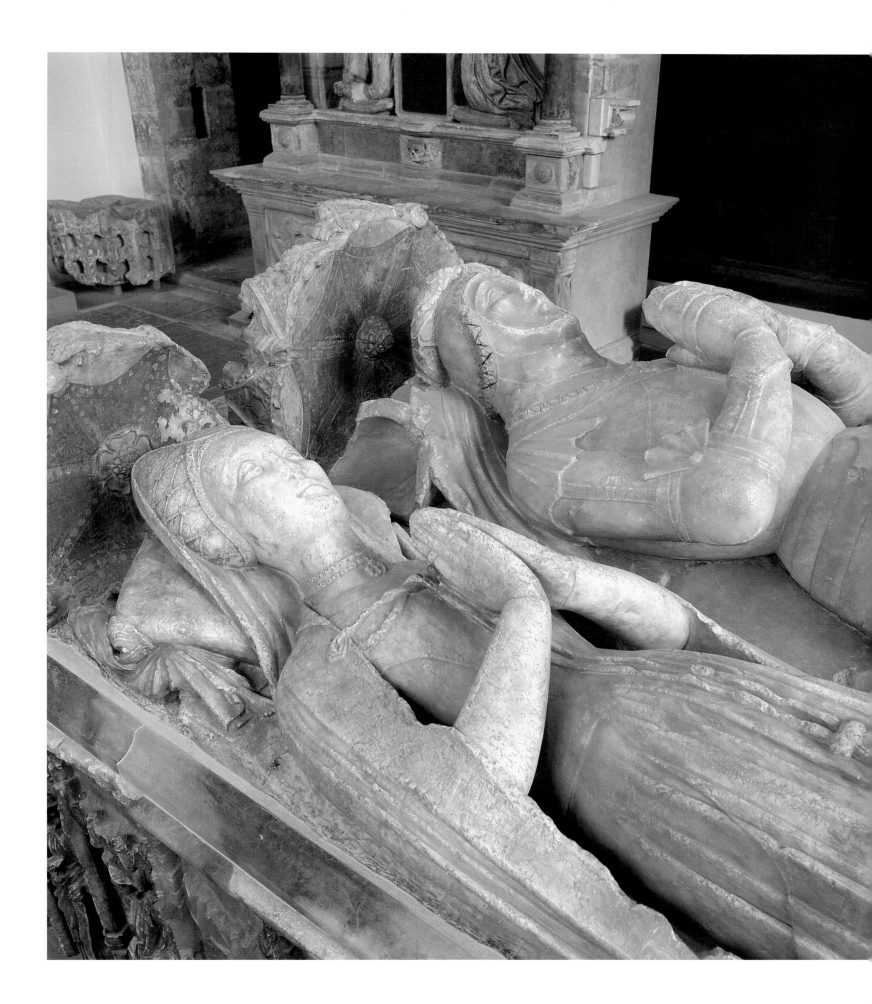

411. Sir William Herbert, his wife,
Anne Devereux, and King Edward IV;
and The Battle before Troy, Illuminations
from the Troy Book, c.1462, 395 × 279

court, approached through a gateway flanked by two hexagonal towers apparently modelled on those of the Château de la Ferté-Milon at Aisne, built by no less than Louis, duke of Orleans, at the beginning of the fifteenth century. The grandeur of the exterior of the castle was matched by the sumptuous interior. In 1507 it contained two massive Arras tapestries, one on the subject of King Nebuchadnezzar and the other the life of the obscure St Ide.[83] Both tapestries probably date from the period of Sir William Herbert and represent the same appreciation of the finest art work of the Low Countries manifested by Sir John Dwnn. Also reflecting the taste of his contemporary and ally, Herbert commissioned Flemish manuscript books. The donor portrait of the 'Troy Book' almost certainly represents Sir William and his wife Anne Devereux kneeling at the feet of Edward IV, which suggests that the manuscript was commissioned as a gift to the king. The text is an English verse translation of Guido of Cologne's *Historia Troiana*.[84] Its visual style is lighter than that of Dwnn's contemporary classical history of Alexander the Great, with most illuminations confined to a square format within one column of the double column text. However, a second manuscript, probably commissioned by Herbert, stands at the other end of the spectrum among the largest and most elaborate productions of its age. Although known as the 'Pembroke Hours' it is, in fact, the only fully illustrated psalter known to have been executed in the Low Countries in the fifteenth century. It contains

right:

412. The Master of Anthony of Burgundy
and Others, Esdras Renewing the Law;
The Advent of Christ; Christ Carrying the
Cross; and The Nativity, Illuminations
from the Pembroke Hours,
before 1469, 290 × 210

[83] 'A chambre of arras of the story of Nabugodhonosour cont[aining] two pecis in thre score sextene yardis. A counter poynt with thole bed of the same story. A chambre of arras of the story of Ide, cont[aining] two pecis in thre score and sextene yardis.' *Calendar of Patent Rolls … [of] Henry VII* (2 vols., Nendeln, Liechtenstein, 1970), II, 1494–1509, p. 601. When Charles I visited Raglan in the early stages of the civil wars, 'Some of the chief rooms were richly hung with cloth of Arras, full of lively figures and ancient British stories'. John Roland Phillips, *Memoirs of the Civil War in Wales and the Marches 1642–1649* (2 vols., London, 1874), II, p. 27.

[84] For interest in the history of Troy in the period, see Scot McKendrick, 'The Great History of Troy: A Reassessment of the Development of a Secular Theme in Late Medieval Art', *Journal of the Warburg and Courtauld Institutes*, 54 (1991), 43–82. The Troy Book is BL MS Royal 18D II.

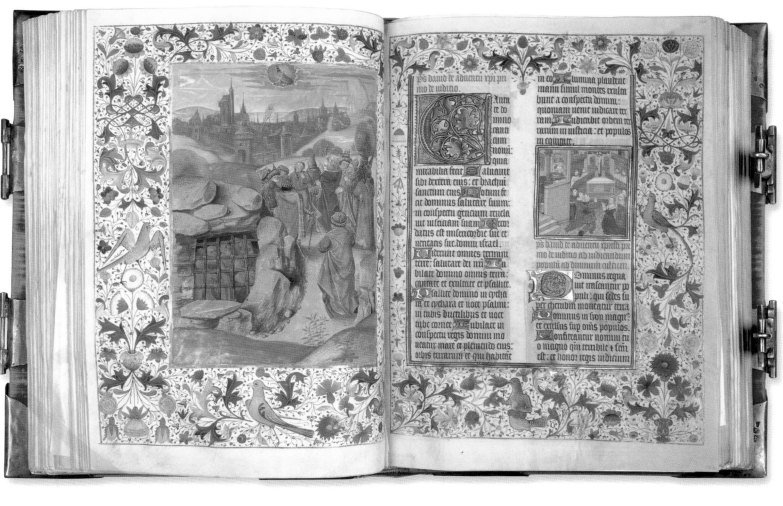

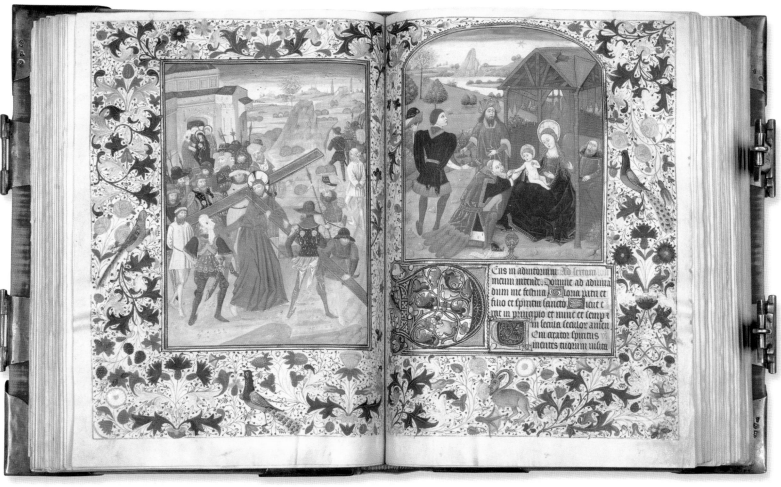

ten full-page illuminations and no fewer than 174 illuminations within the text columns, which are, themselves, enlivened with illuminated capitals. In addition there are twenty-four roundels illustrating the labours of the months and the signs of the zodiac.[85] The overall concept of the psalter reveals considerable sophistication, presumably the result of advice given to the patron by a theologian. Its individuality is asserted from the first full-page illumination, which depicts Esdras who, according to Jewish tradition, rewrote the holy books partly from memory after they had been burnt by the enemy. The burning of the books is depicted in the background.[86] The image of Advent, used to illustrate Psalm 97, is also idiosyncratic in visual terms, though its literary and musical source was deeply familiar in the period. Advent is the first theme to be explored in the Golden Legend, one of the most popular texts of the Middle Ages. The author, Jacobus de Voragine, emphasized the seven Advent Antiphons, sung in the week before Christmas, the words of which are accurately imaged in the illumination. The fourth antiphon, for instance, which asks 'Come and from the prison house release man enchained and sitting in the shadow of death', is precisely delineated, though the prison house takes the startling form of a cave.[87] The illuminations to the salvation cycle are exercises in typology and reference, though they are constructed from incidents in the New Testament rather than by juxtapositions of Old and New Testament scenes. All involve the Virgin Mary, so that, for instance, an illumination of Christ carrying the cross (in which the Virgin is glimpsed in the background) occupies a left-hand page in dramatic contrast to a Nativity, on the right. Opposite the final shedding of blood at the Crucifixion is set its type, the first blood of the Circumcision.

The making of such an unusual and ambitious manuscript, which involved at least six illuminators, must have generated considerable interest in Bruges in the 1460s. Only an immensely wealthy foreign patron could have contemplated such a work and, indeed, one of the illuminators, the Master of Anthony of Burgundy, otherwise worked almost exclusively on courtly commissions.[88] However, like its companion, the Troy Book, the Pembroke Hours was left unfinished. The reason for the failure to complete the manuscripts is not difficult to find. In 1469 the fortunes of the Lancastrians in the Wars of the Roses revived briefly with victory at the battle of Banbury. William Herbert (and his brother Richard) were taken prisoner and, two days later, on the order of the victorious earl of Warwick, they were executed at Northampton, an event much bewailed by the poets. William Herbert's son, the second earl (also called William), was either unable by reason of his age or not disposed to order the completion of the manuscripts even though family fortunes rapidly revived with the restoration of Edward IV in 1471.[89] The unfinished Troy Book must have been taken into the possession of Herbert's daughter Maud, since it was completed by an English workshop under the patronage

[85] The figures in the roundels are one of the few elements in the manuscript which are not entirely original. They were developed from the Saint-Maur Hours, a Parisian manuscript of the early fifteenth century attributed to the Boucicaut Master. For this and other detailed observations on the structure and execution of the manuscript, see Tanis (ed.), *Leaves of Gold*, pp. 60–4. The Pembroke Hours is Philadelphia Museum of Art MS 1945-65-2.

[86] The conventional frontispiece to a psalter of the period was a portrayal of King David.

[87] The image of the cave may have been taken from Plato's *Republic*. The emergence from the dark and into the light of wisdom described by Plato in the allegory of the cave had obvious resonance with Advent and the beginning of the cycle of events which would bring the light of Christ to the world. The period in which the Pembroke Hours were created witnessed a great revival of interest in the ideas of Plato.

[88] For the attribution to the Master of Anthony of Burgundy, see Tanis (ed.), *Leaves of Gold*, p. 64, note 7.

413. Tomb of William Herbert, Earl of Pembroke, at Tintern Abbey, Monmouthshire, Manuscript Illumination from *Herbertorum Prosapia*, late 17th century, 185 × 255

of her husband, Henry Percy, earl of Northumberland, early in the sixteenth century. The Pembroke Hours followed a different route, eventually finding its way into the hands of a later William Herbert, presumably through his father, Sir Richard Herbert of Ewias, who was the older William Herbert's illegitimate son.[90] Sometime after 1548 this younger William Herbert enclosed the psalter in a collection of prayers, enlivened by his coat of arms and emblems, and a miniature depicting him at prayer. It may have been necessary for the family to reclaim both manuscripts in their entirety from the workshops at which they were under production in the Low Countries. However, it is equally possible that the completed folios of the manuscripts were already installed at Raglan, having been delivered in parts to await binding.

It had been William Herbert's intention that he be buried at the Priory Church of Abergavenny, alongside his father. He made provision in his will for the windows (presumably those of the family chapel) to be 'Glazed with the Stories of the passion of Christ and of the Nativity and of the Saints of mine that be in my Clozett at Ragland'.[91] What form these depictions of the saints had taken is unspecified. They may have been murals, an altarpiece, tapestries or, indeed, the illuminations of the Pembroke Hours. Whatever their form, in death as in life Herbert would be accompanied by his guardian saints. However, consistent with the discontinuity manifested in the failure to complete the Flemish manuscripts and a break in the building work at Raglan, his wishes remained unfulfilled.[92] He was buried at Tintern, where an elaborate tomb was constructed which did not survive the ravages of the civil wars in the seventeenth century.[93]

The example of William Herbert's liberal patronage of fashionable visual culture was replicated by other members of his extended family, at least on their personal memorials. His sister Margaret had married Sir Henry Wogan of Wiston, Pembrokeshire, another Yorkist who had experienced the vicissitudes of fortune in civil wars. The effigies of Henry and Margaret are alabasters of high quality, originally set on a tomb chest in an elaborate niche with the family arms at the Commandery Church at Slebech.[94] The detail of the hair, head-band and collar of Margaret, which retain their restrained original colouring, is particularly refined. It was clearly created by a sculptor who

[89] There is some confusion regarding the age of the second earl on the death of his father. The *Dictionary of Welsh Biography* gives 1460 as his date of birth, which would make him about nine, but Ralph A. Griffiths, *Sir Rhys ap Thomas and his Family: A Study in the Wars of the Roses and Early Tudor Politics* (Cardiff, 1993), p. 32, maintains that he was 'about sixteen'. He married Mary Woodville, the queen's sister, cementing even more securely the family's close relationship to the Yorkist dynasty. In 1479 he exchanged his title for that of earl of Huntingdon, by which he is usually known, to enable the king to bestow the earldom of Pembroke on his ill-fated son, the prince of Wales.

[90] For the tomb of Sir Richard Herbert of Ewias, see above, pp. 247–8. Richard's son, William, the eventual owner of the psalter, became first earl of Pembroke of the second creation. His son, Henry Herbert, second earl of Pembroke of the second creation, commissioned a portrait reproduced in Lord, *The Visual Culture of Wales: Imaging the Nation*, p. 30. Among the descendants of the Sir Richard Herbert executed in 1469 was Edward Herbert, first baron Herbert of Chirbury, a notable patron of visual culture. Three of his portraits are illustrated in ibid., p. 30.

[91] Quoted from an unspecified source by A. J. Taylor, *Raglan Castle, Monmouthshire* (London, 1950), p. 10.

[92] The redevelopment of the castle seems to have been halted on the accession of the second earl. See ibid., p. 12.

[93] The date at which the tomb was constructed is unknown. The earl of Huntingdon was also buried at Tintern, the patronage of which had passed to the family with the lordship of Chepstow in 1468. The tombs are known from drawings in Cardiff Central Library MS 5.7, *Herbertorum Prosapia*.

[94] The remnants of the badly damaged memorial are kept at Scolton Manor in Pembrokeshire. It is unclear if, in Wogan's time, the Church of the Knights Hospitallers of St John of Jerusalem at Slebech also functioned as a parish church. The church was abandoned in the nineteenth century.

414. John Carter, Tomb of Sir Henry and Margaret Wogan in the Church of St John, Slebech, Pembrokeshire

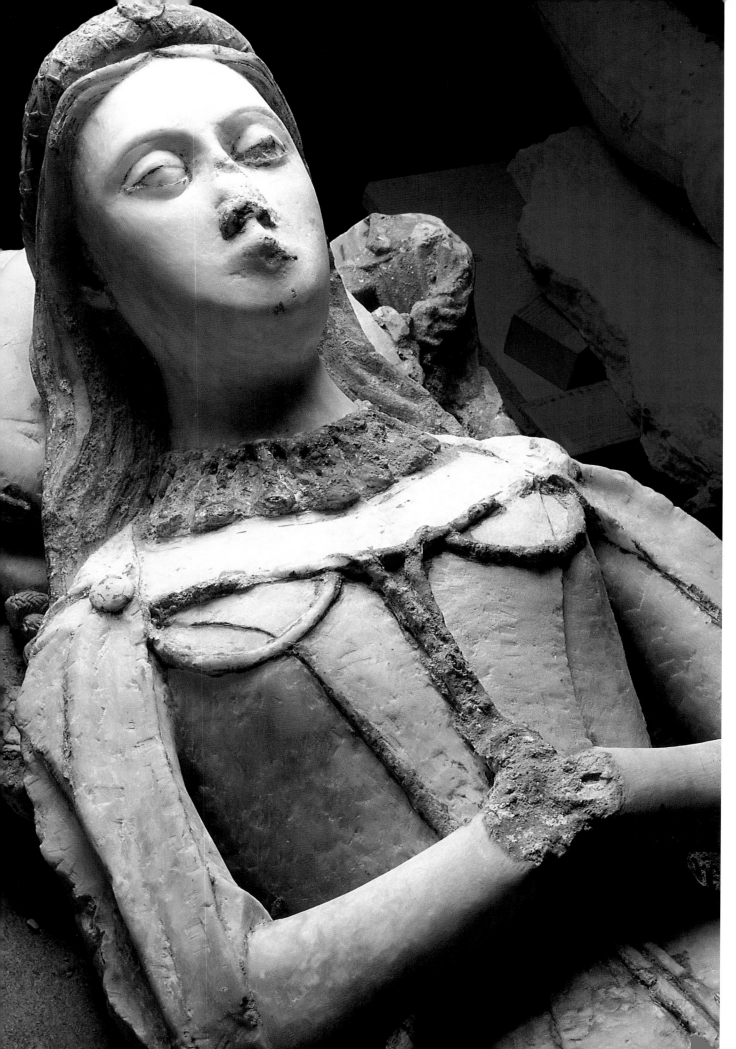

415. Tomb Effigy
of Margaret Wogan,
formerly in the
Church of St John,
Slebech,
Pembrokeshire,
before 1483,
Alabaster

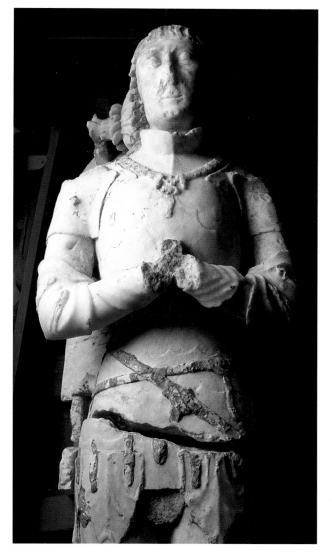

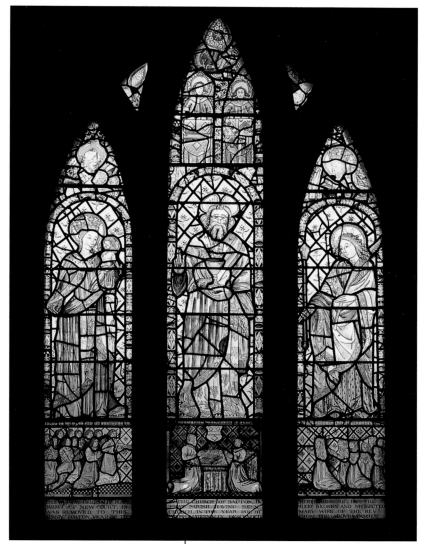

416. Tomb Effigy of Sir Henry Wogan, formerly in the Church
of St John, Slebech, Pembrokeshire, before 1483, Alabaster

417. Figures of Christ,
the Virgin Mary and St John the
Evangelist, with donors, originally
in the Church of St Faith, Bacton,
Herefordshire, before c.1488,
Painted glass

was working while she was alive or who had been given a very detailed
description or a portrait of her after her death since she is depicted with a
distinctive deformity of the lower jaw. Her husband, Henry Wogan, wears the
same collar of suns and roses with a lion pendant, symbolic of his allegiance to
Edward IV, as does John Dwnn in Memling's triptych, which suggests that the
tomb dates from before the death of the king in 1483.[95]

Of similar date, though commissioned by the next generation of the family,
is the unusual glass originally set in the east window of the Church of St Faith,
Bacton, on the Herefordshire–Monmouthshire border. William Herbert's other
sister, Elizabeth, had married Sir Henry Stradling of St Donat's, and their
daughter, Joan, married Miles ap Harri of Bacton, who commissioned the work.
The biblical iconography of the window is conventional – Christ in the act of

[95] The effigies were identified by E. Laws and E. H.
Edwards, 'Monumental Effigies, Pembrokeshire',
Arch. Camb., 6th series, XI (1911), 371–80.

[96] The will of Miles ap Harri mentions only five sons, the others having presumably predeceased him, in which case the glass may have been commissioned some considerable time before his own death in 1488. On the other hand, sometimes children who had died young were depicted as if they had grown to maturity. Alternatively, the family groups in the window may also represent grandsons and granddaughters, though their appearance does not suggest that this is the case.

[97] For further discussion, see the Appendix.

[98] The precise date of the eisteddfod is uncertain, but it may be associated with the rebuilding of the castle, c.1451–5. For Dafydd ab Edmwnd and his family, see above, p. 229, and for his role in the Carmarthen eisteddfod see D. J. Bowen, 'Dafydd ab Edmwnt ac Eisteddfod Caerfyrddin', Barn, 142 (August, 1974), 441–8.

[99] 'This reorganization of Yorkist government in the western parts of Wales allowed no place for Gruffydd ap Nicholas's family in the 1470s and early 1480s.' Griffiths, Sir Rhys ap Thomas and his Family, p. 36. On the other hand, the official guide to Carew (Haverfordwest, n.d.), p. 8, claims that Rhys's 'astute support for the House of York helped him accumulate wealth and power during the turmoil of the Wars of the Roses'. The historians' view of this civil war would appear to be as muddled as the shifting family allegiances which drove the events themselves. The skirmish at Pennal in which Thomas died has usually been associated with William Herbert's campaign of 1468, but Griffiths, Sir Rhys ap Thomas and his Family, p. 32, suggests a date of 1474. For literary references to the incident, see D. Huw Owen and J. Beverley Smith, 'Government and Society 1283–1536' in J. Beverley Smith and Llinos Beverley Smith (eds.), History of Merioneth. Volume II: The Middle Ages (Cardiff, 2001), pp. 126–7.

benediction, flanked by a Virgin and Child and St John the Evangelist – as indeed are the donor portraits below, though Joan's prodigious family, apparently comprising twelve sons and seven daughters, ranged in serried ranks behind their parents, must have distinguished her somewhat among her contemporaries.[96] However, the work is most notable for being the only example known to have been commissioned by a Welsh patron of glass painted in fashionable *grisaille*, like John Dwnn's Alexander the Great manuscript and the wings of his Memling triptych.[97]

The lower public profile of William, earl of Huntingdon, in contrast to that of his father, the earl of Pembroke, may have assisted the family successfully to shoot the political rapids of dynastic change in 1485. As we shall see, they flourished under the Tudors as they had under Edward IV, though they then found themselves in close proximity to those whom they had helped to suppress under the Yorkist monarchy. Prominent among them was Rhys ap Thomas of Carew in Pembrokeshire. Gruffudd ap Nicholas, grandfather of Rhys, had been a beneficiary of the redistribution of power which followed the Glyndŵr rebellion, and was responsible for at least one important act of patronage of the arts. The eisteddfod at which Dafydd ab Edmwnd – who later revised the rules which governed the metrical system of the poetry of the period – won the chair was held at his castle at Dinefwr, probably sometime between 1451 and 1455.[98] The family was subsequently constrained by its underlying Lancastrian sympathies. Thomas, son of Gruffudd, probably died in a skirmish at Pennal, and his surviving son, Rhys, kept a low profile until 1485.[99] However, in that year he provided crucial assistance to Henry Tudor on his return to Wales and he was knighted on the field of battle at Bosworth. He rose steadily in power and influence from that point, his status confirmed by his elevation to Knight of the Garter in 1505.

418. Carew Castle, Pembrokeshire, rebuilt late 15th century

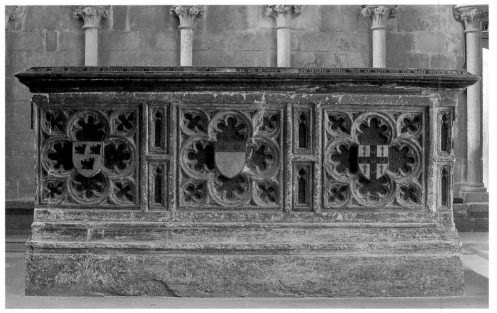

419. Tomb of Gruffudd ap Rhys, Worcester Cathedral, 1521, Purbeck marble

Like some of his erstwhile enemies, Rhys ap Thomas had experienced the Renaissance splendours of the Burgundian court at Bruges, where he lived with his father in the second half of the 1460s.[100] The architecture of his rebuilding of Carew Castle as his main residence reflects that experience as, no doubt, did the interior. As at Raglan, the great hall was a 'goodlie, spaciouse, roome, richlie hanged with cloath of Arras and tapistry', though we know nothing of the subject matter of the textiles.[101] The hall was entered through a new porch on which were carved the arms of Prince Arthur and Catherine of Aragon, which gives a date *c*.1497–1501 for the building. As we have seen, the marriage of Arthur was the occasion for much celebratory patronage in Wales, but Sir Rhys had a particular reason to memorialize the event. His son, Gruffudd, was a member of Arthur's household and seems to have been close to the prince. Gruffudd was created a knight of the Bath during the wedding celebrations and was a witness to the fifteen year-old's boast, made when he emerged from his bedchamber, flushed with success and demanding a cup of ale, that 'I have been this night in the midst of Spain. Masters, it is good pastime to have a wife.'[102] No doubt Sir Rhys anticipated the day when Arthur and Catherine, on royal progress, would enter his hall at Carew through the porch which carried their arms. If so, it was to be a dream unfulfilled because Arthur died at Ludlow only five months later. At his funeral in Worcester Gruffudd carried the prince's banner before the coffin. Gruffudd, too, would be buried there, close to his royal master, in 1521.[103] His tomb chest is a sombre affair of Purbeck marble, unadorned by supporting figures. It appears to reflect Sir Rhys's taste in these things, since it is similar to the tomb chest of Edmund Tudor, father of Henry VII, which had been installed at Greyfriars, Carmarthen. Sir Rhys had been entrusted by Henry with the arrangements for the commission around 1500. The tombs are somewhat unusual in their restraint and contrast strongly with the elaborate alabasters favoured by most patrons.[104] Sir Rhys's own tomb, close to that of Edmund in Greyfriars, was of the more fashionable type, and it may not be fanciful to suppose, therefore, that it reflects the taste of his executors rather than his own. Originally it was shrouded by a pall carried on a hearse – an iron framework which held the cloth above the images. At the Reformation it was noted in an inventory of the contents of the monastery as 'a goodly tumbe of Sir Ryse ap Thomas, with a grate of yronabowthe him; a stremer [and] banner of his armys with his cote armor and helmit'.[105]

The influence of Burgundian courtly life on Sir Rhys ap Thomas was most dramatically demonstrated by the tournament which he organized in 1506 to celebrate the first anniversary of his elevation to the Order of the Garter. The Burgundian tradition of 'learned chivalry' had only recently become fashionable as a result of its imitation at the court of Henry VII and so Sir Rhys's 'Great Tourney' set him at the forefront of refined taste.

[100] The precise dates of the period spent in the service of Philip the Good (d. 1467) and Charles the Bold (d. 1477) in Bruges are unknown. Griffiths, *Sir Rhys ap Thomas and his Family*, p. 172, note 4, suggests that father and son may have gone abroad *c*.1465, and possibly returned *c*.1470–1 on the occasion of the brief restoration of Henry VI, ibid., pp. 31–2.

[101] Ibid., p. 252. The Life of Sir Rhys ap Thomas, written by Henry Rice *c*.1622–7, appears in full in ibid., pp. 148–270. The patronage of his son, Edward Rice, is discussed in Lord, *The Visual Culture of Wales: Imaging the Nation*, pp. 87–9.

[102] Quoted in Griffiths, *Sir Rhys ap Thomas and his Family*, p. 51.

[103] The chantry constructed to contain the tomb of prince Arthur is described in Mrs Edmund McClure, 'Some Remarks on Prince Arthur's Chantry in Worcester Cathedral', *Associated Architectural Societies Reports and Papers* (42 vols., London, [1851]–1937), XXXI (1911–12), pp. 539–56.

[104] The tomb in which King John was reburied at Worcester was designed in the same restrained and sombre mode as the tombs of Gruffudd ap Rhys and Edmund Tudor. Purbeck marble is a hard stone, unsuitable for great elaboration.

[105] Terrence James, 'Excavations at Carmarthen Greyfriars, 1983–1990', *Medieval Archaeology*, XLI (1997), 189. For further discussion, see the Appendix.

420. Ivor Mervyn Pritchard, *The Tomb of Sir Rhys ap Thomas*, reconstruction drawing, 1914

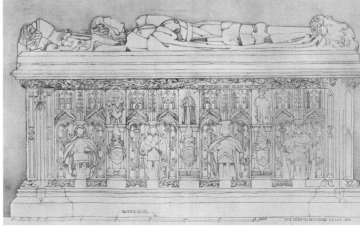

421. Probably Harry ap Griffith,
The Derwydd Bed, c.1506, Wood,
panel lengths 1650

[106] The account of the tournament refers to 'manie new hymnes and anthemes they had made of purpose for that solemnittie, and there [at Lamphey] sung; some for the long life, peace, and prosperitie of the king; others for the rest of St George his soule, and his safe deliverance out of purgatorie'. Griffiths, *Sir Rhys ap Thomas and his Family*, p. 251. The document also refers to poetry accompanied by the harp, Griffiths, *Sir Rhys ap Thomas and his Family*, p. 253. Two Welsh composers of the period – John Lloyd and Robert Jones – were members of Henry VII's chapel and may have been known to Sir Rhys. The reference in the same document to secular drama is among the earliest Welsh records of such performances: 'To supper then they come, after which they had a comedie acted by some of Sir Rice his owne servants, with which these majesticall sights and triumphs were concluded.' Ibid., p. 257.

[107] The owner of the Pembroke Hours, who completed the manuscript.

[108] Griffiths, *Sir Rhys ap Thomas and his Family*, p. 252. St George was the patron of the Order of the Garter but the symbolism of the table – probably a painting but possibly carved – was the unity of England and Wales in the person of the king.

[109] Ibid., caption to plate 6, expresses the view that the scene represents a campaign in the French wars, but this seems most unlikely given the presence of ladies. A pair of chairs carved with the arms of Sir Rhys and the garter may also have been commissioned in connection with the tournament (National Museums and Galleries of Wales, Museum of Welsh Life).

The religious and military ceremonial represented a new Renaissance romanticism focused on an imagined bygone age of chivalry rather than a continuity of medieval tradition – a courtly drama rather than a military exercise – which was reinforced by visual imagery, music and plays.[106] Sir Rhys's tournament, which began on St George's eve and continued for five days, drew knights and esquires from many of the families whose patronage we have already noted, such as the Wogans, the Butlers and, from the north, the Wynns of Gwydir. Among the children of famous fathers, eager to advance their reputations, came Gruffudd Dwnn, son of Sir John Dwnn, and William Herbert,[107] son of Sir Richard Herbert:

… Sir Rice having reserved a great companie of the better sort for his guests, he leads them to the castle, with drummes, trumpetts, and other warlike musicke. Over the gate, at the entrance, was hung up a goodlie faire table, wherein was represented the species and pourtraiture of St George and St David embracing one another with this mottoe, *Nodo plus quam Gordiano* [Knot stronger than the Gordian].[108]

Sir Rhys memorialized his tournament in the somewhat unlikely form of a bedstead, which was made either for himself or perhaps to be presented to his son (who played a prominent role in the proceedings) on the occasion of his marriage. The frame and the posts are carved with the arms of Sir Rhys and an elaborate frieze of longbowmen, crossbowmen and lancers, mounted jousting knights, ladies, a monk and a harpist. The gate of the castle guards the corner of one of the panels.[109] The carver was probably Harry ap Griffith, who is identified on another work, a framed group of carved panels which may be a tester from the same or another bed, or perhaps taken from a cupboard.[110] The panels have no common theme, but represent the Tudor arms flanked by the Instruments of the Passion and music making, and Adam and Eve (an unusual conflation of the Temptation and the Expulsion) flanked by St George and the Dragon and an unidentified narrative. The frame in which these and two other panels are mounted is enlivened with images of huntsmen and dogs pursuing a stag, a hare and a fox, and falconers with their birds. A cadaver carrying a spear and Father Time, who wields a scythe above his bearded head, are more sombre reminders of the cycle of life and death.[111]

The patronage of Sir Rhys ap Thomas extended well beyond Carew and his immediate household. He rebuilt several churches, some as far afield as that of St Gwenog, Llanwenog, Cardiganshire, where a new tower carries his arms. It seems likely that he was also a substantial patron of St David's Cathedral, since his arms are carved in the roofs of the south aisle, the Holy Trinity chapel and the Lady Chapel ante-chapel.[112]

422. Probably Harry ap Griffith,
The Cotehele Tester,
early 16th century, Wood

[110] The panels are known as the Cotehele Tester owing to their present location at Cotehele House in Cornwall. They almost certainly arrived there on the occasion of the marriage of Catherine St John, widow of Gruffudd ap Rhys, to Piers Edgecombe of Cotehele.

[111] The panels depicting the unidentified narrative and music making are illustrated in Lord, *The Visual Culture of Wales: Imaging the Nation*, p. 19. The tester is usually dated *c*.1530–40, though if, as seems most likely, it belonged to Gruffudd ap Rhys, it dates from before his death in 1521. Figurative wood carving above two doorways at Rhydowen, Carmarthenshire, must also be connected to Sir Rhys ap Thomas, since it carries his arms, though the nature of the connection is unclear. Alongside the arms are a pelican, the symbol of piety, and an owl mobbed by other birds, images well-known from misericords of the period. The inside of this doorframe is carved with a hunting scene and the other frame carries an image of spitting profile heads, for which see above, p. 161. The style of the carving is so similar to that of Sir Rhys's bedstead and the Cotehele Tester that it is reasonable to conclude that all are the work of Harry ap Griffith. The panels are illustrated in RCAHM, *An Inventory of the Ancient Monuments in Wales and Monmouthshire. V. County of Carmarthen* (London, 1917), p. 69.

[112] The magnificent wooden roof over the main body of the church dates from after the death of Sir Rhys ap Thomas. The work was begun *c*.1538 by the Cathedral Chapter when William Stradling of Merthyr Mawr was Chancellor and Master of the Works. Stradling personally invested the substantial sum of £90 6s. 8d. in the roof, though in 1542, after his death, his executor, Thomas Stradling, endeavoured to recover the money, which he claimed had been a loan. The re-roofing of the nave at St David's is exactly contemporary with that at Llanidloes, above pp. 100 and 231, demonstrating that major new work was undertaken at a period conventionally associated with destruction. Nevertheless, the two roofs contrast strongly in style, that at Llanidloes being in the Gothic of the high Middle Ages, while that at St David's displays Renaissance features.

[113] For an image of Raglan soon after the depredation of the civil wars, see Lord, *The Visual Culture of Wales: Imaging the Nation*, p. 85.

[114] Royal Commission on Historical Manuscripts, *Twelfth Report. Appendix, Part IX: The Manuscripts of the Duke of Beaufort, K.G., the Earl of Donoughmore, and others* (London, 1891), p. 3. The precise date of the design of the gardens as described is unknown. It is reasonable to suppose on the basis of earlier though less specific comment that they were fifteenth- or early sixteenth-century in origin, but they may be later. The last redevelopment of the castle was undertaken by William Somerset, grandson of Charles, in the second half of the sixteenth century.

The period of the dominance of Sir Rhys ap Thomas in the south-west coincided with dynastic change in the south-east at Raglan. In 1492 Elizabeth Herbert, heir to the second William Herbert, earl of Huntingdon, married Charles Somerset, the illegitimate son of Henry Beaufort, duke of Somerset, and therefore the king's cousin. He took the title of Lord Herbert. The couple did not take possession of the castle until some time after 1507 and the death of Sir Walter Herbert, who lived there following the death of his brother, the earl of Huntingdon. However, it was Elizabeth's descendants, further enriched by the English possessions of her husband, who lived at Raglan until it was destroyed in the civil wars of the seventeenth century, at which time they moved to Badminton in Gloucestershire.[113] Charles Somerset rose to high rank in the royal service and concerned himself with the consolidation of Raglan. No doubt features such as the gardens were developed. As late as 1646 there survived:

> … gravel walks and pleasant gardens, and fair built summer houses, with delightful walks 430 feet long, beneath which was a very large fish pond of many acres of land, ornamented with many and various divers artificial islands and walks, near which stood an orchard 400 feet long and 100 broad planted with choice fruit trees.[114]

115 Sir Walter's wife, Anne, was the daughter of the duke of Buckingham and, therefore, also related to the queen. The queen was pregnant at the time, and subsequently died in childbirth.

116 See above, pp. 200–1.

423. Probably Robynet, Old Testament Figures from the Orphreys of Eucharistic Vestments, Roman Catholic Church of Our Lady and St Michael, Abergavenny, Monmouthshire, early 16th century, Embroidery

The political rise of Charles Somerset was substantially aided not only by his own kinship with the king but by that of his wife to the queen. Elizabeth Herbert was a first cousin to Elizabeth of York, and the two women were close friends. These associations also appear to have resulted in the enrichment of the castle by an extraordinary gift. In 1502, only a few months after the death of Prince Arthur, the queen journeyed from London to visit both the family house of Troy at

424. Probably Robynet, The Apostles Bartholomew, James and John from the Orphreys of Eucharistic Vestments, Roman Catholic Church of Our Lady and St Michael, Abergavenny, Monmouthshire, early 16th century, Embroidery

Monmouth, presumably to stay with Elizabeth, and Raglan, at the time still occupied by Sir Walter.[115] The queen, who was noted for her generosity, almost certainly brought with her the elaborate embroidered vestments which we have already noted.[116] She employed her own embroiderer, named Robynet, and payments made from her privy purse indicate his engagement on an unusually ambitious project prior to the queen's progress to Wales.[117]

425. John Skinner, *The Hall, shewing the ornaments and devices …*, 1832, Watercolour

The patronage of Charles and Elizabeth Herbert themselves is evident in three surviving works. Two of them seem to be related to the period of Charles's most rapid rise at court, the result of his involvement in the French campaign of Henry VIII in 1513. The symbols included in an elaborate frieze, which probably adorned the great hall at Raglan, indicate that it was carved in celebration of the elevation of Charles to the earldom of Worcester shortly after. The royal badges of Henry VIII and Catherine of Aragon[118] are linked to the portcullis of the Beaufort family of Charles and the lion rampant of the Percy family, to whom Elizabeth was related by marriage.[119] Among the family emblems are entwined religious symbols (notably of the Passion), grotesques and a series of profile heads. They are of a Renaissance type newly fashionable in the period, of which fine but probably later examples also survive from either a town house in Cardiff or from the castle itself.[120] They may be portraits, though they have not been identified. Probably at about the same time as the Raglan frieze was made, Charles Somerset commissioned a painted portrait of himself carrying the wand of the Chamberlain, an office granted him for life by the king in 1514, but comparison is difficult since he shows a nearly full face in the painting.

[117] The case that the embroideries, now scattered between churches at Skenfrith, Monmouth, Abergavenny and possibly Laugharne (and including a lost group formerly at Usk), were the gift of the queen to the Herbert family is convincingly made by Kirstie Buckland, 'The Skenfrith Cope and its Companions', *Textile History*, 14 (1983), 125–39. In 1509 Henry VII bequeathed a comparable set of vestments and copes to Westminster Abbey, which were also made by the embroiderer Robynet. The documents relating to this commission throw further light on the practice of embroidery at court, especially with regard to the source of the raw materials in Italy. See Lisa Monnas, 'New Documents for the Vestments of Henry VII at Stonyhurst College', *Burlington Magazine*, CXXXI, no. 1034 (1989), 345–9.

[118] Henry Tudor married Catherine of Aragon, widow of his elder brother, Arthur, in 1509.

[119] The frieze is illustrated in Lord, *The Visual Culture of Wales: Imaging the Nation*, pp. 18–19 and analysed in detail by John Morgan-Guy in Lord, *The Visual Culture of Wales: Medieval Vision* (Cardiff, 2003), CD-ROM, Time Galleries.

[120] The heads are now in the Church of St John in Cardiff, but probably came from a group of town houses, one of which was owned by George Herbert, brother of William Herbert, earl of Pembroke. See Lord, *Visual Culture of Wales: Imaging the Nation*, p. 19. The transmission of the continental fashion for the profiles, sometimes referred to as 'Romayne' heads, was probably aided by the wide distribution of woodcuts. For a German example c.1545, see Max Geisberg, *The German Single-Leaf Woodcut 1500–1550*, rev. and ed. Walter L. Strauss (4 vols., New York, 1974), III, p. 816.

427. Panel, set in the Screen of the Church of St John the Baptist, Cardiff, Glamorgan, early 16th century, Wood, 200 x 510

426. Anon., Charles Somerset, 1st Earl of Worcester, c.1514

429. Jan van den Einde, Screen surrounding the Tomb of Charles Somerset and Elizabeth Herbert, St George's Chapel, Windsor Castle, Berkshire, early 16th century, Bronze, ht. 2255

428. Effigies of Charles Somerset and Elizabeth Herbert, St George's Chapel, Windsor Castle, Berkshire, early 16th century, Alabaster, on tomb l. 2440

121 The other screens, presumably seen by Charles Somerset (if his was not the first), were for the chapels of Notre Dame and Santa Croix in the Church of St James, Utrecht. E. M. Venables, 'The Beaufort Chapel', *Annual Report of the Friends of St George's Chapel, Windsor* (1952), pp. 14–21.

122 For further discussion, see the Appendix.

123 Torrigiano also made a terracota bust of Henry VII, which closely resembles an effigy displayed at the king's funeral. The head of the effigy is almost certainly a death mask. For the relationship between the two, see Phillip Lindley and Carol Galvin, 'Pietro Torrigiano's Portrait Bust of King Henry VII', in Lindley, *Gothic to Renaissance*, pp. 170–87.

124 The red dragon was among the battle standards flown by Henry Tudor at Bosworth Field. For the use of the red dragon as an emblem of the Tudor family and its adoption as a symbol of the Welsh nation, see Carl Lofmark, *A History of the Red Dragon*, ed. G. A. Wells (Llanrwst, 1995), pp. 66–74.

The third and most extravagant act of patronage of Charles Somerset and Elizabeth Herbert, which also involved imaging themselves, was their tomb chest. It was commissioned to occupy its own chantry at St George's Chapel, Windsor, in 1506. The chantry was lavishly endowed and funded in perpetuity by income from the Wyesham manor in the lordship of Monmouth. The effigies, mounted on a Purbeck marble tomb chest, are larger than life size, since Charles extends almost the full eight-foot length of the slab on which he rests. However, the most remarkable feature of the tomb is the bronze screen by which it is enclosed, which demonstrates again the high prestige of Flemish design and craftsmanship in the period. It was made by Jan van den Einde of Malines, who is known to have been at work on two screens of similar design in 1517, at which time the patron was in the country, at the court of Emperor Maximilian I.[121]

The only bronze screen in England at the time, other than that commissioned by Charles Somerset and Elizabeth Herbert, was made for Henry Tudor and Elizabeth of York, the king and queen, to surround their own tomb. This screen was made by another smith from Flanders known only by the name Thomas, though the monument it was intended to enclose was not that which survives. Henry had planned to be buried in a new Lady Chapel built around 1494–8 at St George's Chapel, Windsor, which was also to house a shrine to his uncle, King Henry VI. However, it was decided that a burial in Westminster Abbey would be more appropriate and so the unfinished tomb was transferred to the coronation church but abandoned in about 1506 in favour of a new design by an Italian sculptor.[122] This second project was also left in abeyance at Henry's death in 1509 and the contract was finally awarded by his son to Pietro Torrigiano in 1512 on the basis of his successful design for the tomb of the king's mother, Margaret Beaufort, made the previous year.[123] Only the screen survived from the original project, surrounding a tomb of strongly Renaissance character with putti and profile heads, surmounted by bronze effigies.

430. Portrait Medallion
depicting Henry VII and
Elizabeth of York, 1485,
Copper alloy,
diam. 60

431. The Red Dragon of Cadwaladr,
Vestibule of the Lady Chapel, Westminster
Abbey, London, early 16th century, Stone

Henry's chapel at Westminster was a
statement of dynastic permanence. From
his marriage in 1485 to Elizabeth of York,
depicted in a double-portrait medallion struck in
that year, to his burial in 1509 at Westminster, where the
carved red dragon of Cadwaladr in the vestibule of the chapel guards access to
his tomb,[124] the king sought to express continuity and unity. These were the twin
foundations of his claim to legitimacy and they were made plain from the beginning
in the resonant naming of his first son, Arthur. From the bronze gates through
which the king's chapel was entered to the glazing of the east window, the heraldic
expression of dynasty dominated religious imagery even in the great monastic
church. Henry's will required that:

> … the said Chapell be desked, and the windowes … be glased … and that the
> Walles, Doores, Windows, Archies and Vaults, and Ymages of the same our
> Chapell, within and without, be painted, garnisshed and adorned, with our
> Armes, Bagies, Cognissaunts, and other convenient painteng, in as goodly and
> riche maner as suche a work requireth, and as to a Kings werk apperteigneth.[125]

Nevertheless, the sculptural decoration of the chapel, nominally that of the Virgin
Mary, includes many appropriate religious images, several of which reflect the
spiritual life of Henry in particular ways. Prominent among the saints depicted is
the Welsh martyr St Winifred. The sculpture was probably the work of a Flemish
artisan, who had an unusual and distinctive style, and her image is far from the
conventional ideal of a female saint. She is presented as an individual who seems
plucked from life.[126] As we have seen, notwithstanding her Welsh associations,
Winifred was the object of widespread devotion. Two images of St Arthmael,
whose cult was centred at Ploermel in Brittany, represent a more unusual devotion
on the part of the king. Arthmael was a Welsh-born saint of the sixth century who
was probably educated at the monastery of Llantwit Major, from whence he
proceeded to Brittany. In this and other elements of the saint's life the king may
have recognized types of his own narrative. The legend of Arthmael describes how
he freed the part of Brittany in which he settled from the unwelcome attentions
of a dragon by leading him to a river with his stole and commanding him to throw
himself into the stream. The king is thought to have believed that he had been
protected by the intervention of the saint on two occasions – during a storm at
sea, and at Bosworth Field.[127]

[125] T. Astle (ed.), *The Will of King Henry VII*
(London, 1775), pp. 4, 6, 7, quoted in Richard
Marks, 'The Glazing of Henry VII's Chapel,
Westminster Abbey', in Benjamin Thompson
(ed.), *The Reign of Henry VII: Proceedings of the
1993 Harlaxton Symposium* (Stamford, 1995),
p. 158. The glazing has not survived, but it is
clear from descriptions and comparison with the
glazing of King's College Chapel, Cambridge, also
commissioned by Henry VII, that the predominant
theme was dynasty. Religious imagery appears to
have been confined to the upper tiers: 'the entire
ground storey glazing was given up to family and
dynastic display – remarkable not because of the
presence of these elements in an ecclesiastical
building but by their quality and prominence',
Marks, 'The Glazing of Henry VII's Chapel,
Westminster Abbey', p. 168. Similarly, at King's
College Chapel a red dragon takes a dramatic
and suggestive place in the east window, just
above the head of the crucified Christ.

[126] The sculptor is unknown by name, but was
almost certainly also responsible for work at Eton
College. See Phillip Lindley, 'Two Late Medieval
Statues at Eton College', *Journal of the British
Archaeological Association*, CXLI (1988), 169–78.

[127] For Arthmael, also known as Arthfael, Artmail
and Armel, see S. Baring-Gould and John Fisher,
The Lives of the British Saints (4 vols., London,
1907–13), I, pp. 170–3, and *Dictionnaire des
Saints bretons* (Tchou, Paris, 1979), pp. 28–31.
St Eloi, a focus of another primarily Breton
devotion, is also depicted in Westminster chapel.

432. St Winifred, and St Arthmael,
Lady Chapel, Westminster Abbey,
London, early 16th century, Stone

The desire of enthusiasts for the new dynasty to demonstrate their loyalty through images has already been noted in the widespread celebration of the marriage of Prince Arthur. Emulation of devotions relating to Henry reflected the same desire in a more personal and intimate way. The cult of St Arthmael did not attract many followers in Wales or England, but it was adopted by some of Henry's close friends and supporters. John ap Edward of Plas Newydd at Chirk fought with Henry at Bosworth and was well rewarded for his services. St Arthmael is depicted on one of two alabaster panels which were probably part of a reredos belonging to his family. The second panel depicts the bound Christ awaiting execution, in the manner of the Mostyn Christ.[128]

The celebration of Henry's origins in Anglesey may lie behind the creation of another icon of loyalty, in the form of an alabaster tomb carrying the effigies of Goronwy ap Tudur and his wife Myfanwy at the Church of St Credifael, Penmynydd. The tomb was made in about 1490, over a hundred years after the death of Goronwy, who is nonetheless accurately depicted in the armour of the late fourteenth century.[129] It may be that the initiative to create the tomb came from the king, whose great-grandfather, Maredudd, was Goronwy's younger brother. The descendants of Goronwy remaining in Anglesey had been reduced to the status of impoverished squires. However, it seems more likely that the neighbouring and wealthy Bulkeley family, who had been consistent Lancastrian supporters in the Wars of the Roses, were responsible for the commission. William Bulkeley had been constable of Beaumaris Castle in 1440 and served as deputy to Sir William Stanley in 1488 until his death the following year. At Beaumaris the tomb of William Bulkeley and his wife, Ellen Griffith of Penrhyn, is strikingly similar in design to that of the Tudors, both in the monumental quality of the effigies and

433. St Arthmael,
found at Plas-y-pentre,
Llangollen, Denbighshire,
late 15th–early 16th
century, Alabaster,
ht. 406

434. Man of Sorrows,
found at Plas-y-pentre,
Llangollen, Denbighshire,
late 15th–early
16th century,
Alabaster, ht. 635

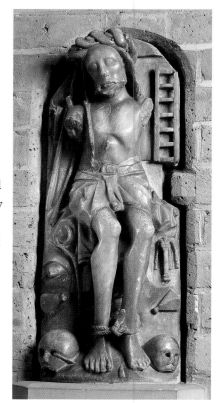

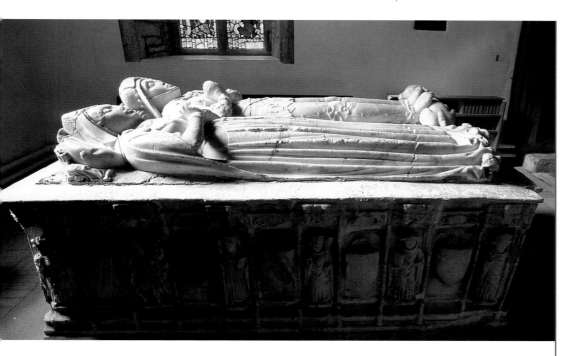

435. Tomb of William Bulkeley
and his wife, Ellen Griffith, Church
of St Mary, Beaumaris, Anglesey,
late 15th century, Alabaster

below left:

436. Tomb of Goronwy ap Tudur
and his wife Myfanwy, Church of
St Credifael, Penmynydd, Anglesey,
late 15th century, Alabaster

in the idiosyncratic *trompe l'œil* hanging of the shields carrying the family arms on pegs around the chest. William Bulkeley's will set aside £20 for the erection of his tomb and it seems certain that the same workshop was responsible for the Penmynydd tomb, which may have been made at his command slightly earlier.[130]

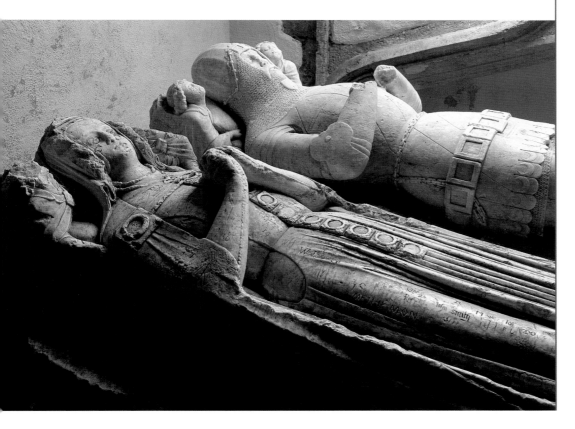

[128] See above, pp. 163–4. The panels were found concealed under the floor at Plas-y-pentre near Llangollen, Denbighshire, in 1834, a house owned by the Edwards family, though it seems likely that they were hidden there after their removal from Plasnewydd at the Reformation. In the early twentieth century the panels found their way to London churches, the bound rood to the Church of St Philip and St James at Whitton, Twickenham, and that of St Arthmael to the Church of St Mary, Brookfield, Highgate. Edwards, 'Fifteenth-Century Alabaster Tables and the Iconography of the Bound Rood and St Armel', *Arch. Camb.*, CXCI (1992), 64. St Arthmael is also depicted on a late fifteenth-century wooden reredos at Romsey Abbey, Hampshire, and on the tomb of Cardinal Morton in Canterbury Cathedral. Morton was a close friend and confidant of the king.

[129] Goronwy was a first cousin to Owain Glyndŵr through his mother. He died by drowning in 1382, but the allegiance of his surviving brothers to Glyndŵr resulted in the impoverishment of the Anglesey branch of the family.

[130] Tradition suggests that the Bulkeley tomb at Beaumaris had been removed to the church from Llan-faes at the dissolution, but this cannot be so. The will of Richard Bulkeley, made in 1537, speaks of 'a Tumbe werein my parents and ancestours ben buried and do lye' at Beaumaris. D. Cyril Jones, 'The Bulkeleys of Beaumaris, 1440–1547', *Anglesey Antiquarian Society and Field Club Transactions* (1961), 1–20. The painted arms were still visible to the herald Randle Holme in 1621. See Lord, *The Visual Culture of Wales: Imaging the Nation*, pp. 36–7. On the Penmynydd tomb the painting of the arms was carried out over lines incised in the alabaster, which remain visible. The Penmynydd tomb, which now lies in a cramped side chapel, was originally in the chancel of the church.

131 The range of Henry's patronage and the significance of his attitude towards it are discussed by Gordon Kipling, 'Henry VII and the Origins of Tudor Patronage' in G. F. Lytle and S. Orgel (eds.), *Patronage in the Renaissance* (Princeton, 1981), pp. 117–64: 'Henry can claim to be the great innovator of Tudor patronage, the creator of a royal literary and artistic establishment that he passed on to his heirs.' Ibid., p. 118.

132 Ibid., p. 149.

133 Ibid., p. 127. However, see also Janet Backhouse, 'Illuminated Manuscripts associated with Henry VII and Members of his Immediate Family', in Thompson (ed.), *The Reign of Henry VII*, pp. 175–87. Backhouse placed a stronger emphasis than Kipling on French influence on Henry's taste, which was manifested in his choice of manuscripts. She attributed this to Henry's exile in Brittany and France, ibid., p. 179.

134 The manuscript is known as the 'Chatsworth Hours', due to its location in the collection of the dukes of Devonshire at Chatsworth.

437. Inscription in the
Hand of King Henry VII,
The Chatsworth Hours, 1503,
Vellum, 205 × 140

Through the elaboration of church buildings and the construction of equally lavish palaces such as Sheen at Richmond, Henry expressed to his people the permanence and stability of the state embodied in his person. Through their high standard of design and execution, he declared his power and status to the world. Furthermore, Henry's use of visual culture to underpin the modern state was notable not only for its quality and scale, which was unprecedented in England, but for its systematic deployment. The king built his patronage into the apparatus of the state by creating and redefining royal offices such as librarian, tapestry maker, glazier and portrait painter.131 He went far beyond the efforts of predecessors, though, like Edward IV, he took as his primary model the Renaissance court of Burgundy, to whose ideas he had been exposed at Raglan before he first set foot in England in 1485. Burgundian influence was manifested not only in the general style and intention of his patronage, but also in the attraction to his court of continental craftspeople, mainly from Flanders, whose influence transformed English practice in the early sixteenth century.132 Whereas Edward IV and his supporters, Sir John Dwnn and William Herbert, had commissioned their magnificent manuscripts in Bruges, Henry was able to bring illuminators to work in England. His royal librarian, the Flemish Quintin Poulet of Lille, was both a craftsperson and an administrator. He began the process of attracting to the court some of the finest Flemish illuminators of the period. Under his direction even the documents relating to the establishment of the Westminster chapel, written in 1504, were lavishly decorated.133

Among the many manuscripts associated with the king's patronage is an illuminated book of hours which contains a remarkable perspective image of the celebration of the Mass, drawn from the west end of the choir. Henry gave the book to his daughter, Margaret, on the occasion of her marriage to James IV, king of the Scots, and inscribed it in his own hand in a way which brings him to life as an individual rather than as an embodiment of the state:

pray for your lovyng fader that gave you
thys book and I geve you att all tymes godds
blessy'g and myne. Henry Ky.134

Margaret was one of the sitters for the many portraits commissioned of Henry and his family. Her picture was among a group taken to Scotland by the king's official portrait painter, Maynard Wewyck, prior to her marriage to James IV in

438. Attributed to Giraudon,
Margaret Tudor, mid-16th century,
Médiathèque Municipale
Ville d'Arras MS 266

1503. By that time Wewyck had probably already completed the pictures known as the 'standard' portrait series of the reign, which included the king and Queen Elizabeth, Margaret Beaufort, the king's mother, and his sons Arthur and Henry. It was also from his patterns that Torrigiano created the tomb effigies of the king and his mother. Wewyck was probably a native of the Low Countries, again suggesting the importance of the influence of the practice of the Burgundian court on the new dynasty, lavishly expressed at the same time in the purchase of Flemish tapestries and glass, and in the institutionalization of patronage.[135] Henry had inherited a post of royal painter, but the incumbent, John Serle, was a generalist artisan, required to undertake a wide variety of painting tasks such as the creation of temporary armorial decoration and images to accompany events. For instance, among his works were banners hung about the hearse at the funeral of Prince Arthur, which included one displaying images of Cadwaladr and Brutus. The employment of Maynard Wewyck overlapped that of Serle and represented the first stage of the development of specialism in art forms which, during the sixteenth century, gradually filtered into practice beyond the court and led to the creation, by the eighteenth century, of a hierarchy of categories of artisan, portrait, landscape and history painters.[136]

[135] Wewyck was probably a Walloon. See Kipling, 'Henry VII and the Origins of Tudor Patronage', p. 135, note 52. The style of the works suggested to Kipling that the taste of the king for Flemish work had been formed by the gift of the portraits of the Archduke Philip and Duchess Joanna in 1496, ibid., p. 136.

[136] For the evolution of categories of practice from the sixteenth century, see Lord, *The Visual Culture of Wales: Imaging the Nation*, CD-ROM, Visual Journeys: Practice.

439. The Requiem Mass on All Souls' Day, Illumination from the Chatsworth Hours, 1503, Vellum, 205 × 140

440. Anon., *The Family of Henry VII with St George and the Dragon*, 1503–9, Oil on panel, 1384 × 1423

A painted panel of *The Family of Henry VII with St George and the Dragon* belongs to the artisan tradition of Serle, and as such represents a remarkable survivor of works commissioned for a particular occasion rather than as a permanent memorial or object of devotion. In many ways the panel epitomizes the perception of Henry which the king encouraged among his contemporaries. It combines dynastic and religious symbols in the context of chivalric display. The family kneel at prayer, divided between male and female by an angel, each group under the canopy of a pavilion which displays the royal badges. The portraits are symbolic rather than realistic since they include Arthur, who had died in 1502, and Catherine who was born and died the following year but is portrayed as a young woman.[137] The presence of the fully armed St George, who slays the dragon threatening the crowned Virgin and the Lamb, perhaps indicates that the picture was painted to mark awards of the Order of the Garter at a tournament of the kind created by Sir Rhys ap Thomas to celebrate his own elevation to the order in 1505. As we have seen, Sir Rhys had commissioned just such a piece of allegorical painting to adorn the gate through which participants would pass.[138]

[137] For portraits of Prince Arthur, see Frederick Hepburn, 'The Portraiture of Arthur, Prince of Wales', *Journal of the British Archaeological Association*, CXLVIII (1995), 148–68.

[138] See above, pp. 267–8. The provenance of the panel, sometimes misleadingly referred to as the *Sheen Altarpiece*, is uncertain. It cannot be proven that it was ever at Sheen and it is almost certainly not an altarpiece. It did not enter the Royal Collection until the 1880s. The panel is discussed by George Scharf, 'On a Votive Painting of St. George and the Dragon, with Kneeling Figures of Henry VII, his Queen and Children', *Archaeologia*, XLIX (1886), 243–300.

The establishment of the Tudor dynasty, celebrated in *The Family of Henry VII with St George and the Dragon*, marked the end of a period of deep uncertainty for many Welsh people, and a new beginning. The likes of Sir Rhys ap Thomas chose to see the prophecy of Merlin fulfilled, and participated in the establishment of a new social and political order in Wales. The union symbolized in the image of St George and St David, so prominently displayed by Sir Rhys at the Carew tournament of 1506, would not be given its legal framework until the Acts of Union of 1536–43 were passed in the reign of Henry VIII. However, the spiritual union had been achieved in the person of that king's father, Henry VII.

The core of the patronage of the visual culture of Wales would, for the best part of three centuries, lie in the hands of the gentry class which had been formed in the fifteenth century and which had crystallized under the new dynasty by the end of that century. It would represent both a regeneration from within and one which, at the highest social levels, derived much of its intellectual stimulus from the Continent. As we have seen, from the reign of Edward IV onwards leaders of Welsh society such as Sir Rhys ap Thomas, Sir John Dwnn, the Herberts of Raglan and Henry Tudor himself, though rooted in the Middle Ages, engaged through the visual culture with new ways of understanding themselves and their world in a manner which can truly be described as a Welsh Renaissance.

A p p e n d i x

Chapter 1

[64] The presumption that sculpture is not coloured is a nineteenth-century one. Both in the classical tradition, and in most non-academic traditions of carving in Europe, the norm has been for sculpture to be coloured, and in the absence of evidence to the contrary, that should be the assumption for the stone crosses of the Celtic, Anglo-Saxon, Norse and Pictish traditions. Some contemporary Anglo-Saxon crosses were certainly coloured, for which see Richard N. Bailey, *England's Earliest Sculptors* (Toronto, 1996), pp. 5–7, 109. Redknap, *The Christian Celts*, p. 51, points to the evidence of the inscribed stone from Defynnog, Breconshire: 'An elaborate cross is carved over an earlier inscription … and this would have been difficult to see unless the inscription had been whitewashed over, and the carving coloured.'

[66] The relatively late development of the sculptured stone cross in Wales has been ascribed to the emergence of the Welsh Church from a period of isolation as a result of a dispute over the dating of Easter, resolved in 768 by the decision of Bishop Elfoddw of Gwynedd to adopt the Roman system. This religious reintegration with surrounding cultures, it is argued, was reinforced at the secular level by the stabilization of relations with Mercia following the construction of Offa's Dyke shortly afterwards. This argument was proposed by C. A. Ralegh Radford, *An Inventory of the Ancient Monuments in Anglesey* (London, 1937), p. xcv, and was accepted by Nash-Williams, *The Early Christian Monuments of Wales*, p. 202. Although Welsh rulers were forming alliances with Mercia as early as the mid-eighth century, the construction of the Dyke by no means indicated a cessation of hostilities: 'Indeed, though English aggression may not have been continuous the problem certainly persisted long after the clarification of a frontier, and the "Ordinance of the Dunsaete" took care to insist that no-one crossed the frontier between English and Welsh without a guide.' Davies, *Wales in the Early Middle Ages*, p. 113. The Ordinance of Dunsaete was an agreement, probably of the tenth century, regulating trade between Welsh and English in the south-east. While the appearance in Wales of motifs in combinations commonly found on Northumbrian crosses (such as a cross-shaft from Penally, Pembrokeshire, Nash-Williams, *The Early Christian Monuments of Wales*, p. 200, no. 363) indicates interaction, to cite such examples as indicative of the emergence from 'the cultural isolation in which Wales had lingered almost since the Roman period' (ibid., p. 202) is to overstate the case, since it is clear from other sources that such interactions had, particularly in the sixth and seventh centuries, been intense.

Chapter 2

[15] Both in its unusual type (it is based on a Hebrew pattern) and in its decorative details, the psalter is strikingly similar to an example of uncertain provenance in Edinburgh, which has led Gillian Conway to remark: 'They have such similar ornamentation that one can only conclude that they are from the same school of manuscript decoration.' Gillian Conway, 'Towards a Cultural Context for the Eleventh-century Llanbadarn Manuscripts', *Ceredigion*, XIII, no. 1 (1997), 26. It is unclear whether 'school' is intended to imply Llanbadarn or, in a looser sense, the work of scribes and illuminators working in a variety of locations which incorporates a comparable fusion of elements reflecting a common training. The Llanbadarn Psalter is Trinity College Dublin MS 50. Alison Peden, 'Science and Philosophy in Wales at the time of the Norman Conquest: A Macrobius Manuscript from Llanbadarn', *Cambridge Medieval Celtic Studies*, 2 (1981), 21–45, cites initials in the Southampton Psalter (Cambridge, St John's College MS C.9), which has an Irish provenance, as a late ninth- or early tenth-century precursor of the Llanbadarn Psalter. Illuminations in two bifolia of Bede's *De natura rerum*, NLW MS Peniarth 540, suggest that this manuscript was also made at Llanbadarn. For a full discussion and further references, see Daniel Huws, *Medieval Welsh Manuscripts* (Cardiff, 2000), pp. 104–22.

[17] The manuscript also contains a number of Ieuan's own compositions, including a description of Llanbadarn which is notable for the expression of his strong sense of identity as a Briton, perhaps informed by the current political situation, and also for one of the earliest surviving comments on the Welsh landscape: 'For I am born of the famous race of Britons [which] once withstood the Roman army energetically, when Julius Caesar retreated, a fugitive. That the land of Ceredig [i.e. Cardiganshire] is certainly my homeland, I confess openly to all – once extremely rich, spiteful to enemies, kind to travellers, excelling all Britons in hospitality. This [land] exhibits the form of a table with four sides. For a lofty mountain [i.e. Plynlimon] rises at the source of the sun [i.e. in the east], advantageous [in providing] much pasture for flocks. An immense river [i.e. the Teifi] irrigates the right-hand side [of the country, i.e. the south]; and then the wide sea washes the western side. But a mighty river [i.e. the Dyfi] divides the region of the north. Thus by the sea, together with the mountain and the two rivers, this fertile region is discerned on all sides.' Lapidge, 'The Welsh-Latin Poetry of Sulien's Family', 83, 85.

[18] In particular compression forms in the text, although the paucity of earlier comparative Welsh material makes it difficult to gain a clear picture of indigenous style in all its aspects. BL MS Cotton Faustina C 1, written in a Carolingian script of the twelfth century, may also be a product of the Llanbadarn scriptorium, dating from after the two manuscripts written and illuminated in the Celtic manner. Recent scholarly opinion is divided on this matter, some regarding the manuscript as English, even though it contains material composed by Rhygyfarch ap Sulien. On the other hand, Peden, 'Science and Philosophy in Wales at the time of the Norman Conquest', 22, was unequivocal in regarding the manuscript as the product of the Llanbadarn scriptorium: 'However, this Caroline miniscule uses abbreviations, spelling forms, punctuation, and syntax marks which are characteristic of the two manuscripts known to be the product of Sulien's family. Although the script of MS Faustina C1 is of a later date than the other two manuscripts, it must be considered a product of the same tradition.' Notwithstanding its Carolingian script, the manuscript includes a single, tiny zoomorphic detail at the foot of f. 74. For an overview of medieval book production in Wales, see Huws, *Medieval Welsh Manuscripts*, passim.

[22] 'There are three powerful altars we have heard of their miracles / Between sea and woody hill-side and the powerful tide: / Mary's altar from the Lord, a most sacred and most trustworthy relic; / The altar of Peter which should be praised in his authority; / And the third altar which was bestowed by heaven: / Blessed will be its dwelling place because of its hospitality. / Blessed will be the one who will be, in fulfilment, / Where the lord of the country of Ednyfed lives; / Blessed will be the disposition of the one honoured there, / Like the Church of David was it made: / The beautiful church of Cadfan, brilliant white to the eyes, / A white church which has been whitewashed, has been splendidly whitened, / The church of faith and religion and belief and communion, / As though it had been designed by God himself.' The reference to the church of David may be to St David's or, given the monastic context, equally to Llanddewibrefi. The Church of St Cadfan in Tywyn and the poem by Llywelyn Fardd (c.1125–1200) are discussed by Huw Pryce, 'The Medieval Church' and Gruffydd Aled Williams, 'The Literary Tradition to c.1560' in J. Beverley Smith and Llinos Beverley Smith (eds.), *History of Merioneth. Volume II. The Middle Ages* (Cardiff, 2001), pp. 261–4, 523–6.

33 The theme of lamentation, focused in particular on the Virgin Mary, is generally considered to be of fundamental importance in the European consciousness of the period, and is manifested both in the visual and the literary arts in Latin (where it is known as the *Planctus Mariae*) and in many vernacular traditions: 'The theme of the sorrow and the compassion of the Virgin, so wondrously and lyrically illustrated by the vast repertory of *Planctus* transmitted to us, is indicative of the important role of the *Planctus* in providing to successive centuries one of the most original and fundamental themes of the spirituality of the eleventh and twelfth centuries, but also of its trenchant efficacy in setting forth and in making more plausible, with rich expressiveness and profound humanity, the intensity of grief of the Mother's heart, utterly and entirely possessed by the absoluteness and the fullness of the bloody human drama of God incarnate.' Sandro Sticca, *The Planctus Mariae in the Dramatic Tradition of the Middle Ages* (Athens [Ga.], 1988), p. 178. It is surprising, therefore, that neither the secular nor religious Welsh poetry of the period manifests the *Planctus* tradition. In their praise of the Blessed Virgin as the mother of Christ the Poets of the Princes concentrate exclusively on her power of intercession in response to prayer and describe her beauty and purity rather than her grief and compassion. Unfortunately, because of the paucity of surviving visual images of the Blessed Virgin from the eleventh and twelfth centuries it is impossible to demonstrate whether the same tendency was expressed in the visual culture of Wales. For the few instances of the Virgin's sorrows in later Welsh poetry, see Andrew Breeze, 'The Blessed Virgin's Joys and Sorrows', *Cambridge Medieval Celtic Studies*, 19 (1990), 41–54.

42 The style of late Celtic carving, such as that on the Anglesey fonts, tends to reinforce this view. The Welsh carvers maintained a manner of cutting interlace which revealed its origins in two-dimensional work. The impression of interlacing was created by breaking the continuity of one string where it met a second, without in fact carrying the string below the plane surface, which was maintained as if it were a sheet of paper or a skin. The work of the Herefordshire schools is often more fully three-dimensional, one string of interlace descending below the general surface level and ascending the other side, its continuity broken only by the overlaid string. Malcolm Thurlby, *The Herefordshire School of Romanesque Sculpture* (Almeley, 1999), pp. 9–32, discusses sources for the Herefordshire style. Thurlby presents both the evidence for fusion, based largely on visual parallels, and also indicates some of the difficulties. However, he does not consider the possibility that the style was essentially continental, and was transmitted by the patrons.

43 In northern Europe generally in the Middle Ages the beard had more than aesthetic importance. It was common to swear by the beard and to injure a man's beard deliberately was considered a deep insult. Since the beard was also significant in Jewish culture (see 2 Samuel 10:14, for instance) and in Welsh culture (as described in the Law of Hywel Dda), the precise origin of the iconography both of the continental examples and possibly that at Monmouth is difficult to determine. The iconography of the Eardisley font is discussed in R. E. Kaske, 'Piers Plowman and Local Iconography. The Font at Eardisley, Herefordshire', *Journal of the Warburg and Courtauld Institutes*, 51 (1998), 184–6.

72 The Royal Commission on Ancient and Historical Monuments, *An Inventory of the Ancient Monuments in Wales and Monmouthshire. Volume V. County of Carmarthen* (London, 1917), p. 234, suggests that the heads represent Christ as a youth (without beard), as a man (bearded), crucified (head falling to the left), and glorified (crowned). However, the crowned head has an open and twisted mouth, as if in pain, which hardly seems consistent with Christ in glory. Since the head on the stoup at Pencarreg is damaged and heavily whitewashed it is impossible to discern its precise nature. However, the iconography of the heads may be considerably more complicated than either of these suggestions allow. Elizabeth Parker McLachlan, *The Scriptorium of Bury St Edmunds in the Twelfth Century* (New York and London, 1986), pp. 212–15, has drawn attention to four heads representing the four winds in close proximity to the symbols of the evangelists and an image of Ezekiel in an illustration to the Bury Bible. The reference is to the second vision of Ezekiel 37:9: 'Come from the four winds, O breath, and breathe upon these slain, that they may live.' The font is where the baptizand is made a 'member of Christ and a child of God'. Here the winds of the Spirit breathe upon those slain by sin. Just as the four evangelists bear witness to the fruits of the spirit, themselves endowed with its Pentecostal grace, so do those who receive the spirit through the waters of baptism. The four winds can be represented by the four beasts (for the evangelists) as well as by four masks or heads on the font. In shorthand form, the iconography may present a summary of the doctrine and significance of baptism.

99 The connection between Ewenni and Cormac's Chapel was made by Roger Stalley, 'Three Irish Buildings with West Country Origins', *Medieval Art and Architecture at Wells and Glastonbury: The British Archaeological Association Conference Transactions of the Year 1978* (London, 1981), p. 63. Stalley was constrained at that time by the conventional dating of the construction of Ewenni, which placed it after Cormac's Chapel. However, in a detailed study, 'The Romanesque Priory Church of St. Michael at Ewenny', 281–94, Malcolm Thurlby revised the dating of the construction of the Welsh building to 1116–26. If this dating is correct, then it is possible that the mason who worked at Cormac's Chapel was familiar with Ewenni.

103 The excavation of Strata Florida was undertaken by Stephen W. Williams and his published account of 1889 remains of fundamental importance. The nationalist agenda of the period coloured his interpretation of the carving: 'Among the *débris* were found … fragments of capitals, bosses, and brackets for angle-shafts, all of the Transitional and Early English period, and displaying certain features which point to a Celtic element, more especially in the peculiar interlacing of the foliage, as if the carver had been accustomed to cutting the interlaced ropework that is so peculiar to Irish and Celtic art, and could not help introducing the same feeling in his foliage. I think this opens a wide field of enquiry as to who were the workmen that were employed at Strata Florida. They could scarcely be English. Could there have been a school of native carvers in Wales at that time? Or did they employ French, Flemish, or Irish masons?' Stephen W. Williams, *The Cistercian Abbey of Strata Florida* (London, 1889), pp. 40–1. Williams's proposal, radical at the time, that the work at Strata Florida might have been carried out by Welsh or Irish artisans remains valid, but his desire to preclude English participation on the grounds that the patron, Lord Rhys, was engaged in hostilities against the Normans, does not. For Williams, see David H. Williams, 'An appreciation of the life and work of Stephen William Williams (1837–99)', *The Montgomeryshire Collections*, 80 (1992), 55–94.

107 Llanthony Prima was abandoned (though possibly not completely) in 1135. The monks first resorted to Hereford and then to Gloucester where they set about building a new home. Portable items, including books, were removed from Llanthony Prima to Llanthony Secunda. However, the mother-house was rebuilt from c.1175, and so a new library was required. It seems unlikely that this would have involved the return of books from Llanthony Secunda, whose material ambitions in the period were scathingly reported by Giraldus Cambrensis. In c.1205 the two priories became independent of each other. However, by 1481 Llanthony Prima had declined to such an extent that it was given to what had originally been its daughter-house and probably at that stage the second library of Llanthony Prima went to Gloucester. It was received, or shortly afterwards documented, by a monk known as Morgan of Carmarthen. On this basis it is possible to be clear about which material was created at, or given to, Llanthony Prima. However, K. Bennett, 'The Development of Twelfth-century English Book Collections with Particular Reference to Llanthony Priory' (unpubl. University of Kent MA thesis, 2000), p. 17, notes that in 1421 Henry V committed the priory of Carmarthen to the custody of the prior of Llanthony for two years, and concluded that this resulted in the employment of Morgan as 'librarian'. At the dissolution many of the manuscripts from the library of Llanthony Secunda, including the library of Llanthony Prima, went ultimately to Lambeth Palace, where they remain.

Chapter 3

[101] Unaware of the existence of the Amlwch examples, White concluded that the carvings were of thirteenth-century date and associated with the court, but he was unclear as to what their function might have been. David Longley, 'The Royal Courts of the Welsh Princes of Gwynedd AD 400–1283', in Nancy Edwards (ed.), *Landscape and Settlement in Medieval Wales* (Oxford, 1997), p. 45, accepted a thirteenth-century date for the stones. Subsequent to the discovery of the four stones at Amlwch, Lynch concluded that they were of late fifteenth- or early sixteenth-century date, chiefly on the grounds that some of the faces seem to be crowned by headgear reminiscent of that worn by lawyers and ecclesiastics in the Renaissance period. However, she was unable to suggest their function or an appropriate context for the Aberffraw examples if, indeed, they could not have been a relic of the court by virtue of their date. Other stones, apparently carved by the same hand and also from Anglesey, have been noted from Plas Gandryll and Beaumaris. The Plas Gandryll example, illustrated in Lynch, 451, bears a striking resemblance to the carved heads from Castlemartin, Pembrokeshire, p. 87, which may lend some weight to the argument for a thirteenth-century date. Comparison with the corbel head from Castell y Bere (p. 131), which is known to be the product of the patronage of Llywelyn ab Iorwerth, is difficult because of the very worn condition of the Anglesey work. However, the downturned mouth and ribbed hairstyle of the Castell y Bere head is not dissimilar to some of the Anglesey heads, again suggesting an early date. This remarkable group of carvings presents an apparently intractable problem both of dating and context.

[132] Ivor Waters, *A Chepstow Notebook* (Chepstow, 1980), pp. 40–1, believed the heads represented 'medieval Chepstonians, one of them wearing a Monmouth cap', clearly an erroneous identification since the drawings upon which it was based bear little relation to the bosses themselves. However, a more plausible interpretation of the faces is hampered by the present partition of the undercroft, which partially obscures one of the carvings. The identification of the central boss as Oceanus depends on the interpretation of the surrounding foliate design as seaweed, as on the Romano-British Mildenhall Plate. Clearly, this is a matter of debate and the design may represent oak leaves, in which case Bacchus is the more likely candidate.

[136] The evidence in favour of the identification of the priest as Dafydd Ddu Hiraddug is summarized in Gresham, *Medieval Stone Carving in North Wales*, pp. 224–7. However, doubt is cast on the identification by R. Geraint Gruffydd, 'Wales's Second Grammarian', *Proceedings of the British Academy*, XC (1995), 1–29, primarily on the evidence of genealogies. Gruffydd believes that the effigy was that of Dafydd ap Hywel ap Madog, who was a grandson of one Madog Rwth, but he acknowledges that the crests on the tomb chest do not support the identification and neither is this Dafydd recorded as being a priest.

Chapter 4

[48] The poet Gruffudd ab Ieuan ap Llywelyn Fychan also saw an image of the Scourging at Rhuddlan priory in 1518: 'Yonder is an image heavy with grief / through the work of Pilate by a pillar / O holy, worthy, guardian God, / your image melts our grief', J. C. Morrice, *Detholiad o Waith Gruffudd ab Ieuan ab Llewelyn Vychan* (Bangor, 1910), p. 40, translated in Ifor Edwards, 'Fifteenth-century Alabaster Tables and the Iconography of the Bound Rood and St Armel', *Arch. Camb.* CXLI (1992), 62. The poem exists in a large number of MS versions. Gruffudd ab Ieuan ap Llywelyn also sang in celebration of the rood at Tremeirchion, Morrice, *Detholiad o Waith Gruffudd ab Ieuan ab Llewelyn Vychan*, pp. 21–6, but after the dissolution and the suppression of images under Henry VIII and Edward VI he no longer favoured portrayals of Christ's suffering on the cross, ibid., pp. 31–4.

[56] Enid Roberts has argued in 'Y Crist o Fostyn', *Bulletin of the Board of Celtic Studies*, XXI, part 3 (1964–6), 236–42, that the Mostyn Christ was the sculpture described at Rhuddlan priory by the poet Gruffudd ab Ieuan ap Llywelyn in 1518, see pp. 163–4. However, the poet described the figure as bound to a post, the characteristic iconography of the Scourging which is not evident in the Mostyn Christ. Furthermore, the Mostyn Christ is a seated figure, more characteristic of depictions of Christ immediately before the Crucifixion than of the Scourging, though there are some exceptions. Edwards, 'Fifteenth-century Alabaster Tables and the Iconography of the Bound Rood and St Armel', 56–73, accepted Roberts's suggestion and also repeated an inaccuracy in an earlier discussion of the Mostyn Christ that the iconography itself was 'extremely rare', W. J. Hemp, 'The Mostyn Christ', *Arch. Camb.*, XCVII (1943), 231. In fact the iconography is widespread in Brittany and Ireland where, for instance, a close parallel among a group of wood carvings from Fethard (now NMI) shows how the arms and bound wrists of the Mostyn Christ almost certainly appeared before they were broken and also shows how the image would have been coloured.

[83] The cross is iconographically very similar to that at Cwm-iou. The reverse of the Irish cross is carved with symbols of the Passion – the instruments and the wounds. Madeleine Gray, *Images of Piety: The Iconography of Traditional Religion in Late Medieval Wales* (Oxford, 2000), p. 48, implies in her dating of the Cwm-iou cross 'as late as the thirteenth century' that the archaic form had generally ceased to be followed by that time. The example of the Irish crosses makes it clear that this was not the case, and the Cwm-iou cross may be much later than the thirteenth century. See J. M. Lewis, 'The Cwmyoy Crucifix', *Monmouthshire Antiquary*, 16 (2000), 47–50.

[92] However, the prominence of what appears to be the emblem of the Yorkist dynasty in the period of the Wars of the Roses presents a problem in the identification of the patron. The principal estate in the area was Mathafarn and the head of the family was the poet Dafydd Llwyd, a conspicuous Lancastrian supporter, for whom the red rose was 'a favourite emblem', H. T. Evans, *Wales and the Wars of the Roses* (2nd ed., Stroud, 1995), p. 6. Even for the purposes of political expediency it seems highly unlikely that Dafydd Llwyd would have commissioned glass which gave such prominence to the white rose and, indeed, its use in the church by another patron must have seemed a considerable provocation if, indeed, the emblem carried the clarity of identification with the house of York before the Tudor period which later historians have tended to assume. It may simply be a symbol of purity and, by extension, of the Virgin Mary. For political influence on patronage in the period of the Wars of the Roses, see chapter 5.

[140] The wooden roofs of the fifteenth century at Llangollen in Denbighshire and Tenby in Pembrokeshire also include carvings of angels playing musical instruments. The writings of the Englishman, Richard Rolle, provide an insight into the reason underlying the frequent representation of angels in roofs, and particularly those depicted making music: 'Whiles truly I sat in this same chapel, and in the night before supper, as I could, I sang psalms, I beheld above me the noise as it were of readers, or rather singers … Soothly it is the sweetness of angels that he has received into his soul and with the same song of praise …, though it be not in the same words, he shall sing to God. Such as is the song of the angels so is the voice of this true lover, though it be not so great or perfect, for frailty of the flesh that yet cumbers. He that knows this, knows also angels' song, for both are of one kind, here and in heaven.' Frances M. M. Comper, *The Life of Richard Rolle, together with an Edition of his English Lyrics* (London and Toronto, 1928), pp. 92, 96.

[171] The legend depicted in images of St Christopher in Wales derives from the *Legenda Aurea* or the Golden Legend. Its popularity was reinforced in the fifteenth century by Caxton's printed version of an English translation, published in 1483. It is recorded in Welsh in a pair of poems, one in the *englyn* form, known from at least four sixteenth-century manuscripts. Offerus asks: 'Why, thou fair and beautiful little Child whom I carry on my shoulders, is bearing you such a burden for me? Why art thou, O prophesied One who takes away pain, slaying me with thy weight?' The child Jesus answers: 'Do not wonder, wise and good man, at how heavy is the wearisome burden [which you bear]; you are carrying not only the world and its long sorrows, but also the true flesh of the Lord who created it', quoted in Enid Roberts, 'Englynion Cristoffis', *Denbighshire Historical Society Transactions*, 16 (1967), 149–51. In earlier tradition Christopher was known simply as a martyr, and the later legend may have its origin in an attempt to provide a derivation for his name, Christophorus as 'Christbearer'. Versions of the later legend give the giant's original name in various forms, including Offerus and Reprebus.

[190] The well was the property of the Cistercian monastery at Llantarnam. Income from the shrine after the installation of the statue provided a fifth of the total income of the monks. *Valor Ecclesiasticus* (1535), quoted in Cartwright, *Y Forwyn Fair, Santesau a Lleianod*, p. 72, note 2. Given the increasing awareness of the revenue-raising possibilities of pilgrimage in the period, the sudden elaboration of the legends associated with the well at Pen-rhys and the provision of the statue may not be coincidental. For the same reason the volume of poetry written in honour of a shrine may not necessarily be a reliable guide to its popularity, since the poets might be commissioned to write by patrons who were keen to develop the reputation of their devotion. Nevertheless, the evidence of the poems regarding the particular popularity of the Virgin of Pen-rhys is reinforced by the evidence of Hugh Latimer, bishop of Worcester, in a letter to Thomas Cromwell in 1538, in which he describes the corruptive effect of the image of the Virgin in his own church: '… She hath been the devil's instrument to bring many, I fear, to eternal fire; now she herself, with her old sister of Walsingham, her young sister of Ipswich, with their other two sisters of Dongcaster and Penryesse, would make a jolly muster in Smithfield. They would not be all day in burning.' *Letters and Papers, Foreign and Domestic, of the Reign of Henry VIII*, vol. 13, I, p. 437. On 26 September, at Cromwell's command, the Virgin of Pen-rhys was taken down: 'The images of our ladie of Walsingham and Ipswich were brought up to London, with all the jewels that hung about them, and divers other images both in England and Wales, whereunto any common pilgrimage was used, for avoiding of Idolatrie; all which were brent [that is, burnt] at Chelsey by Thomas Cromwell, privie seale.' John Stowe, *The Annales or Generall Chronicle of England* (London, 1615), quoted in Jones, 'Celtic Britain and the Pilgrim Movement', 343.

[191] The robing of images, a practice current in some continental churches, is attested in Wales both by descriptions and by an entry in an inventory of the contents of the monastery of the Greyfriars at Carmarthen, taken at the Reformation. It includes 'ii pore cotis for owre Lady'. The inventory is given in Terrence James, 'Excavations at Carmarthen Greyfriars 1983–1990', *Medieval Archaeology*, XLI (1997), 188–9.

[194] Foxe's *Book of Martyrs* records the barbaric circumstances under which the image was burnt. A monk named John Forest was to be executed in the presence of, among others, Hugh Latimer: 'And a little before the execution a huge and great Image was brought to the gallows; which Image was brought out of Wales, and of the Welshmen much sought and worshipped. This Image was called Darvell Gatheren, and the Welshmen had a prophecy that this Image should set a whole Forest a fire; which prophecy now took effect, for he set this friar Forest on fire, and consumed him to nothing. This friar, when he saw the fire come, and that present death was at hand, caught hold upon the ladder [of the scaffold], which he would not let go; but so unpaciently took his death, that no man that ever put his trust in God never so unquietly nor so ungodly ended his life', quoted in Evans, 'Derfel Gadarn', 147.

[195] Parts of wooden shrines survive at the Church of St Erfyl, Llanerfyl, in Montgomeryshire, and at the Church of St Eilian, Llaneilian, in Anglesey. The superstructure of the Llanerfyl shrine remains, but at Llaneilian only the base survives. However, it is clear that at one time the Llaneilian shrine carried a superstructure on six columns. The stone shrines of St David and St Caradog survive at St David's Cathedral, for which see Nona Rees, *The Mediæval Shrines of St Davids Cathedral* (St David's, 1998). In a lecture given at St David's College, Lampeter (9 December 2000) J. Wyn Evans argued that the shrine of St David, now located in the north quire, was originally free-standing before the high altar. At the dissolution it was moved to make room for the tomb of Edmund Tudor, earl of Richmond and father of Henry VII, which continues to occupy that place. The Tudor tomb was removed from Greyfriars in Carmarthen. As the father of the new ruling dynasty, Edmund Tudor might be seen by the people of Reformation Wales as St David had been seen by their medieval ancestors. The stone base of what was probably the shrine of St Decumanus remains in his church at Rhoscrowther, Pembrokeshire.

Chapter 5

[97] The Bacton glass was removed to Atcham in 1811. Some jumbling of the pieces occurred on this occasion, though it may have been deliberate. In its original form the figure of St John probably followed the iconography of the poisoned cup, above, pp. 181 and 258, but the cup was given to Christ as a eucharistic symbol. At the same time a window depicting Blanche Parry, granddaughter of Miles ap Harri, was also transferred from Bacton to Atcham. Blanche Parry (c.1508–90) was a confidante of Elizabeth I, and the window depicts her facing the queen, both figures in profile. The design closely resembles that of her remarkable carved memorial, which remains at Bacton. Most of Blanche was buried at the Church of St Margaret, Westminster, but the Bacton tomb may contain her heart. For the windows, see G. McNeill Rushforth, 'The Bacton Glass at Atcham in Shropshire', *Transactions of the Woolhope Naturalists' Field Club for 1933–5* (1935), 157–62.

[105] Two such hearses survive in England, at West Tanfield, North Yorkshire, and at Warwick. Scholarly opinion differs on whether the tombs were draped throughout the year or only on particular festivals. The inventory of the contents of Carmarthen Greyfriars also recorded 'a paule of clothe of tussey, for the Erle of Richemunte's tumbe', demonstrating that it, too, was draped. Terrence James, 'Excavations at Carmarthen Greyfriars 1983–1990', *Medieval Archaeology*, XLI (1997), 188. At the dissolution the tomb was removed to the place of honour before the high altar at St David's Cathedral, possibly replacing the shrine of St David, see Appendix, chapter 4, note 195. It was heavily restored c.1872–5 and the brass inlay on the slab dates from that period, for which see Lewis, *Welsh Memorial Brasses*, pp. 106–9. The tomb of Sir Rhys ap Thomas was removed to the Church of St Peter, Carmarthen, at the dissolution. It was substantially rebuilt in 1865, though the effigies were not altered. See p. 267.

[122] The sculptor Guido Mazzoni was commissioned almost certainly because of the celebrity he gained for the design of the tomb of Charles VIII of France at St Denis. However, it appears that his radical design was not considered entirely satisfactory and by 1507 it had been rejected in favour of a third project which retained only the life-size kneeling figure of the king which had been conceived by Mazzoni. The degree of vacillation in the choice of design serves to emphasize the importance attached to achieving a memorial combining magnificence and modernity. For the tombs of both the king and Margaret Beaufort, see Phillip Lindley, 'Una Grande Opera al Mio Re': Gilt-Bronze Effigies in England from the Middle Ages to the Renaissance', *Journal of the British Archaeological Association*, CXLIII (1990), 112–30. For the Mazzoni project, see Barbara Hochstetler Meyer, 'The First Tomb of Henry VII of England', *Art Bulletin*, 58 (1976), 358–67. Mazzoni made for the king a remarkable portrait of his son, the future Henry VIII, for which see J. Larson, 'A Polychrome Terracotta Bust of a Laughing Child at Windsor Castle', *Burlington Magazine*, 131 (1989), 618–24.

Acknowledgements

Every attempt has been made to secure the permission of copyright holders to reproduce images.

The following people and institutions have been acknowledged for the kind loan of transparencies and any copyright requirements. We acknowledge the co-operation of the Church in Wales. All churches have been acknowledged with their relevant images in the captions.

Abbot and Community, Caldey Abbey: 5 (photo: Charles and Patricia Aithie)
Archbishop of Canterbury and the Trustees of Lambeth Palace Library: 125, 126, 127
Archives de l'Université catholique de Louvain: 404
Board of Trinity College Dublin: 41, 72, 73
Bodleian Library, University of Oxford: 12, 268
Boydell Press: 102
Brecknock Museum and Art Gallery, Brecon: 29 (photo: Charles and Patricia Aithie)
British Library: 94, 229, 306, 403, 405, 406, 407, 411, 425, 430
CADW: Welsh Historic Monuments. Crown Copyright: 1 (photo: Charles and Patricia Aithie), 2, 31 (photo: Charles and Patricia Aithie), 34 (photo: Martin Crampin), 45 (photo: Charles and Patricia Aithie), 62, 149, 165, 206, 212, 214, 409
Cardiff Central Library: 398, 413
Carmarthenshire County Museum, Diocese of St David's Collection: 117 (photo: Charles and Patricia Aithie), 309, 355 (photo: Charles and Patricia Aithie)
Chapter of Worcester Cathedral (U.K.). Photograph by Mr Christopher Guy, Worcester Cathedral Archaeologist: 419
Charles and Patricia Aithie, ffotograff: 6, 7, 13, 23, 25, 30, 32, 33, 35, 36, 37, 38, 40, 42, 43, 46, 47, 50, 52, 53, 56, 57, 58, 59, 61, 66, 67, 69, 70, 71, 76, 78, 81, 82, 83, 86, 88, 89, 92, 93, 94, 96, 97, 98, 99, 100, 101, 103, 104, 105, 106, 108, 109, 110, 111, 112, 114, 115, 116, 137, 140, 151, 152, 153, 156, 157, 158, 161, 166, 169, 170, 171, 172, 174, 175, 179, 182, 183, 186, 188, 190, 191, 192, 197, 199, 216, 217, 218, 220, 221, 222, 223, 226, 228, 230, 231, 233, 235, 237, 239, 240, 241, 249, 250, 252, 254, 259, 260, 262, 263, 264, 265, 271, 272, 274, 276, 277, 278, 279, 280, 281, 282, 283, 284, 285, 286, 288, 289, 290, 291, 294, 296, 297, 299, 300, 301, 302, 305, 307, 311, 312, 314, 315, 316, 317, 318, 320, 321, 322, 323, 324, 325, 326, 328, 329, 331, 332, 333, 334, 335, 336, 337, 339, 340, 341, 342, 344, 346, 347, 349, 351, 352, 353, 354, 356, 357, 358, 359, 360, 361, 365, 366, 367, 368, 370, 371, 372, 373, 374, 375, 376, 377, 378, 381, 382, 383, 384, 385, 387, 389, 391, 392, 393, 394, 395, 396, 397, 399, 410, 415, 416, 417, 423, 424, 427, 435, 436
Chepstow Museum: 80 (photo: Charles and Patricia Aithie)
Chris Warren Photography: 418
Church of St Mary, Brookfield, Highgate, London (photo: Matthew Hollow Photography): 433
Church of St Philip and St James, Whitton, Twickenham (photo: Matthew Hollow Photography): 434
City & County of Swansea: Swansea Museum Collection: 39 (photo: Charles and Patricia Aithie), 208, 313 (photo: Charles and Patricia Aithie)
College of Arms: 164
Copyright: Dean and Chapter of Westminster: 431, 432
Dean and Canons of Windsor: 402, 428, 429
Dean and Chapter of Bangor Cathedral: 163, 304
Dean and Chapter of Hereford and the Hereford Mappa Mundi Trust: 20, 21, 159, 243
Dean and Chapter of Lichfield: 14, 15, 16, 17, 18, 19
Dúchas, The Heritage Service: 118, 167
Free Library of Philadelphia, Rare Book Department: 400
Haverfordwest Town Museum / CADW: Welsh Historic Monuments. Crown Copyright: 287 (photo: Charles and Patricia Aithie)
Keith Hewitt/Country Life Picture Library: 95
Master and Fellows of Corpus Christi College, Cambridge: 75
Médiathèque Municipale, Ville d'Arras: 438
Monmouth Museum: 85 (photo: Charles and Patricia Aithie)
Musée Central, Metz: 60 (photo: La Photothèque Gallimard)
National Gallery, London: 408
National Library of Wales: 4, 8, 22, 48, 49, 54, 55, 68, 77, 87, 90, 91, 95, 120, 121, 122, 123, 129, 132, 139, 147, 148, 150, 160, 162, 173, 176, 177, 178, 180, 184, 185, 187, 193, 195, 196, 200, 201, 202, 224, 225, 227, 234, 236, 238, 242, 245, 246, 253, 258, 261, 269, 270, 303, 310, 319, 327, 330, 345, 348, 363, 364, 369, 379, 380, 386, 388, 401, 414, 420
National Museum of Ireland: 51
National Museums and Galleries of Wales
National Museum and Gallery Cardiff: 3, 11, 24, 26, 27, 28, 44, 65, 74, 113, 134, 135, 138 (photo: Charles and Patricia Aithie), 142, 144, 198, 205, 209, 210, 211, 213, 215, 244, 255, 256, 257, 266, 267, 273, 295, 308, 390
Museum of Welsh Life: 10, 247, 248, 251, 421
National Museums Liverpool (owners). Norton Priory Museum Trust: 338
National Trust Photographic Library – Cotehele House: 422
Newport City Museums and Heritage Service: 130 (photo: Charles and Patricia Aithie), 275 (photo: Charles and Patricia Aithie), 350 (photo: Charles and Patricia Aithie)
Philadelphia Museum of Art: The Philip S. Collins Collection, gift of Mrs Philip S. Collins in memory of her husband, 1945: frontis., 412
Photo ©Woodmansterne: 207
Photo: A. Netting: 136, 203
Photo: David H. Davison: 189
Photo: Gareth Lloyd Hughes: 194
Photo: John Morgan-Guy: 133
Photo: Martin Crampin: 154, 155, 168, 343
Photo: Peter Lord: 9, 64, 124, 131, 143, 181, 204, 219, 232, 292, 298, 362
Pierre Belzeaux: 79
Private Collections: 63, 293 (photo: Charles and Patricia Aithie), 426
Public Record Office: 146
Royal Collection ©2003, Her Majesty Queen Elizabeth II: 141 (photo: National Museums and Galleries of Wales), 440
Royal Commission on the Ancient and Historical Monuments of Wales. Crown Copyright: 145
Syndics of Cambridge University Library: 128
Tenby Museum and Art Gallery: 107 (photo: Charles and Patricia Aithie)
Trustees of the Chatsworth Settlement: 437, 439
Trustees of the National Library of Ireland: 119

Picture captions
Sizes are given in millimetres, height before width.
Some artefacts are not sized owing to their inaccessibility.
Reproductions of line illustrations taken from printed books and periodicals are not sized.

Index